KINFOLK

TRAVEL

KINFOLK

TRAVEL

SLOWER WAYS *to* SEE THE WORLD

JOHN BURNS

MASTHEAD

John Burns
EDITOR IN CHIEF

Staffan Sundström
ART DIRECTION & BOOK DESIGN

Harriet Fitch Little
EDITOR

Julie Freund-Poulsen
DESIGN ASSISTANT

Susanne Buch Petersen
PRODUCTION MANAGER

Edward Mannering
DISTRIBUTION MANAGER

Lourenço Providência
ILLUSTRATIONS

Rodrigo Carmuega
JACKET PHOTOGRAPHY

SELECTED CONTRIBUTORS

Eman Ali

Eman is a visual artist based between London and Oman and is a winner of the 2020 Female in Focus award.

Anthony Blasko

Anthony is a photographer from Ohio whose work has appeared in the *Atlantic*, *The New Yorker* and *Victory Journal*.

Stephanie d'Arc Taylor

Stephanie is a travel guidebook author and the founder of an award-winning startup in Beirut.

Louise Desnos

Louise is a photographer based in Paris. In 2016, she was a finalist at the Festival de Hyères.

Asaf Einy

Asaf is a photographer and visual artist based in Tel Aviv.

Teri Henderson

Teri is a staff writer at *BmoreArt* and the founding director of Black Collagists.

Monisha Rajesh

Monisha is a London-based journalist and the author of *Around the World in 80 Trains*.

Tristan Rutherford

Tristan is a six-time award winning travel writer and an editor at large at *Tonic* magazine.

FOR FULL LIST OF CREDITS SEE PAGE 344

CONTENTS

PART ONE

URBAN

Introduction

Wherever you are in the world, some destinations featured in *Kinfolk Travel* will feel far away and others more familiar. In truth, the locations are not what matter most.

This book approaches travel as an attitude of discovery as much as an action or destination. The focus is on *how* to travel rather than *where* to travel, for it's possible to feel just as inspired ten miles from home as it is ten thousand. Our proposition is to see the world slowly, by which we mean thoughtfully. It may seem counterintuitive that by doing less, you will see more, but slow travel is an invitation to explore things at a pace that allows you to absorb your surroundings as you move through them—on terms that are meaningful for both you and the people and places you encounter.

The stories in this book transport us to over twenty-five locations across six continents—to Mumbai and Muscat, Senegal and Scotland, Israel and Iran. Each destination in this book is introduced through a simple activity and a local guide, rather than an exhaustive list of its best hotels, restaurants or sights. It is unlikely that every place and pursuit we suggest will appeal to you: each reader will have their own tastes and requirements. The hope is that *Kinfolk Travel* can act as a guidebook of a different stripe: one that sparks deeper ways of thinking about new journeys and destinations.

What all our guides have in common is a strong sense of personal connection with the places they call home, which they have cultivated by engaging in each new day as if it were the first. In our Urban and Wild chapters, friends old and new welcome us into their corner of the world and reveal the private universes they have discovered within them. These gentle ways of exploring—lingering in a museum, browsing bookshops, cycling, bird-watching, walking, enjoying a bottle of wine—offer a reminder that however close we are to home, and whether in the city or in nature, there is always something new to discover.

Our Transit chapter focuses on transport as a transportive experience; we believe adopting less convenient, but more memorable, ways of getting from A to B can turn journeys from a means to an end into an end in themselves.

It is our hope that at least some of the ways in which we explore the world in *Kinfolk Travel* can be applied wherever you might next find yourself. And if that turns out to be no farther than an armchair perched next to a window at home, then we hope you enjoy these journeys vicariously. Traveling can be as simple as that: taking stock of ourselves, considering what's around us at any given moment and finding new ways to bridge the gap between the two.

URBAN

Movement, food and cultural idiosyncrasies: simple pleasures are the key to carving out space in a city and finding ways to enjoy yourself within it.

In suburbs and commuter towns, experimental housing estates represent a different vision of Parisian living. For Italian designer Fabrizio Casiraghi, these architectural outliers are a bracing contrast to the saccharine center of his adoptive home.

The Suburban Sights of Paris

Be it elegant hôtels particuliers, vaulted churches or the Hausmannian typology that has made Paris so readily identifiable, the city's romanticized history lies in its structural silhouette. Fabrizio Casiraghi, a Milan-born Paris-based interior designer with an urban planning background, considers France's respect for its past an asset. "If you're on the Pont Neuf, and you see the Seine, it's fantastic," he remarks. "It's like in every movie, and it's the best landscape."

Casiraghi's own architectural touchstone, however, is an outlier to cinematic Paris: the remarkable and gargantuan Espaces d'Abraxas, conceived by Spanish architect Ricardo Bofill in the suburb of Noisy-le-Grand. The structure is in Marne-la-Vallée, an hour's ride east of the Paris perimeter on the region's RER A commuter trains. Casiraghi was floored by its sheer scope during his first encounter: "You feel very small; it's the scenography of a theater," he says. "That's a feeling we need sometimes, to rediscover new things about ourselves."

Bofill's utopian edifices were designed to represent a truly alternative approach to Parisian living—tellingly, Espaces d'Abraxas served as the backdrop for dystopian movies like *The Hunger Games: Mockingjay* and *Brazil*. As a foreigner, Bofill wasn't beholden to French traditions or codes—and this is

what makes the three buildings (Le Palacio, Le Théâtre and L'Arc) so thrilling. Their expansiveness is a kind of exhale relative to Paris's constricted density, and even its conservative homogeneity. The experiential value of Bofill's buildings is the new sculptural sense of space they inspire, one that is radically different from the rigorous uniformity of the city center.

The Espaces d'Abraxas offer a singular visual vocabulary and unusual scale for the Île-de-France—so much so that Casiraghi likens a trip to the Espaces d'Abraxas to his first teenage visit to New Delhi, in that it provoked a kind of sensorial overload. "Only Bofill could do that, and that is its strength. It's like a piece of art," he says. Its aesthetic punch stems from its oversize proportions: "Everything is neoclassical—like typical Greek columns—but enormous! When you walk along the agora, it's completely different than walking along a boulevard."

Vast estates on the outskirts of Paris, known as banlieues, were originally built in the latter half of the twentieth century to house—and sequester—immigrant populations. The communities and topographies alike were stigmatized, although these projects were framed under the utopian narrative of a *ville nouvelle*, or new city. The stigma stemmed from socioeconomic factors and the implementation of utilitarian

structures, a kind of explicit "othering" by flouting any continuity with archetypal French design and lifestyle.

Most banlieue buildings are "horrible boxes with no connection to the city and no architectural value," Casiraghi states. Bofill, however, applied new iconography to the banlieue, as well as a specific conceptualization of metropolitan living: a mélange across ethnic, social, economic and generational lines. Based on sociological studies he'd read, he saw the necessity of social mixing, insisting that a certain percentage of recent immigrant communities be threaded with local French ones within the residences. Casiraghi concurs that this is the crux of well-adapted urban living.

A handful of Paris's other suburban sites are worth visiting too: the cluster of stainless-steel residential buildings Les Tours Aillaud of Cité Pablo Picasso in Nanterre (which have recently undergone a vast multi-million-euro renovation), the four-tiered buildings bundled as Les Damiers at La Défense in Courbevoie and the ten remarkable buildings with bulbous balconies producing undulating forms known as Les Choux (*choux* being French for cabbage) in Créteil.

Casiraghi's own polished, understated aesthetic—a mix of Parisian decorative tradition and Milanese sobriety—has made him a draw for discerning design commissions: boutiques for Lemaire and Kenzo in the Haut Marais, or the interiors for Café de l'Esplanade in the seventh arrondissement, and Drouant restaurant in the second. "I live in the ninth— one of the most fancy, trendy arrondissements in Paris. In my street, there are two social housing buildings. When you put social housing next to people who can buy an apartment for two million euros—it's something," he said. "Having total uniformity of people from the same backgrounds doesn't work."

Today, whether these aging banlieue projects are particularly livable is debatable—in fact, there were plans to demolish the Espaces d'Abraxas development in 2006, which were blocked.

France is deeply proud of, and protective of, its heritage— perhaps most fervently in the realm of architecture. Visitors and residents alike tend to want the mythology of Paris— with its elegance and taste—to remain undisturbed, rather than refreshed, even in the twenty-first century. But Paris is in the process of implementing an ambitious urban plan for the future: bridging the divide between the underprivileged banlieues and the central arrondissements. The hope is to make communities less sectarian and less isolated. Perhaps it will also lead to a flowering of culture outside of the city center.

Casiraghi believes that if Bofill's original vision for the Espaces d'Abraxas had been better maintained, the complex could have become a design destination, joining the pantheon of long-standing Paris landmarks. Even in a place as seemingly suspended in the past as Paris, what possesses value and beauty can shift. "A person living in the first or second arrondissement doesn't want to go to the eighteenth," Casiraghi laughs—by extension, the reticence to go to Noisy-le-Grand is even greater. "Yet people will travel to the chapel made by Le Corbusier in middle-of-nowhere France. Why couldn't they come here?"

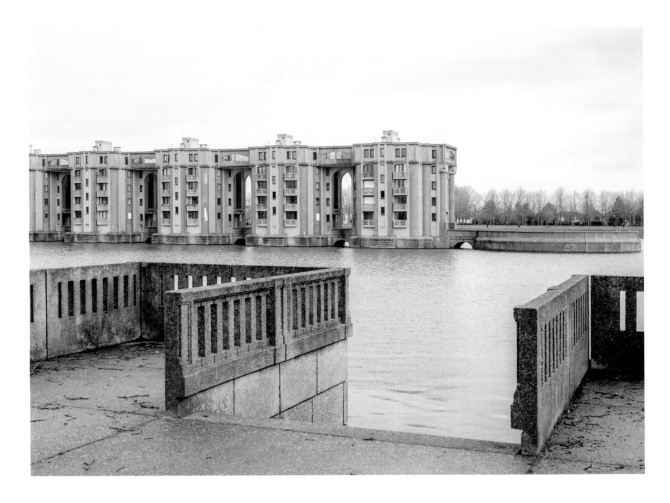

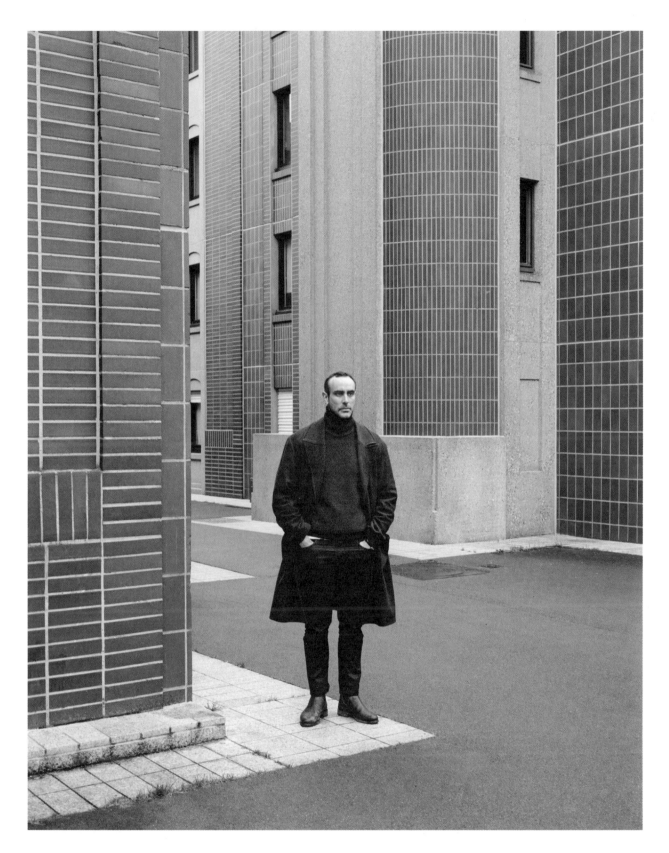

Opposite
—
Les Arcades du Lac at Saint-Quentin-en-Yvelines is just over an hour on the train from Paris's Gare du Nord. The social housing project was the first that architect Ricardo Bofill completed in France.

Above
—
Casiraghi walks through Les Arcades du Lac, which are entirely pedestrianized. The apartment blocks were designed to mimic the hedgerows of a formal French garden.

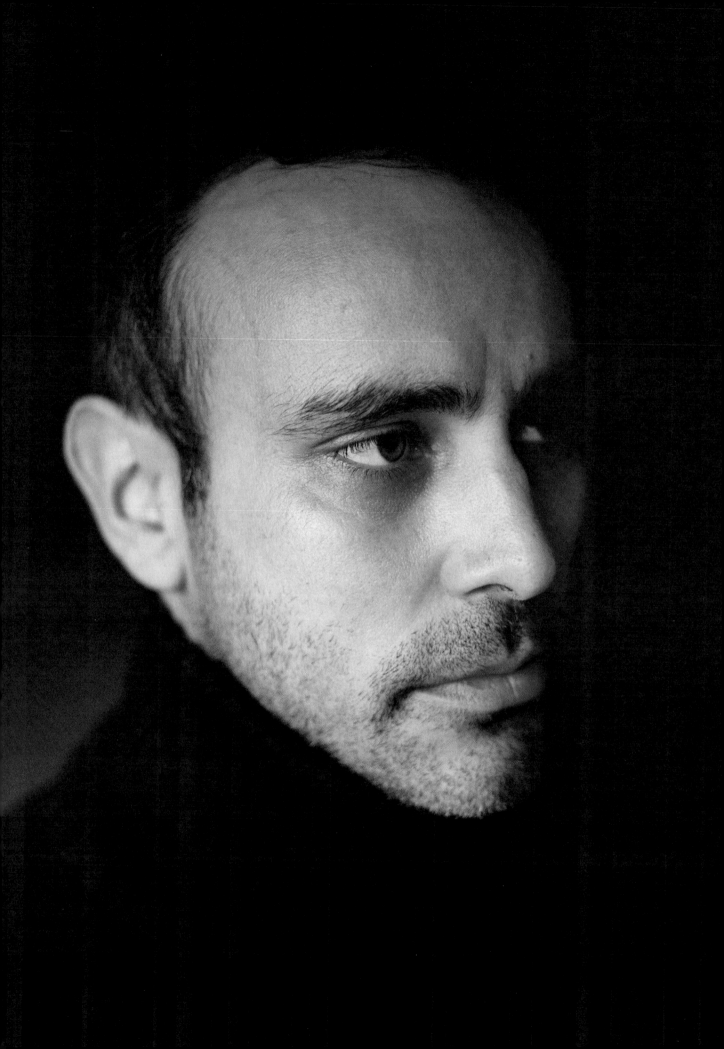

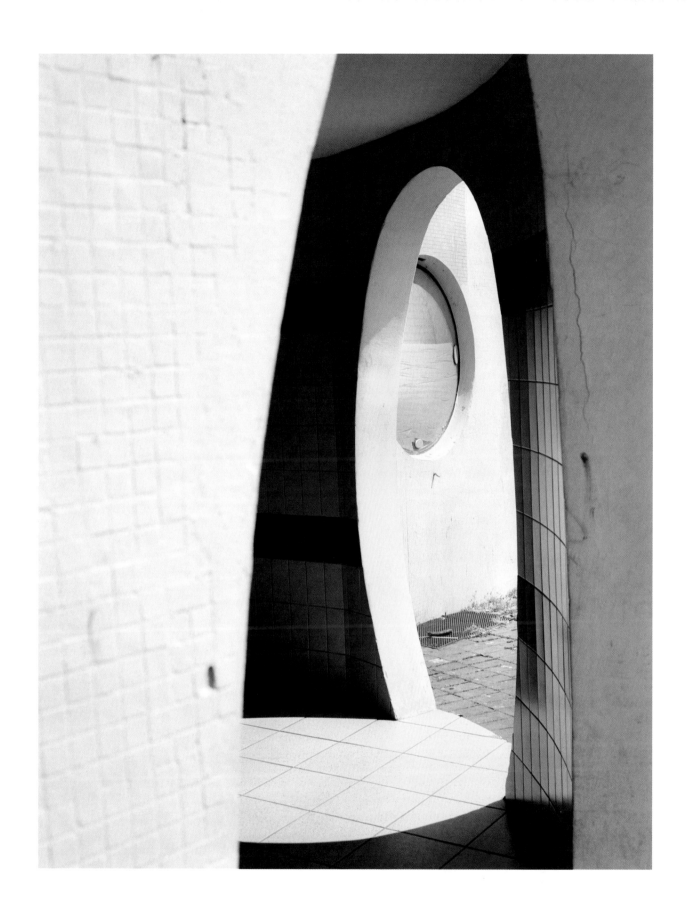

"You feel very small. . . . That's a feeling we need
sometimes, to rediscover new things about ourselves."

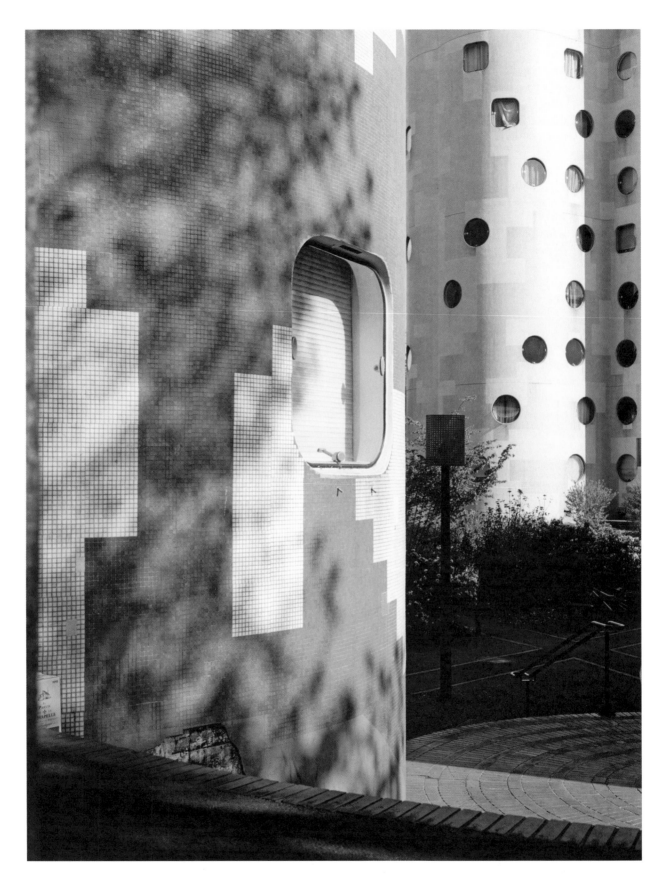

Above
—
Les Tours Aillaud (a thirty-minute train ride from Châtelet–Les Halles station) were built in 1976 and comprise over 1,600 apartments.

Opposite
—
What unites each apartment at Les Tours Aillaud is Aillaud's retro-futuristic window design—each is circular or shaped like a water droplet.

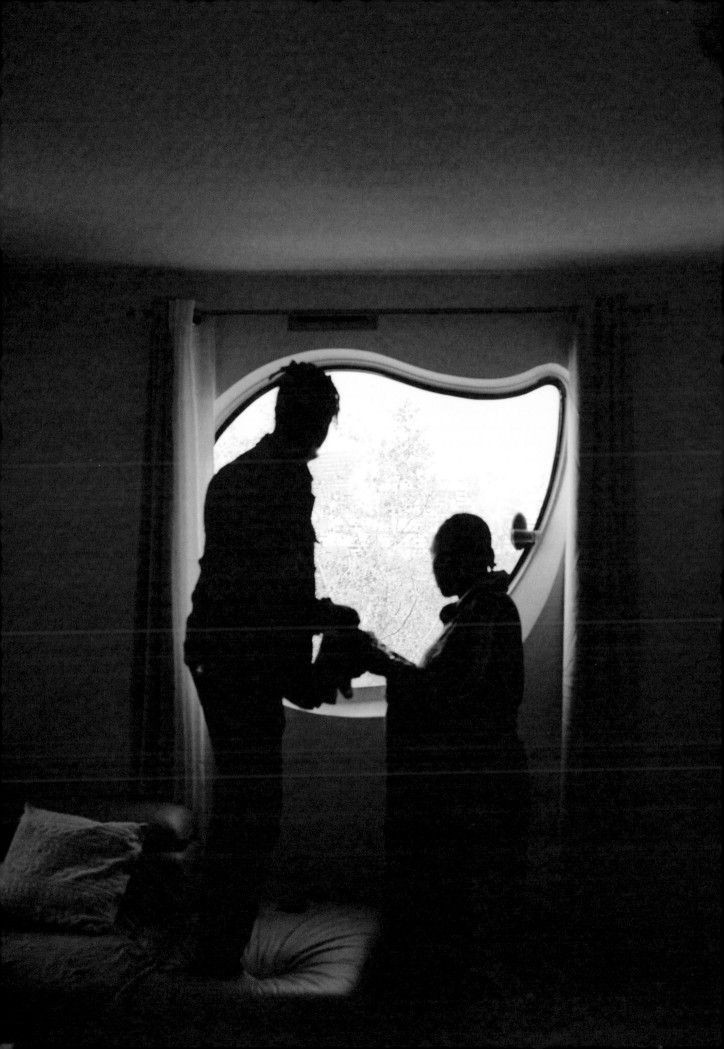

Above Right
—
Sarabande pour Picasso, a sculpture by Spanish artist Miguel Berrocal, is just one the decorative flourishes at Les Arènes de Picasso. The social housing complex is sometimes referred to as "Les Camemberts."

Opposite
—
Designed by Manuel Núñez Yanowsky and inaugurated in the mid-1980s, Les Arènes de Picasso (a twenty-five-minute train ride from Châtelet–Les Halles station) is one of Noisy-le-Grand's most striking sites.

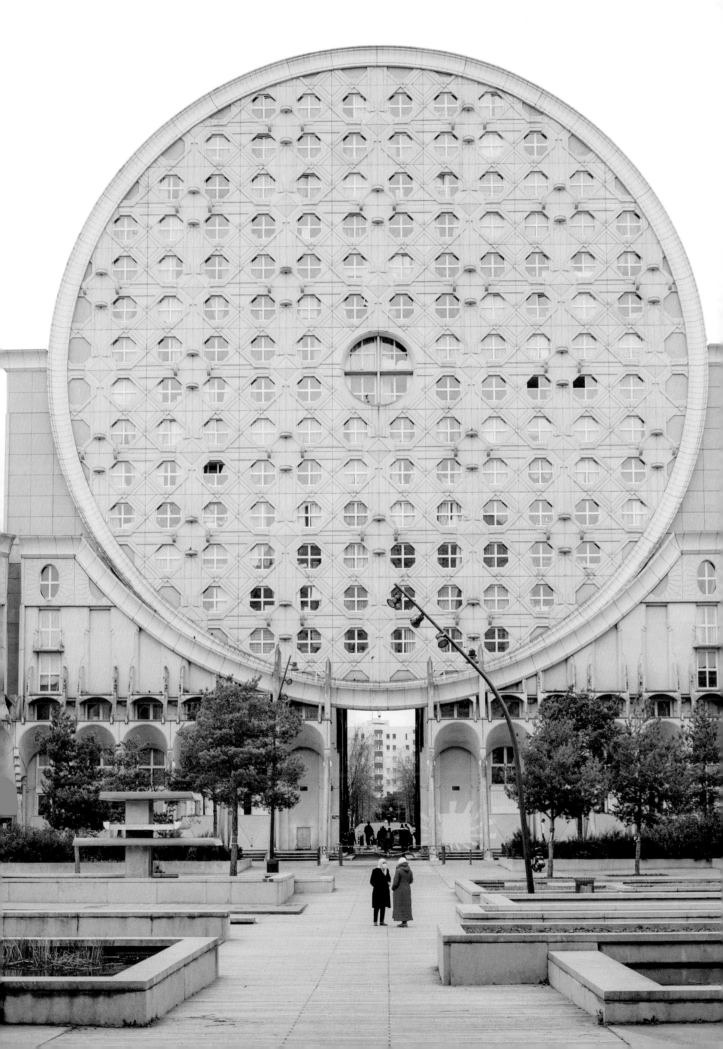

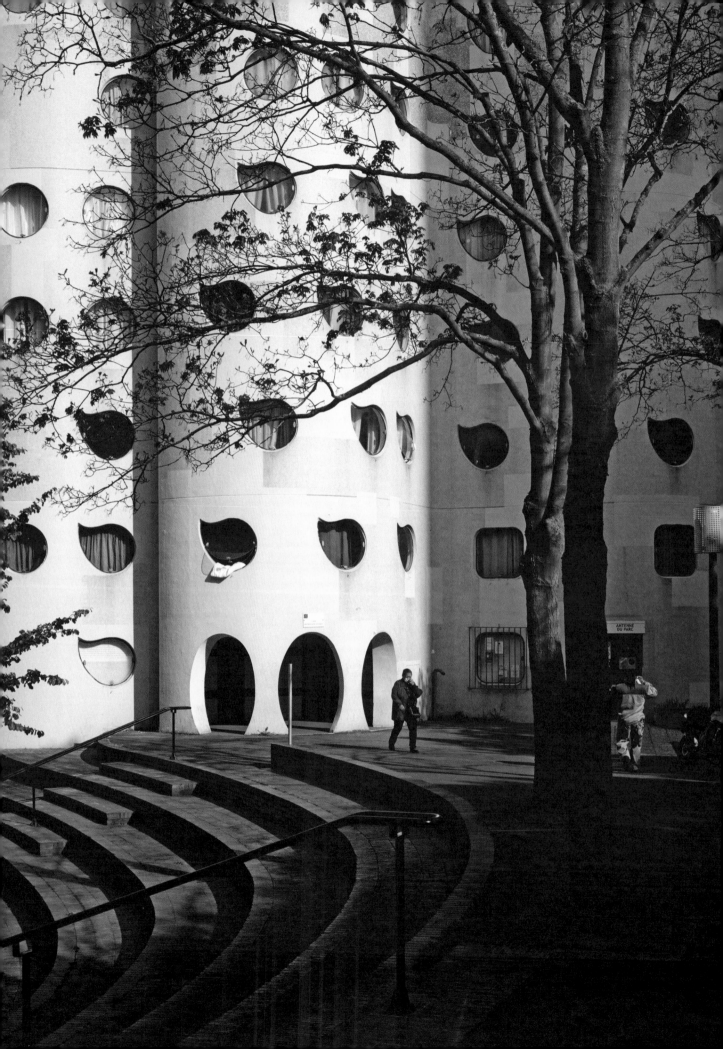

1

LES TOURS AILLAUD CITÉ PABLO PICASSO

The soaring steel spires of La Défense are a world away from the Paris you think you know. On the edge of the city's famous business district are the white, pink and blue-veneered Tours Aillaud, more commonly known as the Tours Nuages—or Cloud Towers—whose insouciant undulations add a touch of whimsy to an otherwise gray district.

Nanterre, Paris

2

LES DAMIERS DE LA DÉFENSE

These two pyramid-shaped apartment buildings from the 1960s are looked on affectionately by many—including Brutalism buffs and the two tenants who have so far resisted eviction. To the Russian heritage group whose plans to transform the Damiers into two soaring spires have so far gone unrealized, they are eyesores whose time has been and gone.

Courbevoie, Paris

3

LES ESPACES D'ABRAXAS

Ricardo Bofill conceived Les Espaces d'Abraxas as an "urban monument." The three main buildings feature design flourishes—cornices and columns—inspired by neoclassical buildings in the city center.

Noisy-le-Grand, Paris

4

LES ARCADES DU LAC

The mixed suburban and low-income housing complex of Les Arcades du Lac, built in 1981 by Ricardo Bofill's Taller de Arquitectura, was designed as a response to two very disparate architectural projects. First, they exist in opposition to Le Corbusier's stark white housing projects of the 1960s. But also they are a reaction against the opulence of the nearby Château Versailles.

Montigny-le-Bretonneux, France

5

CITÉ DU PARC

Viewed aerially, the Brutalist Cité du Parc housing complex in the Ivry-sur-Seine suburb of Paris doesn't look particularly hospitable—its spiky jags of concrete make it look more like a huge throwing star than a welcoming apartment complex. But look closer: down in those nooks and crannies are leafy balconies and cozy, homely comforts.

Ivry-sur-Seine, Paris

6

LES ORGUES DE FLANDRE

The Organs of Flanders, four Brutalist towers in the nineteenth arrondissement, are named after types of musical compositions: prelude, fugue, cantata and sonata. They seem to undulate musically too: leaning over the street here, a staircase spiraling upward there. But Brutalist principles hold true in that the towers are also assigned functional numbers to identify them.

24 Rue Archereau, Paris

7

LA CITÉ CURIAL-CAMBRAI

The interlocking balcony systems of the Cité Curial-Cambrai, by which one corner of the building is connected to another, gives it the appearance of a vertical maze. With this unifying effect, it's easy to forget that the block comprises dozens of separate apartments, divided internally by innumerable walls.

Curial-Cambrai, Paris

8

CHOUX DE CRÉTEIL

Paris has its asparagus—that's the nickname Parisians gave the Eiffel Tower when it was first erected in 1887—and the suburb of Créteil has its cabbages. Ten white, 1970s-era towers of fifteen stories each grow out of the ground, with leaf-shaped balconies from which to enjoy the view.

Créteil, Paris

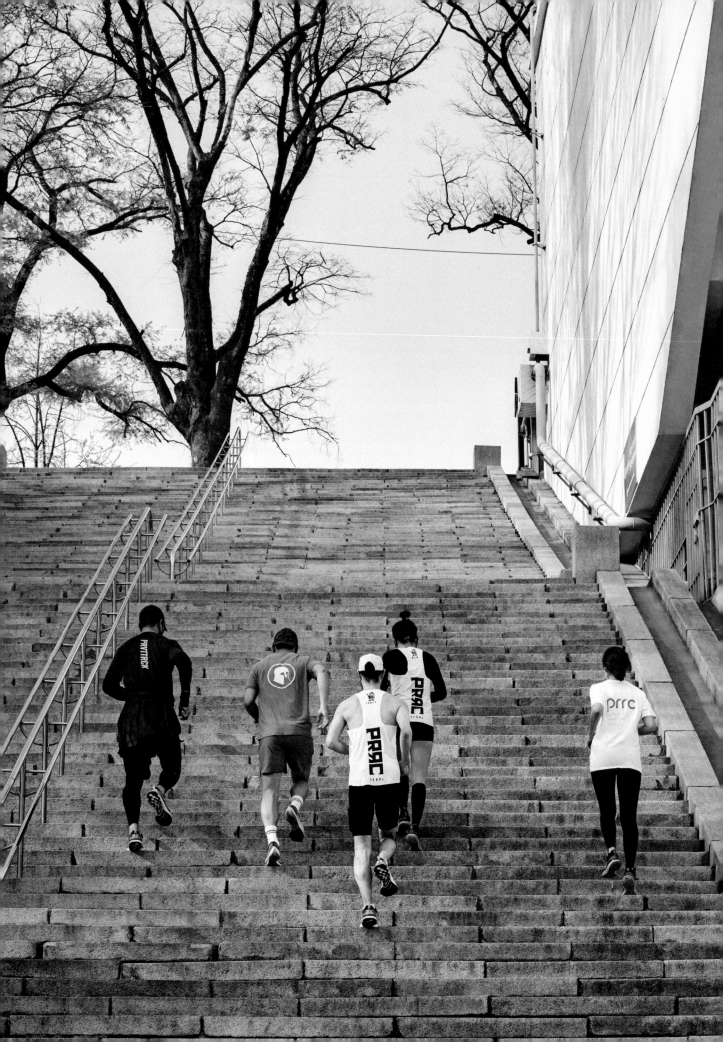

Racing through city streets may seem counterintuitive to slow travel. In Seoul, however, running brings motivation and a means by which to explore the Korean metropolis—at least for local running club founder James Lee McQuown.

Running the Streets of Seoul

As one of the world's most frenzied megacities, Seoul might not seem the likeliest setting in which to seek a runner's high. The sidewalks are stuffed with vendors and pedestrians; the roads rammed end-to-end come rush hour. Yet local runners know that it's precisely this chaos that gives crossing Seoul on two feet a certain unparalleled feeling of relief—maybe even of meditative reprieve.

Ten years ago, running wasn't the trend it is now in South Korea. The casual observer would have been hard-pressed to spot anyone partaking besides the occasional ajeossi, a middle-aged man, most likely wearing a pair of short shorts and maybe even carrying a handheld tape player to listen, without headphones, to some old-timey tunes. Since then, however, the running scene has greatly expanded, and the culture surrounding it has too—thanks in no small part to one underground crew of DJs.

In 2013, six members of the 360 Sounds collective of musicians and artists decided to broaden their domain from the nightclubs to the roads, at first simply as a way to bring balance to their unhealthy lifestyle of late nights and heavy drinking. They called their group the Private Road Running Club—it was an informal get-together of friends at the time. But when more and more people—and brands—inquired about getting involved, PRRC opened up to the public.

"There has been a huge growth in the community, and it's awesome we were able to be a part of that spark," says PRRC cofounder James Lee McQuown, thirty-eight, who works as a model and DJ in Seoul. "When we started, people were like, 'What are these kids doing?' ... When everyone's out just drinking, having fun, we're going out and sweating. It took a few years for people to catch on."

Since its founding, membership at PRRC—@prrc1936 on Instagram—has grown to be hundreds strong, with between thirty and fifty members showing up regularly for runs. Lee himself went from rarely running anything beyond five miles (8 km) before PRRC to lacing up on a near-daily basis, rain or shine (or, in Korea, fine dust or no fine dust). Over the years he has participated in six marathons and nineteen other races. "Private Road Running Club sort of became a metaphor, because even if you run with other people, you still have to physically run your own private road. If life is a marathon, it's your responsibility to pace yourself," he says.

Seoul, with its urban variety and versatility, has become a premier running city. One day, a runner could choose mountain courses and dirt trails; the next, the wide-open space of a park or the flat, even path of a track. In spring, dedication to the practice will be rewarded with the sights and scents of

cherry blossoms; in autumn, the foliage falling in rich rusts and auburns.

For sociable runners, PRRC is a friendly group that encourages people to #JoinTheMotion and will welcome any tourists who reach out. "Come out and be part of the movement," Lee says. And for those who prefer to run and explore alone, he has no shortage of recommendations to offer.

"In terms of routes, the prize of our city has to be the Han River. The river acts as an equator, splitting Seoul into north and south, so it's the most accessible and largest open space within our city limits," he says. "The Han stretches beyond the city so you can run to your heart's content. I've run several solo marathons riverside." Another pleasant waterway to follow is Cheonggyecheon, which flows through an area of urban renewal downtown, eventually connecting with the Han. Lee also suggests the popular routes of Seoul Forest, Olympic Park, Yeouido Park, Sky Park and Namsan, the park and mountain at the heart of the city.

But, he adds, visiting runners shouldn't limit themselves to preset paths. "Just go out and run in one direction. Get lost. And then you can always catch a cab or get a train and find your way back," he says. "It's a great way to see the city. Because it's not dangerous here, you can be a little bit more ambitious, a little more adventurous."

There is no better way to get to know Seoul, Lee believes, than running your way through it. "It allows you to appreciate your surroundings more," he says. "There's an intimacy that develops when you traverse certain distances by foot. You get a feel for the environment, you notice the wildlife, you take in the smells, and even feel the season—all things that would be missed if locked away in a car or train."

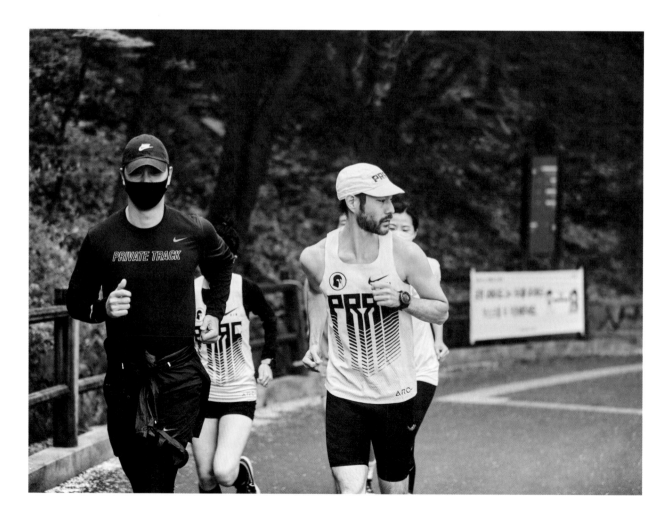

Opposite
—
Lee (right) and members of the Private Road Running Club take a route through Namsan Park, directly north of Itaewon. The park includes the entirety of Namsan mountain.

Above
—
Itaewon-ro is a lively street near Namsan Park. The streets that wind down through the surrounding neighborhood are full of cafés where you can unwind postworkout.

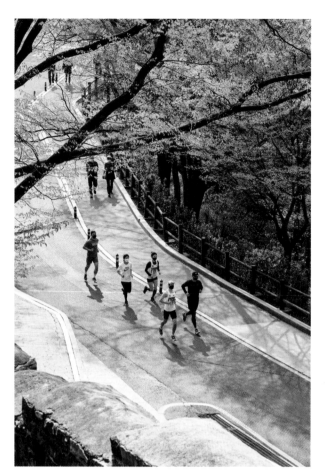

Above
—
The routes through Namsan Park
are steeply inclined; the park is
known for the 860-foot (262 m) peak
at its heart. At the top you'll find the
iconic Seoul Tower and spectacular
views of the Seoul cityscape.

Opposite
—
Itaewon is Seoul's most international
neighborhood and where you'll find
some of the city's most exciting
restaurants, retail stores and night-
life. The name Itaewon alludes to its
former abundance of pear trees.

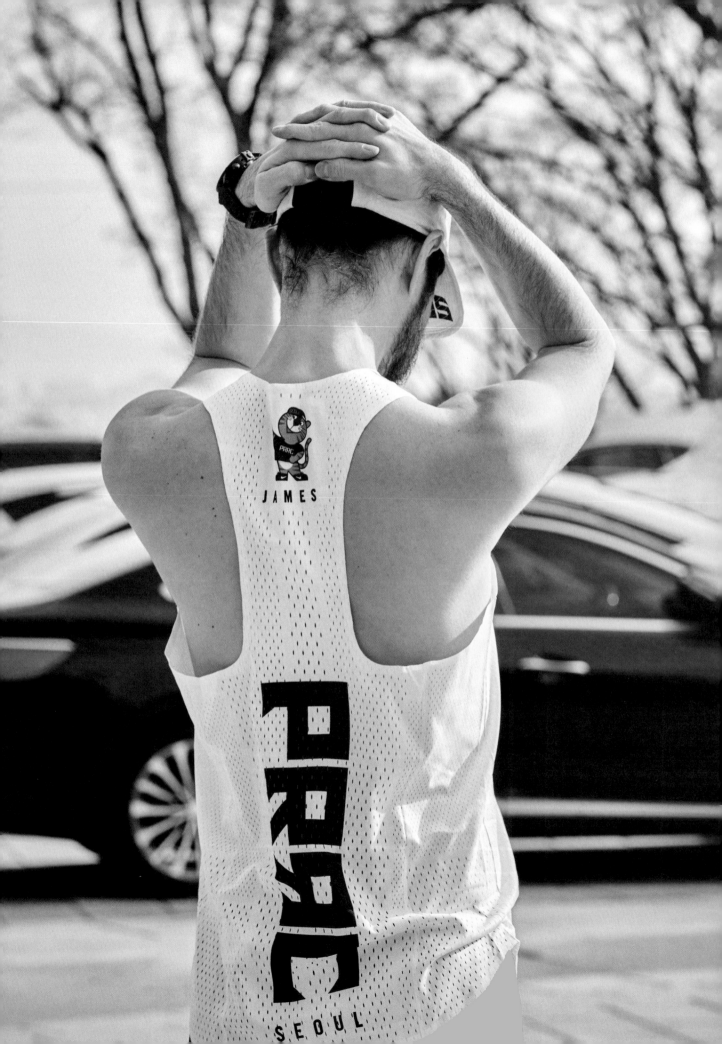

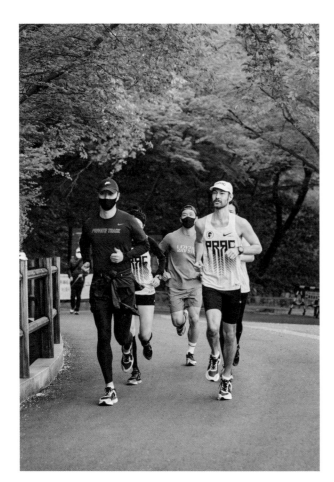

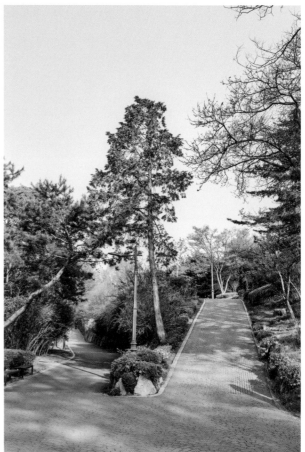

Above Left
—
Private Road Running Club welcomes any tourists who would like to join in and explore Seoul. Lee encourages anyone who would like to take part to simply reach out over social media.

Above Right
—
Namsan Park can be seen from all over Seoul, and residents use the grassy parklands and tree-lined path-ways in the park surrounding it for daily exercise. The park is at its most picturesque during cherry blossom season each spring.

1

HAN RIVER

There are pathways wending along the banks of the Han River on both of its sides that make ideal running routes. A loop between the Banpo and Hannam Bridges takes you through several riverside parks on a roughly four-mile (6.4 km) circuit.

4

YEOUIDO PARK

A five-mile (8 km) run around the island of Yeouido in central Seoul affords views of the National Assembly building, the Korea Development Bank and other scions of the metropole.

6

HANEUL PARK

Built on the site of a former landfill in central Seoul, Millennium Park features trails that culminate at Sky Park, or Haneul Park in Korean. Run up 291 stairs that crisscross a steep embankment, then down and over to one of the four other interconnected parks that make up the complex.

2

NAMSAN PARK

The largest park in Seoul features over six miles (10 km) of paved pathways, as well as a 1.2-mile (2 km) steady climb up to the higher ground, where the Seoul Tower presides over the city. Visits in spring are spectacular, as the park is also home to the city's largest concentration of cherry blossom trees.

5

BUKHANSAN NATIONAL PARK

It's just a twenty-minute drive, traffic depending, from central Seoul to the visitor center at Bukhansan National Park. Once you get there, you'll find three craggy granite peaks to hike and over thirty square miles (78 sq km) of forest to run through. Pause for temple visits and rock climbs.

7

CHEONGGYECHEON

A major urban renewal project completed in 2005, Cheonggyecheon Stream runs over six miles (10 km) through central Seoul, passing some of the most vibrant entertainment, shopping and economic centers of the city. Along the route, Candle Fountain is of particular note, featuring spectacularly lit thirteen-foot-high (4 m) water features.

3

YANGJAECHEON

One of the tributaries of the Han River, Yangjaecheon Stream is a verdant public works project running 4.3 miles (7 km) between Gangnam and the Seoul Racecourse Park. Along the trail are hundreds of mature metasequoia trees, providing shade and a calming atmosphere.

8

OLYMPIC PARK

Built to host the 1988 Summer Olympics, Seoul's Olympic Park is home to the World Peace Gate, which harbors an eternal flame and a series of murals. Zoom by the flame and carry on to check out the two-hundred-plus pieces in the Sculpture Park, flag plaza and the fragrant Rose Park.

The Chilean capital marches to the beat of its own drum. According to electropop musician Javiera Mena, there's no better way to feel Santiago's spirit than by listening to it—on an evening spent hopping between music venues and bars.

The Soundtrack of Santiago

Chile's snow-dusted Andean backbone stretches impressively over Santiago; below, the glittering skyline of the capital's financial quarter is punctured by the Gran Torre Santiago, South America's tallest building. At street level, however, things are more dynamic: a thriving underground scene, strident protests and wider demographic shifts are amplifying the soundtrack of a city in transition.

Silence is an unfashionable commodity here. "I'm a downtown girl," says electropop artist Javiera Mena, who grew up between the colorful Mapocho, Yungay and República barrios in the heart of the city. In 2019, she moved to Spain to explore new career opportunities. "I feel like I never really left Santiago," she says. "I'm always coming and going. My roots are in the city center, and that's where I go to reconnect with who I am." This neighborhood offers a window into Santiago's vibrant nightlife: "Santiago is so segregated geographically and economically that people rarely get to mix, but the center is where you really see what's going on in Chile," she says.

Mena and her contemporaries have given Santiago an experimental, electronic makeover. Mena was born in 1983 under General Augusto Pinochet's repressive dictatorship, and struggled to find common ground with Nueva Canción, the austere folklorists popular with her parents' generation.

"I didn't like it at all as a rebellious teenager," she says. "It was serious music for hippies."

As one of the lucky few to have internet in the mid-1990s, she set about downloading British and German music and later spent long afternoons in front of the computer composing her own. Back then, she says, there were almost no foreigners, but migration to Chile has climbed sharply in just a few short years: nearly 1.5 million foreign nationals now reside in the country. In turn, the city's rhythm has taken a marked departure from the iconic soundtrack of the 1960s and early '70s, when the protagonists of the Nueva Canción movement propelled Chilean music onto the world stage.

Mena soon found herself bridging the mainstream and experimental at the city's small venues alongside alternative rock bands including Congelador and Pánico, as well as hip-hop acts like Tiro de Gracia and Makiza. She was eventually invited to perform at Blondie—a renowned underground club in the city center that remains one of her favorite venues.

With several floors hosting live DJ sets, Blondie has been paving the way for the city's gay-friendly venues since the 1990s. "It was the place where the misfits and outsiders would meet up, and where I first realized that there were actually a lot of people like me," says Mena. "I grew up frightened

of saying that I was a lesbian because I knew what the consequences could be. There were always spaces for gay men, but there weren't many openly gay women at that time. I see progress every time I am back in Santiago now."

Mena says that she also heads to Club Bizarre whenever she returns, and recommends Recreo Festivals, the pop-up electro events that temporarily breathe energy into abandoned spaces across the city. No matter where your night begins, chances are you will end up in one of two popular barrios, Brasil or Yungay, where nineteenth-century avenues are lined with lively bars, nightclubs and cultural venues. At one end of Calle Agustinas, a street in Yungay, the Centro Cultural Matucana 100 puts on a comprehensive program of theater, dance, live music and visual arts—attracting top Chilean and international acts. At the other end of the neighborhood are the Estación Mapocho and Palacio Pereira cultural centers, both of which Mena used to perform at early on in her career.

Since the spring of 2019, Santiago has been gripped by a visceral protest movement, calling out Chile's deep inequalities and challenging the country's outward image of economic success. In the days after the protest movement exploded into life, the anthems of the Nueva Canción generation rang again through the streets, and cacerolazos—pot-banging protests—united the city in a clamorous, revolutionary cacophony. "The cacerolazos bring a tear to my eye because they are such a primitive, unifying expression of dissent. But this is a pop culture movement too," says Mena. Amid an explosion of color, music, performance and art, graffiti artists were quick to transcribe their dissent onto the walls of downtown Santiago. Across the Mapocho River in Bellavista, another barrio long established as one of Santiago's best for bars and live music, the Museo del Estallido Social has collected much of the art from the protests alongside video and audio recordings.

"Ever since I was a child there has been social discontent," says Mena. "This was just the drop that made the glass overflow." While Santiago remains a foreign travelers' gateway to the Patagonian ice fields, Easter Island and the Atacama Desert, music and protest have intertwined to give the Chilean capital's downtown a rhythm all of its own—that of a city adjusting to a new era.

Opposite
—
Before her acclaimed breakthrough, Chilean synth-pop musician Javiera Mena started out in Santiago, performing at the city's underground parties and clubs.

Above
—
Bar El Bajo, located within Centro Cultural Gabriela Mistral, opened at the end of 2020. Inside is a stage for live music, and outside plant-filled terraces overlook Plaza Zócalo.

Above Left
—
The decorative spires of Catedral
Metropolitana de Santiago are the
centerpiece of Plaza de Armas, San-
tiago's historic public square.

Above Right
—
Come evening, bars and cafés spill
out onto the streets of Bellavista, a
popular neighborhood for nightlife.

"My roots are in the city center, and that's where I go to reconnect with who I am. . . .
The center is where you really see what's going on in Chile."

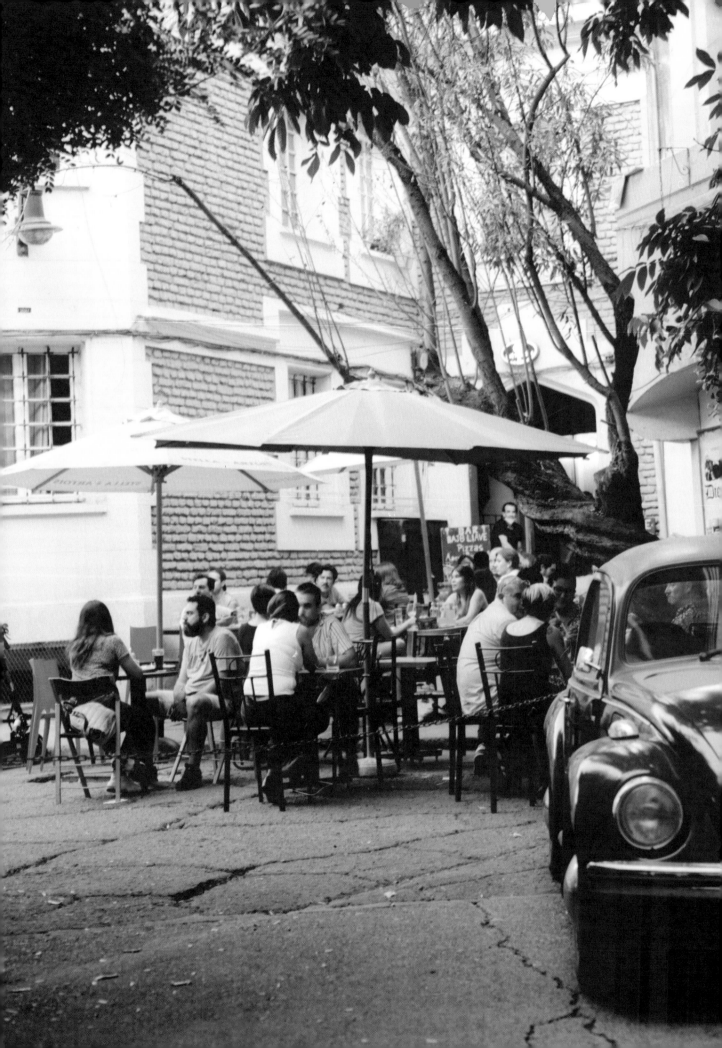

WHERE TO SAMPLE SANTIAGO BY NIGHT

1
BAR EL BAJO
If you fancy rubbing shoulders with the musicians, actors and dancers who pass through the Centro Gabriela Mistral, make for Bar El Bajo. As the name would suggest, the bar is situated right under the arts center in the city's bustling Lastarria district and serves sharing plates in case you strike up a conversation.

Av Libertador Bernardo O'Higgins 227, Santiago

2
MATERIA PRIMA
This spot arrived on the scene at the end of 2018, and happy oenophiles have been popping corks there ever since. Materia specializes in local and organic wines, so it's an ideal spot to get acquainted with the renowned Chilean wine scene.

Constitución 187, Bellavista

3
NOA NOA
Tiny Noa Noa draws the club set to its carefully designed space: floor-to-ceiling monotone color, flattering amber lighting throughout and a striking wall-to-wall LED screen behind the second-floor DJ booth. On the lineup are a unique mix of underground Chilean and South American electronic artists and DJs.

Merced 142C, Santiago

4
BAR CUENTO CORTO
Cuento Corto is a great place to dabble in pisco: the brandy, made from distilling fermented grape juice, is the national drink of both Chile and Peru. It is worth taking a moment to admire the graceful old mansion that houses the bar. Inside, the drinking atmosphere is tranquil. Outside, in the courtyard, musicians regularly provide an atmospheric accompaniment.

Av Republica 398, Santiago

5
BAR LORETO
This indie club hosts a diverse array of local and international bands and DJs, sometimes on the same night. Check out the band playing downstairs, then ascend to electronic bliss on the thumping second floor. You won't get lost: the club's capacity is a (relatively) intimate four hundred.

Loreto 435, Recoleta

6
CHUECA BAR
You might not expect a publicist and a lawyer to be behind Chueca, a bar that has a real countercultural feel. It is Santiago's first explicitly feminist, LGBTQ+ friendly lesbian-owned bar. A vegan menu is available, though you may be content just checking out the kitschy interior, festooned with shoes glued to the ceiling.

Rancagua 406, Providencia

7
GRACIELO BAR
Gracielo is a friendly cocktail bar on the roof of a casona—one of Santiago's old manor houses. Locals and visitors chat over pisco cocktails and posh bar snacks, looking out over views of Santiago's skyscrapers and the mountains beyond.

Cirujano Guzmán 194, Providencia

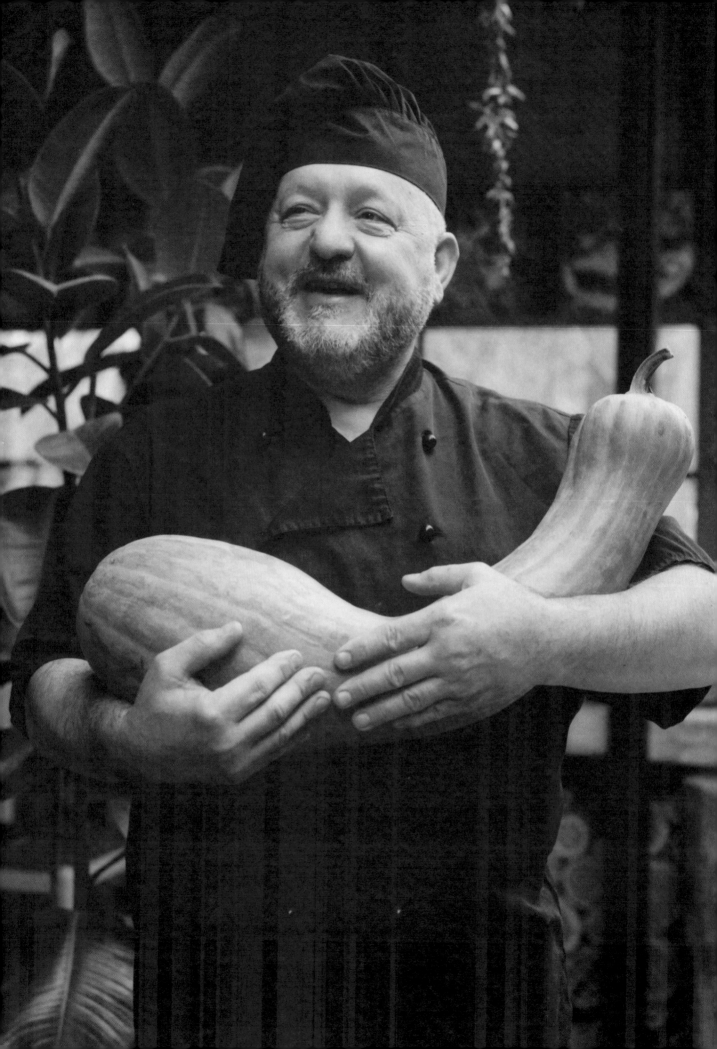

Under decades of repressive rule, Albania was largely closed off to visitors. Now, as the country forges a path onto Europe's holiday map, a cohort of thoughtful chefs and winemakers, like Flori Uka, are using its homegrown bounty to lead the charge.

Tirana's Farm-to-Table Movement

"Eating is an agricultural act," wrote the American author Wendell Berry in his 1989 manifesto "The Pleasures of Eating." By this he meant: the way we eat and source our food shapes our land and environment.

In Albania, local chefs want people to engage with food in a deeper way, and for sustainable agricultural practices to repair the land. In Tirana, the country's capital, many chefs have returned to their homeland after spending years abroad to create menus that blend authentic Albanian cuisine with affordable, high-quality ingredients. For a quick snack, Oda, a family-run restaurant near Pazari I Ri, the city's main market, is the place to go. Here you can also try local dishes like peppers stuffed with cottage cheese and kukurec, grilled lamb's intestines. At Mullixhiu, chef Bledar Kola brings the rustic roots of Albanian gastronomy—shepherd's cheeses, sausages, polenta, quails and traditional Albanian pasta dried in the sun and served with mushrooms or blueberries—together with fine dining.

A rise in visitors to Albania over recent decades has made coming home an appealing prospect for the country's food specialists. Under the forty-year dictatorship of Enver Hoxha, which stretched from the end of World War II until 1990, the "land of eagles" was almost entirely off-limits to tourists from countries not part of the communist bloc. Today, Albania is still one of Europe's lesser-known treasures—but the beautiful beaches, wild coastline and great food have started to gain traction with visitors.

On the outskirts of the city, fifteen minutes by car on the road toward the international airport, is Uka Farm—a laboratory of sorts, with a focus on sustainable agriculture. Professor Rexhep Uka, the former minister of agriculture, founded the farm in 1996 and applied the philosophy of permaculture farming—organisms working together to create a single ecosystem, copying the forest and thriving without human intervention. Two decades later, his son Flori, a young wine specialist and chef, added a biodynamic vineyard and farm-to-table restaurant where dishes of organic produce—grilled zucchini, potatoes, tomatoes and peppers—are served on checkered tablecloths in a covered patio surrounded by vineyards. "Our philosophy is to work in harmony with nature and respect the ecosystem," Flori Uka says. "We use only products off our land and honor traditional dishes while exploring inventive flavor combinations."

The menu offers the best of Albanian cuisine: byrek, a tasty salty pie made with filo pastry and spinach; fërgëse, a casserole with peppers, tomatoes and cottage cheese; tavë kosi, a quiche-like

dish made with lamb, eggs and yogurt; and fli, multiple crêpe-like layers brushed with cream and butter and served with sour cream. Depending on the season, other dishes might include pumpkin pies, grilled porcini mushrooms and pomegranate salads. "If you come here in winter, you'll never find the same dishes that are offered during summer. Everything follows the flow of nature and its seasons," Uka says.

Uka's efforts to champion Albanian produce are not limited to gastronomy and sustainable farming. In 2005, he planted organic grapevines native to the region on-site at Uka Farm and began producing wine. After studying enology in Italy, he trained at several wineries in Friuli-Venezia Giulia and observed how Italian winemakers celebrated their local traditions. He carried the philosophy back with him to Albania: today, Uka Farm is the only place on earth where you can drink a glass of cëruja, a native Albanian grape with notes of citrus and honey.

"Until a few years ago, few people in Albania were aware of the value of our land's wines," he says. "Albania has no reason to envy Italy or France in terms of wine production. The country has a perfect climate for it. There is still a lot of work to be done, of course, but a new generation of winemakers and enologists are starting to produce excellent wines."

All over the country, wineries have opened their doors to visitors, offering guided tours to taste local grape varieties for half the price of nearby Italy. Among them are Çobo Winery, located at the base of Mount Tomorr near the UNESCO fairy-tale town of Berat; Kantina Arbëri in the surroundings of Lezhë, known for its award-winning Kallmet Riserva; and Kokomani Winery, famous for being the home to the local grape Shesh i Zi.

What's next? Uka has recently traveled all over the country to collect native grapes from other local winemakers to create a palette that is exclusively Albanian. "The wine is named Udha, which means 'the road,' and has the aim of unifying my homeland in a bottle," he says. A glass of it is perhaps the best way to experience the nature, terroir and variety of flavors that this small but diverse country has to offer.

"Albania has no reason to envy Italy or France in terms of wine production."

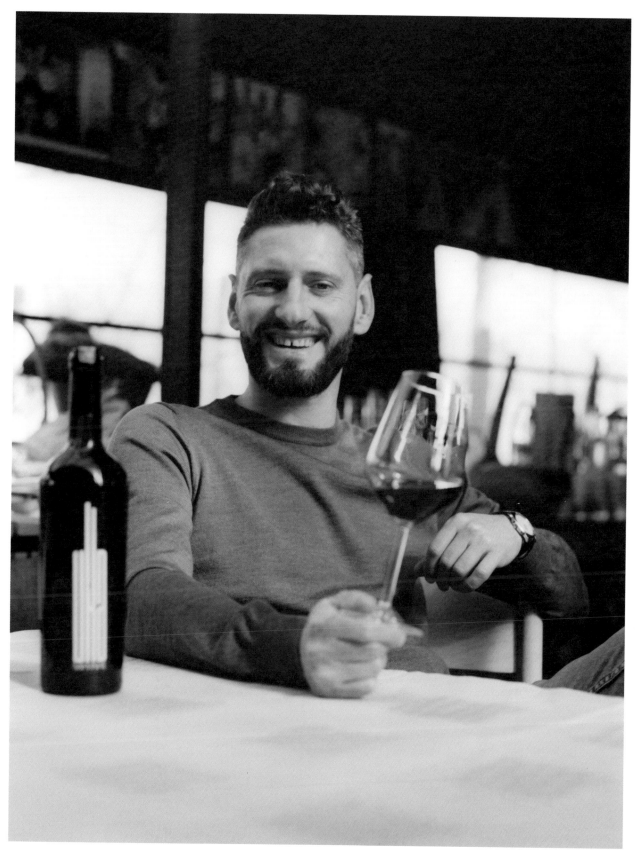

Opposite
—
In the kitchen at Uka Farm, chef Fabio Cavicchi (pictured on page 46) uses produce grown or raised at Uka Farm in his traditional Albanian cooking.

Above
—
Flori Uka, who took over his father's farm and business, is one of Albania's most prolific enologists and is currently ranked second among the country's sommeliers.

Above
—
One of the restaurant's waiters lends a hand on the farm during the daily harvest. Acacia trees are dotted throughout the property; an impressive row flanks the driveway.

Opposite
—
Red Russian kale sprouts in the on-site greenhouse where Uka and his colleagues experiment with growing different vegetable seeds under biodynamic principles.

Above
—

Uka's restaurant serves a seasonal menu, but staple dishes include rice and beans, fresh goat's cheese and fergese—a ricotta-style cheese blended with tomato sauce and peppers.

Opposite
—

Uka Farm is a family affair: It was originally founded by Flori's father Rexhep in 1996. Flori's aunt Shpresa (pictured, planting vegetable seeds for the new season) also works on the farm each day.

1

UKA FARM

At Uka Farm, northwest of Tirana, lucky guests feast on spinach byrek and homemade fergese on gingham-covered outdoor tables, underneath ancient grapevines. The vines aren't just for show, though: Uka produces six wines made from locally grown grapes, under the leadership of one of Albania's highest-rated sommeliers.

Rruga Adem Jashari, Laknas

2

MULLIXHIU

Mullixhiu means "miller" in Albanian, which gives a good enough sense of the restaurant that bears the name. Making use of working millstones to grind grains and nuts, chef Bledar Kola (formerly of Noma, in Copenhagen) turns out a menu that walks a delicious line between refined and rustic.

Lasgush Poradeci Blvd, Tirana

3

ODA

Housed in an Ottoman-era building that was once a private house, Oda's two salons (or odas) feature communal seating and handwoven carpets on the walls. Guests dine on archetypal Albanian delicacies like peppers stuffed with cheese and grilled lamb's intestines washed down with mulberry raki, a fruit-flavored aperitif.

Rruga Luigj Gurakuqi, Tirana

4

MET KODRA

In a city with a history as tumultuous as Tirana's, it's quite a feat for a restaurant to have survived past the half-century mark. That Met Kodra has is a testament to the fact that it does one seemingly simple thing extremely well: qofte zgare, or meatballs on a stick.

Sheshi Avni Rustemi, Tirana

5

SITA

The same lauded chef behind Mullixhiu now plies his trade on the literal streets of Tirana, at the food stand Sita behind Skanderbeg Square (the two restaurants even share the same millstone for flour). The truck slings classic Albanian delicacies like qofte and fergese on eco-friendly single-use plates.

Near Skanderbeg Square, Tirana

6

GURRA E PERRISE

Gurra e Perrise is just thirty minutes east of downtown Tirana, but a world away from the city sprawl. Within the grounds of Dajti Mountain National Park, simple food is served next to a cerulean fish-filled pool and against a backdrop of panoramic park views and elegant stone archways.

SH47, Tirana

7

MRIZI I ZAVANE

In the village of Fishte, about an hour and a half north of Tirana, Mrizi i Zanave sets the bar for agritourism in Albania. Its kitchens thoughtfully prepare traditional Albanian dishes with ingredients grown on or near the farm, including bread made from house-milled flour.

Rruga Lezhe–Vau i Dejes, Fishte

8

PAZARI I RI

Excellent cheap restaurants line the edges of Tirana's central farmers' market, but the real show is put on by the traders plying their wares. Up for grabs is everything you might expect, and the best of it: fruit and vegetables, meat, fish, cheese and honey. It's all fresh and local—including the raki.

Shenasi Dishnica, Tirana

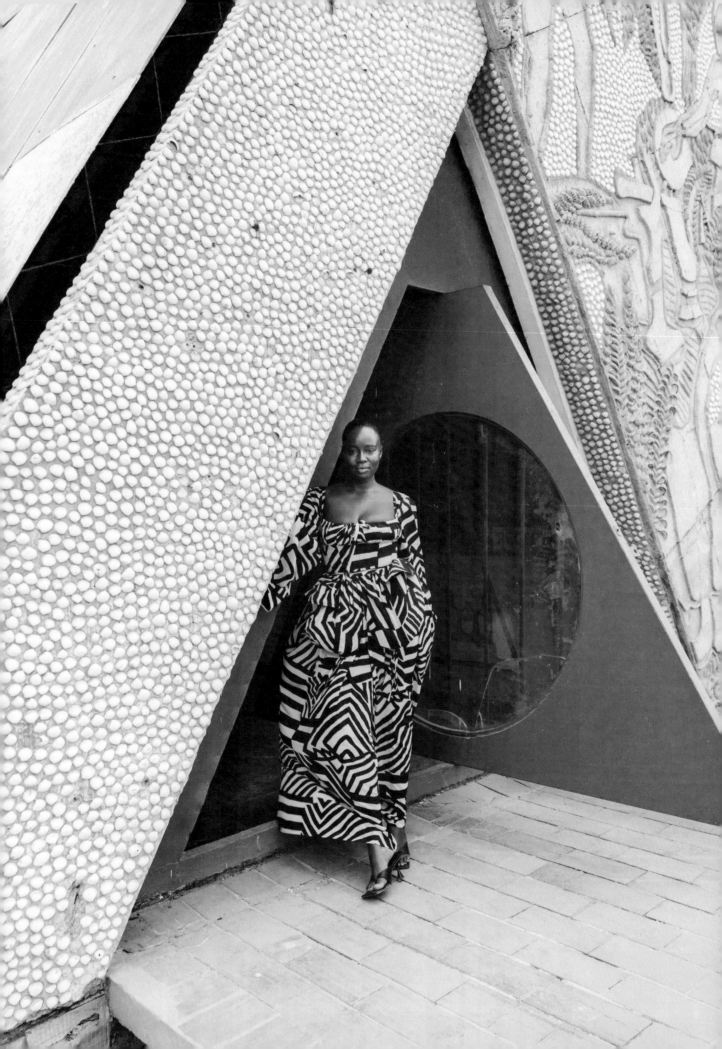

Clothing is chosen carefully in the sunny Senegalese capital. From haute-couture showrooms to side-street tailors, local designer Sarah Diouf shares the defining details that underpin Dakar's sartorial gestalt.

Homegrown Fashion, Senegalese Style

A symphony of sounds rings out through the streets of Dakar every day, but the real call to arms may be the metal *clang-clang* of the city's mobile tailors as they chop the air with large metal scissors. The sound signals their services as they stroll the streets, and their ubiquity—an estimated twenty thousand tailors practice in Dakar—suggests how central sartorial concerns are to life in the Senegalese capital.

The robust network of tailors is just one example of the "custom flair" that has earned Dakar its rightful place in the pantheon of style meccas according to Sarah Diouf, the Senegalese designer behind the Dakar-based label Tongoro.

Diouf and her Made in Africa brand are celebrating five years of business in 2021, and while she cites Senegal as a source of inspiration, the appeal of her designs—and her ambition—is global. Beyoncé, Alicia Keys, Naomi Campbell and others would agree; all have been spotted wearing Tongoro pieces. "When I launched the brand, the idea was to highlight the talent of the artisans here and promote them on a global level," she says. "We keep hiring more tailors and artisans, perfecting the craft and expanding."

Diouf describes Dakar's fashion and design scene as one of vibrancy, color and joy. "The way we dress always makes me think of music and dance," she says. "Everyone dresses happy.

When I see women in the streets in these vibrant colors . . . I'm trying to translate that movement through my designs. It's more like a feeling—it's very tied to personal identity and a reflection of self."

Dakar style can include mixing traditional bògòlanfini, or mudcloth prints, from Mali with contemporary fabrics—something other Dakar-based brands like Nio Far and Kakinbow do well. Or taking the traditional boubou (long, flowing robes often worn to religious ceremonies) and cutting them into chic, cropped jumpers for women—a style perfected by Adama Ndiaye, the designer behind Adama Paris and founder of Dakar Fashion Week.

In a city that sits on the westernmost tip of Africa, where the desert sands of the Sahara clash against the green scrub of the savanna, blending different elements is one aspect that makes the everyday sartorial choices of Dakar's residents stand out. "As much as Dakar is a place that is obviously evolving toward modernity, tradition plays a huge part in our day-to-day lives," says Diouf. "It's all about the people. Senegalese culture is about sharing—if you don't buy something, you will still have an experience with someone. It's the way I see Dakar—everything is very human-to-human."

Markets in Dakar supply fabric and accessories for all conceivable occasions and budgets that range from designing your own 5,500 CFA ($10) shirt to commissioning a tailored boubou that costs more than ten times that. "It's where life happens," Diouf says. "I love getting lost in the market. It's where my process starts." Some of her favorites include Colobane, where shoppers can find a wide array of second-hand and vintage clothing and accessories, and HLM market, which she says is a hot spot for all kinds of fabric and jewelry. "You have all the Senegalese fantasy jewelry," says Diouf, "and the latest fabrics that are on trend in Senegal." Wax fabric can cost as little as 1,500 CFA (around $2.50) per meter, but high-quality bazin can run to 11,000 CFA ($20) for the same length. Negotiating is a must, but remember to keep a sense of humor when haggling. Vendors can playfully tease you in Dakar, in a way that may seem serious to those unaccustomed to the local vernacular.

Adding to the plethora of Senegalese styles are the ever-growing number of fashion designers and stylists who call Dakar home. Some of the shops to seek out include the showroom of Selly Raby Kane—another Senegal designer worn by Beyoncé—in the Sicap-Liberté neighborhood, and Adama Paris's location across from the Soumbedioune fish market.

According to Diouf, the number of designers—and the variety of styles on offer—is growing in Dakar. She sees this as an opportunity—a chance to level up the local fashion ecosystem. "I think that we need to structure the artisanal way of doing things. If we manage to make it work the way it's supposed to, it's going to be very interesting and dynamic, without losing the essence that makes it so special and unique." With the world's eyes on the scene, there is a chance for Dakar to ascend even further. After all, having been dubbed the "flyest city on the planet," the only place it has to outstyle is itself.

"The way we dress always makes me think of music and dance."

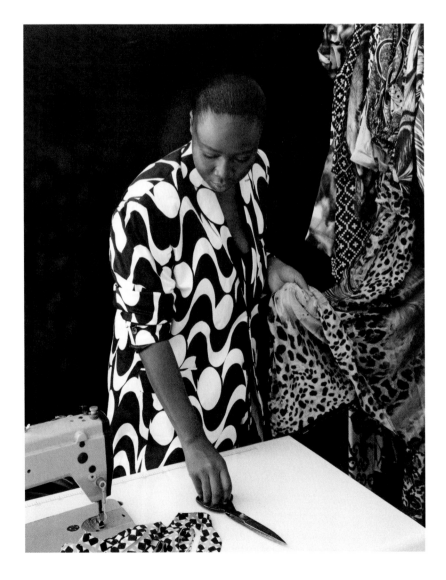

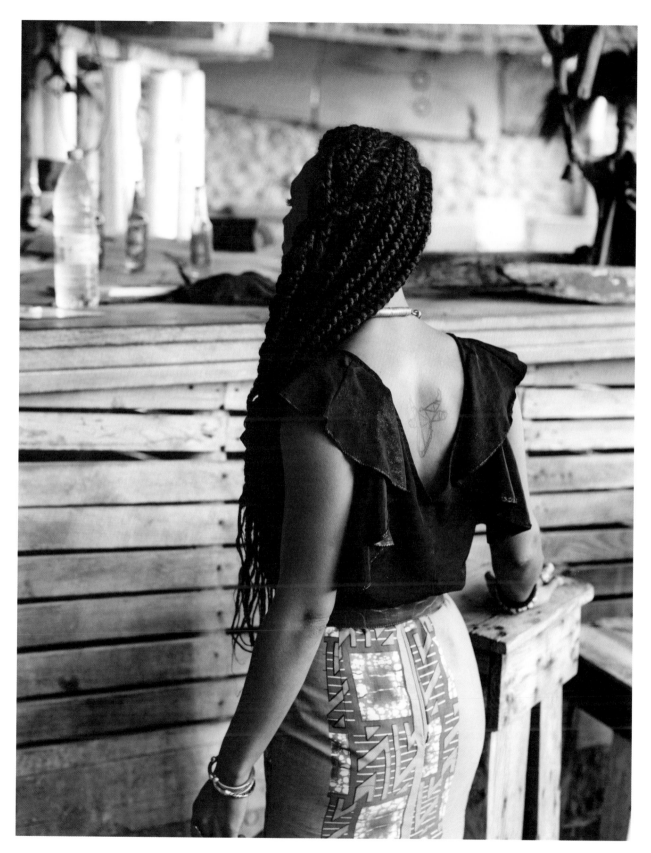

Opposite
—
Diouf in the atelier of her fashion brand Tongoro, which sources materials made throughout Africa and employs local tailors from Dakar.

Above
—
Diouf describes Dakar's sartorial flair as "vibrant" and "happy"—a mix of traditional West African prints and modern cuts, as demonstrated by local resident Marème Diaw (pictured).

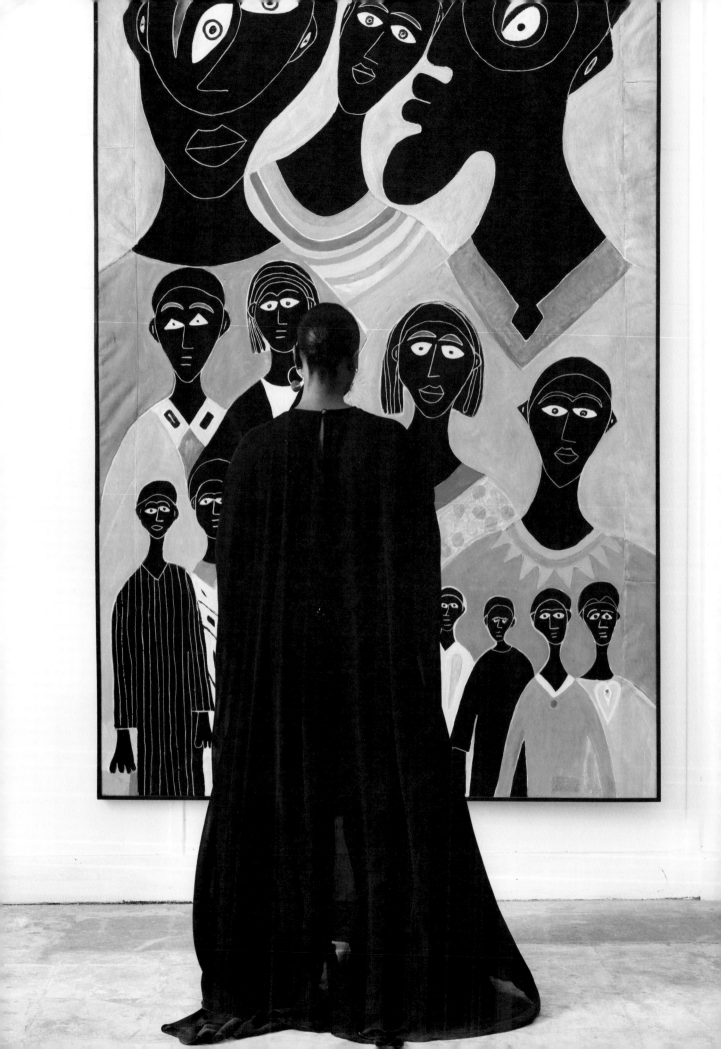

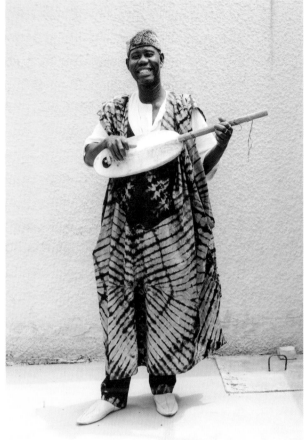

Above Right
—

A local xalam player wears a pair of babouche—the leather-bound pointy-toe mules synonymous with thiossane, or Wolof heritage. Historically, the town of Ngaye Mékhé was the epicenter of Senegal's shoe industry.

Opposite
—

Diouf stands in front of *De génération en génération*—a painting by Alioune Diouf on display at Selebe Yoon gallery in Dakar.

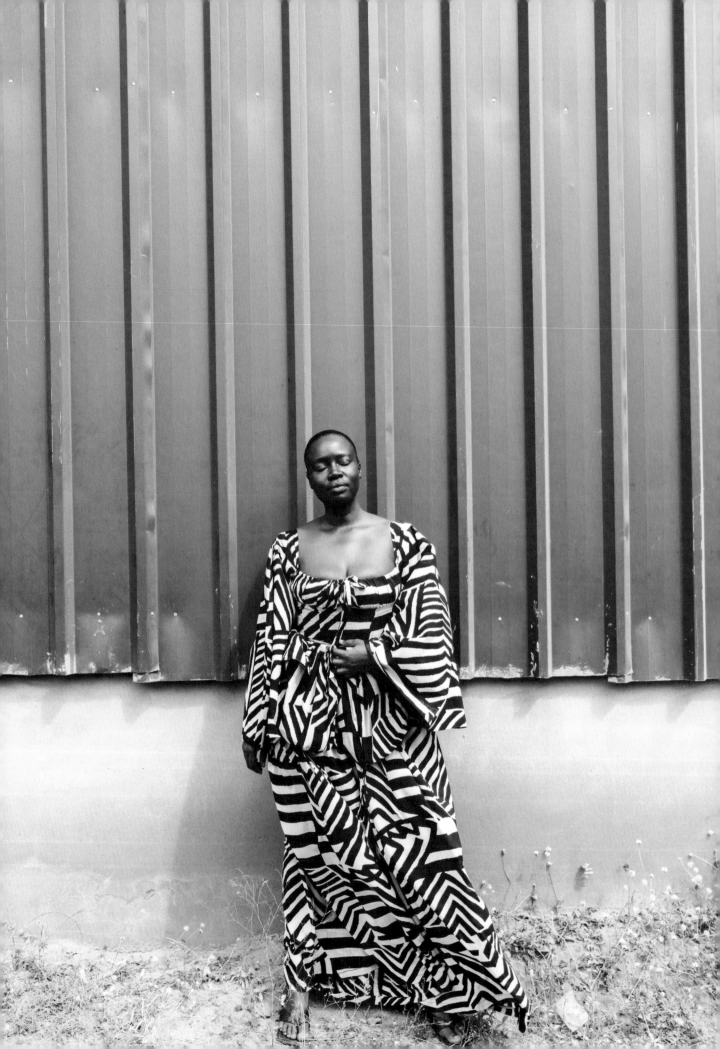

1

MARCHÉ HLM

If you've ever dreamed of having an outfit—clothes, bag, shoes, even jewelry—custom-made to your own requirements, your prayers can be answered by the fabric traders and tailors working the stalls of Marché HLM. You'll find Dutch wax, and silks, lace and intricate embroidery are available here too.

Marché HLM, Dakar

2

SELLY RABY KANE

Dakar roots run deep for fashion designer Selly Raby Kane. The city's past, present and infinite possible futures inspire everything she does: Afrofuturism-informed clothes, yes, but also a 2011 parade through the city's medina and a psychedelic film imagining the train station in the midst of a UFO invasion.

Rue SC 103, Dakar

3

TONGORO

Tongoro's eye-catching pieces, with prints billowing dramatically out from the body, have caught the eyes of Beyoncé and Burna Boy, as well as the international press. But the brand's business model, centered on a commitment to working with Dakarois tailors and locally sourced fabrics, has also earned it recognition as one of the city's most innovative companies.

Sicap Foire, Dakar

4

AÏSSA DIONE

Aïssa Dione has reimagined everything about traditional Senegalese textiles, from the design of the loom to supply chain management. The resulting textiles are sold to the world's top luxury brands—including Hermès and Fendi—but also inspire unexpected collaborations, like that with Japanese kimono maker Okujun.

Rue 23, Medina, Blvd Martin Luther King, Dakar

5

SOPHIE ZINGA

Many Senegalese designers err on the side of ebullient; Sophie Zinga Sy's designs are unique in their elegant restraint. Her sleek, sensual collections, all made in Senegal, have been inspired by everything from the thirteenth-century Abyssinian Empire to the textures and shapes of roses.

7 Nord Foire, Dakar

6

ADAMA PARIS

The daughter of diplomat parents, Paris dabbled in the world of finance before turning to fashion. Her references may be eclectic, but her multidisciplinary background has forced her to focus her vision: the result is voluptuous, bubbly pieces pinned to the body with embroidered brocade.

Route de la Corniche O, Dakar

7

BANTU WAX

Yodit Eklund woke up one day and canceled her contracts with Opening Ceremony and Barneys, reasoning that her beachwear and surf equipment was intended for those surfing the breaks off the coast of Dakar, rather than the New York fashion set. So instead, she opened a flagship store in a repurposed shipping container on the beach.

Corniche des Almadies, Dakar

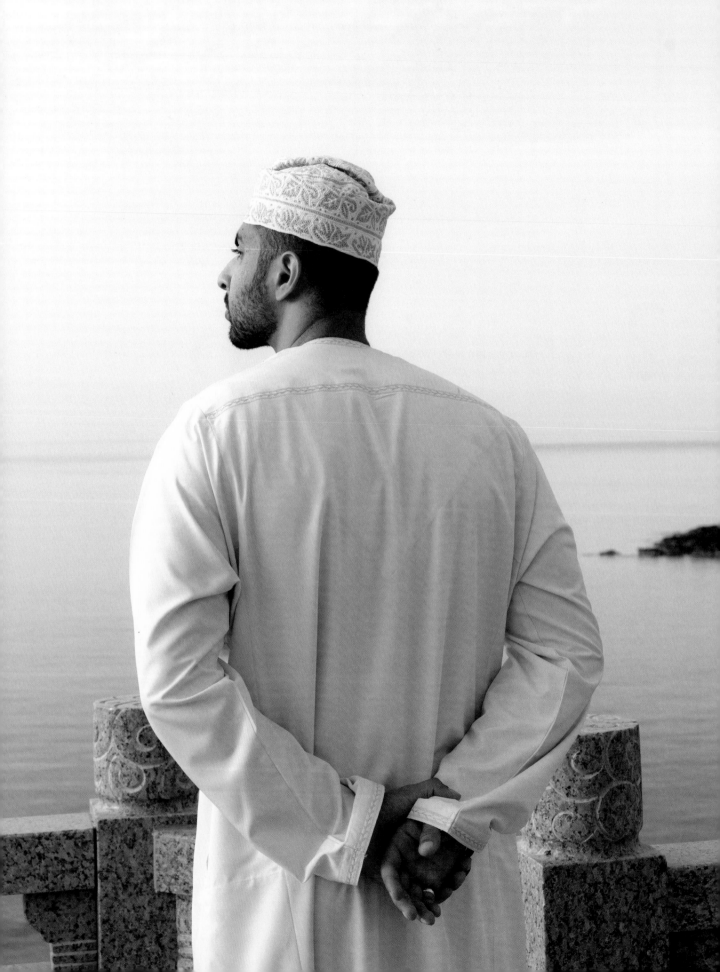

The corniche of the Omani capital braids a confluence of jagged mountains and quiet shores. To take heed of this gentle Arabian giant's heritage, photographer Eman Ali suggests a leisurely stroll among Muscat's seaside markets and minarets.

A Promenade Along Muscat's Seafront

The gently curving facade of Muscat's corniche wraps around the city like a comma. Here in Muttrah, at the eastern end of the Omani capital, the whole of life is to be found on a smile-shaped strip of land between the mountains and the sea. Situated on trade routes between the Horn of Africa, India and China, this is a gentle city shaped by geographic good fortune—and oil.

The corniche was built in the 1970s as a pathway between the city's old commercial district of Muttrah and the new, in Ruwi. Following the discovery of oil in 1964, Oman's global fortunes flourished and the old commercial center of low-slung, whitewashed buildings was no longer adequate to support the city's booming trade interests.

Today, the seaside stretch is instead home to a dhow harbor and several attractions including the Oman Royal Yacht Squadron; the city's old and new fish markets; the Muttrah Souq marketplace; and a giant sculpture that honors Oman's frankincense trade. Unsurprisingly, most locals' favorite thing to do at the corniche is to simply stroll along it.

The days are hot, so sunrise and sunset are when the corniche comes alive. In the early morning, fishermen can be seen transporting fresh catch from the harbor to the fish markets, where they share stories across the stalls as shoppers file in. Dorado fish, known for the green and yellow jewel tones of their scales, glisten on the stands, still wet from the sea. The old fish market, built in the 1960s, was bolstered with the construction of a new one, designed by Snøhetta, in 2017. Located close to the original market at Port Sultan Qaboos, the building has fast become a landmark for the city. The design features a slatted rooftop canopy, reminiscent of an intricate fishbone, and the building's public spaces and restaurant bring tourists together with the local community.

Omani photographer Eman Ali likes to begin her strolls at this end of the coastline. "There is so much beauty to see along the way," she says. "I start at the fish market, and from there I like to walk past Sur Al Lawatia, a neighborhood of nineteenth-century merchant houses." Sur Al Lawatia—an old residential quarter fortified by towers and gates—is perhaps one of the richest architectural spots in all of Muttrah. Likely to be the last still-inhabited heritage neighborhood in Oman, the area features nearly three hundred homes constructed from limestone, seashells and palm fronds, with wooden balconies that protrude over the narrow streets. For decades, this scenic quarter was closed to all but members and guests of the Lawati tribe who lived there; visitors are still requested to respect its residents' privacy. Also nearby is Bait Al Baranda,

an exhibition hall located in a heritage house hosting interactive exhibitions about Omani history.

Elsewhere along the corniche, people of all backgrounds come together to stroll or relax on public benches. "I think the important thing about Muttrah is that it is an example of the tolerance of Omanis," says local resident and architect Ali Jaffar Al-Lawati. "In our history, there have been a lot of wars between the hinterland and the inland of Oman. But when you see the port city of Muttrah, and the small bay, you see how different cultures have settled here together."

In winter, seagulls flock to the shores where they are fed by generous locals. "It's such a beautiful sight against the backdrop of the seaport," says Ali. However far you walk from the market, you will find it hard to forget the fish. The deep-rooted significance of the fishing industry is on display at Samaka Roundabout, which marks the start of the corniche and features a large sculpture of two fish emerging from a fountain (*samaka* means "fish" in Arabic). The corniche's benches are often placed between more sculptures of fish.

Muttrah Souq is perhaps Muttrah's main attraction for visitors. Dating back two hundred years, the traditional market is a popular place to buy clothing, antiques, frankincense and much more. It is also known as Al Dhalam Souq, meaning "darkness" in Arabic; there is no natural light inside, sinking the labyrinth of narrow lanes and crowded market stalls into the shadows.

At the end of the corniche is Al Riyam Park, home to a large, monumental mabkhara, or incense burner, that symbolizes the country's long history of exporting frankincense. The monument is situated at the top of a large hill, and the climb features lush gardens, playgrounds and picnic areas. With its scenic views over the city, the spot is an ideal place to conclude a corniche promenade.

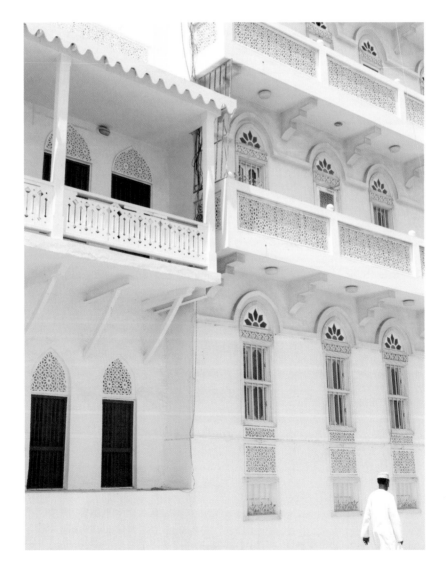

Opposite
—
Muttrah corniche displays many elegant examples of traditional Omani architecture. High-rise buildings are forbidden in Oman by royal decree, to instill local pride in the landscape.

Above
—
Visual artist Eman Ali enjoys strolling along Muttrah corniche when in Oman. She splits her time between Muscat, London and Bahrain.

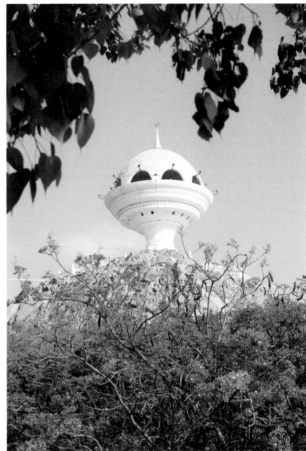

Above Right

—

Riyam Incense Burner, located atop a
hill at the eastern end of the corniche,
is one of the most iconic structures in
Muscat. It was built to honor Oman's
twentieth National Day and is sur-
rounded by lush gardens and picnic
areas.

Opposite

—

Masjid Riyam is one of many mosques
along the corniche. Farther inland,
Sultan Qaboos Grand Mosque—
Oman's magnificent national
mosque—welcomes non-Muslim
visitors between 8 and 11 a.m. every
day except Friday.

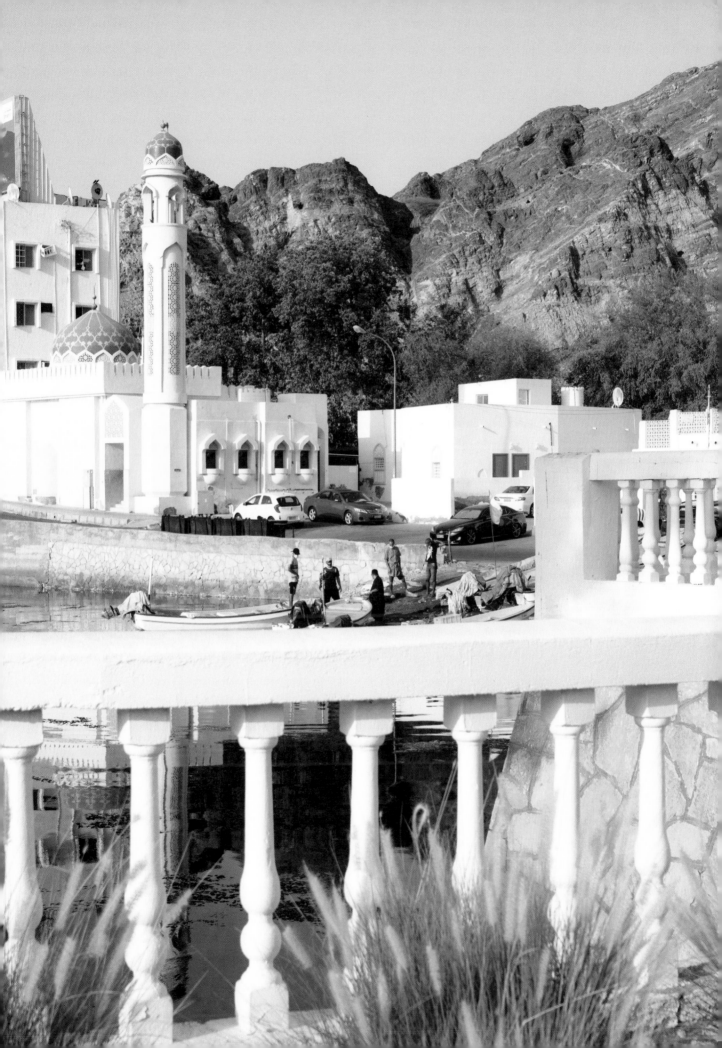

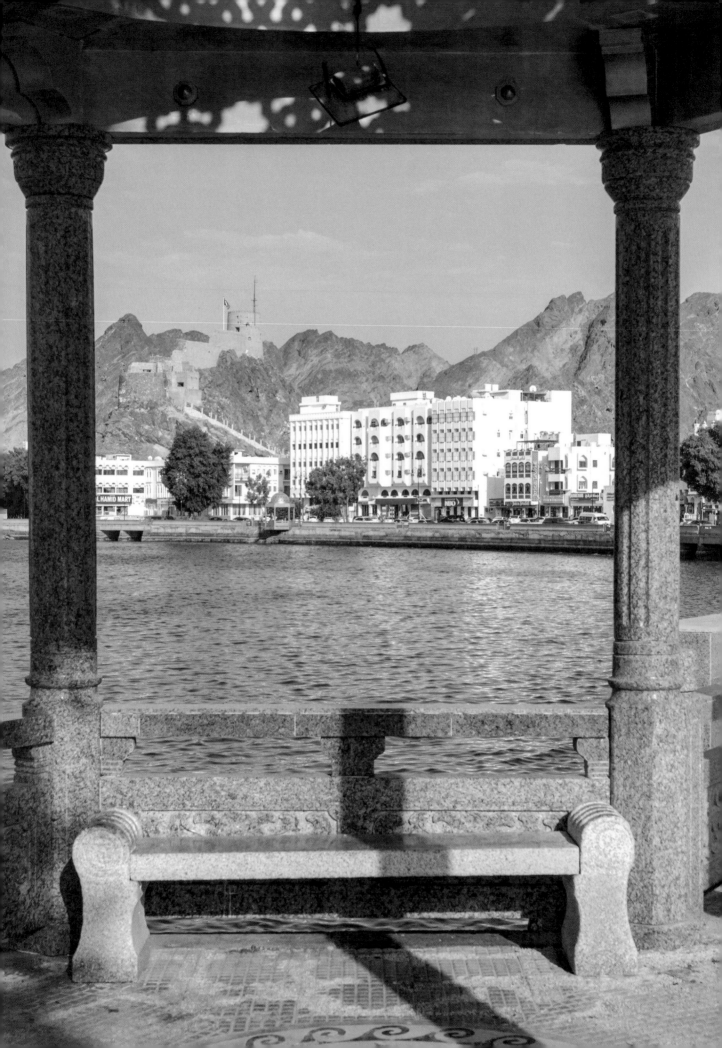

1

MUTTRAH FISH MARKET

Designed by the Norwegian firm Snøhetta, Muttrah Fish Market has become a new architectural landmark for the Omani capital. Though it's a working fish market on the country's busiest harbor, the building has also become a meeting point for Muttrah's local community. Roof terraces, a restaurant and the addition of a fruit and vegetable market encourage residents and visitors to use the space alongside local fishermen.

Samakh, Muttrah

2

BAIT AL BARANDA

Bait Al Baranda is a renovated 1930s residence, once known as Bait Nasib after the building's original owner. Over time, the building has been home to an American mission and the British Council. Today, it is under the management of Oman's Ministry of Culture, Sports and Youth and functions as a museum, tracing Muscat's history and cultural heritage through interactive exhibitions that encompass the area's ancient geology, paleontological discoveries and folk art.

Al Mina St, Muttrah

3

MUTTRAH SOUQ

There are certain places around the souq where visitors ought to respect the privacy of local residents: the traditional coffee house at the entrance, where elder community members meet; and the historic Sur Al Lawatia neighborhood (which is gated for a reason). Otherwise, the fun of the souq is in getting lost among its many narrow and labyrinthine alleys, where you'll find everything from antiques to aluminum tableware, spices to sandals, and novelty alarm clocks in the shape of mosques. Most vendors accept cards, but discounts are more likely with cash.

Muttrah Corniche, Muttrah

4

SULTAN QABOOS GRAND MOSQUE

Sultan Qaboos Grand Mosque is first and foremost an active place of worship. The main mosque in Oman, it is also a magnificent example of modern Islamic architectural style, commissioned by the late Sultan Qaboos bin Said to mark his thirtieth year of reign. The carpet inside is the second-largest hand-loomed Iranian carpet in the world; it contains 1.7 billion knots, which took six hundred women four years to weave. The mosque is open to visitors every day except Friday; dress modestly and expect to leave ID as a deposit.

Sultan Qaboos St, Al Ghubrah, Muscat

5

ROYAL OPERA HOUSE

The Royal Opera House in Muscat is the city's leading arts and culture destination, housed in a beautiful contemporary building designed to blend seamlessly with Muscat's heritage and honor traditional Omani palaces. It was the first opera house to be built in the Gulf; since opening in 2011, the program has included performances by cellist Yo-Yo Ma, the London Philharmonic Orchestra and the American Ballet Theatre.

Al Kharjiyah St, Muscat

6

MUTTRAH FORT

Built in the 1580s under Portuguese occupation, Muttrah Fort—also known as Koot Muttrah—has long been used for purely military purposes and only opened its doors to visitors a few years ago. As such, there is not an awful lot to see inside, but a climb to the top of the tower does offer stunning views over the city and coast. It was an observation tower for centuries, after all.

Muttrah, Muscat

Among the winding streets of South Mumbai, a supportive stronghold of serene art galleries offers respite from the city's chaos and, say gallerists Mortimer Chatterjee and Tara Lal, an insight into India's cutting-edge culture.

The Mumbai Art Walk

For all that Mumbai fulfills a textbook description of a metropolis in constant flux—with its frantic construction and hyperactive energy—the city has a lot to offer that is enduring and timeless. The undulating corniche of Marine Drive, for example, or the city's architectural heritage—a curious mix of styles ranging from Gothic to art deco. The city also has deep ties to art, and peace can be found in the serene contemporary galleries that cluster around the South Mumbai cultural delta of the Fort, Colaba and Kala Ghoda neighborhoods.

Prominent among them is Chatterjee & Lal. Located beyond the iconic Gateway of India, on a street curving away from the sea, it occupies space in two buildings that were originally built as warehouses under British colonial rule in the 1850s. "The city's art history goes back to the early twentieth century, when the Bombay Art Society and the Artists' Centre sprung up," explains Mortimer Chatterjee, who cofounded the gallery along with Tara Lal.

The duo, who met in 2001 while working with auction house Bowrings, set up their venture in 2003. "Neither of us had particular links to the city, but we believed Mumbai was conducive to visual arts," he recalls. Colaba—with its dramatic art deco buildings and credentials as the city's cultural outpost—seemed like the place to be, given that it was already home to several significant galleries. "The establishment of the Taj Art Gallery and the Jehangir Art Gallery in the 1950s, followed by Gallery Chemould [now Chemould Prescott Road] and Pundole's in 1963, cemented the area as an art hub," he says. It is also home to storied institutions such as the National Gallery of Modern Art and the Chhatrapati Shivaji Maharaj Vastu Sangrahalaya Museum.

When they set up shop, their objective was twofold: to provide a platform to artists working in installation, video and performance art, and to contextualize contemporary works in a larger historical trajectory. "We wanted to rediscover practices from the mid-twentieth century—before what we understand now as the contemporary moment. For us, it was always this mix of contemporary with historical material," says Chatterjee. A recent exhibition, *Simple Tales*, reflected these twin interests, "looking at the idea of storytelling and how artists have engaged in mythology through time periods in Indian history."

Chatterjee & Lal's founding coincided with considerable changes in the city's art scene. "In the late 1990s, when there were fewer galleries, the concept of representation, where an artist has an exclusive relationship with a gallery, hadn't caught on," says Chatterjee. The 2000s brought change, when

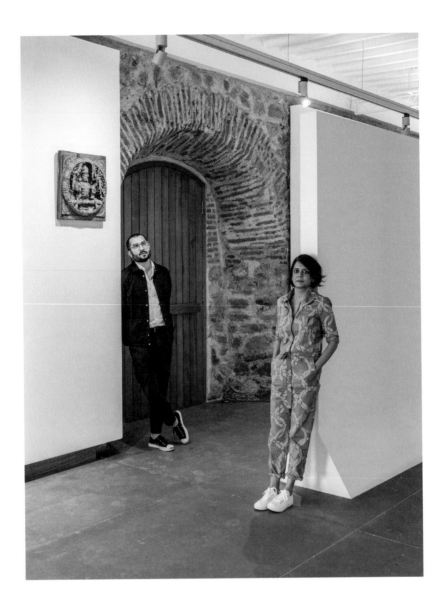

the increasing numbers of individual collectors became the driving force behind the art market. There was also an uptick in international interest in South Asian art, which had a catalytic impact on the domestic art scene, leading to the creation of a more organized structure for cooperation between galleries. "In the last decade, galleries have come together to speak as one rather than a multiplicity of voices," says Lal.

A unified approach, certainly, but one that still hinges on galleries retaining distinct identities through their diverse programs. So while Galerie Mirchandani + Steinruecke works with young artists expressing themselves in their medium of choice, from oil on canvas to drawings on Chinese rice paper, somewhere like Project 88—housed in a century-old printing press—covers the gamut of visual art, from fashion photography to graphic novel art. Chatterjee also appreciates the diversity of works on display. "If you visit six galleries, you get six very different art experiences because of the sheer variety," he says.

The spectrum is wide, but organized endeavors like Art Night Thursdays help art lovers to traverse it. "This occurs every second Thursday of the month in Colaba; galleries stay open until 9:30 pm," explains Chatterjee. "We try and have as many previews as possible." Another time to see the art district in full swing is at the Mumbai Gallery Weekend, held citywide each January, when galleries put on their biggest exhibitions of the year, offer walk-throughs and host parties. To help visitors navigate, the Mumbai Gallery Weekend's website offers an online list of show timings and an art map, which comprises a smattering of spaces farther inland than Colaba, including the Dr. Bhau Daji Lad Mumbai City Museum in Byculla—the city's oldest museum, opened in 1872.

These initiatives to gently nudge people into art spaces are just one of the elements that make Mumbai so welcoming and distinctive. "There is something quite organic about the art scene here. There is a sense of discovery in navigating Mumbai's lanes and byways, and suddenly coming upon a gallery in what looks like a commercial complex. It adds to the experience," says Chatterjee.

That the art district dovetails with tourist hot spots is a nice benefit. "You can shop, sightsee, eat a great seafood meal and then tour the galleries," says Lal.

Opposite
—
Mortimer Chatterjee and Tara Lal, the husband-and-wife founders of Chatterjee & Lal—a contemporary gallery within walking distance of Mumbai's iconic Gateway of India monument.

Above
—
Mumbai has the world's second-largest collection of art deco buildings, surpassed only by Miami. Most are clustered in the city's southern tip, along Marine Drive and in the blocks surrounding Oval Maidan park.

Above Left
—
Chatterjee and Lal often bring together contemporary and historical works, as in a recent exhibition when wooden masks from Arunachal and Himachal Pradesh were placed alongside current video works.

Above Right
—
The large, loftlike interior of Chemould Prescott Road in Fort. Established in 1963, Chemould was one of the first galleries in India to focus on modern and contemporary art.

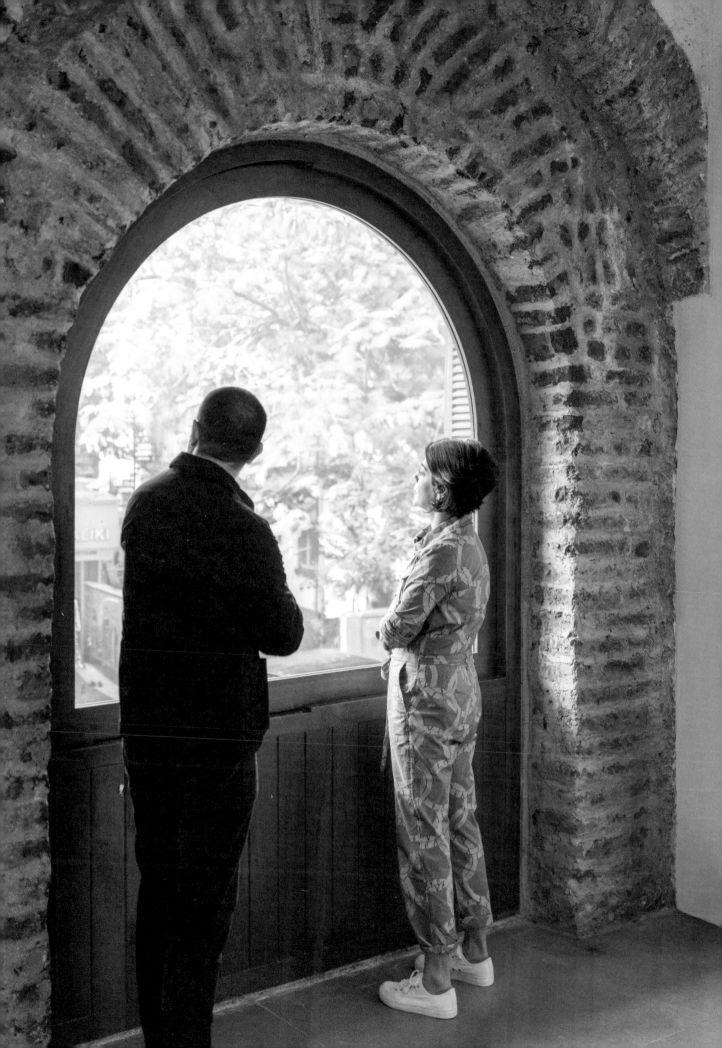

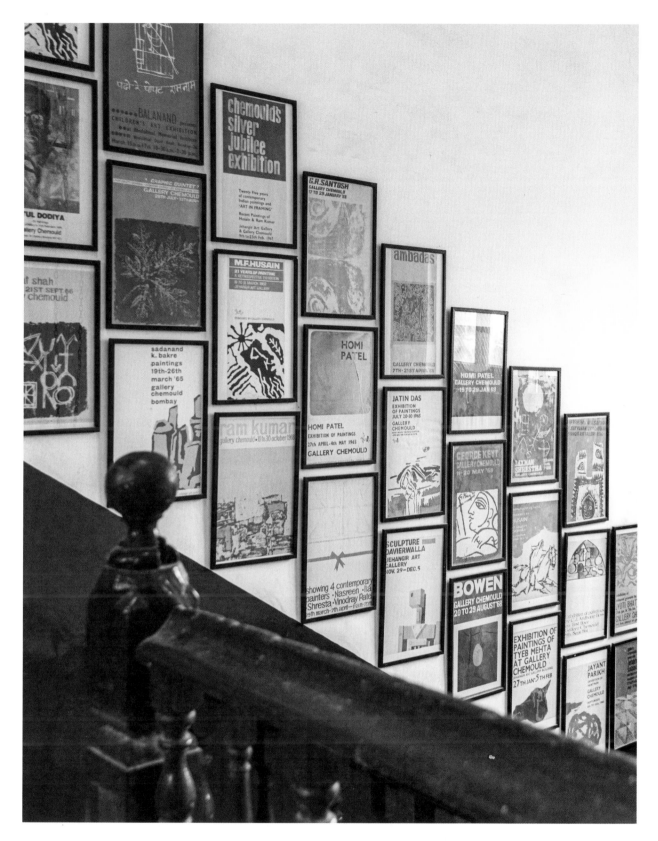

Opposite
—
Chatterjee & Lal has a reputation for unearthing India's most exciting emerging talent. It was among the first to host performance artist Nikhil Chopra, who has since graduated to residencies all over the world, including at the Met in New York.

Above
—
Vintage exhibition posters line the stairwell at Chemould Prescott Road, which has championed some of India's leading artists in the early stage of their careers, including Tyeb Mehta, Bhupen Khakhar and Anju Dodiya.

1

CHATTERJEE & LAL

When Chatterjee & Lal opened in a warehouse in Colaba in 2003, it was a momentous occasion for Mumbai's contemporary art community. Today, exhibits range from pop culture to performance art, like when artist Mark Prime re-created an industrial factory in the gallery.

1st Floor, Kamal Mansion, 01/18 Arthur Bunder Rd, Colaba, Mumbai

2

PROJECT 88

Art is a family affair for Sree Banerjee Goswami, whose mother, Supriya Banerjee, founded Gallery 88 in Kolkata in 1988. Housed in a hundred-year-old printing press in Colaba, Project 88 has been making waves in Mumbai since 2006, having partnered with Frieze London, Art Basel and other international exhibitions.

Ground Floor, BMP Building, Narayan A Sawant Rd, Colaba, Mumbai

3

JHAVERI CONTEMPORARY

Art seems to spring to life against the concrete and white-painted walls of Jhaveri Contemporary. The gallerists—sisters Amrita and Priya Jhaveri—literally wrote the book on Indian art: a 2010 guidebook to modern and contemporary Indian artists.

3rd Floor, Devidas Mansion, 4 Mereweather Rd, Colaba, Mumbai

4

CHEMOULD PRESCOTT ROAD

Chemould is one of India's oldest modern art spaces, founded in 1963 by Shireen Gandhy in her family's framing shop. Now in a new location in a historic Mumbai neighborhood, the gallery is celebrating over fifty years in business with a continuously impressive roster of national and international creators.

3rd floor, Queens Mansion, G. Talwatkar Marg, Fort, Mumbai

5

GALERIE MIRCHANDANI + STEINRUECKE

Usha Mirchandani spent her formative years at an advertising firm in New York; Ranjana Steinruecke ran a gallery featuring Indian artists in Berlin. In Mumbai, the two bring an international perspective, with the aim of nurturing emerging Indian talent making political and personal art.

1st Floor, Sunny House, 16/18 Mereweather Rd, Colaba, Mumbai

6

VOLTE

Volte is a gallery, but not in the sense you might recognize. You're welcome to come look at art, but you're also encouraged to just hang out here; there's a café, bookstore and film club connected to the Colaba gallery.

2nd Floor, 202 Sumer Kendra Building, Pandurang Buhadkar Marg, Worli, Mumbai

7

GALLERY MASKARA

You won't find modern or contemporary art at this Colaba space; rather, Maskara exhibits "art of the present"—think cutting-edge work with a global outlook. The space, a repurposed cotton warehouse, was renovated by architect Rahul Mehrotra to preserve its character.

6/7 3rd Pasta Ln, Colaba, Mumbai

8

DR. BHAU DAJI LAD MUMBAI CITY MUSEUM

First established in 1872 as the Victoria and Albert Museum in Bombay, the Dr. Bhau Daji Lad museum features a splendid permanent collection of decorative arts from Mumbai's rich cultural history. The exhibition program features emerging artists' responses to the permanent collection.

In Veer Mata Jijbai Bhonsle Udyan and Zoo, 91/A, Dr Baba Saheb Ambedkar Rd, Byculla East, Mumbai

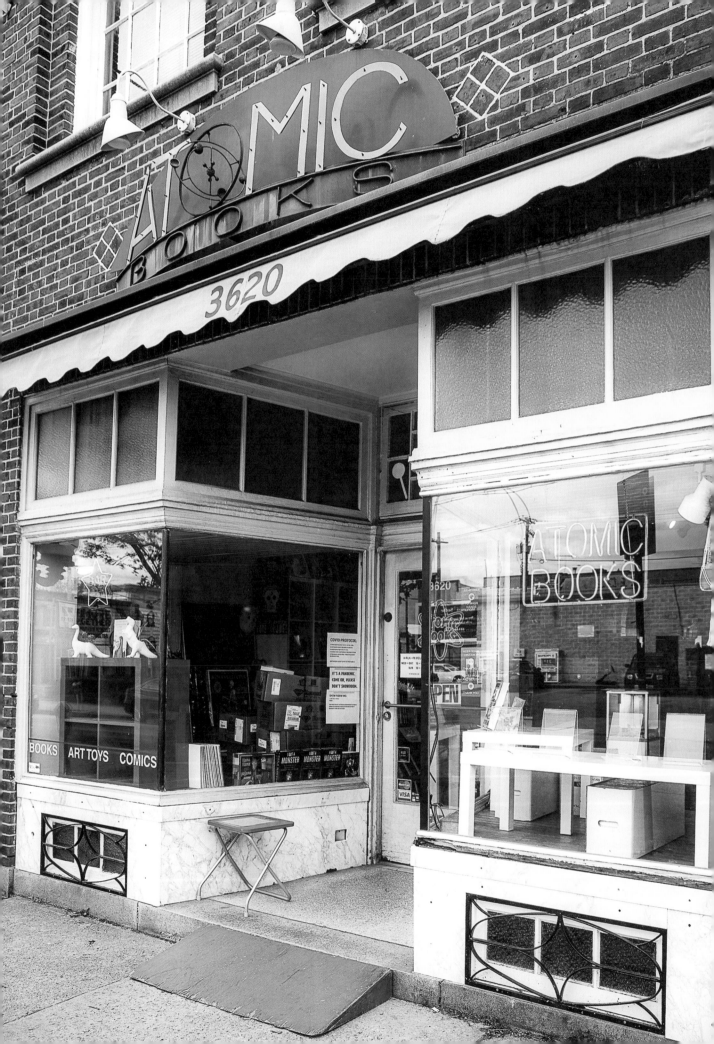

If reading a good book is a must on your itinerary, you'll find plenty in Charm City. Local author D. Watkins offers a tour of Baltimore's literary legends, from eccentric neighborhood bookstores to radical reading communities.

The Bookish Side of Baltimore

Baltimore is a place of manifestation and renewal. It's a place where ideas come to fruition, inspired by all of the hustle and beauty of Charm City; a town below the Mason-Dixon Line with East Coast sensibilities, where row houses are juxtaposed with neoclassical architecture, and abandoned structures lie minutes away from the marble mansions of Roland Park.

Nina Simone sang a ruminating ballad about Baltimore many years ago: "In a hard town by the sea / Ain't nowhere to run to / There ain't nothin' here for free." But one thing has long been both free and healing in Baltimore: storytelling.

"Baltimore: The city that reads" is a slogan that was once printed on wooden benches throughout the city, but its rich literary history can be found etched far beyond. Visitors can visit the homes of Gertrude Stein, F. Scott Fitzgerald and Edgar Allan Poe. Pulitzer Prize–winning novelist Anne Tyler has used Baltimore as a backdrop to eleven of her novels. Ta-Nehisi Coates was born here; his father, William Paul Coates, still runs Black Classic Press—a publishing house dedicated to books by and about people of African descent.

The work of Black writers is especially critical for a city with a population that is 63 percent Black. The vestiges of slavery and discrimination still exist in Baltimore: in Bolton Hill,

a quiet neighborhood near the Maryland Institute College of Art (MICA), you'll find McMechen Street. It was named in honor of George W. F. McMechen, a Black, Yale-educated attorney whose move into an affluent neighborhood in 1910 led to the creation of a racial ordinance law that segregated Black and white residential areas. In 2015, following the death of twenty-five-year-old Freddie Gray while in police custody, the widespread civil unrest in Baltimore became part of the national news agenda.

The Black creative renaissance that has erupted in the past few years has been bubbling in Baltimore for decades. The urgency to tell stories about the city is always palpable and felt most acutely in the tales that are being printed and circulated here. Beloved bookstores like Greedy Reads, Atomic Books and Bird in Hand all carry books by Black authors who live, work and write in Charm City, among them Devin Allen, Kondwani Fidel, Wes Moore and D. Watkins—a son of Baltimore and one of its rising stars.

Watkins is an author, journalist, college professor, husband and father. He writes stories of race and identity in a way that is endearing, sincere and critical for both Black and white audiences. Watkins's writing practice originates in his appreciation for Baltimore's long-standing tradition

of storytelling. "I always loved listening to people telling stories. I would listen to my grandmother and my aunts talk about what happened at Odell's—you know, who goes, who getting money, who lying," he says of an iconic Black-owned former nightclub in Baltimore—one of those storied and hallowed spaces in the city that has become the subject of art exhibitions in the past few years. "All of my people would always just tell stories about what was happening in the streets."

These oral histories carry the poetic tradition of African griots; tales that move through Baltimore and down through generations. Watkins never thought that writing would be his career, though. "I don't think I'm the best storyteller, even from where I come from. I'm lucky to be in a position to keep some of those traditions alive," he says. Watkins believes that "Baltimore is just a unique place, and there is a very aggressive style of storytelling that exists within the communities and the stories."

Watkins lists the radical, cooperatively owned Red Emma's as his favorite brick-and-mortar place to buy books in Baltimore. Red Emma's has long been a creative hub for writers and artists in the city; a hybrid shop that sells books and vegan food, and hosts events.

Watkins divided the writing of his book *The Beast Side* between the University of Baltimore's campus, his car and Red Emma's. "The first little, like, under the radar type of book I ever put out was through Red Emma's," he says. "They saw some things in me before I even saw them in myself."

In recent years, Watkins has received job offers at Berkeley, to run Salon from its San Francisco office, and multiple offers in New York. But, he says, he was born and raised in this city and considers it critical that he stay and work here.

"My whole family is here. My wife's whole family is here. I've been here my whole life, and there are still parts of the city that I don't even understand because I'm just so tied into what I'm used to," he says. "I'm just a local person. I love Baltimore."

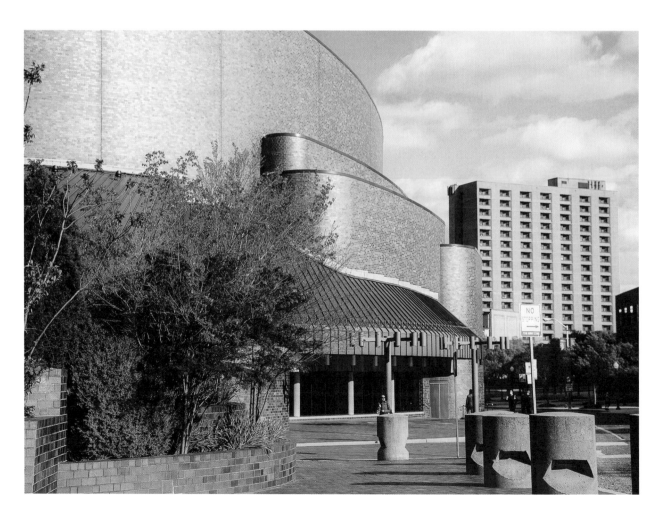

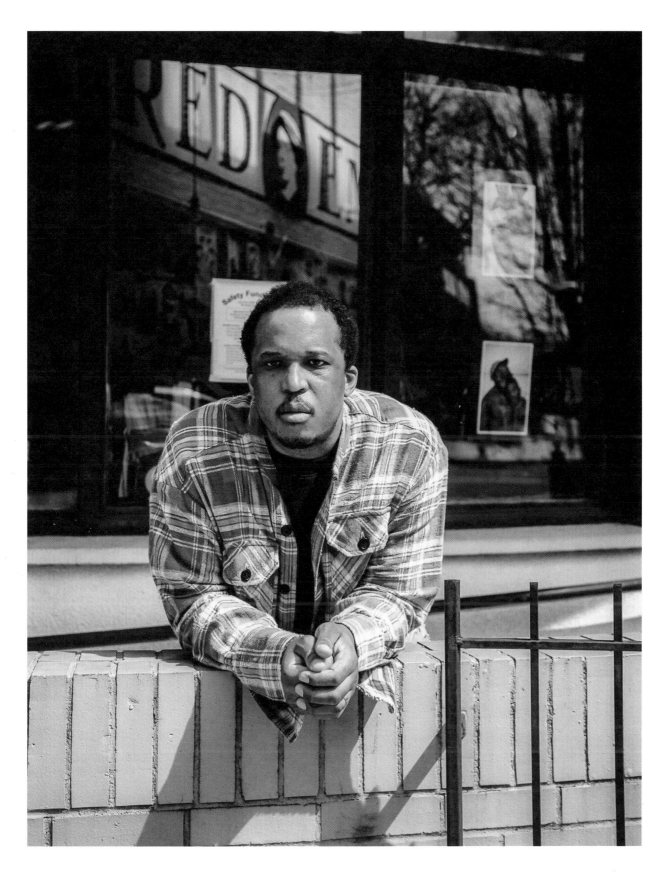

Opposite

—

Baltimore has plenty of other
cultural offerings beyond its rich
literary scene. The Joseph Meyer-
hoff Symphony Hall is just across
the street from Red Emma's.

Above

—

D. Watkins, author of two *New York
Times* best-selling memoirs about
his life in Baltimore, stands outside
of Red Emma's—his favorite book-
store—in Mid-Town Belvedere.

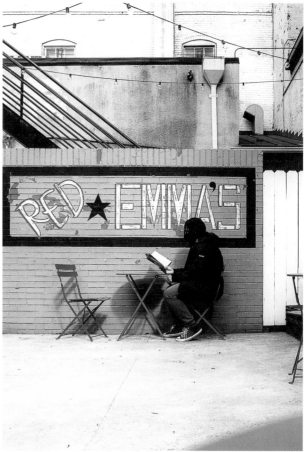

Above
—

There are many bookstores around
the kitschy and colorful 36th Street
in Hampden, an area that has fea-
tured in many John Waters movies.
Atomic Books, at the intersection
of 36th Street and Falls Road (and
pictured on page 82), also has a bar.

Opposite
—

Many literary greats have called
Baltimore home, including F. Scott
Fitzgerald, Gertrude Stein and Edgar
Allan Poe. Poe's former home on
North Amity Street is now a museum,
and his poem "The Raven" is the
namesake of the Baltimore Ravens
NFL team.

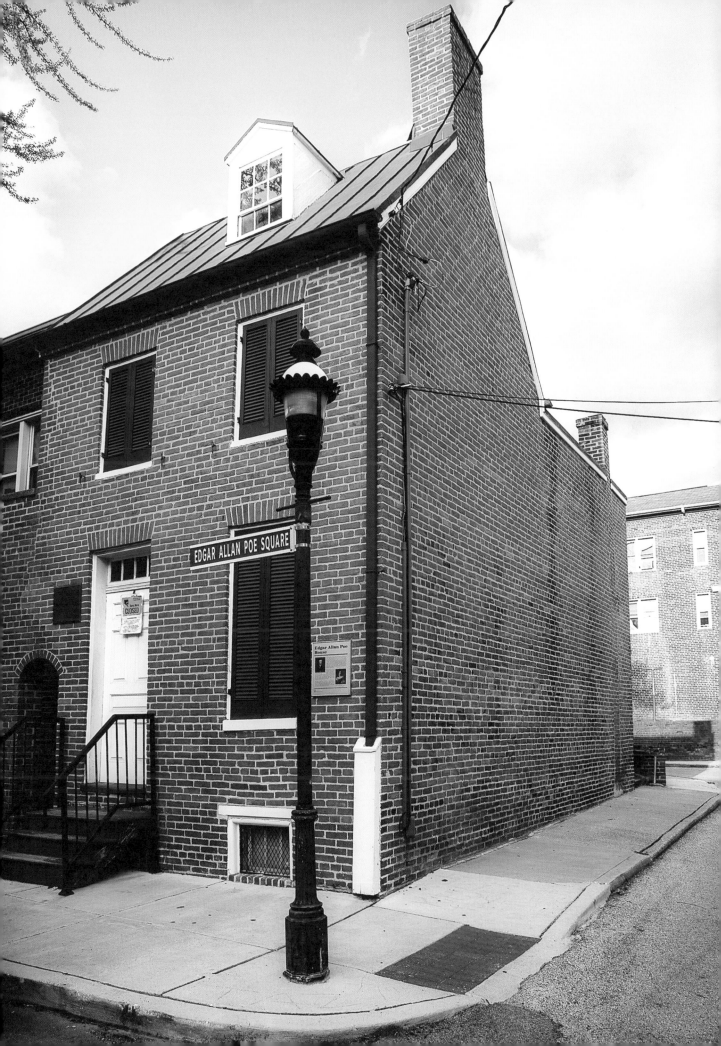

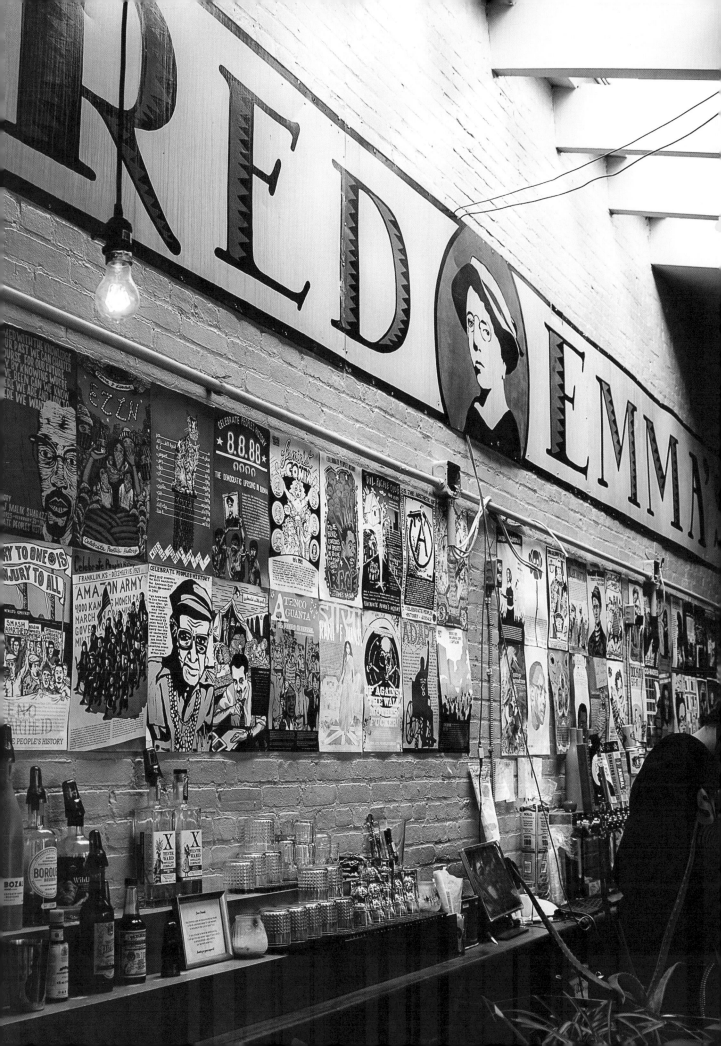

THE BEST BOOKSHOPS IN BALTIMORE

1

ATOMIC BOOKS

If you've got a message for cult movie director John Waters, Baltimore's hometown hero, you'll need to drop into Atomic Books in Hampden—he collects his fan mail here. While you're at it, pick up a book, comic or zine and a locally brewed elderflower mead at the bar.

3620 Falls Rd, Baltimore

2

THE BOOK THING OF BALTIMORE

Here's a novel idea: free books. The Book Thing is a nonprofit bookstore with a mission to put unwanted books into the hands of people who want them. All books are totally free, and there's no limit to how many you can take. Just pass them on when you're done.

3001 Vineyard Ln, Baltimore

3

THE KELMSCOTT BOOKSHOP

The largest used and antiquarian bookstore in Baltimore, Kelmscott is housed in a historic row house on West 25th Street, also known as Book Row. Presiding over the thousands of immaculately preserved rare books, maps and artifacts are two resident cats, Pierre and Upton Sinclair.

34 W 25th St, Baltimore

4

CHARM CITY BOOKS

Charm City is of the community and for the community of Baltimore's Pigtown neighborhood. Offering music lessons, story time for kids and all manner of book clubs and workshops (including floral arrangement and acting master classes), Charm City is a one-stop shop for a little human connection.

782 Washington Blvd, Baltimore

5

GREEDY READS

Occupying a handsome corner of a classic brick building in waterside Fell's Point, Greedy Reads may be small, but it specializes in giving space to traditionally underrepresented voices. Tell them your three favorite books and your current mood, and the staff will send you home with your next favorite in a custom tote.

1744 Aliceanna St, Baltimore

6

THE IVY BOOKSHOP

If you like your bookstores quaint, the Ivy won't disappoint. But that's not to detract from its selection, which includes titles you'd be hard-pressed to find elsewhere in Baltimore. Best of all, it's located slightly outside the city within two acres (.4 ha) of wooded grounds, with meditation paths, lawns, and pocket gardens to explore.

5928 Falls Rd, Baltimore

7

RED EMMA'S

That's Emma, as in the anarchist Emma Goldman, and red as in, well, you know. Emma's is worker-owned and -operated since 2004, meaning everyone in the collective owns an equal share of the business. On top of the politics, there's a cracking vegetarian café and progressive lit selection.

1225 Cathedral St, Baltimore

8

THE BOOKSTORE NEXT DOOR

Charlotte Elliott specializes in vintage clothes, furniture and antique ceramics from China and Japan. But objects aren't the only things that get better with time—a book with a patina of age tells more stories than just the plot. Pop in for first editions and rare books as well as used paperbacks.

837 W 36th St, Baltimore

Tasmania's outlandish Mona Museum attracts even the most infrequent museumgoers. For Bianca Welsh, a local restaurateur and design enthusiast, lingering in this or one of the island's many other, often unusual, museums offers a memorable pause.

Museum Hopping in Tasmania

Tasmanians are a casual bunch. In the decade since opening its doors, the Museum of Old and New Art—the island's mothership cultural institution—has welcomed over a million visitors. Still, its Google search description remains somewhat blasé: *Mona: a museum, or something. In Tasmania, or somewhere. Catch the ferry. Drink beer. Eat cheese. Talk crap about art. You'll love it.*

Until this curious, subterranean icon surfaced on a Hobart peninsula in 2011, the isolated island had been best known for its otherworldly wilds and unhurried pace. Mona may have since landed Tasmania on the world's cultural map as the southern hemisphere's largest privately funded museum, but those who choose to take the ferry to visit it can still opt to do so "cattle class"—sitting on the sheep-shaped seats that decorate the deck.

In general, there is little pomp around the local art scene. Mona entry remains free to all Tasmanians, which encourages the eclectic mix of visitors for which the museum has become known; members of the art world elite descend into the labyrinth of hewn Triassic sandstone galleries alongside kids from Hobart's tougher neighborhoods, who might have never set foot in a museum before. Beneath its air of nonchalance, Mona exemplifies the island's cultural heart—one that forever beats strong, crosses generations and connects Tasmanians in a way that's largely unseen at surface level.

"There's something magical and otherworldly when you're in a Tasmanian town and fall into a secret rabbit hole," says restaurateur and Tasmanian design aficionado Bianca Welsh. "You can be walking through streets that seem empty, and then step into a hive of activity. It's a little like the entrance to Mona: you think you're stepping into a one-story building then, like Alice in Wonderland, you fall through tunnels and secret rooms carved into the cliffside into Mona's artistic underbelly," she adds.

Welsh is the co-owner of Stillwater Restaurant, Seven Rooms and Black Cow Bistro—three award-winning businesses in the town of Launceston, about a two-hour drive north of Hobart. There, Welsh volunteers her time at Design Tasmania, another beloved cultural institution that dates back to 1976 and is known for its celebration of rare Tasmanian timbers and designers. Despite having been awarded the title Young Restaurateur of the Year and having been state finalist for Young Australian of the Year, Welsh positions herself as a classic Tasmanian: unfussy.

She sees parallels between her role at Design Tasmania and within her hospitality businesses. "At our restaurant, food is

like art," she says. "It's an experience, rather than just food on a plate. It's the taste, the smell, the surroundings, the music, the feel of the chairs, how produce got to the plate, the chef's influence. I feel the same when I walk into Design Tasmania and I can smell the scent of Huon pine timber, likely hundreds of years old. I become absorbed in the experience. It's a feast for the senses."

Day to day, Welsh says it's the quiet moments she relishes at the museum. "We have more than one hundred thousand people come through Design Tasmania annually," she says. "I always try to arrive early for meetings so I can sit and look out of a particular, beautiful window. It's like a picture frame for our city park—a window that transports to a calming realm."

Finding Tasmania's cultural pulse, Bianca believes, is a little like traveling around Tasmania. Those who feel they can tick off highlights in a handful of days might see a glimpse of Cradle Mountain through the clouds or take brisk steps into a convict's world at Port Arthur Historic Site, but it's in stillness and "rabbit holes" that Tasmania comes to life. For museum hoppers, those who tick off only Mona might miss the opportunity to get lost in the island's other institutions, like Design Tasmania and Welsh's other recommendations: the Queen Victoria Museum and Art Gallery in Launceston, for example, or the Tasmanian Museum and Art Gallery (TMAG) in Hobart.

Still, Mona is a mind-bending start. "I remember moving through Mona in the darkness into a light-filled room where Australian artist Cameron Robbins's 'drawing machine' was madly capturing patterns of the wind on a dark and stormy day, translating them onto paper. I got lost in time. Another time, James Turrell's permanent outdoor installation at Mona, *Amarna*, literally changed the shade of the sky during golden hour and left me in some type of hypnotic trance," Welsh says. "It's in these pauses that Tasmania does its talking."

"It's in these pauses that Tasmania does its talking."

Previous
—
Bianca Welsh sat on the board of directors at Design Tasmania until 2021. In Launceston, she also co-owns and manages three award-winning restaurants. The museum overlooks a park, and Bianca finds the views (like the one pictured opposite) calming.

Above
—
Design Tasmania is home to a permanent collection of contemporary Tasmanian wood design. Pieces include John Smith's Riptide Chair (left), Brodie Neill's Alpha Chair (center) and Brad Latham's Tiger Chair (right).

Above Left and Opposite
—
The Wood Collection at Design Tasmania comprises over eighty pieces, including Ben Booth's sculptural *Vicissitude* (opposite, right) and Pippa Dickson's *Variable Coupling* (opposite, far right), which doubles as a bench.

Above Right
—
Design Tasmania is located in Launceston's City Park—a beloved feature of the city. The park is also home to a troop of Japanese macaque monkeys and, on weekends, a miniature train.

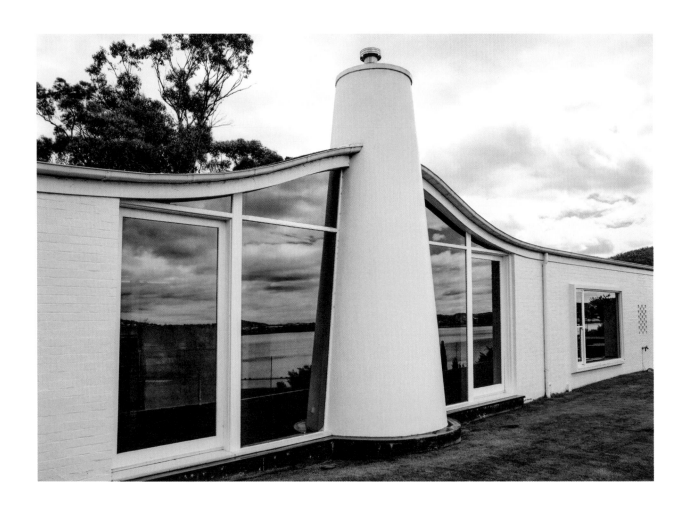

Above
—
The museum's entrance, Roy
Grounds Courtyard House (pic-
tured), was originally the home of
the architect Roy Grounds, who
designed several of the buildings
that were already on site at Mona.

Opposite
—
The large white sphere that beck-
ons from the Pharos wing of Mona
is actually the shell of an installation
by light artist James Turrell—set in
the middle of a tapas restaurant.

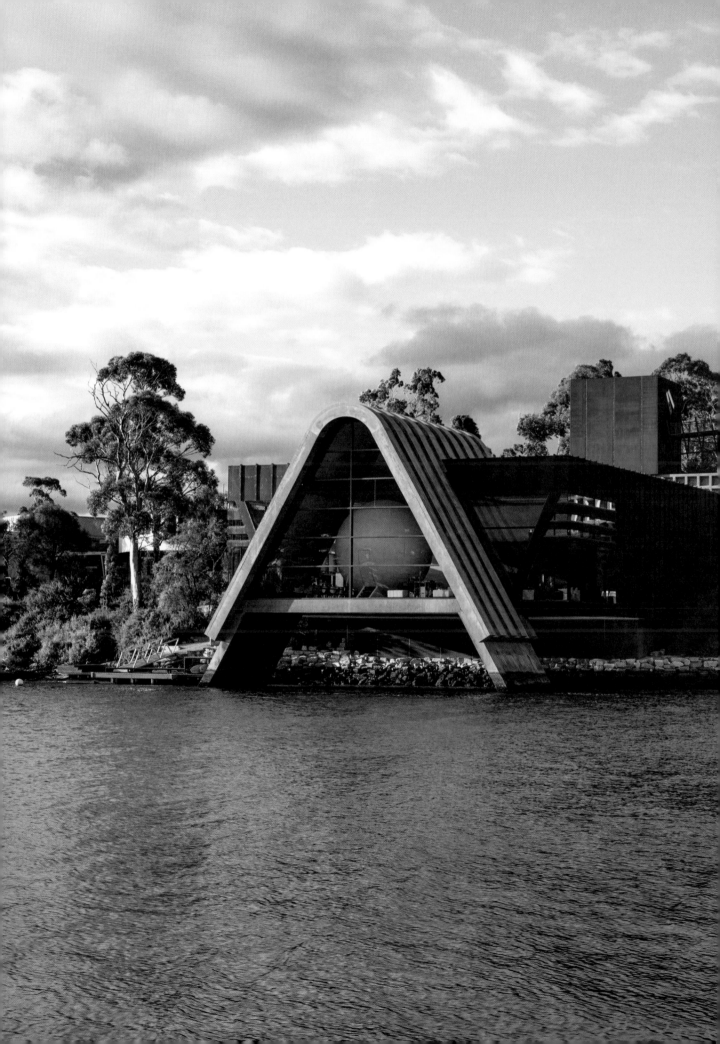

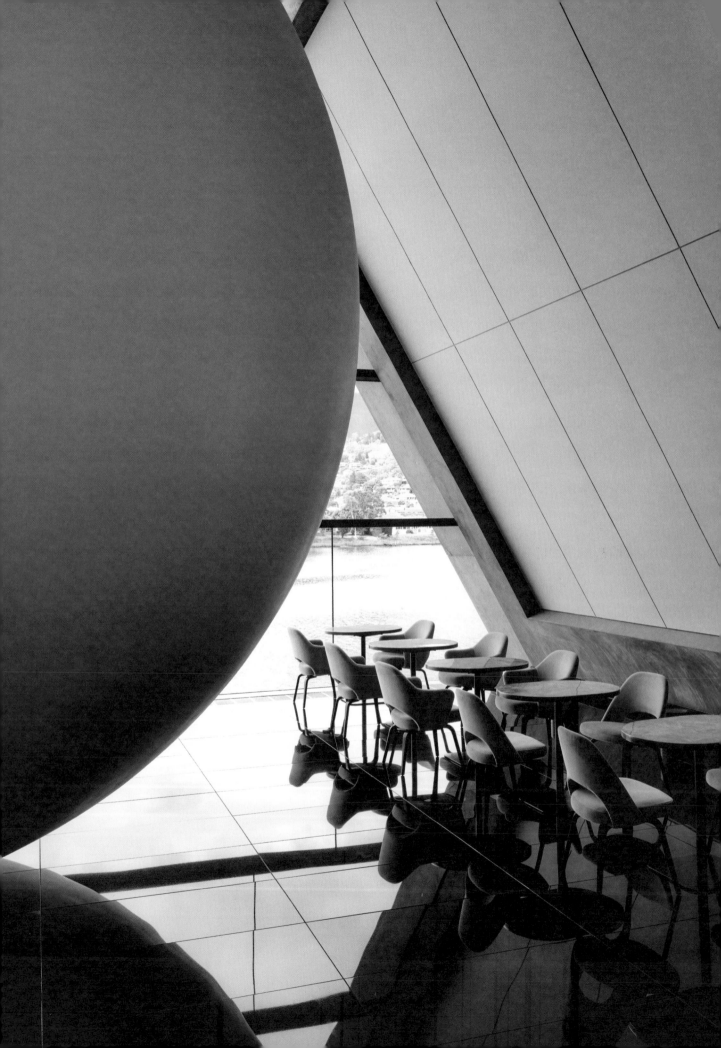

1

MONA

Created by gambler turned art collector David Walsh, Mona is a museum in the loosest sense. It has the titular old and new art, yes, but also a collection of hangout zones, a hotel and an exhibition space that once hosted a gala dinner where invasive species were on the menu—including cat consommé.

655 Main Rd, Berriedale

2

DESIGN TASMANIA

Since its founding in 1976, Design Tasmania has funded the practices of artists of all experience levels from Tasmania, mainland Australia and beyond. Since 1991, it's also been home to the Design Tasmania Wood Collection, which now numbers over eighty pieces ranging from furniture to kitchen implements to abstract objects.

Corner of Brisbane and Tamar Sts, Launceston

3

TIAGARRA

The first project in Tasmania devoted solely to First Nations Tasmanians, Tiagarra's traditional shelters are used for cultural events and educational group tours. The coastal site is home to many culturally significant resources, including plant foods and weaving materials, as well as historic rock incisions that may be petroglyphs.

1 Bluff Access Rd, Devonport

4

MAKERS' WORKSHOP

Perched on the beach in the northwestern coastal town of Burnie, the Makers' Workshop is a high-sheen metallic building designed to reflect the tidal flats and ocean birds. Inside, papermaking workshops, a cheese shop and a gift shop featuring design-minded Tasmanian crafts are the icing on the cake.

2 Bass Hwy, Burnie

5

TASMANIAN MUSEUM AND ART GALLERY

Dating back to 1848, the Tasmanian Museum and Art Gallery engaged in some reprehensible colonial-era museum behavior. Uniquely, the museum has issued a heartfelt, detailed apology to Tasmania's First Nations community for its historical actions, which it described as morally wrong, and has recommitted to working with the community toward a new future.

Dunn Pl, Hobart

6

QUEEN VICTORIA MUSEUM AND ART GALLERY

Originally founded in 1891 to house a mineral and zoological collection, the Queen Victoria Museum and Art Gallery now hosts wide-ranging exhibits. Recent subjects have included life in First Nations Tasmania and an art exhibit depicting the journeys of refugees coming to Australia.

2 Invermay Rd, Invermay

7

SALAMANCA ARTS CENTRE

Housed in a series of historic sandstone warehouses just off Hobart's waterfront, Salamanca is a series of studios, exhibition spaces and cafés showcasing Tasmanian art and design. There's also a warren of galleries and shops if you're in the market for some art to take home.

77 Salamanca Pl, Battery Point, Hobart

8

ROYAL TASMANIAN BOTANICAL GARDENS

The Royal Tasmanian Botanical Gardens feature dozens of plants you won't see elsewhere in the country: there is a Cactus Collection and Australia's only Subantarctic Plant House. The exhibits and collections are spread over thirty-five acres (14 ha). Green-thumbed visitors should also check out the Tasmanian Herbarium at the Tasmanian Museum and Art Gallery.

Lower Domain Rd, Hobart

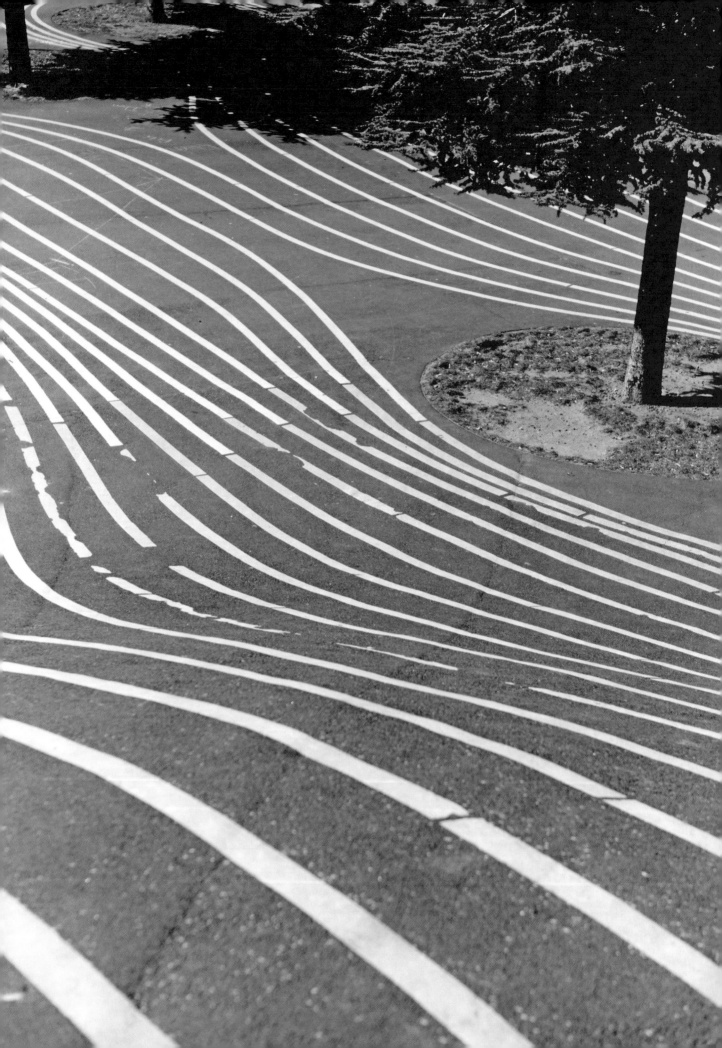

HOW TO AVOID
THE INFLUENCER TRAP

In Don DeLillo's 1985 novel *White Noise*, academic Jack Gladney goes on a day trip with his friend Murray Jay Siskind. Driving past meadows and orchards, the pair soon spot signs to "the most photographed barn in America." They get out at the designated viewing point, where tourists are dutifully assembled with cameras, tripods and tele-photo lenses. "No one sees the barn," Murray comments wryly. "Once you've seen the signs about the barn, it becomes impossible to see the barn." The barn is photographed because it is photographed, famous for being famous. It is as if the barn itself has evanesced in the glare of flashbulbs, leaving only an aura of fame.

White Noise was published twenty-five years before the invention of Instagram, but anyone who has spent time doom scrolling the feed might feel a shiver of recognition. The barn is all over Instagram, of course, and not just in the thousand-plus photos geotagged at the superbly photogenic T. A. Moulton Barn in Wyoming (DeLillo's real-life inspiration). There are also the Smurf-blue walls of Moroccan town Chefchaouen, the luminous Tolkienesque expanse below Norway's Trolltunga cliff, the sapphire waters of Slovenia's Lake Bled. All these have achieved barn status online. Do people take pictures because they are moved by the beauty of these spots? Or is it because, when you go to these places, taking photos is simply what you do?

In just a few short years, Instagram has transformed the travel industry. A 2018 study found that over 40 percent of people under the age of thirty-three now prioritize "Instagrammability" over any other factor when selecting their next vacation destination.

We might relate to DeLillo's cynical tone, inundated as we are by generic travel content and influencers posing by the Taj Mahal, but taking photos has been an intrinsic part of traveling ever since George Eastman made photography accessible with the first Kodak camera in 1888. Even if influencers irritate you, is there anything fundamentally wrong with taking photos of your travels and sharing them with others?

To answer this, we must first understand why people take travel photos in the first place. Throughout the twentieth century, tourists took photos and compiled them into albums and scrapbooks—personal archives where they could store memories off-site. These photographs could have potent effects when reviewed later: who hasn't experienced the sensory chain reaction sparked by an old holiday snapshot, when an image rekindles long-forgotten sounds, scents and memories?

Yet until the arrival of the internet, these photographic archives were to be seen only by friends and relatives. Instagram, the most image-driven of the popular social platforms, changed that. Travel photography is no longer the compilation of a personal archive for the future but a present-tense performance for an audience of acquaintances and strangers.

"To collect photographs is to collect the world," wrote Susan Sontag in her influential 1977 essay collection *On Photography*. Even back then, travel photography was interpreted as a way of acquiring social capital. Sontag noted drily: "It seems positively unnatural to travel for pleasure without taking a camera along. Photographs will offer indisputable evidence that the trip was made, that the program was carried out, that fun was had." On Instagram, this "evidence" of our tourism, of our wonderful, enviable lives, has an almost unlimited potential audience.

In his 1974 book *Topophilia*, influential Chinese photographer Yi-Fu Tuan commented that one takes photos of a lake not just to show off to friends, but also to validate one's own experience: "A snapshot that failed to register is lamented as though the lake itself has been deprived of existence." The ubiquity of cameras and images in modern culture has created a society that has lost faith in its own memories; as the internet saying goes, "pics or it didn't happen."

This is why the act of taking a travel photo is so urgent that over 250 people have died trying to take selfies from perilous positions. It is why countless tourists take eerily similar photos of the same views in the same places, a trend expertly skewered by the account @insta_repeat, which posts collages of identical photos from different users: twelve views of verdant fields through the opening of a blue tent; twelve girlfriends with long, messy hair leading us by the hand down a forested path; twelve people

jumping over the same gap between Icelandic rocks, all wearing canary-yellow rain-coats. Though these images look homogeneous to the outside observer, *our* photos are different, of course, because *we* are in them.

The potential social rewards—and the financial remuneration, in the case of professional travel influencers—can lead certain Instagrammers to blur the line between documentary and fiction. While followers may see a lone figure gazing wistfully over the magnificent Lake Ringedalsvatnet in Norway, the photo carefully crops out the line of hikers waiting to take the same shot. What looks like a serene lake reflecting the tourist standing at Bali's Gates of Heaven temple is an illusion created by an enterprising local holding a mirror beneath the camera lens. Other users are more blatant, erasing crowds or adding blue skies with Photoshop, or even transplanting themselves wholesale to places they have never visited. It doesn't matter if it's real, as long as it looks good.

Travel influencers impact the places they visit. Because of its new popularity on social media, annual visitors to Norway's Trolltunga cliff have increased from eight hundred to one hundred thousand in a decade. Today, many destinations have their own social media strategies and advertise themselves as "Instagrammable." This is not entirely new—Kodak put signs at the entrances of American towns listing what to photograph as early as the 1920s. But through the internet, such strategies have a far greater impact. While increased tourism can prove a boon for local economies, several viral Instagram destinations have suffered from their newfound fame—Thailand's Maya Bay, Boracay in the Philippines and Hanoi's "train street" were all forced to shut themselves off to tourists due to the unmanageable numbers.

In one of the stranger manifestations of this phenomenon, there is the suggestion that the images themselves might even impact tourists' health. Since the 1980s, a small number of Japanese tourists have reported dizziness, vomiting and hallucinations as a result of what is termed "Paris syndrome," a culture shock caused by disappointment when the French capital fails to live up to its idealized media image.

If both taking and sharing photographs can have adverse effects, then what can we do? Can we travel ethically without giving up Instagram? Sontag argues that tourists put up their cameras as a barrier against discomfort in a foreign place: "Unsure of other responses, they take a picture. This gives shape to experience: stop, take a photograph, and move on." But it doesn't have to be like this.

Travelers can use their cameras for the opposite reason, to engage more profoundly with a place. The spirit of travel is to meaningfully encounter a new space alongside its people and culture. It is something you do for yourself, not for a digital audience. Rather than gormlessly snapping a picture of the most-photographed barn, you might go off-piste and discover something that has never been seen before. Or you might simply look more deeply and seek to understand why that barn got so famous in the first place.

THE MYTH OF AUTHENTICITY

"I hate traveling and explorers." So begins *Tristes Tropiques*, the memoir of legendary anthropologist Claude Lévi-Strauss, in which he then somewhat contradictorily proceeds to recount tales from his own voyages to Brazil and other countries. Explorers, he laments, perpetuate the illusion of "a vanished reality" now tarnished by contact with Western cultures. The book was published in 1955 but Lévi-Strauss's dilemma still rings true today: traveling to experience the "real" essence of a destination, whatever it may be, is a self-defeating target. The presence of foreign visitors irreparably alters the places they seek to explore. In a globalized world, the traveler's nostalgia for an unspoiled encounter with different cultures seems outdated, and a lost cause.

What would an authentic journey entail, anyway? For some, it means the opposite of charter cruises and preplanned holidays: it's about connecting to what's not for sale, going off the beaten path, embedding in the "real lives" of local residents. For others, though, it means nothing at all. "I don't think authenticity is important to all people—it's a concern to those who identify as cosmopolitan," says Robert Shepherd, an adjunct professor of anthropology specializing in the politics of tourism at George Washington University. "There's a class-driven assumption that travel is inherently more authentic, or better, than tourism."

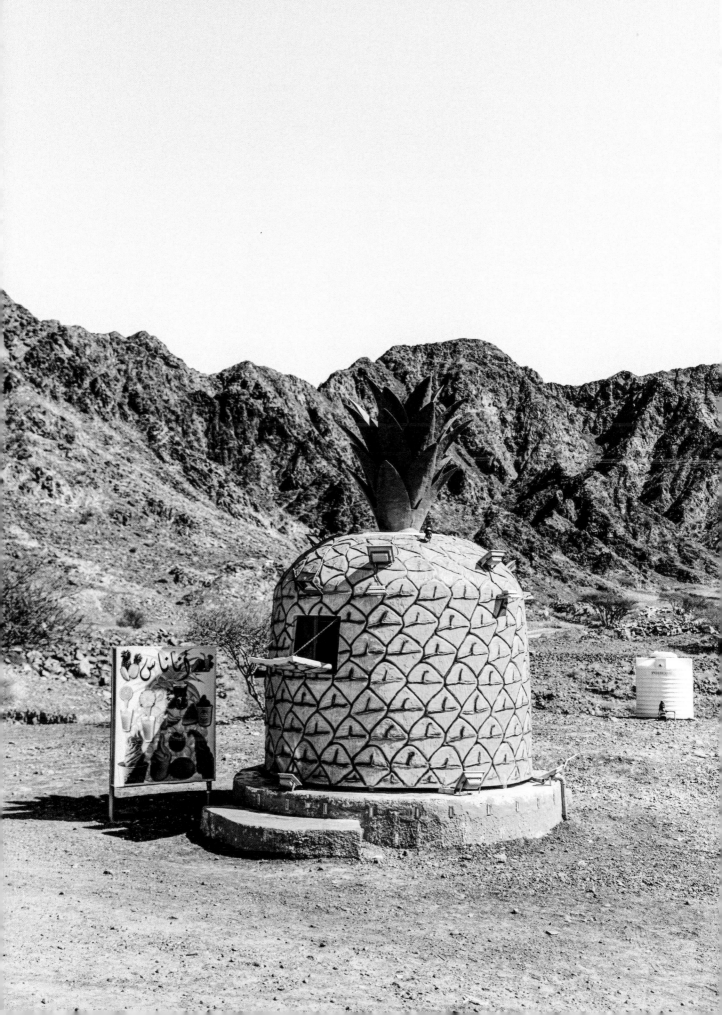

While many self-professed travelers wish to see themselves as different from tourists, the distinction between the two is difficult to articulate. Like tourists, "travelers" visit countries for leisure because they can afford to do so. The traveler/tourist dichotomy deems the former noble and the latter vulgar, yet both categories perceive what's foreign through a consumer lens: they purchase an experience marketed to them as outsiders, be it in an all-inclusive resort or a local Airbnb rental. "One could say it's a trap—that in seeking to experience what's authentic, you experience the market product," says Shepherd. "But there's also no basis in history for the notion that objects that circulate for money are somehow profane. In Europe, wherever you find a cathedral, you find a market. It's always been like that."

Our search for realness can often be boiled down to one for purity: a place free from the market dynamics that control our lives, a world where Maasai warriors wouldn't use cell phones and Bolivian shamans wouldn't speak fluent English. Yet the one-sided nature of this quest makes it problematic. Shepherd points out that it is primarily a Western concern: Chinese nationals, for instance, who make up the largest tourist-sending group worldwide, do not share the same anxiety for finding cultures untouched by modernity. "I find this to be a profoundly unreflected-on part of neocolonialism," he says. "There's a complete lack of consideration for those you are looking at. They become passive things to consume."

Indeed, longing for authenticity abroad bears some resemblance to seeking organically sourced produce at the supermarket: it's a consumer sensibility, argues Joseph Pine, coauthor of *Authenticity: What Consumers Really Want*. "As life becomes

> "One could say it's a trap—that in seeking to experience
> what's authentic, you experience the market product."

more of a paid-for experience, people increasingly question what is real and what is not," he says. What makes some tourists uncomfortable is realizing that much of what they witness is created for and catered to them as outsiders. Locals living off the tourism industry will perform for them as "authentic," be it through donning traditional garments, exaggerating their national traits or putting their culture on show. Dreaming, like Lévi-Strauss, of what a civilization would have looked like in years past, before its first encounter with the West, undeniably carries colonial undertones. Yet resenting this state of affairs means denying some cultures the right to evolve and profit from tourism, a key industry in many countries, all for our personal enlightenment.

Travelers probably always experience some level of artifice abroad, but that doesn't mean they are doomed to perceive all trips as inauthentic. "If I go to Venice and just walk through the city, that experience can be very authentic to me," says Pine. "I can also walk through Venice and interpret it as a show for tourists—a city artificially kept in the thirteenth century."

Citing the late *New York Times* architecture critic Ada Louise Huxtable, Pine contends that our travel experiences can be "fake real," built on an illusion of authenticity that isn't itself entirely fake. In her book *The Unreal America*, Huxtable deemed Universal CityWalk—the shopping promenade adjacent to Universal Studios in Los Angeles—one of those "fake reals." Its shiny, artificial facades were visibly juxtaposed to unadorned buildings; visitors could see the real Los Angeles from inside at all times. Its fakery was hiding in plain sight. In that vein, accepting that there's a performative element to our travel encounters doesn't necessarily prevent them from also being real. A Venice gondolier may primarily work for tourists, and as such make a show of his craft, but he still could have spent years perfecting his technique. Who's to say he lacks authenticity? A street vendor who is fluent in four languages has a greater claim to being cosmopolitan than the well-heeled traveler buying from her: understanding this could be another step to a fuller understanding of the realities of travel.

Ironically, the most authentic trips are often those where authenticity isn't part of the conversation: they're about simply experiencing life abroad, understanding one's place in a different society. As foreigners looking in, what we can control is how genuine our own approach is, and our impact on the communities we visit. That, in itself, could help us shift from a purely consumerist approach into a more two-sided relationship with the places we explore. Rather than longing for a reality unknown, real travel is perhaps about coming to terms with the world as it is, and our own place within it.

ON SOUVENIRS

Home reinforces a rote sense of self. Travel, at its best, disorients it. In the silence of the Jordanian desert or the clangor of a Yangon street market, we can suddenly be struck by the awareness that our interior world is expanding. The mind gives way to wonder not just at our surroundings, but at all the selves we might have been, or still might be. These transcendent moments are precious, but they also threaten to fade as soon as they arrive. So, like travelers for thousands of years before us, we look around for something, *anything*, to take with us to preserve them, to make them tangible. A pebble from underfoot. A bit of lacquer work from a nearby stall. A souvenir.

The word *souvenir* is adopted from French—"to remember"—and finds its origins in the Latin *subvenire*, meaning "occur to the mind." Scholars of souvenirs note several distinct types. Pebbles, along with jars of sand or leaves pressed in books, are referred to as "pieces of the rock," something taken from the natural environment. The lacquer, the woven shawl or the quart of olive oil that loses its terroir on the plane ride home are "local products." These objects, we hope, are souvenirs only to us, something we imbue with the meaning we found in the place.

But wherever there is a deep human need, there's also commerce. And in gift shops, we find the souvenir impulse played out in kitschy satire. Shrink-wrapped spoons, usually flimsy and always strange. A wooden block of no apparent use burned with the phrase "Great Smoky Mountains." A pewter statuette of Mao Tse-tung. Moose-shaped maple candy. The obligatory matryoshka doll from Moscow. Stalls stuffed so thick with Eiffel Tower keychains that they threaten to outweigh the structure itself.

"Incurious curiosities" is what the literary critic Elizabeth Hardwick called them, looking out from her hotel room at the "small, futile shops" in Times Square. And who could argue with her? The gift shop boils a location down to its most ostensible external symbols, molded in plastic and shipped from Guangzhou. It seems to sell the tourist only what they knew before arriving.

Experts refer to these types of mass-produced souvenirs variously as "pictorial images" (postcards), "markers" (mugs) and "symbolic shorthand" (the Statue of Liberty paperweight). Their simplest purpose is proof of presence—as in, "I flew to Acapulco and all I got was this T-shirt." There was a time, of course, when certain objects could genuinely certify that the owner had traveled. A well-heeled man returning from an eighteenth-century grand tour would be expected to bring home rare wines, books and Venetian glasswork that would have been otherwise unobtainable. But the democratization of travel and the globalized nature of supply chains have eroded this status ritual. Travel is no longer available only to a select few and, in most cases, anything can now be bought from anywhere online.

A seasoned traveler may roll her eyes at gift shops and instead seek the market-less-traveled. But words like *local, traditional* and *artisanal* have themselves grown threadbare in the language of travel, signaling an obsession with differentiating authentic from ready-made experience. Rolf Potts, who explores the history and psychology of what we buy abroad in his book *Souvenirs*, questions the distinction:

"It's easy to forget how even our quest for external authenticity can be about imbuing our travels with a sense of existential authenticity—a sense that [an] object represents

"When travel is new and exciting, even a Chinese-made keychain in a
Paris souvenir shop can certify a trip to Europe on a personal level."

a meaningful moment in the context of our own lives. When travel is new and exciting,
even a Chinese-made keychain in a Paris souvenir shop can certify a trip to Europe on
a personal level. Years later, the same traveler might instead shop for wine or perfume.
But on an existential level, both purchases reflect an authentic sense of interaction
with the place."

Souvenir taking is not limited to travel. Parents keep their children's baby teeth.
Doctors regularly field requests from patients who want to keep organs removed during
surgery. In the 1950s, soldiers at Los Alamos were repeatedly disciplined for spirit-
ing away small bits of uranium as mementos. Political prisoners have been known to
keep certain items—cloth shoes, for example—as personal evidence of the years in
which they disappeared. When a deeply important experience threatens to flee from
us, we seek to preserve it in an object. Souvenirs are most closely associated with travel
because travel by its nature provides condensed, transitory experiences.

Christian pilgrims in the Middle Ages, among the first large groups of voluntary
travelers, brought home fragments from Jerusalem. Custodians of holy sites had to
guard against those who would chisel away bits of stone and wood in order to keep
some small part of their divine essence. Caretakers at the Sanctuary of the Ascension
had to regularly replace dirt in a spot where Jesus was said to have walked, because
worshippers in their fervor would regularly scoop it up.

These sites begot a thriving industry in sacred Christian souvenirs: vials of oil,
small crucifixes, miniatures and even badges certifying the place visited. All alike, all
seemingly divine for the traveler who brought them home. Though the attachment to
these objects was informed by religious sensibilities, the belief that they contained
the spiritual essence of the place is mirrored in modern souvenir seeking. The stone
from the sunset at Montmartre contains that sunset, if only for us. As Potts describes
it, "The religious experience of a pilgrimage site is similar, emotionally, to the subtle
epiphanies and joys of personally motivated travel."

The medieval pilgrim would be lucky to reach Jerusalem and return alive once in
their lifetime, and when they looked at their vial of oil, or silver bell, the sacred element
of its meaning would likely remain the same over time. Today's souvenirs are more
promiscuous. As we scan our shelves, we see a few items that still genuinely give off
the scent of real memory, the face of someone we fell for, the smell of market spices.
More often, though, they become obscured as we ourselves are changed by time. Why
exactly did I buy an Irish drum? What does the plate from Barcelona that says, simply,
te amo mean now?

"I think souvenirs inevitably become memento mori," Potts notes, referring to
objects that are meant to remind us that life is transient. "In this way, souvenirs, when
collected in the moment, are a reminder of the attempt to hold on to and honor
experience—and then, back home, they are a reminder of the fleeting, holy nature of
past experiences."

WILD

Climb mountains, wade rivers and connect with nature's
overwhelming majesty on a human scale. The wilderness is
calling, and it's closer than you think.

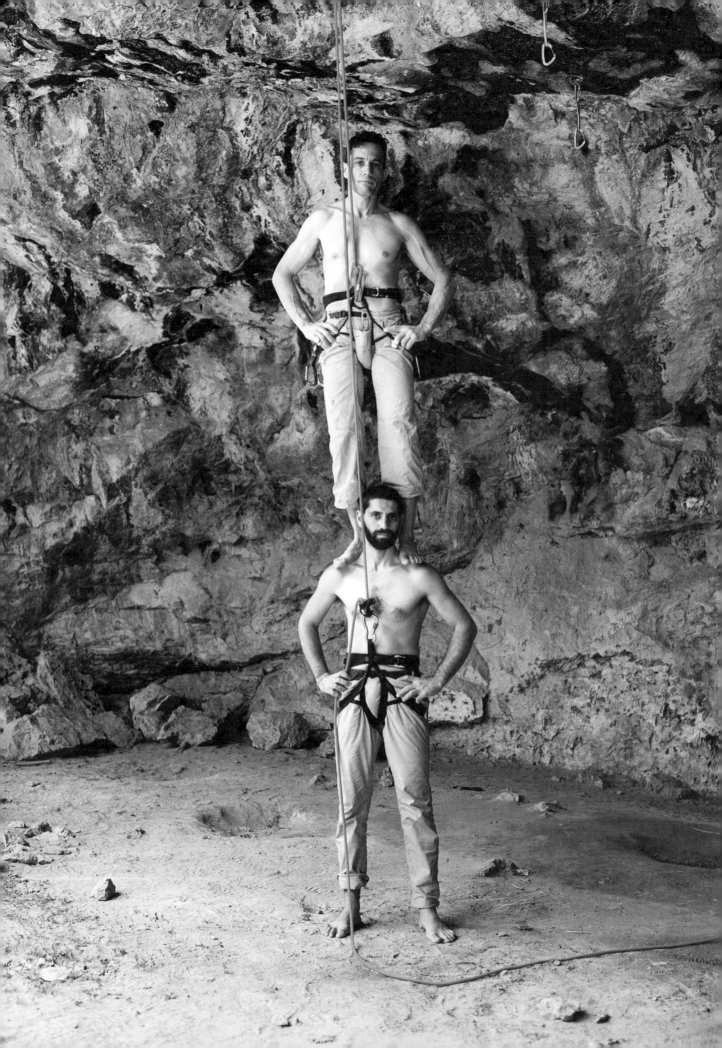

Israel's craggy Mediterranean rock faces are gaining a foothold with a community of young climbers. For Ofer Blutrich, who bolted most of the country's new routes, the sport is a salve—his connection to the land runs deeper with each new ascent.

Rock Climbing in Israel

Ofer Blutrich had walked past the climbing gym in his hometown of Ramat Yishai, Israel, countless times before he thought to go in. One day, a friend convinced him. "I got hooked immediately," says Blutrich of an infatuation turned career that has seen him emerge as one of the country's leading climbers. Alongside his work as a physical therapist, Blutrich has spent the past two decades doggedly scaling the rugged limestone cliffs, caves and canyons that populate Israel. His obsession has helped transform the national climbing scene from an underground movement into a sport with a foothold firmly in the mainstream.

Like other Mediterranean countries, Israel boasts a rugged landscape and a dry, temperate climate. But the diversity of its geography is unusual. The fertile agricultural hills of Galilee are located a 124-mile (200 km) drive from the Negev desert's arid expanse, with famed cultural and religious sights all within a short distance too. Blutrich suggests that visiting climbers base themselves in Haifa, a port city at the foot of Mount Carmel that's popular with foreign visitors for its Bahá'í Gardens. Most major climbing sites are nearby, while Tel Aviv and Jerusalem are within easy reach for day trips. Experienced climbers can find guidance on crags from local outlets, such as the Israel Climbers' Association, a Facebook

page called *Boulder Haifa* and Blutrich's own website, which offers a free guide to the country's most advanced routes. For newcomers to the sport, Blutrich advises contacting Amit Ben Dror, a local climber who runs climbing clinics through his company High Point.

"I think Israel is the perfect winter vacation opportunity for climbers," Blutrich says of his homeland. "It is usually very comfortable to climb here when Europe is under snow. You can see all the holy places and go to the beach on the same day."

Today, climbing in Israel enjoys unprecedented popularity. According to Blutrich, the Israel Climbers' Association currently estimates its number of members at twenty-five thousand—an increase of more than 1,000 percent in just a decade. Bouldering gyms dot every city, their ubiquity providing easy access to the sport and diversifying its enthusiasts into a broader assortment of fitness lovers attracted to the extreme physical challenges that climbing presents.

That wasn't always the case. When Blutrich first discovered climbing in 2001, he recalls a hardcore squad of roughly a hundred climbers, "very adventurous, outdoor people," who had emerged as fringe communities clustered around the country's only two indoor climbing gyms in Ramat Yishai

and Kiryat Ono. As for outdoor options, they barely existed, hindered by a law (still in existence) that bans climbing in Israel's nature reserves. "A lot of climbers start climbing illegally, and then some places ended up getting authorized ten years later," he explains of the bureaucracy involved, which sees Israeli authorities reject formal requests only to backtrack retroactively when spots became established through unofficial means.

In 2017, Czech climber Adam Ondra faced criticism on social media after he completed Israel's first 9a (a grading system in rock climbing that denotes the level of difficulty) in Nezer Cave and named it "Climb Free." The name—chosen to draw attention to the Israeli government's prohibitive attitude to climbing development—was criticized for being insensitive and indicative of extreme privilege, given the military occupation that Palestinians live under. In climbing, these political tensions remain ever present.

While Israelis can venture freely into nature reserves in the occupied West Bank along roads built especially for them, their Palestinian counterparts often face restricted access. And although a burgeoning community of climbers exists in Ramallah, a city in the West Bank, there has been no formal collaboration between Israeli and Palestinian climbers to date. "The issues between Israel and Palestine remain the same even with rock climbing—it doesn't bridge the gap," says Blutrich.

Despite these obstacles, Blutrich remains optimistic about Israel's potential as an internationally sought-after climbing destination. After years spent traveling overseas to countries that offered more developed climbing scenes, he is now within easy reach of northern Israel's most challenging routes, many of which he established himself. With each painstakingly inserted bolt, Blutrich helped set a new benchmark for local climbers. Now, he says proudly, they have somewhere to train in their own country.

His favorite place is Nezer Cave, or "Crown Cave," which is located in a crater around an eighty-minute drive from Haifa. The cave sits in the middle of a field with distant views of Lebanon; inside, its bell-shaped atrium is illuminated by a circular opening to the sky above. It took Blutrich eight years to develop the network of climbing routes that snake across the cave's rough walls, a physically arduous and mentally challenging experience that he likens to solving a puzzle.

"In rock climbing, there's this process of problem solving all the time," he explains. "And there's an element of uncertainty because you don't really know what's going to be ahead. You're always on the edge between succeeding and failing—you never know where the next hold is, how it's going to feel."

By the time he's solved the puzzle presented by a new crag, Blutrich has an exhaustive knowledge of its surface. In Nezer Cave, his expertise has taken on an almost intimate quality. "I know every piece of rock there," he says. "It's like being home."

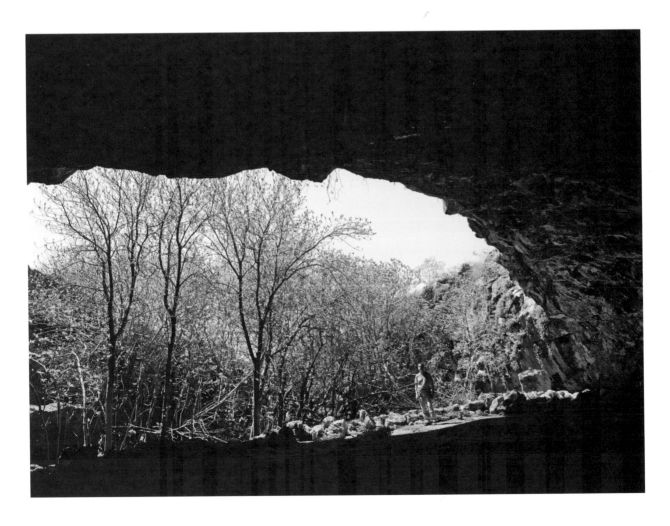

Opposite
—
Nezer Cave has the hardest climbing in all of Israel, and Blutrich bolted its two trickiest routes: Blue Bear, graded 8b, and Matrix, graded 8c.

Above
—
Blutrich has bolted routes elsewhere in the world that he recommends, particularly the Glory on the south face of Jebel Um Ishrin in Jordan's Wadi Rum region.

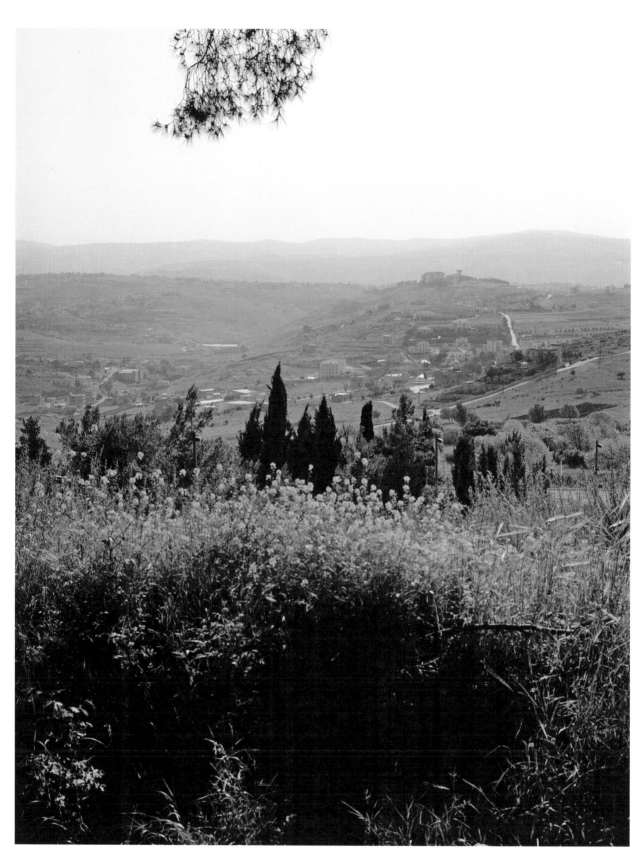

Above
—
Nezer Cave lies in a hidden spot in the hills of northern Israel and only came onto the radar of climbers in 2005. The cave is located approximately half a mile from the UN-patrolled border with Lebanon.

Opposite
—
Points of etiquette for climbing in Israel's caves include the fact that only members of the Israel Climbers' Association may bolt the cave, although loose bolts may be tightened if you're carrying the right equipment.

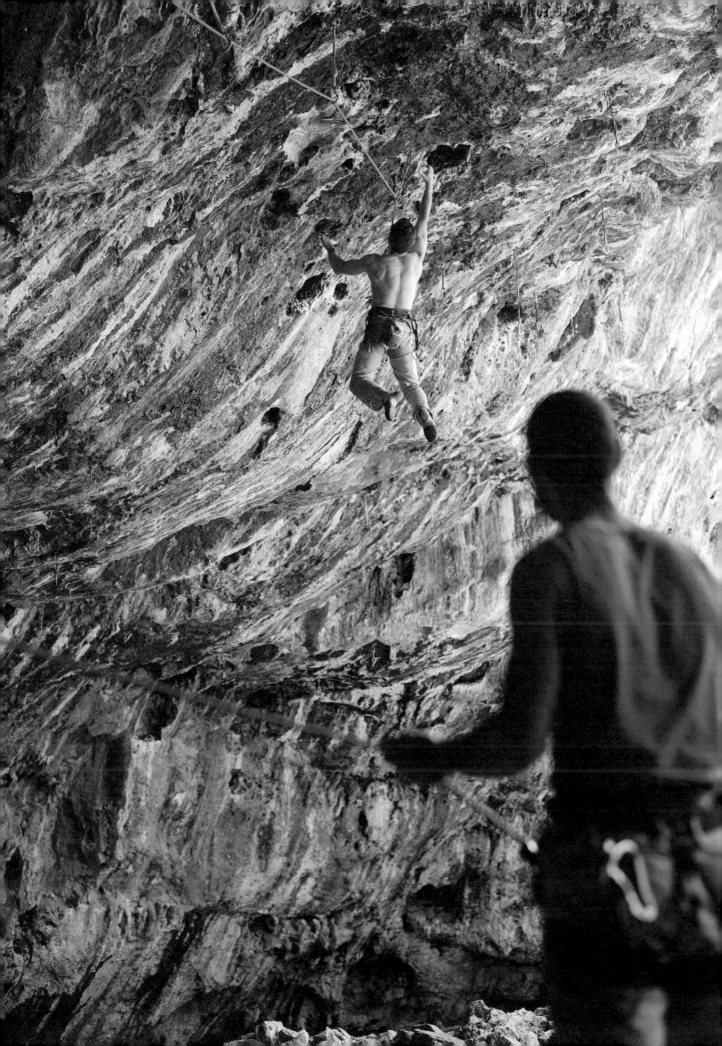

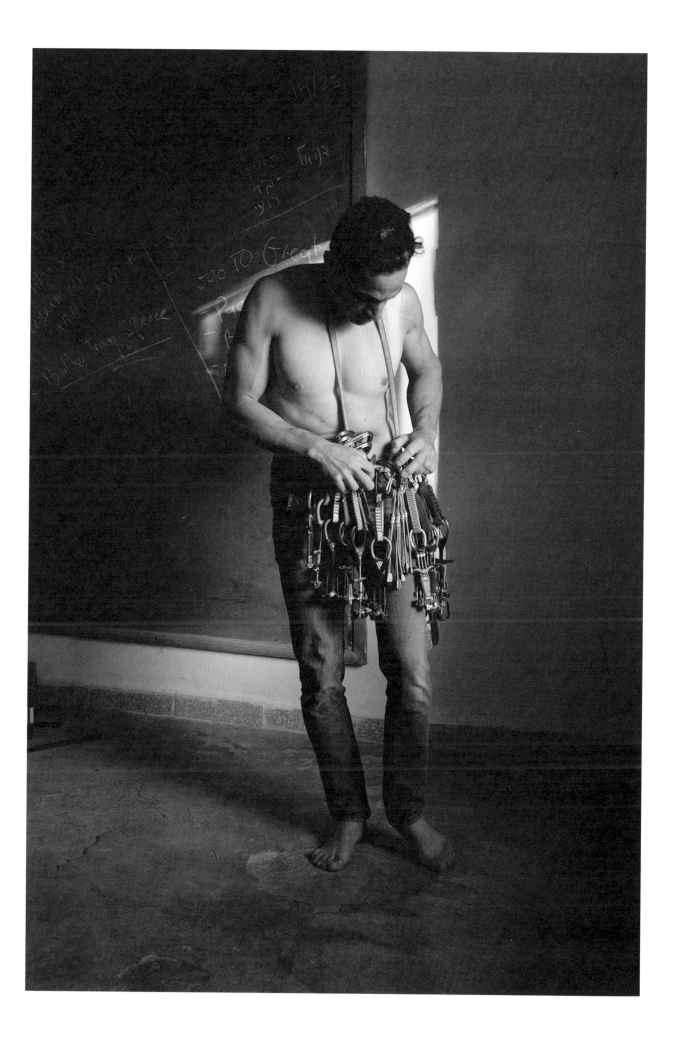

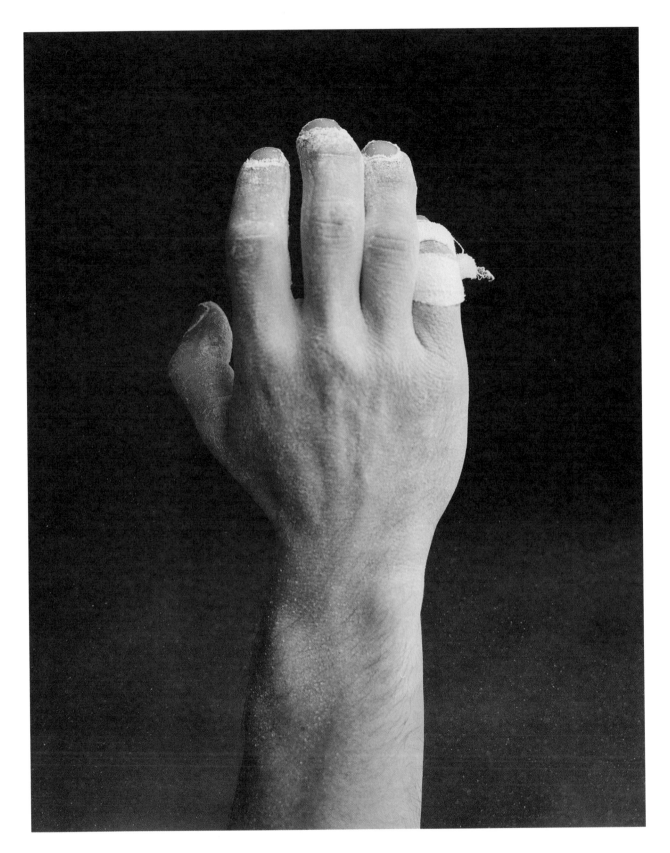

Above
—
Essentials for any climbing trip include a chalk bag, to improve your grip on tricky surfaces, and climbing tape, which can be used to prevent skin tears when climbing cracks or to tape up hands after a demanding session.

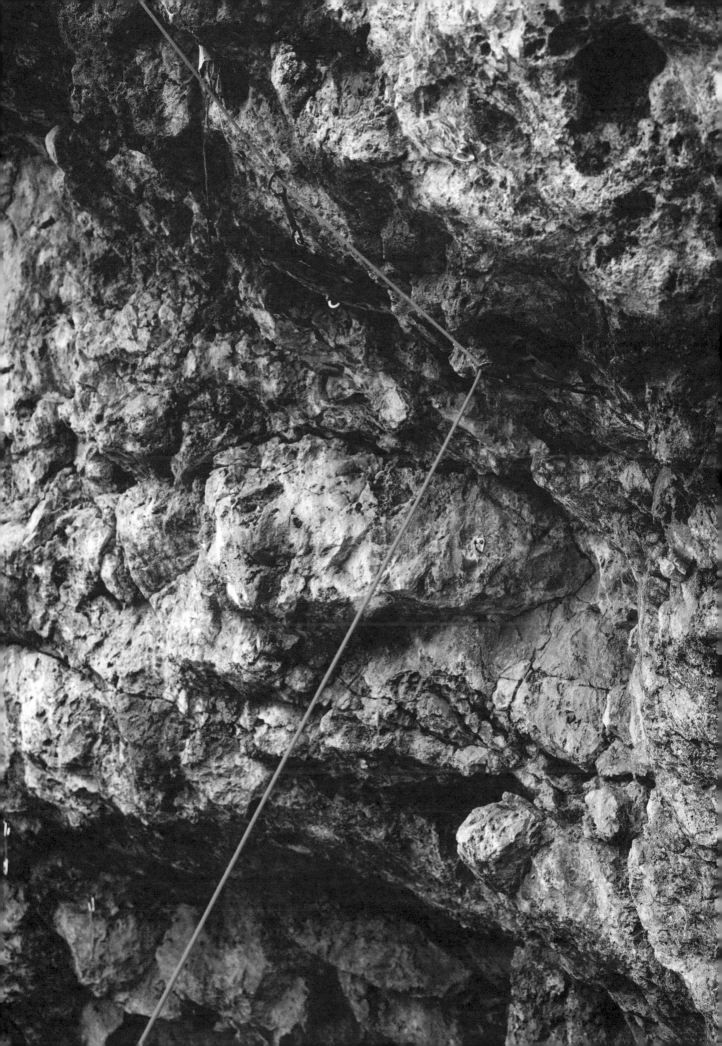

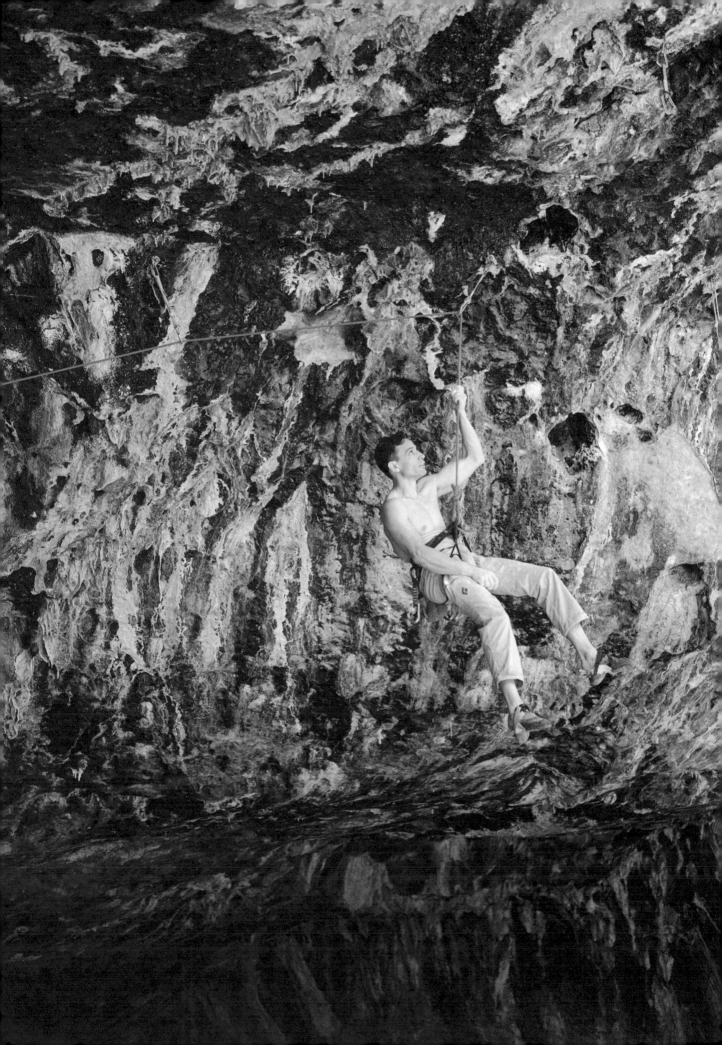

MORE OUTDOOR CLIMBING DESTINATIONS

LAS VEGAS, UNITED STATES

Just sixteen miles (26 km) from the neon hedonism of the Las Vegas Strip, southern Nevada features a huge array of climbing routes, from limestone crags to huge sandstone faces. Red Rock Canyon is a twenty-minute drive from the city and boasts miles of climbable rock face in astonishing hues of, yes, red.

HUU LUNG, VIETNAM

Deep in the Hmong heartland, in a remote valley sixty-two miles (100 km) northwest of Hanoi, the karsts of Tân Thành soar over orchards, fields and jungle. Intrepid climbers trickle in here and make the vertical pilgrimage, clinging to limestone for heart-in-the-mouth views.

DAHAB, EGYPT

A small community of sport climbing is emerging in this Egyptian resort town. The Wadi Qnai canyon has granite walls as well as boulders at levels that match all skill levels, including children and beginners. The draw here is a real-life oasis deep in the canyon.

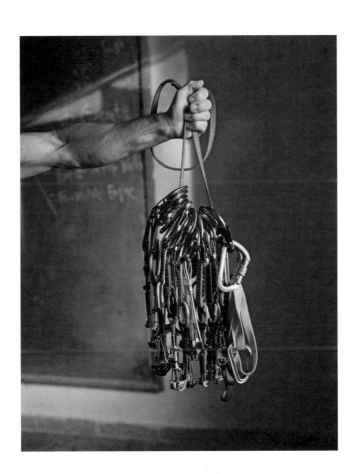

RAMALLAH, PALESTINE

Sport climbing in the West Bank got its start when two Americans studying abroad in Jordan traveled to Ramallah, a city about forty-five minutes north of Jerusalem, and got a look at the surrounding limestone cliffs. Their company Wadi Climbing started a craze. As of last year, their climbing gym and excursions are run exclusively by Palestinians.

YANGSHUO, CHINA

Amid the soaring limestone karst towers of China's southeastern Guangxi province sits Yangshuo county and a city of the same name. The karsts feature plenty of grippy tufa rock, and Yangshou even has a little climbing bar called Rusty Bolt where you can top up on chalk and trade tips over a beer with other climbers.

SKOPJE, NORTH MACEDONIA

For casual climbers, Matka Canyon is nine miles (15 km) from the North Macedonian capital of Skopje. Its five climbing sectors overlook a massive dam and lake in what's otherwise a protected wilderness area. For those looking for a longer trip, Demir Kapija is just over sixty-two miles (100 km) south of the capital and features a wider variety of routes over twelve sectors.

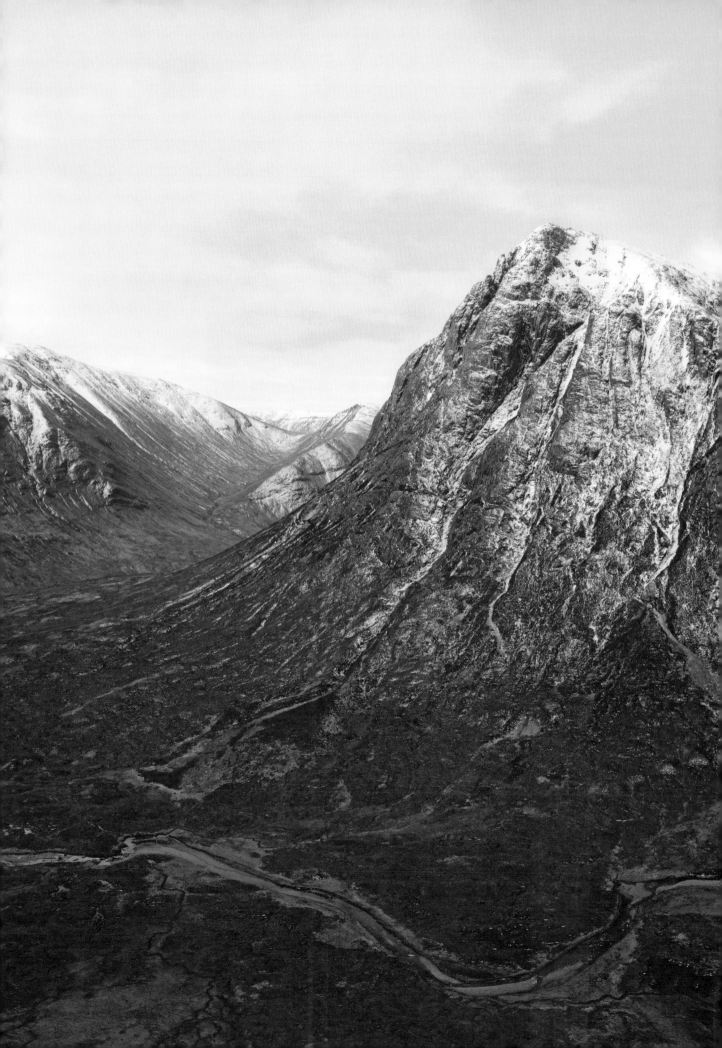

Glasgow is a stone's throw from some of Scotland's most spectacular lochs, glens and Munros. Heading for the hills, says regular hiker Zahrah Mahmood, unleashes a streak of independence—the same spirit that runs throughout these ancient lands.

Scaling a Scottish Munro

The night before a mountain climb, Zahrah Mahmood checks the weather, "religiously, all evening." She makes an omelet that she eats cold, on toast, during the drive out from Glasgow, a road trip snack she remembers her mother making. She also packs jellybeans, pieces of fruit and "something to tide me over on the drive home." With all this in place, she will set off before it gets light: "A full day out is a day well spent," she says.

An hour's drive north from Glasgow—which is Scotland's largest city, although not its capital—takes you to the peaks along the southern edge of Loch Lomond. Scotland is the most mountainous of the UK's four countries, and its landscape includes 282 so-called Munros above 3,000 feet (914 m), as well as the UK's highest peak, Ben Nevis, at 4,413 feet (1,345 m). For Scots like Mahmood, walking is the most popular physical activity, according to the 2018 government household survey. But the call of the mountains is also answered by millions of visitors a year—who primarily stick to the national parks of Loch Lomond and Trossachs, and the Cairngorms in the Highlands. The North Coast 500 trail, a touring circuit of 516 miles (830 km) starting and ending at Inverness Castle, has tempted thousands of tourists further into the wilderness. Hiking brings a fragile, ancient Scotland into view, on pathways that pass rare species of plants, heathland, blanket bogs and elusive animals.

Mahmood's own introduction to the pursuit was Ben Lomond—a tough 3,196-foot (974 m) ascent that almost put her off the idea altogether. "It was a bit of a mistake to start with a Munro," she admits. "I didn't fall in love with it immediately." At the time, she was a stressed-out trainee accountant who needed to escape Glasgow. Friends from her course prescribed a day in the hills: "I was struggling with my exams, and the idea was to get out of my head—just get to the top."

Six months later, she took on Ben Lomond again and then tried a slightly friendlier mountain, West Lomond, in Fife, following a track to the summit past the gnarly, otherworldly rock formations of Bunnet Stane. "Part of it is like a cave. Looking at the view, it hit me that the Prophet Muhammad—peace be upon him—received his first revelation in a mountain cave, while connecting with God out in nature. After that, I've been trying to consciously remind myself that's what I'm doing too."

Tens of thousands of people follow Mahmood's adventures via her Instagram profile @the_hillwalking_hijabi—a visual chronicle of her progress through the Scottish landscape, but also a diary of the spiritual nourishment she takes from the great outdoors. "A lot of people say the mountains are their church.... I always joke that the

mountains are my mosque," she says. Her travel essentials include a lightweight prayer mat with a built-in compass and corner weights.

For a visitor to Glasgow plotting some mountain air in their schedule, Mahmood recommends heading east to Perthshire: "It is underrated. When you ask people where to go for good scenery, they say Aviemore or Glencoe. But Perthshire has so much history too. One of my earliest walks was up Ben Vrackie [2,750 feet/838 m] and I felt on top of the world. You go through a forest, past a body of water, and after the steep last bit, you can see all the way to the Cairngorms," she says.

Glasgow's own relationship with the mountains is complicated. In the early twentieth century, it was mainly society gentlemen who began to chart rock-climbing routes up nearby peaks, taking advantage of their monied leisure time. But shipyard workers later joined them, cycling out to peaks such as the Cobbler on days off and climbing with basic ropes and equipment, sleeping overnight under rock ledges or newspaper tarpaulins. It began a slow democratization of what is now considered a national birthright—the mountain air. The Cobbler remains a popular day-trip climb from Glasgow, along with easier walks such as the Whangie in the Kilpatrick Hills, which passes through a corridor of rock before opening onto wonderful views of the Highlands. The coast-to-coast John Muir Way is also a handy way to parcel up different weekend walks.

Mahmood has now climbed dozens of Munros, having challenged herself to reach a total of thirty before she reached the age of thirty—a plan that was delayed by coronavirus lockdowns. She made up for lost time by climbing fifteen Munros in a matter of months: "I love being immersed in the mountains all day," she says. "I leave feeling very light, mentally and spiritually. Even walking in Glasgow, you can see the Kilpatricks or Campsies and it fills you with peace looking at them."

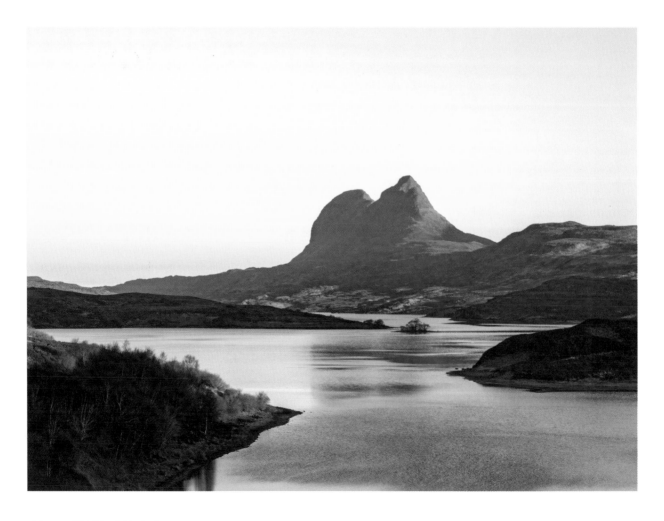

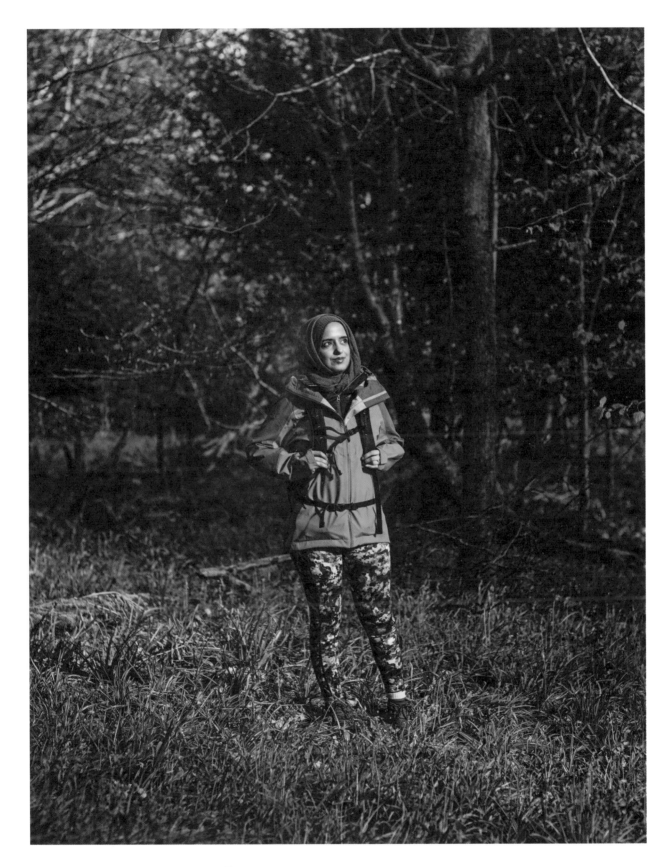

Opposite
—
Experienced hikers will find challeng-
ing routes in the upper Highlands.
Summiting Stac Pollaidh (pictured)
in Assynt—about a five-hour drive
from Glasgow—requires a stiff climb
and a scramble to reach the ridge.

Above
—
Mahmood wasn't an immediate
convert to the joys of hillwalking.
She struggled on her first summit of
Ben Lomond, both with the physical
exertion and the feeling that she was
being stared at by other hillwalkers.

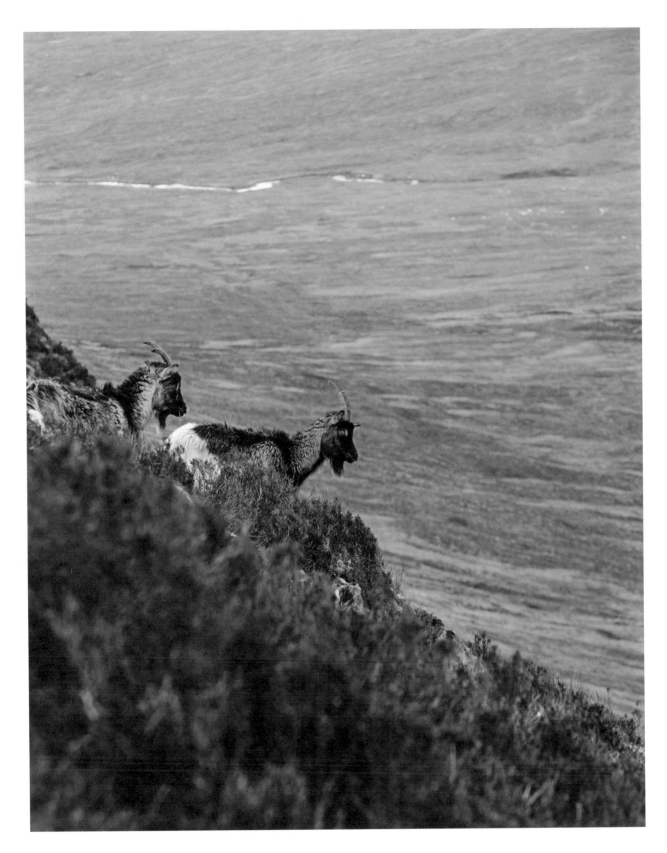

Above
—
Wild goats find a perch on the side of Beinn a'Chrùlaiste, north of Glencoe. At 2,812 feet (857 m), it falls just short of being a Munro and is instead classed as a Corbett—the name given to mountains over 2,500 feet (762 m).

Opposite
—
Scotland's "freedom to roam" laws ensure that everyone has access to public land and water. Loch Carron, the sheltered waters around the Highland village of Plockton, are teeming with marine life: it's possible to spot bottlenose dolphins, porpoises and otters.

DUBLIN, IRELAND

Given its perch on the Irish Sea, Dublin offers walking routes that frequently feature rocky cliffs, quaint lighthouses, sea stacks and rocky beaches for wild swimmers. If you prefer mountains to coast, the nearby Wicklow Mountains have surprisingly steep hikes to keep your blood pumping.

HONG KONG, CHINA

The metropolis of Hong Kong takes up only a portion of Hong Kong island, the steeply mountainous, densely forested thirty-one-square mile (80 sq km) island that's crisscrossed with hiking trails. Walk for a few hours over the mountains and you'll land in Big Wave Bay, where you can watch the surfers.

TRIESTE, ITALY

Closer to Slovenia and Croatia than Venice, Trieste's coastal location in the northeast corner of Italy situates it where the Karst Plateau of central Europe meets the Mediterranean. Trails originating in the city take hikers along white coastal cliffs that plunge precipitously into the sea.

NAGANO, JAPAN

Winter visitors to Nagano can ski in the tracks left by Katja Seizinger and Hermann Maier, who swooshed to victory at the 1998 Winter Olympics held here. In other months, hikers can admire Japan's famous seasonal variations: wildflower blossoms in spring, verdant forests in summer and the changing leaves in fall.

RIO DE JANEIRO, BRAZIL

Think of Rio and mountains immediately spring to mind—or more specifically, the chap hanging out at the top of them. You can get a lift to the mountaintop Christ the Redeemer statue and enjoy a brilliant view of the city, or you can climb the adjacent mountain peaks for a more unexpected perspective.

LUANG PRABANG, LAOS

Trekking through the countryside around Luang Prabang, dotted with karsts soaring high above the dense jungle, feels a world away from, well, anywhere. The Chomphet hike starts a quick ferry ride across the Mekong River from Luang Prabang and takes you past four Buddhist wats, which centuries of monks have adorned with frescoes.

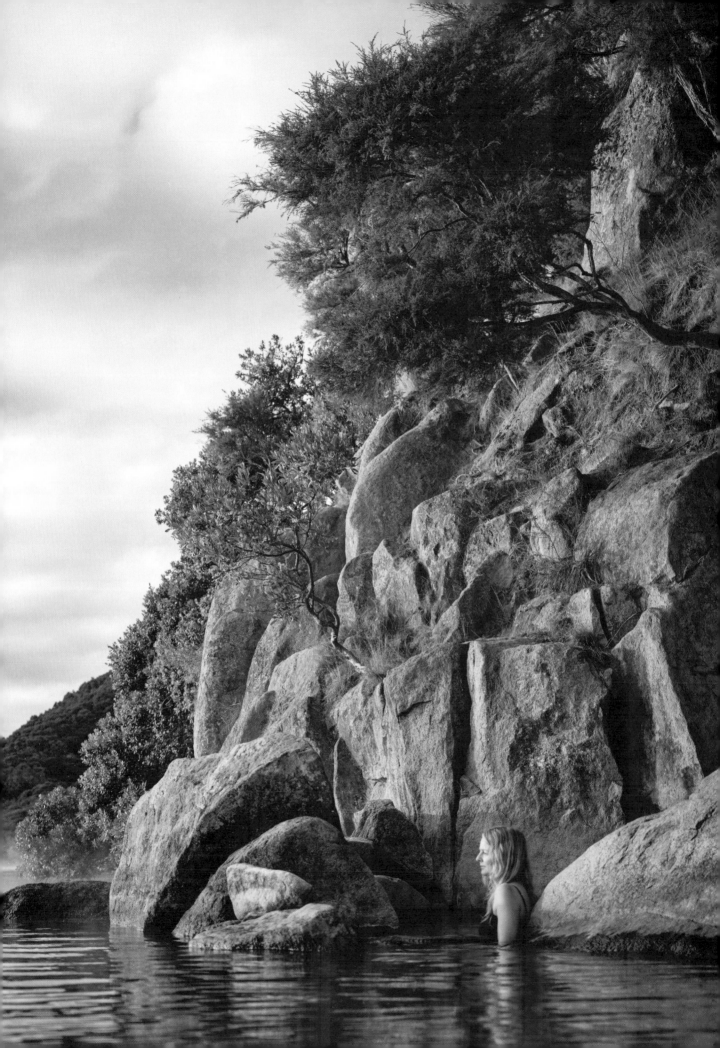

The hot springs of New Zealand present a paradox: to relax in their mystic allure, one must work hard, trekking into often unchartered territory. "Those who do," says Lucy Vincent, a leader in the local wellness industry, "are rewarded with an unadulterated sense of peace."

Wild Wellness in New Zealand

What makes New Zealand such a nigh-on universally desirable destination is its promise of the sort of untamed wilderness that invokes a time before human settlement: dense primeval rain forests, rugged mountains, glaciers and pristine beaches. Its hot springs are no different.

In Rotorua, at the heart of the North Island's thermal region, otherworldly steam rises from the surface of Lake Tarawera. "It makes it look quite ancient and eerie," says Lucy Vincent, the founder of the skincare line Sans Ceuticals. The waters' rich mineral content is understood to be anti-inflammatory and soothing for the skin, says Vincent, who advises bathers not to shower for hours after immersion to fully absorb the benefits.

Vincent moved to New Zealand with her family from the UK at the age of eleven and has counted herself a proud Kiwi since—in part because of the unique and unfettered access that the country affords to nature.

Swimming through Lake Tarawera for the first time, feeling the warm currents jet through the cool waters, Vincent remembers feeling "just how strange it was ... and how amazing." (The sulfurous stench for which Rotorua is notorious did not bother her: Vincent lost her sense of smell as a child.)

That same sense of wonder dates all the way back to the earliest settlement of Aotearoa, the indigenous Māori name for New Zealand, when the Māori prized geothermal waters for their medicinal and restorative benefits. Particular pools were recognized for their spiritual or ritual importance; ngāwhā (boiling springs) would be used for cooking or to prepare flax for weaving, and waiariki (warm pools) would be sites for bathing, laundry and relaxation. From the late nineteenth century, European settlers seized on the benefits of New Zealand's thermal resources, and the government built health resorts. This led to conflict with the Māori: bathing facilities were racially segregated until as late as the 1960s.

Elsewhere in the world, thermal baths invoke an image of pampering: you might expect to find rolled towels, fragrant cosmetics and sun loungers. That experience can certainly be enjoyed in New Zealand at the tourist hot spots that have emerged around springs in Rotorua and, in the South Island, Hanmer Springs, Lewis Pass and Franz Josef. At Lake Taupō, thermal bathers can even swim up to a poolside café and bar. But for a wilder experience, to truly immerse yourself, you might have to work a little harder.

Many of New Zealand's best hot pools are reached on foot through the bush, at the end of a hike of a few hours—or even days, sometimes broken up by a stay in a simple government-managed hut. (Kiwis call it "tramping.") "You don't just flop

out of the car, onto a bed and get rolled to the pool," says Vincent. "It comes with a bit of grit and sweat."

In Kaweka Forest Park in Hawke's Bay, the Mangatainoka Hot Springs is the reward at the end of a three-hour trek through bush and rolling terrain. The three pools, set on a manuka terrace beside the Mohaka River, have the bare minimum infrastructure—a decking area with valves to control the water—and incredible views over the forest canopy.

Be prepared to be "a bit more intrepid" to reach these secret spots, warns Vincent. "There's a sense of adventure with bathing in New Zealand.... We gravitate toward the off-the-beaten-track experience, where the human footprint is low," she says. Some springs may not even be found on a map; ask around in a geothermal area, and a friendly local may be able to point you in the right direction—perhaps down an unmarked track through steep terrain. Take the necessary gear and weather-related precautions; this is wild terrain, after all. If you are headed to Hot Water Beach in the Coromandel, you should also bring a spade: visitors can dig their own pool in the sand.

The sense of luxury is to be found not in the expense or comfort but in the contrast between the restorative waters and the rugged surroundings. For Vincent, the combination makes for a quintessentially Kiwi experience, which stands in stark contrast to the modern-day approach of treating "wellness" as a premium product to be bought and sold. In contrast to the experience offered at European spas, where "everything has been so neatly packaged and sanitized," nature in New Zealand is unadulterated—making the restorative effects all the more potent.

Of all the retreats and holidays Vincent has enjoyed over the years, she says she has never "truly dropped out" of her day-to-day life like she has while camping in New Zealand, whether at a beachside campsite or having hiked to a hot pool.

"When you're in those environments, and all the elements come together, you tune out. You come back into the world feeling quite like a new person," she says. "That's the experience that comes from the wilderness. At a resort, you don't truly escape."

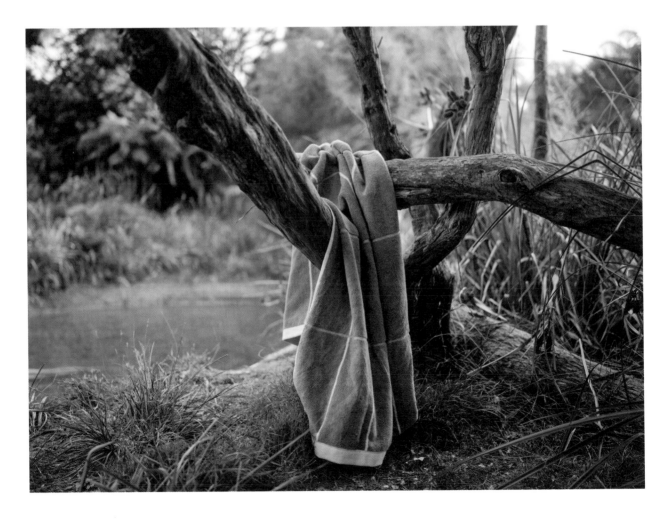

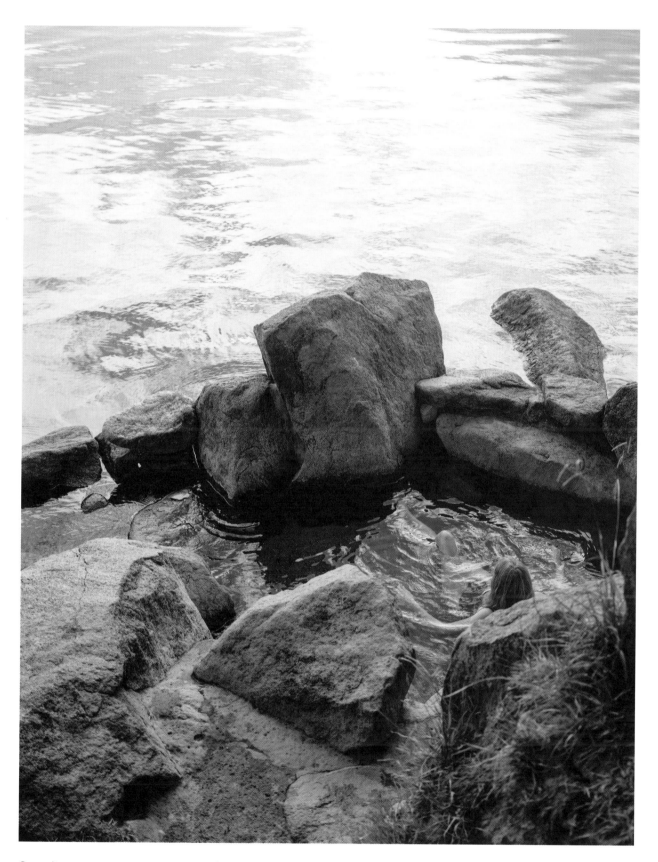

Opposite

—

Visitors have been flocking to Lake Tarawera since the nineteenth century. The Wairua Stream hot pools can be reached by boat or via a footpath along the forested shores of the lake.

Above

—

You can create your own hot pool by forming a circle of large rocks in Lake Tarawera's shallows. In some places, larger rocks have already been placed to create ready-made pools for soaking.

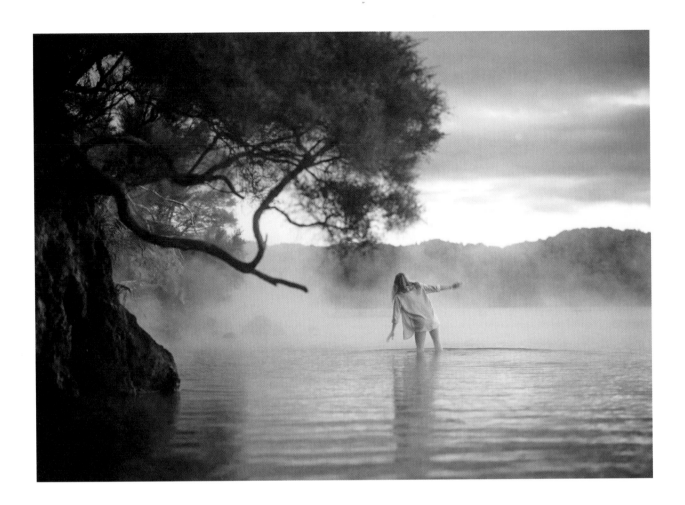

Above
—
Vincent takes a less-is-more approach to beauty and wellness in her product line and emphasizes the importance of sustainability. The hot spas tick both boxes in her book.

Opposite
—
The nine-mile (14 km) Lake Tarawera trail starts at the Te Wairoa car park on Tarawera Road, fifteen minutes outside of Rotorua, and ends on the shores of Hot Water Beach.

MORE PLACES TO RELAX IN THE WILD

DUNTON HOT SPRINGS, UNITED STATES

If you and all your friends have the means and are into old-timey vibes, the entire 1800s ghost town of Dunton, Colorado, is available to rent. A natural hot spring has been diverted for communal bathing in a bathhouse that's been beloved by miners for centuries.

CHENA HOT SPRINGS, UNITED STATES

In 1904, a US geological survey crew saw steam rising from a valley deep in the Alaskan interior. Two gold-mining brothers later found the hot springs at the source of the steam. Today, the spring's complex offers visitors the opportunity to view the Northern Lights while soaking in a natural tub.

LAKE HÉVÍZ, HUNGARY

Hungary's Lake Hévíz is the largest thermal lake in the world suitable for swimming; waters never drop below 73°F (23°C). Its unique chemical composition allows bacteria to flourish, and it's said that these bacteria have special curative properties.

POZAR, GREECE

The Thermapotamus River (that's "Hot River" in Greek) sends steaming hot mineral water into both natural and constructed pools at Pozar, near Greece's border with North Macedonia. Bathers looking for a hot-and-cold experience can plunge into a cold natural pool adjacent to the hot one. Otherwise, sit back and steam away your cares.

HAKONE, JAPAN

Japan is chock-full of onsen, or hot spring, resorts, which are adored throughout the country. The town of Hakone, as well as its rotenburo (open-air bathing pools), sits in the shadow of Mount Fuji, offering bathers the chance to contemplate the mountain's perfect symmetry from the mineral water.

SÃO MIGUEL, AZORES

The Azores are part of the ruggedly gorgeous volcanic islands of Macaronesia, which also comprise Madeira, Cape Verde and the Canary Islands. Thankfully, these days, hot mineral water rather than lava burbles out of the island of São Miguel. Take a dip at the Termas da Ferraria or the iron water pools at the aptly named Furnas.

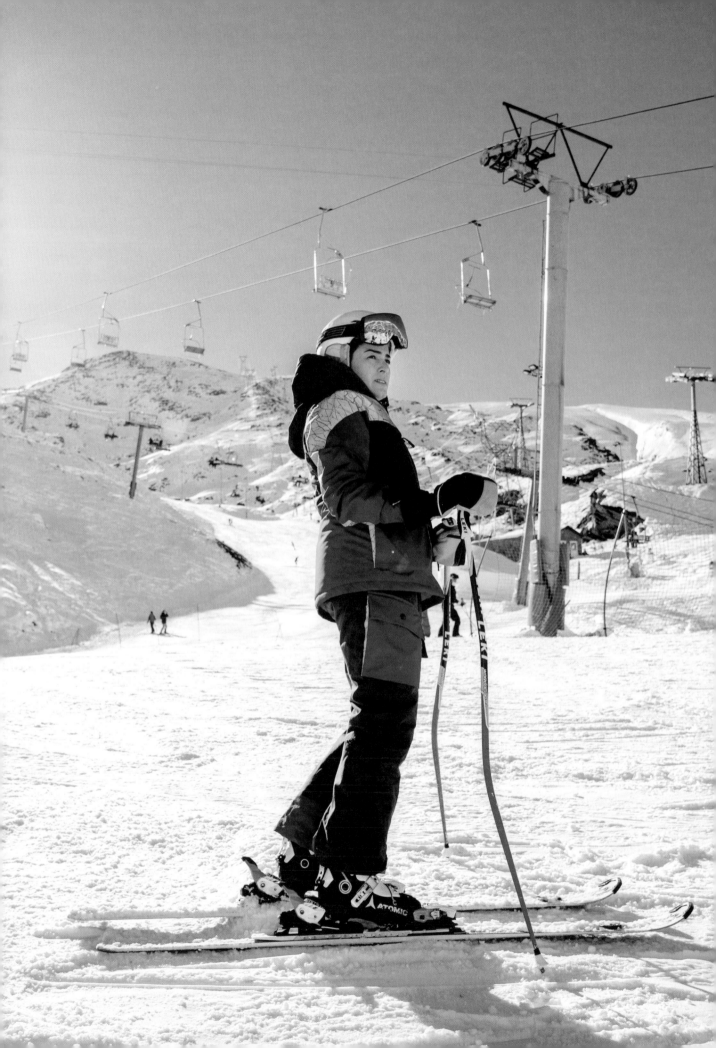

Just a short drive up into the mountains that dominate the skyline of Tehran, the steep, scenic slopes of Shemshak offer consistently good conditions during ski season. For Samira Zargari, coach of the women's national ski team, they also provide a calm counterbalance to city life.

From City to Slope in Iran

The Alborz mountains rise high above the skyline of Tehran, towering over the city's gleaming uptown skyscrapers and separating the arid deserts of the Iranian plateau to the south from the lush forests and beaches of the Caspian Sea to the north. In spring, local residents trek up the foothills to see the flowers bloom or, in summer, to take dips in its cool streams. When the leaves turn red, orange and yellow, Tehranis know that it's soon time to escape the city for the majestic mountains above.

Just an hour north of the Iranian capital sit some of the best ski slopes in the region. The most exciting pistes, or ski runs, lie in the shadow of Mount Damavand—the giant dormant volcano just outside of town, which at 18,400 feet (5,500 m) is the highest peak in the Middle East. For decades, Iranians have been lured by the thrill of racing down the steep slopes that unfold around it.

The most renowned Iranian ski resort is Shemshak. This little village has hosted skiers since the 1950s and is famous for the steepness of its slopes; Shemshak's old rival down the road, Dizin, offers more beginner-oriented pistes. After sunset, the gondola lifts continue to operate, the lights stay on and DJs from Tehran often host outdoor parties with a mix of house music and Iranian pop favorites. Despite these after-hours delights, the main attraction at Shemshak

remains the ski hills, which lure some of the country's best athletes.

"Shemshak is considered Iran's most professional slope," says Samira Zargari, one of the nation's most accomplished skiers and the coach of the Iranian women's national skiing team. "The piste is north facing, gets great sunlight and is covered in powdery snow for much of the season," she says. As global warming forces many European resorts to rely on snow-making machines to compensate for lower precipitation, the Alborz mountains are high and snowy enough that their slopes offer perfect conditions all season. Snow cover is consistent from December to April, allowing for an extended season. During January and February, fresh powder is at its best.

Skiing first arrived in Iran during the 1930s when French influence was at its peak (*merci*, with a Persian accent, is still the most common way to say "thank you" in Iran). Ski lifts were built at a handful of yaylaq, the serene mountain villages and summering spots of Tehran's well to do, which then quickly became winter resorts too. A gondola lift was even erected at Velenjak, an affluent neighborhood on the edge of the city, allowing those without cars to travel up to the resort of Tochal. Skiing has long been a popular pastime in Iran thanks to easy access and low-cost ticket prices (around 850 IRR/$20 for a

day pass). In recent years, however, US sanctions have taken a huge economic toll; the value of the rial has fallen 80 percent, pushing ski tickets beyond the reach of most Iranians.

Zargari has based herself in Shemshak on and off her entire life. Her family moved there when she was just three years old, fleeing the daily bombardment of Tehran for the safety of the mountains during the 1980s Iran-Iraq War. "I started skiing without really realizing it," she jokes. After the war ended, her family moved the family home back to Tehran but continued to spend much of the year in Shemshak. Zargari's formative years on the slopes eventually led to Olympic ambitions and her current work as coach of the national team. "I want to raise the next generation of champions," she says. Zargari also runs Snowy Path Ski School at Shemshak, where she offers lessons for novices. "Shemshak is just an hour from Tehran but feels like a different world. It's calm, uncrowded and one of the most peaceful places in Iran," she says.

The vibe at Shemshak is friendly and relaxed. The slopes are dotted by hotels—some snazzy, like the Barin with its curving white facade and igloo-inspired rooms, others more traditional, like the dozens of log cabins and budget hostels. You'll find après-ski action at most of these options. Warming up with tea brewed slowly over charcoal is a favorite way to recover from the slopes. To eat, Zargari recommends two local specialties: dampokhtak, a steamed rice and beans dish, and valak polo, made with mountain herbs. After dinner, restaurants offer ghelyoon water pipes with tobacco flavors like Orange Mint or Double Apple. Shemshak is a place where Tehranis let loose for the weekend. Your best bet is to make friends and see where it takes you.

"Shemshak is just an hour from Tehran but feels like a different world."

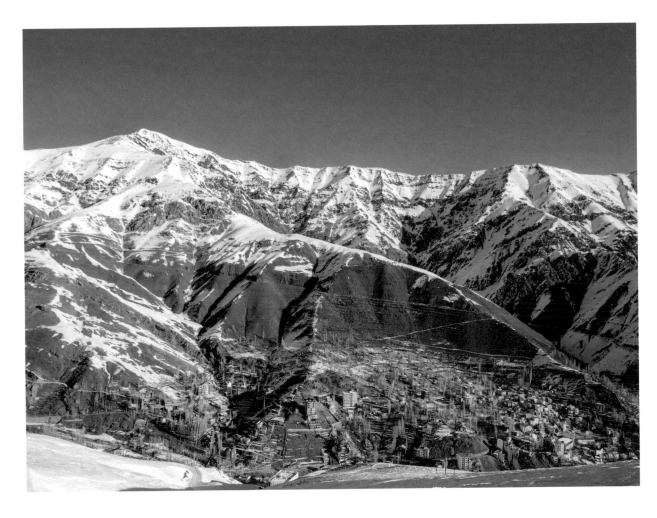

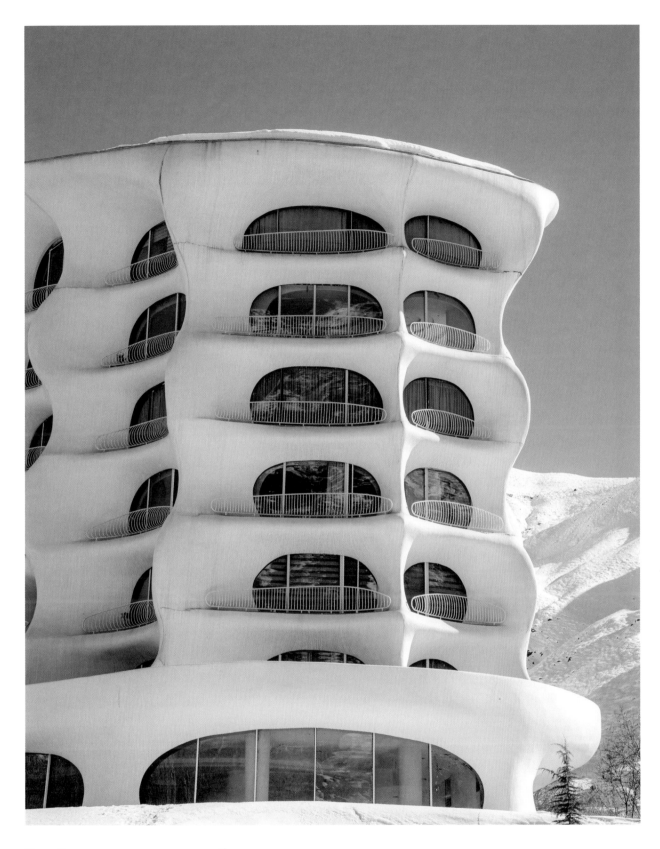

Opposite
—
The dramatic Alborz mountains arc
across the north of Iran. For visitors
looking to appreciate them through
a more sedentary pursuit, there is
a private tourist train that runs day
trips through the mountains from
Tehran station.

Above
—
Barin Ski Resort is perhaps the
most striking building in Shem-
shak. Designed by RYRA Studios
and completed in 2011, its shape is
designed to mimic the forms taken
by drifting snow.

Above
—
You can rent ski equipment and technical wear at resorts in Iran, although it is unlikely to be the latest gear. Tehran has larger specialty stores with new equipment, although prices will be slightly higher than in other countries.

Opposite
—
Although Iran's snow is plentiful in winter, including in Tehran, the season is short. Athletes are limited to approximately three months of good snow, meaning they must sometimes travel overseas to train.

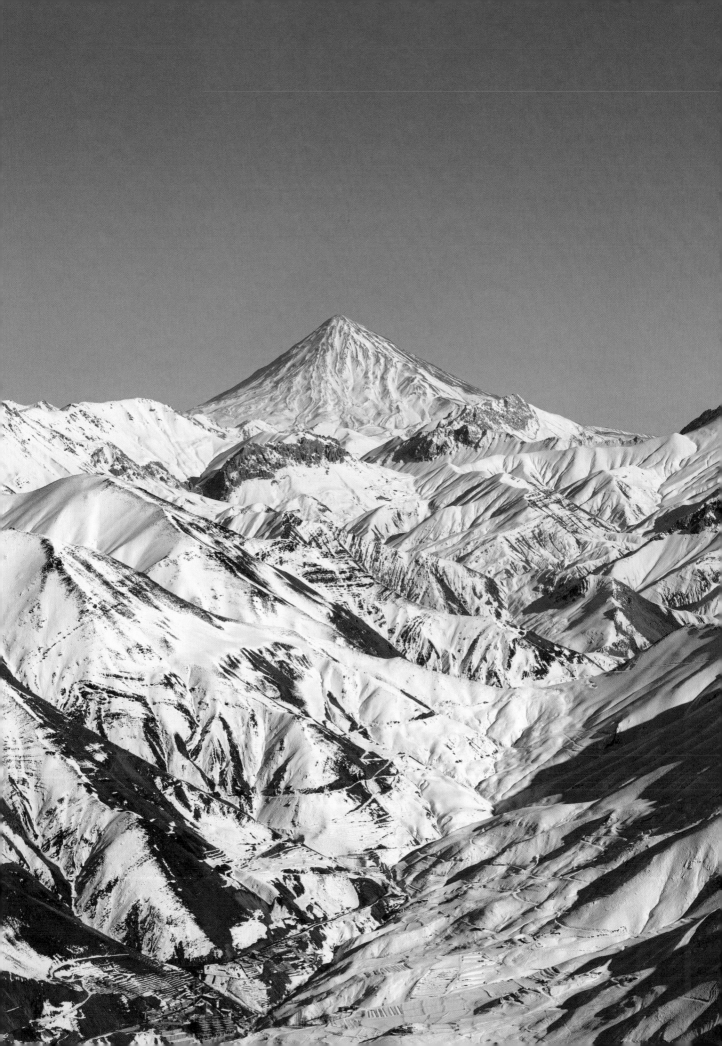

MORE SUNNY SPOTS FOR SKIING

MZAAR, LEBANON

It's only thirty-two miles (51 km) from Beirut to the treeless peaks of the Mzaar-Kfardebian mountain range in central Lebanon. These aren't the Alps, sure, but the slopes are well established. The reward for the motivated is back in Beirut: a dip in the Mediterranean followed by a fish dinner.

MOUNT ETNA, SICILY

Skiing in Italy sends most people's minds to the Alpine-adjacent Dolomites in the country's north. But Etna, rising over 10,800 feet (3,300 m) over Sicily, offers a less typical Italian ski holiday, featuring sea views and smoothed volcanic trails for both alpine and Nordic skiers.

CHRÉA, ALGERIA

Located in one of Algeria's national parks, the ski resort of Chréa has a less-than-recreational history as a military base for various groups, including the FLN—the nationalist group that took on the French during the Algerian War. Today, it's the only official ski resort in the country.

SAN GABRIEL MOUNTAINS, UNITED STATES

On a clear winter day, you can see white-capped peaks from the freeways of Los Angeles. If you drive your car for an hour or so—traffic allowing, remember this is still southern California—you can be swooshing down them. Turn around and come back in time for a sundowner on Malibu beach.

TIFFINDELL, SOUTH AFRICA

One of only two ski resorts in southern Africa (the other is in tiny Lesotho), South Africa's Tiffindell resort features roughly a cumulative mile (1.3 km) of ski runs in the shadow of the staggering Ben Macdhui mountain. But watch out for the cold: it regularly drops to -37°F (-21°C).

THREDBO, AUSTRALIA

Nothing in Australia is very proximate, and Thredbo ski resort is no exception—it's a solid six-hour drive from both Sydney and Melbourne. Once you get there, though, you'll find Australia's highest mountains and a ski resort modeled on St. Anton in Austria. Come summer, you can swoosh down the runs by bike.

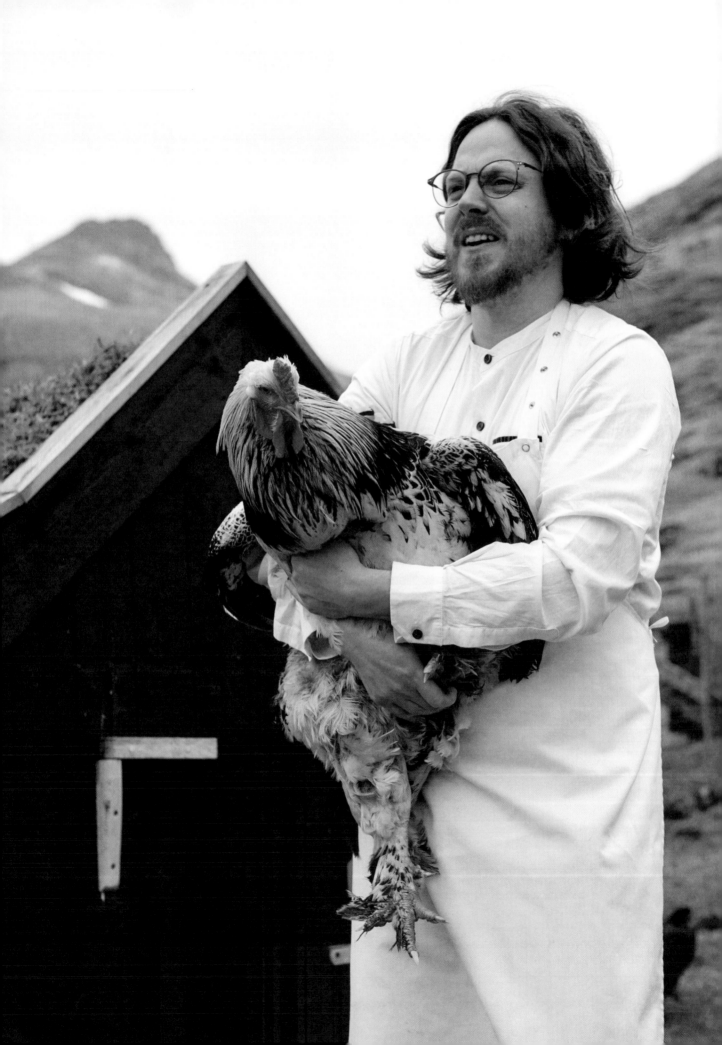

Slow food has always been a necessity on this exposed, unforgiving archipelago in the North Atlantic. Today, contemporary chefs, like Poul Andrias Ziska, are bringing a taste of the Faroe Island's old-timey cuisine—and time-old landscape—to new audiences.

New Old-Fashioned Faroese Food

In the Faroe Islands you are never more than three miles (5 km) from the sea. Isolated in the North Atlantic, this rugged archipelago, fissured with fjords, has only half been tamed by an ambitious road network of mountain passes, bridges and subsea tunnels. These are still the same exposed, unforgiving islands where for centuries the Faroese had to source everything they needed to survive, and the landscape continues to inspire a particular way of life.

Despite the image of an austere unpeopled place that has made these islands an appealingly low-key tourist destination, the Faroe Islands are a modern place to live. They consistently rank among the top countries in development indexes, and the state (an autonomous part of the kingdom of Denmark) has one of the lowest unemployment rates in the world. A subsidized helicopter service connects the more remote island communities.

Dotted around the islands, however, there are still living reminders of a time before global supply chains and supermarkets. One of these is the tradition of fermentation. Prior to refrigeration, most cultures used smoking or salt to preserve food, but few trees grow on the Faroe Islands and there has historically been no means to produce salt. In their place, the Faroese have had to rely on dry fermentation. Hung in the gloom of the hjallar, the small wooden huts that are still found outside most houses, lamb and fish are dried and left to develop a layer of mold. Gaps in the side of the hjallar allow the salty air to blow through the hut, and the proximity to the sea and exposure to the wind inform the intense and complex flavors that are unique to the Faroes; some Faroese can even identify which of the archipelago's eighteen islands the meat was dried on from the taste.

According to Poul Andrias Ziska—the young head chef of KOKS, the Faroes' only Michelin-starred restaurant, and one of the most prominent proponents of Faroese cuisine—around 90 percent of all lamb raised on the Faroes is fermented. "Today it's considered a shame to eat Faroese lamb fresh when you could have fermented it," he says. "Of course, it no longer has anything to do with needing to preserve it. Now we choose to do it for the flavor."

Historically ræst, the pungent fermented meat, and skerpikjøt, which is drier, having been left in the hjallur for longer, was appreciated by few outside the islands. Faroese cuisine, like Faroese culture, had been historically denigrated by the Danish—visitors to the islands in the nineteenth century often reported back to Copenhagen with stories of rancid, maggot-ridden meat.

"I don't think it would have been as bad as that," says Ziska, "but it led us to believe that the food we were eating was not something to serve guests or make for special occasions."

At KOKS, which has helped drive a renaissance in Faroese cuisine, Ziska serves fermented lamb tallow and cod in a playful reinterpretation of a popular traditional dish. Rather than a sauce, he makes a cream from the tallow that is served with a savory version of a góðarað, a normally sweet biscuit that he bakes with cheese. The fermented fish is then grated over the top. "The only thing that you would be able to recognize from the original dish is the biscuit, but that tastes completely different," he says. "The fish and the tallow taste as they should, but the textures, and the way it looks on the plate, is completely unexpected."

Fermented meat is just one of the traditions that Ziska has been reimagining at KOKS for its largely international audience. Those who have secured a reservation have to make their way to the shores of Lake Leynar, twenty minutes out of the capital, where they are met by a Land Rover that takes them up a steep, unmade road to the restaurant—a converted eighteenth-century farmhouse, complete with traditional grass roof.

The idea of paying for a meal, let alone fine dining, is still novel in the Faroes, but the success of KOKS—the restaurant received its first Michelin star in 2017; the second following two years later—has shown that Faroese cuisine can hold its own at the highest level. Johannes Jensen, the restaurateur behind KOKS, has gone on to open thirteen other restaurants on the islands, including Ræst, which is dedicated entirely to the art of fermentation. Others, like Katrina Christiansen, serving a Faroese take on tapas, are following in Jensen's wake. "We have made people proud of what we have around us," Ziska says.

Since it was established in 2011, KOKS has been committed to sourcing everything from the islands. It's a philosophy that not only serves to showcase Faroese produce but demonstrates the direct and unflinching relationship the Faroese have with nature around them. Like Ziska, most still slaughter and butcher their own lamb, a process that the whole family usually participates in some part of.

"For us, it's just a natural part of getting your food. You can't get meat without killing something," Ziska says. "If you distance yourself from this fact then you get a completely disturbed idea of how an entire ecosystem works."

Ziska argues that importing food to the Faroes rather than using what's available locally is unsustainable, but it's an idea that is not just relevant to the 52,000 people who live on this picturesque archipelago. Their local, immediate experience of nature—developed out of necessity and in response to an extreme environment—offers a more responsible and humane way to think about producing and consuming food.

"There's a lot to be learned from how we approach food in the Faroes. It would be a shame to miss out on doing something that's better, easier and much cheaper," says Ziska.

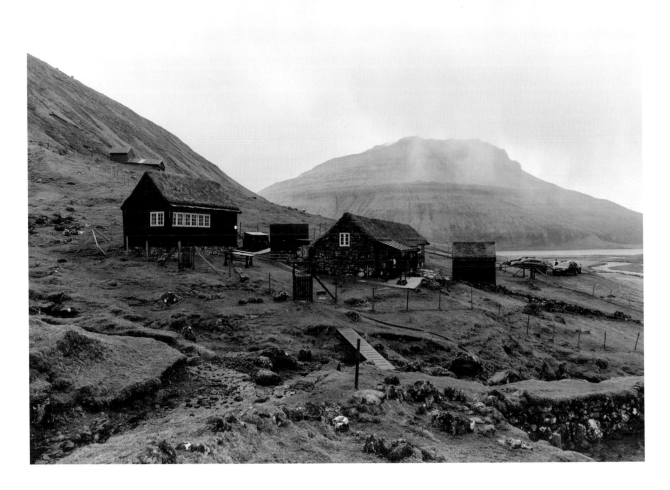

Opposite
—
KOKS is located in the mountain valley of Leynavatn. The main restaurant building has traditional basalt stone walls and a grass roof and dates back to 1740. In 2018, *The New Yorker* called KOKS "the world's most remote foodie destination."

Above
—
The stunning topology of the Faroe Islands makes it an appealing destination for mountaineers. Climbing is a relatively young sport in the archipelago, although it has historic roots: the Faroese would use ropes to climb down sea cliffs, often while hunting seabirds.

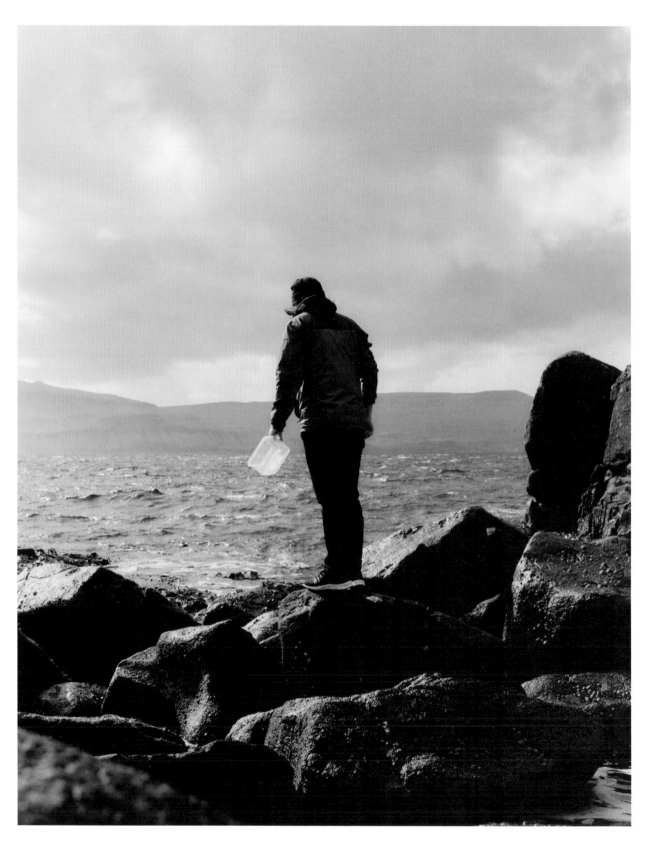

Above
—
The Faroese typically do not eat mussels, which are seen as little more than fish bait. Ziska has made them part of the menu at KOKS, taking advantage of the natural bounty of the rocky coastline.

Opposite
—
A painting in the restaurant depicts the grindadráp, an organized whale hunt. Whale and dolphin hunting is viewed as a "blood sport" by environmental advocacy groups, but it is legal, regulated and viewed as an important source of food locally.

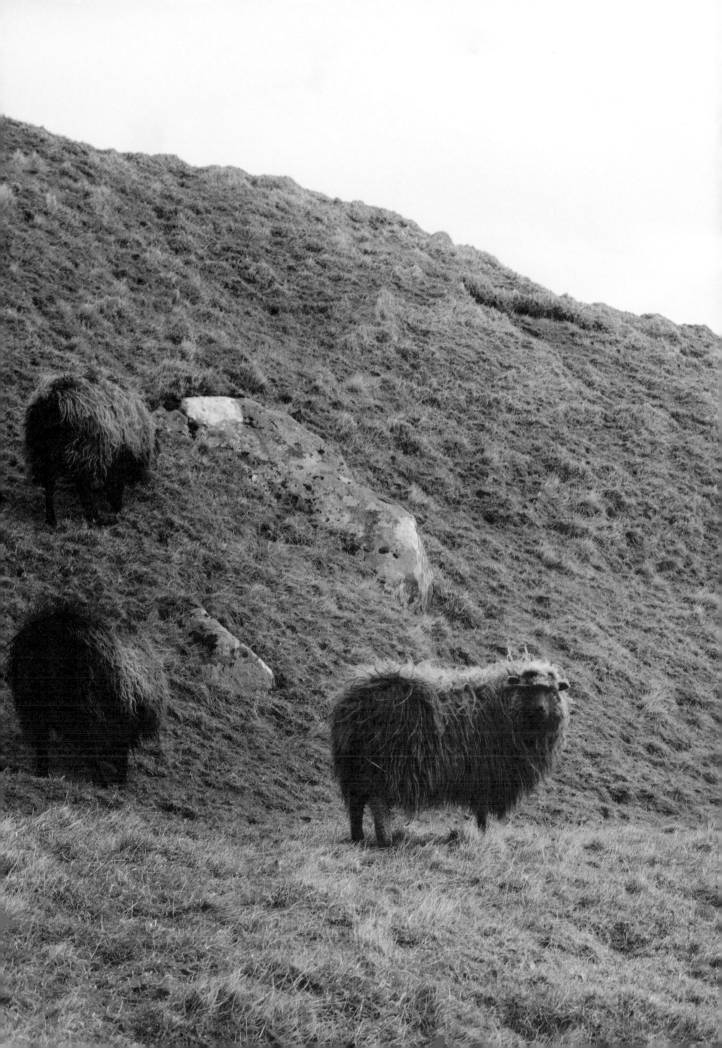

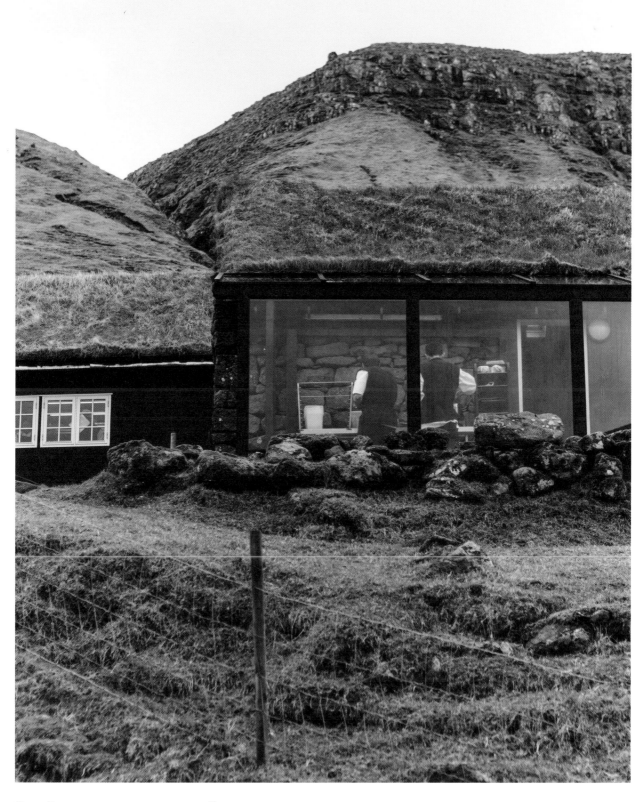

Opposite
—
The success of fermenting fish is dependent on local weather conditions: too hot and the fish will spoil, too cold and the process will stagnate. This is made tricky by the fact that weather is unpredictable.

Above
—
Turf roofs planted over a layer of birch bark are traditional in the Faroe Islands. They provide effective insulation, and the birch waterproofs the building. For curious visitors, it is possible to find hotels and self-catering accommodation with these traditional roofs.

Above Left
—
The marina in Tórshavn is a popular place to get a drink and watch the boats come in. The Faroe Islands had an alcohol ban in place for bars and restaurants until 1992. Even today, many premises operate with a "half license," meaning they only sell wine and beer.

Opposite
—
Heather is one of the dominant shrubs that grows wild on the islands, because it can tolerate moorland conditions and grazing by animals. At KOKS, it is used as a table decoration.

FLORA'S FIELD KITCHEN, MEXICO

Flora's Field Kitchen grew out of Flora's Farms, which provided the resort restaurants of nearby Cabo San Lucas with organic produce. The Kitchen now serves its own guests only what's grown, raised or made on the farm, including ranch pork and chicken.

Animas Bajas, San José del Cabo, Baja California Sur

RESTAURANTE GARZÓN, URUGUAY

In the tiny town of Garzón, in the (relatively) tiny country of Uruguay, sandwiched between Brazil and Argentina, Restaurante Garzón serves lucky guests fish pulled from the nearby Atlantic Ocean. The dining room is located in a large brick building that used to be the town's general store.

Costa Jose Ignacio, Garzón

OPEN FARM COMMUNITY, SINGAPORE

Founded to form a missing link between the people of ultra-urban Singapore and their food sources, the Community's massive plot grows herbs and makrut lime for the kitchen, which sources (a little) farther afield for anything else—like barramundi farmed in the islands around Singapore.

130E Minden Rd

BABYLONSTOREN, SOUTH AFRICA

Forty minutes by car from central Cape Town, a visit to the gardens and wine estate at Babylonstoren feels like straying into an organic farmer's fantasy—a combination of futuristic hanging squash gardens and massive, old-world herb topiaries. Two restaurants dish out produce grown on the estate.

Klapmuts/Simondium Rd, Simondium

CHEZ PANISSE, UNITED STATES

Alice Waters has been slinging lovingly prepared organic meals from her Berkeley kitchen since before it was cool. Chez Panisse opened in 1971, sourcing small quantities of organic produce from local farms and creating what's now known worldwide as California cuisine in the process.

1517 Shattuck Av, Berkeley, California

DE KAS, NETHERLANDS

Amsterdam's preeminent farm-to-table establishment has circumvented the natural limitations of its northern European climate: De Kas uses hydroponics and LED lights in an indoor growing area to harvest herbs and microgreens all year long. A large field outside the city makes up the shortfall.

Kamerlingh Onneslaan 3, Amsterdam

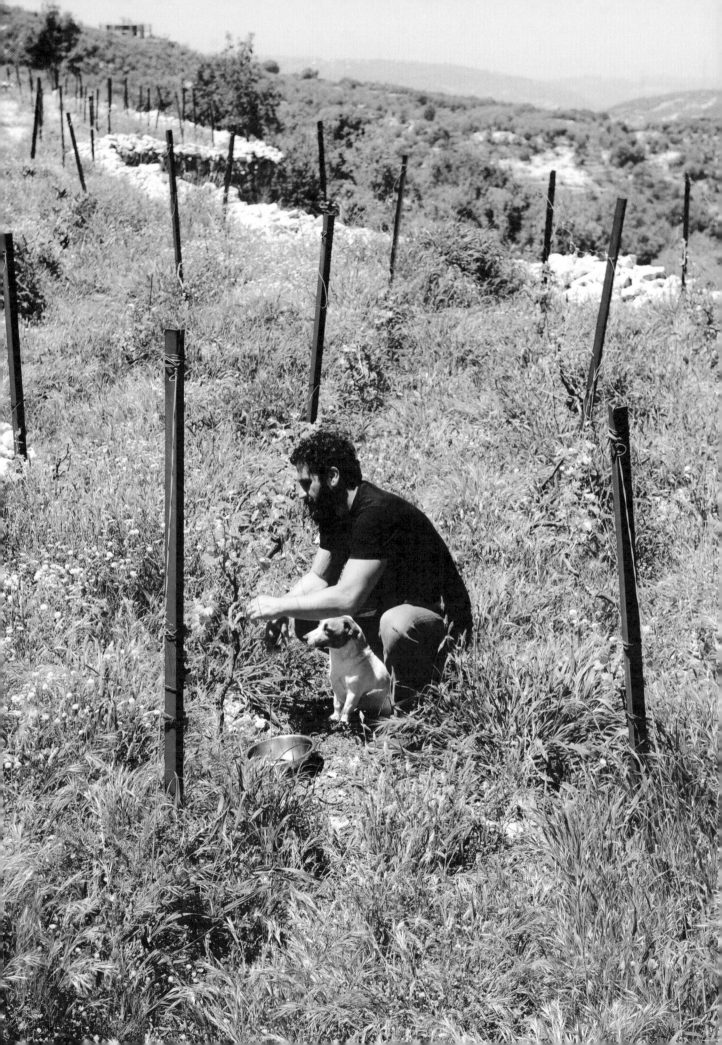

Lebanon's viticultural tradition is a true vintage. A long-drawn-out Mediterranean lunch among the sun-dappled terraces of a rural vineyard, like Maher Harb's Sept Winery, provides an ideal pairing for a local bottle—and a fun way to drink in seven thousand years of history.

In the Vineyards of Lebanon

Sept Winery lies high above the historic Lebanese coastal town of Batroun, at the end of a winding mountain road flanked by oak trees on one side and panoramic views over green valleys on the other. The air up there is crisp, a little dry, redolent with the smells of wild aromatic herbs—thyme, sage, oregano—and alive with the chirping of birds and crickets. The setting offers perfect conditions for Maher Harb, the owner of Sept, Lebanon's only biodynamic winery, to nurture the native grapes that he uses to make natural wines.

Harb is especially passionate about his mission: to highlight the value and singularity of what Lebanese vineyards have to offer. And he's not the only local winemaker who believes in the potential of this terroir. This, after all, is one of the oldest winemaking regions of the world, and tiny Lebanon boasts some fifty-six wineries. The number is made more impressive by the fact that after the end of the country's fifteen-year civil war in 1990, there were just five. Most are in the high-altitude plains of the Bekaa Valley, where a trip to Château Ksara (Lebanon's oldest and largest winery, founded in 1857 by Jesuit monks) or the newer Château Marsyas can be combined with a visit to the Roman ruins of Baalbek, which include a massive temple dedicated to Bacchus, the god of wine.

But Lebanon's winemaking is even older than the Romans; historical evidence shows that the Phoenicians were exporting wine to Egypt as early as 2,500 CE, undoubtedly made with Lebanon's native grape varieties. It is these varieties that

Lebanon's modern boutique wineries are trying to repopularize. While most of the older wineries use primarily French grapes, such as Cabernet Sauvignon, Merlot, and Cinsault, newer ones are using Lebanon's indigenous white varieties, such as creamy Obeidah and citrussy Merwah. Vintners such as Château Kefraya's Fabrice Guiberteau are going further and trying to reintegrate the indigenous red varieties, such as Aswaad Karech and Asmi Noir, that have fallen out of use.

For such a small country, Lebanon's wines have impressive range as well as reach: many are available at boutiques or via online sales across the world. Connoisseurs interested in sampling them would do well to use wine writer Michel Karam's book *Wines of Lebanon* as a purchasing guide. But nothing beats a personal visit to a winery, where one can taste the wine while relaxing on the very terroir that gave it life. Better yet is to get a guided tour of the entire winemaking process from grape to glass, such as the one Maher Harb gives at Sept Winery.

Visit Sept—the best way to do so from Beirut is to rent a car or hire a private taxi—and you are visiting Harb's home, experiencing the same hospitality he would offer any personal guest. He will show you around, taking you across the terraced fields and into the dappled sunshine beneath the vines, explaining how they were grown. If you are hungry, he will cook for you: fresh, seasonal Mediterranean food "with a Lebanese twist." Often the fare includes what he has foraged from around the vineyard: wild asparagus and leeks, tender

shoots of new garlic. He will spread the feast out on a wooden table beneath the open sky on a grassy ridge that overlooks an unmistakably Mediterranean vista: green hills cascading down through wisps of cloud toward the sea glittering at the very edge of the horizon. Various wines and vintages are of course carefully selected to pair with the food. He wants those who taste his wines to come away having tasted "his mountain, his Lebanon, his terroir."

Sept is Harb's passion project, more a calling than a business. This is something many businessmen say to personalize whatever brand they're selling, but in Harb's case, the philosophy by which he runs his vineyard is the one by which he conducts his life. He abandoned a lucrative but soulless career in France to come back and farm the fields that his father, who was killed during Lebanon's civil war, had left him.

Coming back to the land was a healing process for him, and, in turn, he practices the sort of farming that is a healing process for the land. Like all biodynamic vintners, he farms according to the lunar calendar, aiming to understand the earth's rhythms rather than employing chemicals to hurry them along to his own schedule. He uses no pesticides on the vines and no additives in the wine, making it natural.

Lebanon has been going through fraught times of late. The brief hope of an uprising in October 2019 gave way to an economic collapse that was exacerbated by the coronavirus

pandemic. The currency went into freefall and many were left struggling to make ends meet. Then, in August 2020, over two thousand tons (1,814 metric tons) of neglected ammonium nitrate ignited at the Beirut Port, resulting in one of the largest non-nuclear explosions in history. Harb, like so many Lebanese people, has been dizzied by every one of these blows, fighting to recover and readjust. But throughout it all, he has kept the winery running, guided as ever by the rhythms of the planetary and lunar calendars that dictate the days on which to sow and which to reap. Like the land, it is constantly evolving.

And up there on his terraced fields, it isn't difficult to believe that the powerful force that commands the tides can exert the same magnetism on the nectar encased in the delicate skin of every grape. And it isn't difficult to feel, either, that everything that seems so overwhelming and insurmountable now in terms of the country's circumstances is just a brief turbulence across the face of this land's deep history. It has seen upheavals ranging from the rise and fall of empires—Phoenician, Roman, Ottoman—to earthquakes that wiped out entire cities and redrew the coastline. Nature's cyclical lesson becomes tangible when visiting Lebanon: that everything is eventually transmuted by time into the mulch of history, all of it feeding the richness of the terroir that Harb hopes can be tasted in every bottle of wine.

Opposite
—
The peaceful village of Nahle is far from the tourist trail, although for visitors looking to extend their stay the beautiful Beit Douma guesthouse is only a ten-minute drive away.

Above
—
Meadow flowers are grown alongside and among the vines at Sept. The edible ones, such as osteospermum flowers (pictured), make their way into dishes served on the terrace overlooking the Batroun coastline.

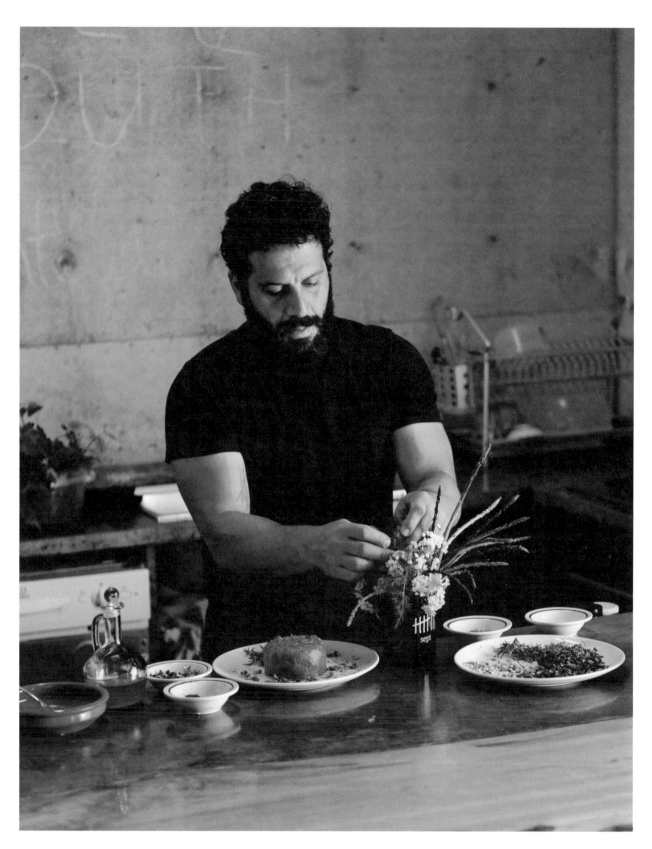

Above
—
Harb prepares kebbet batata, a vegetarian version of the traditional Lebanese kebbeh made with bulgur wheat, potato, onion and spices. The virgin olive oil used to finish the dish comes from the local village.

Opposite
—
The kitchen at Sept prepares seasonal, locally sourced meals. The Lebanese countryside is rich in forageable produce, much of which is used here: wild garlic, dill, thyme, sage and oregano, as well as wild asparagus and leek.

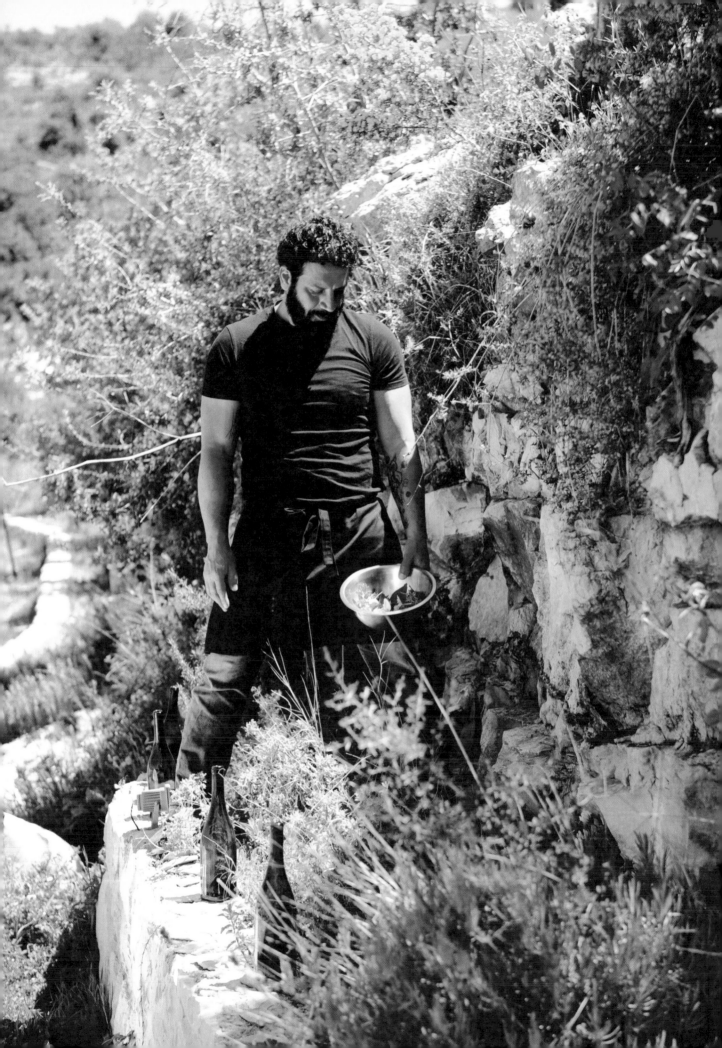

MORE BIODYNAMIC WINE REGIONS

YEALANDS, NEW ZEALAND

The Marlborough region of New Zealand's South Island is dotted with exceptional wineries, and Yealands is one of its most sustainable. Its roofs are covered in solar panels, pruned vines are used as fuel to heat the water and wildflowers are planted between rows of grapevines to increase natural drainage and prevent erosion.

MAYSARA, UNITED STATES

Moe Momtazi, the vintner at Maysara Winery in Oregon's lush Willamette Valley, comes from three generations of winemakers back in Iran. His path to winemaking was more circuitous—he and his family fled revolutionary Iran and ultimately claimed political asylum in the US—but the biodynamic process he uses is much the same as his forebearers.

PODERE LE RIPI, ITALY

Surrounding a medieval castle built on top of a hill to spot approaching enemies, Podere Le Ripi is one of just a handful of biodynamic wineries producing the long-aged, 100 percent Sangiovese Brunello di Montalcino. Clay canyons, or ripi, dot the area, lending a unique minerality to the wine produced here.

KRINKLEWOOD, AUSTRALIA

The winery at Krinklewood is inspired by the classic vineyards of France, from the Provençal gardens in the visitors' area to the Lascaux-inspired bull on the wine bottle labels. The wines produced at Krinklewood, however, venture a little further afield: there's the classic Chardonnay, a semi-sweet Semillon and a Verdelho, best known as a Madeiran grape.

EMILIANA VINEYARDS, CHILE

The alpacas roaming the vineyards at Emiliana, Chile's largest biodynamic winery, aren't there just to look cute. Their manure feeds the grapevines, playing into the circular biodynamic loop that qualifies Emiliana as biodynamic, and that includes all plants, animals and people on the farm.

FONDUGUES-PRADUGUES, FRANCE

At Fondugues-Pradugues, limited-edition, numbered bottles of carefully crafted blends are produced from grapes harvested at night and early in the morning. According to biodynamic principles, this keeps them as cool as possible to prevent the famously balmy Saint-Tropez climes from spoiling their delicate color and flavor.

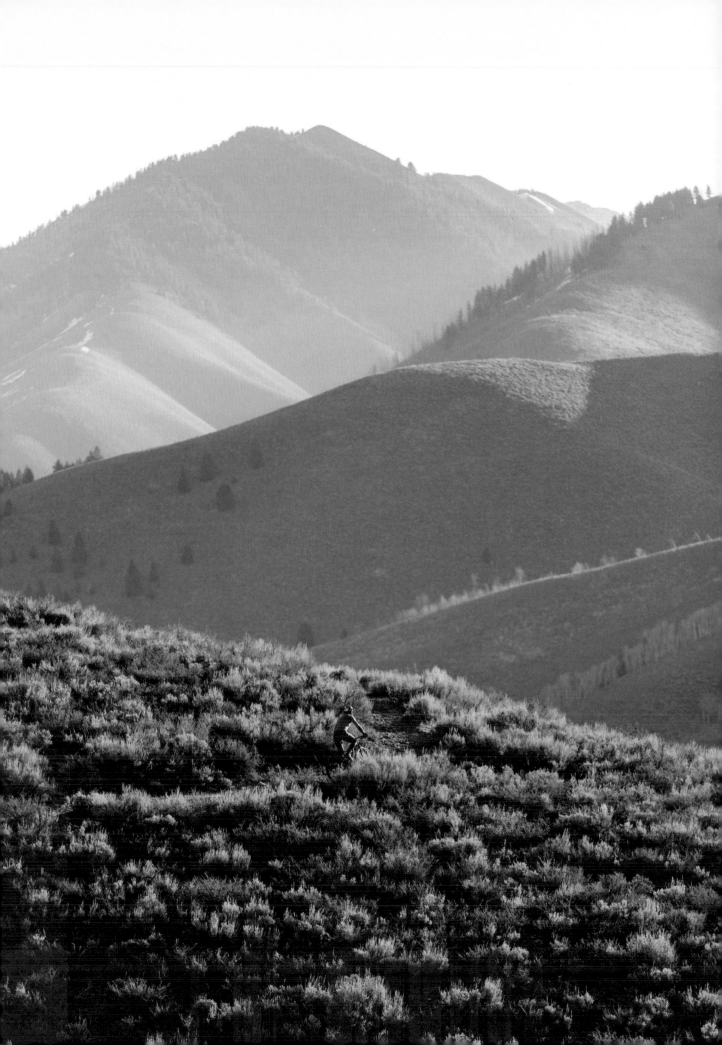

In tranquil Ketchum, all roads lead into the vast Idaho wilderness. Adventure racer Rebecca Rusch has found that biking gravel tracks is both an exhilarating way to explore the state's big, beautiful backcountry—and a form of escape.

Idaho by Bike

Stand in the center of Ketchum and walk just a few blocks in any direction and you'll be on the edge of town. Highway 75 is the only continuously paved road, and it runs all the way through and keeps going. The rest of the roads turn to dirt soon after leaving town. In this small strip of central Idaho, which was once home to the Shoshone and Bannock peoples, you are minutes away from the sprawling expanse of the Sawtooth and Salmon-Challis National Forests, as well as one of the world's oldest ski resorts. A bike will take you into the wilderness quicker and farther than almost any other means of transport, through thick forests, up and down mountain passes and over open plains.

When professional adventure racer Rebecca Rusch first made the journey to Ketchum back in 2001, she was sure she wouldn't like Idaho. Originally from Chicago, she had been driving around the West since 1996, exploring, adventure racing and living out of her red Ford Bronco, Betty. All that she really knew about the Gem State was that it was where potatoes came from (roughly 30 percent of the United States' crop is grown in Idaho). But within walking distance of Ketchum's Main Street, her world suddenly opened up, the mountains rising high around her. "From a geographical standpoint, and also a human one, it felt like a hug," she says.

At first, Rusch didn't realize that she had stumbled across an off-road cycling paradise. There are hundreds of trails covering around two hundred miles (322 km) just within the local area alone. Among her favorites are easy options like the Harriman Trail, a nineteen-mile (31 km) gravel path that runs from the Sawtooth National Recreation Area Headquarters up to Galena Lodge; the more challenging twisting single track of the thirty-five-mile (56 km) Galena Lodge trail system itself; and the twenty-six-mile (42 km) Adams Gulch trail system just behind her house.

Back in 2001, though, cycling was her least favorite part of adventure racing—which also requires participants to kayak, trek and climb to cross rugged terrain. But after witnessing the death of a friend in a race in 2004, and with sponsorship drying up, she began searching for a new passion. She found it in Ketchum. "It's this amazing open space—this wonderland of undeveloped expanse, with a small town of really friendly people who were all super athletic and welcomed me in right away," Rusch says. "I just felt instantly like I wasn't a stranger. I wasn't a visitor."

Local riders embraced her, figuring that she might be perfectly suited for endurance races, if only she could learn to love bikes. By October 2005, Rusch was competing for

team Ketchum If You Can in the 24 Hours of Moab mountain bike race in Utah. Over the following decade, she would quickly establish herself in the cycling world: She won the Leadville Trail one-hundred-mile (161 km) mountain bike race four years in a row, rode all the way to the top of Mount Kilimanjaro in Tanzania in 2016 and biked the length of the Ho Chi Minh Trail in Southeast Asia in 2015 on an expedition to find where her father's plane had disappeared in the Vietnam War. In 2019, she was inducted into the Mountain Bike Hall of Fame. "That's pretty amazing for a girl who couldn't really ride a bike," she says of her achievements.

Hoping to share what she had discovered in Ketchum, Rusch launched her own race, Rebecca's Private Idaho, in 2013. Held every Labor Day weekend, RPI is a gravel grinder, running mostly on dirt roads. Rusch chose gravel because it blurs the lines between road cycling and mountain biking, and also because gravel bikes are perfectly suited for adventure: you can take a gravel bike almost anywhere. If you're looking to rent—or buy—equipment and clothing, Rusch

recommends Sturtevants on Main Street. You'll find half a dozen other bike stores within a few blocks where you can find everything you need.

Rusch's event starts and finishes on Sun Valley Road, a rolling paved route that becomes Trail Creek Road as it heads into the wilderness northeast of Ketchum. Trail Creek is a 1,400-foot (430 m) winding dirt climb on the way out, and, on the return, a challenging descent along a narrow road with no guardrail and a spectacularly distracting view. Less than 150 years ago, wooden wagons would haul ore from mines in Challis to smelters in Ketchum across this treacherous pass. It's the gateway into the Salmon-Challis National Forest. National forests cover more than twenty million acres of Idaho, 38 percent of its surface area. Grizzly bears, elk, bighorn sheep, moose and gray wolves still roam these lands.

Rusch hopes people first come to Ketchum for her race, but stay, or return, to explore further. "You cross that line, and you really do feel like you've gone one hundred years back in time," she says. "There are no homes. There's just open space."

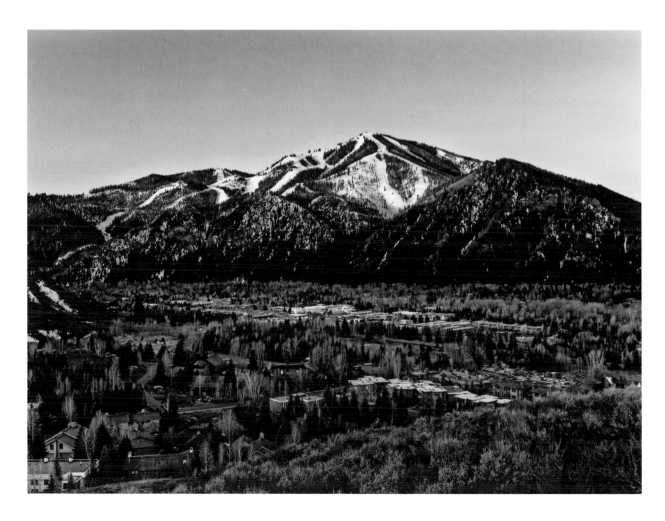

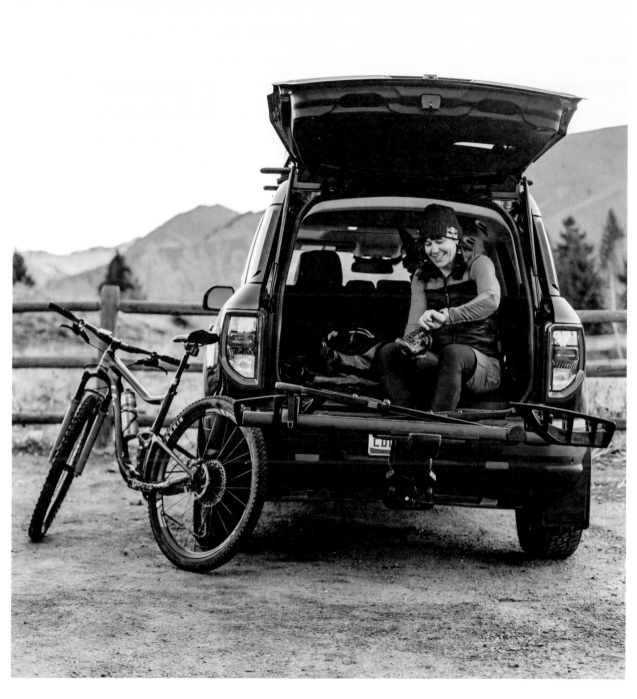

Opposite

—

Ketchum's motto is "Small Town, Big Life." It has welcomed famous visitors over the years, including Ernest Hemingway, who lived locally in later life and is buried in the cemetery. Hemingway's house is now used for writer residencies.

Above

—

Rusch gets her gear on at the Carol's Trailhead car park before tackling the Valley View Loop trail, a short mountain bike route that is suitable for relative novices. The trail takes in views of the valley below and of the Bald Mountain, the Boulders and the Pioneer Mountains.

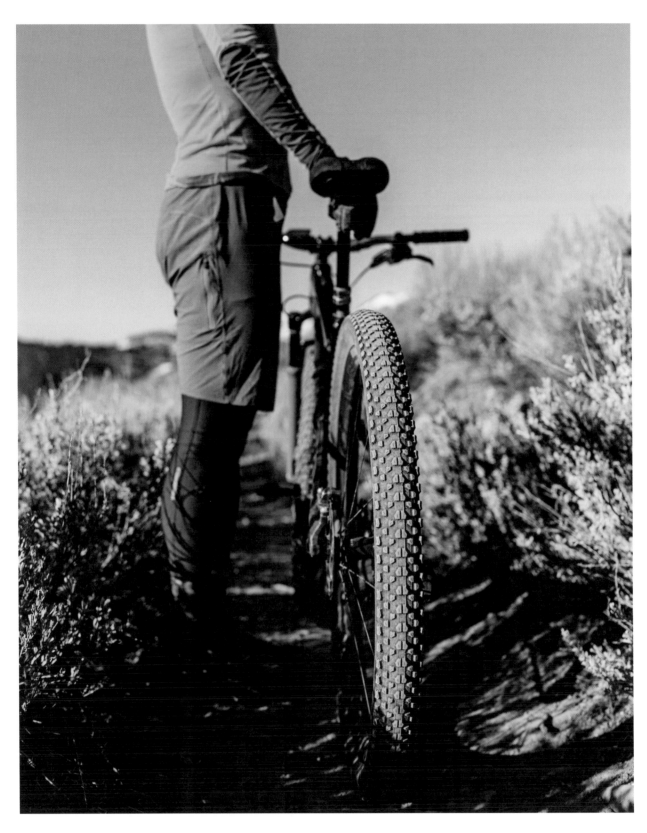

Above
—
Rusch makes her way along a track in one of the areas of Sun Valley Resort that is open to the public. Although it is best known as a ski center, the resort has nearly four hundred miles (644 km) of single-track trails.

Opposite
—
Although the highest points of the Rocky Mountains have year-round snow cover, Ketchum's weather is varied. The summers are warm and dry with mostly clear skies, although it's always worth bringing a jacket as temperatures can drop significantly at night.

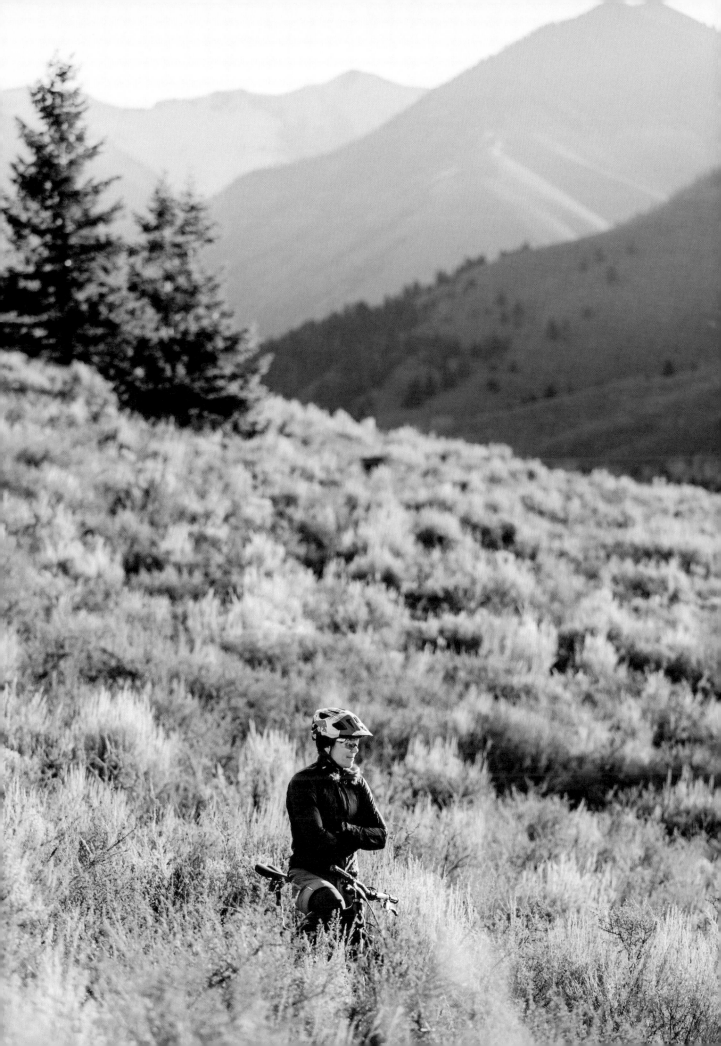

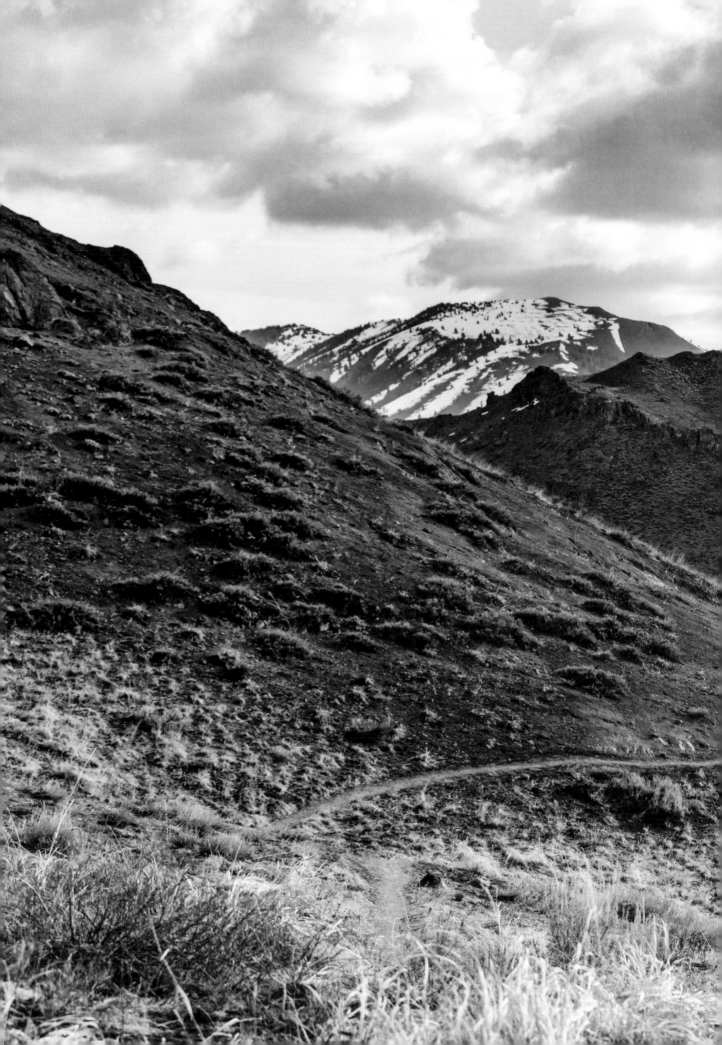

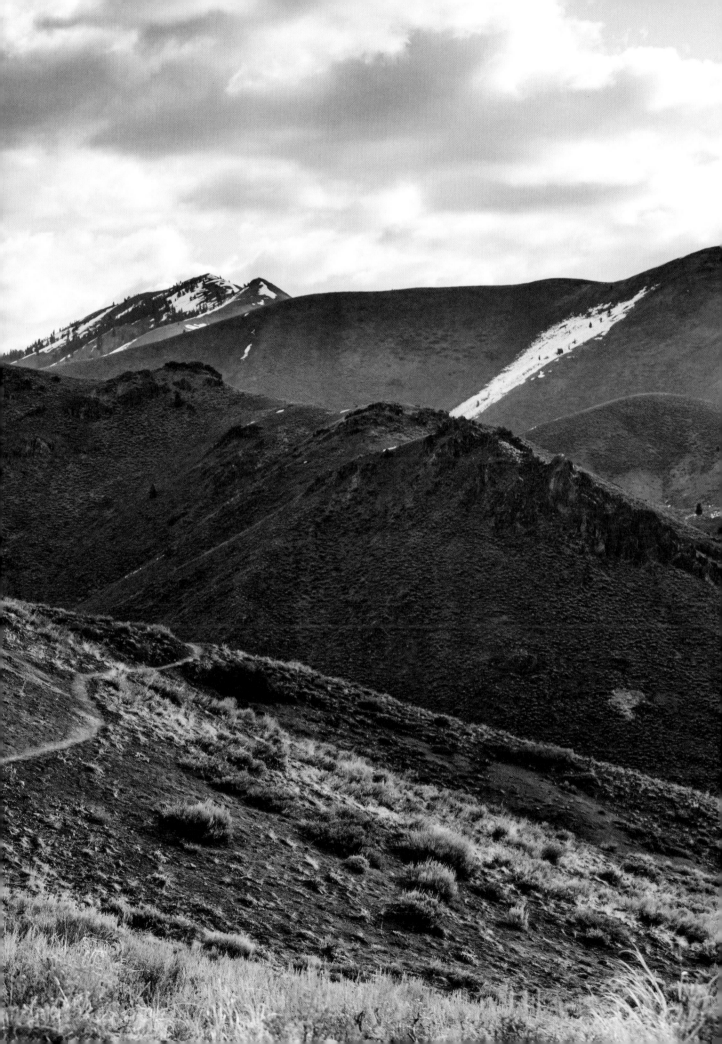

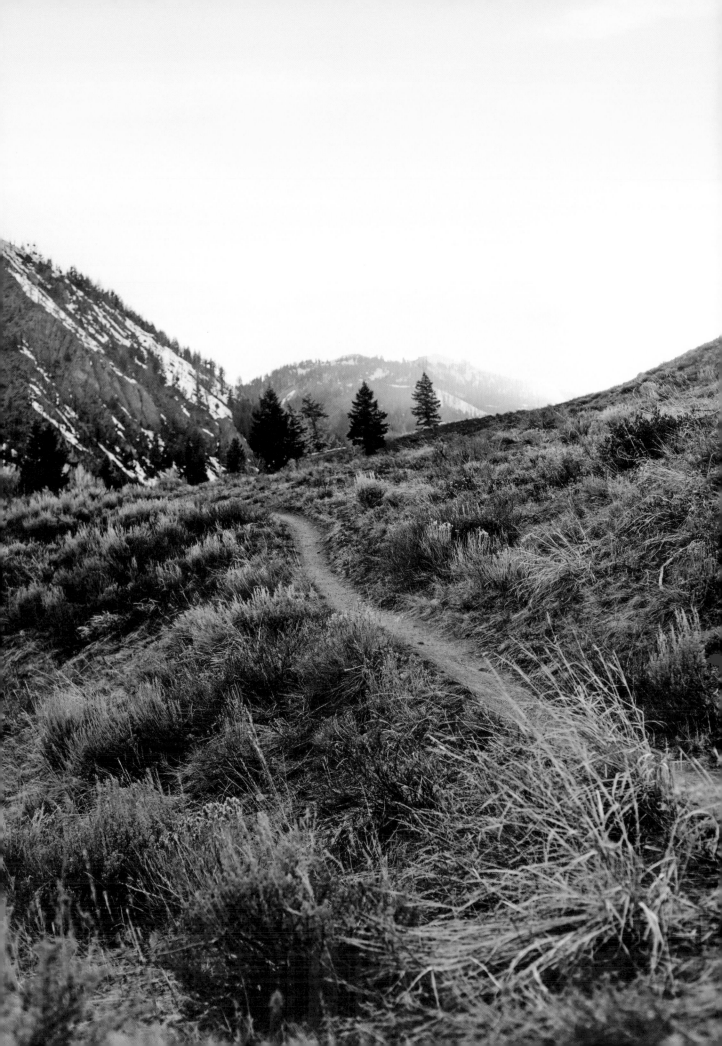

MORE ADVENTURE CYCLING TRAILS

TYROL, AUSTRIA

Tyrol's mountainous landscape is the epitome of alpine, and for sports enthusiasts that means skiing in winter and cycling come summer. The mountain wildflower meadows, alpine pastures, craggy peaks and forested slopes come truly alive when the days get long, not least from the sound of joyful two-wheeled swooshing.

THE SILK ROAD, KYRGYZSTAN

If you undertake a cycling trip on the portion of the ancient Silk Road that passes through southeast Kyrgyzstan, you'll have built-in breaks: China's checkpoints stretch into Kyrgyz territory here, and the officers will check your Chinese proximity visa. It's well worth it to have these mountain trails all to yourself.

SAN MARCOS, UNITED STATES

The university town of San Marcos, just north of San Diego, has finalized plans for over seventy miles (113 km) of trails for recreational use—two-thirds of which are already built. Lakes and ponds dot the area, and gently rolling chaparral-covered hills crest into modest peaks, all glinting in the southern California sun.

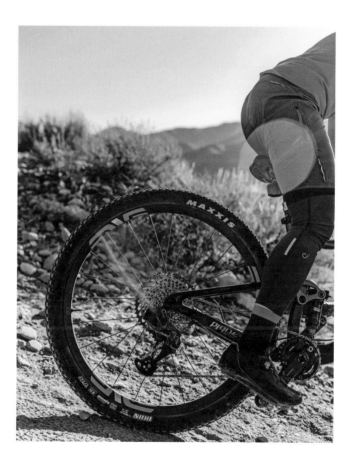

ATLAS MOUNTAINS, MOROCCO

The snowcapped peaks soaring in the backdrop of your holiday photos from Marrakech? Those are the High Atlas Mountains, home to some seriously steep gravel cycling routes through tiny Berber villages and national parks where the rocky mountains are streaked with red and orange.

COROMANDEL, NEW ZEALAND

The Coromandel is on an easily accessible peninsula just east of New Zealand's capital, Auckland. The area's most popular trail is the Hauraki Rail Trail, which wends its way along an old gold-mining route that skirts the gorgeous, cove-studded coast.

SWARTBERG MOUNTAINS, SOUTH AFRICA

A seventeen-mile (27 km) road summits one of the most beautiful mountain passes in the world. You'll have to go slower around the arduous hairpin turns, but a leisurely pace is welcome when you're pedaling through different geologic eras. This area is also rich in birdlife, so look out for black eagles.

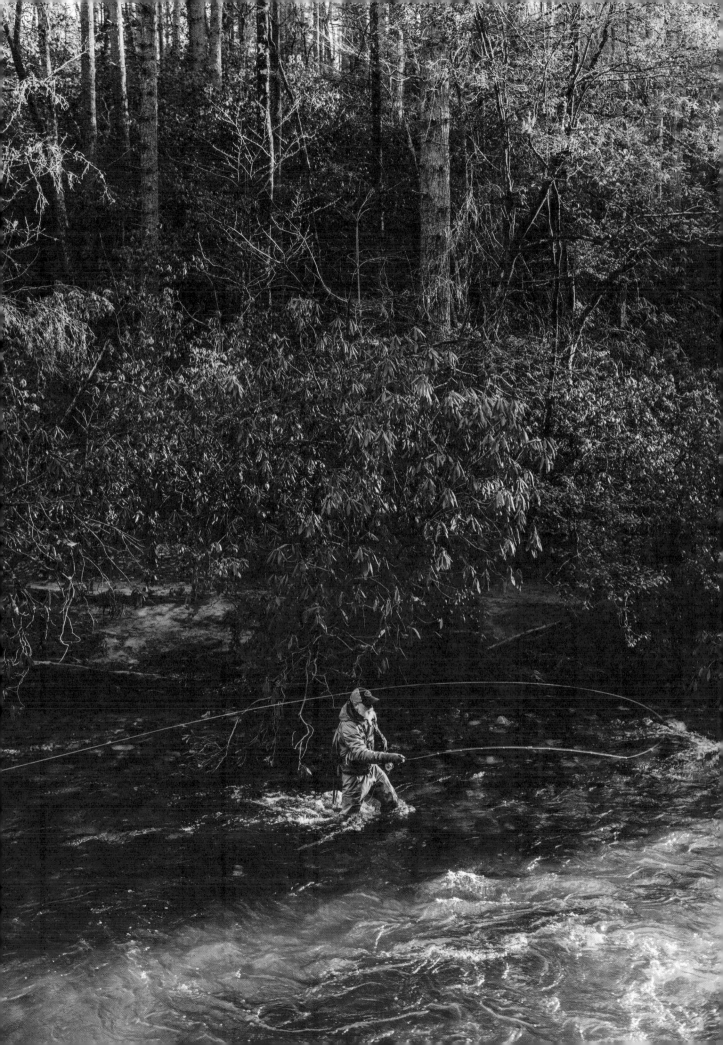

Blue Ridge is a hip Appalachian town, either "the backyard of Atlanta" or "the trout capital of Georgia," depending on who you ask. For those seeking the latter, like fly-fisher Bill Oyster, the rivers here provide year-round sport—and the meditative mind-set that comes with it.

Fly-Fishing in Georgia

By the late eighteenth century, the healing waters of northern Georgia's Appalachian mountain springs were drawing tourists to the town of Blue Ridge and its surrounds. Today, visitors may come to the riverbanks for another reason: to fly-fish.

The Toccoa River runs from south Tennessee into Georgia along the edge of Blue Ridge. The water is temperate for all twelve months of the year, which lures a steady stream of anglers from around the world to come here to cast for rainbow and brown trout.

"It's not like trawling behind a boat where you can go out with a captain, just sit in the chair and reel in a potential world record your first time out: you tend to get what you deserve," says local angler and world-renowned fly rod artisan Bill Oyster. "With fly-fishing, the more you put into it, the more you get back."

On Blue Ridge's Main Street, Oyster's two-story workshop and storefront, Oyster Fine Bamboo Fly Rods, is a welcoming waypoint for locals and visitors alike. Downstairs, anglers commune around a fireplace, and upstairs, a quiet four-room inn hosts friends, guests and clientele of the owners. Although the building was purpose-built, its style matches those in the town's historic center and is evocative of the region's railroad history—the trains that still run behind it, once carrying timber and mining supplies, now carry sightseers along the Toccoa's scenic banks.

This Main Street shop is where Oyster, a South Carolina-born Georgia transplant, builds his traditional fly rods with techniques that date back to the nineteenth century. Crafted meticulously from strips of bamboo planed thinner than a human hair, bound with silken thread and adorned with engraved nickel silver hardware, they can take between forty and two hundred and fifty hours to complete and cost thousands of dollars. Some are custom-made for ardent anglers who live double lives as celebrities, novelists, billionaires or heads of state, from the British royal family to former US president (and Georgia native) Jimmy Carter. Oyster also teaches classes where students can build their own rods, which book out more than a year in advance.

Oyster has fished around the globe, from Patagonia (brown trout) to the Bahamas (tarpon), but he says that fly-fishing around Blue Ridge, in woods bursting with rhododendron and mountain laurel, offers a magic all its own.

Some anglers prefer to "float and fish" from a drift boat, while others wade into the smaller network of streams, some stocked and managed and some wild. Those just starting

out—and those who'd like an insider's introduction to favored spots—will benefit from a guide, Oyster says. One can also learn the basics, as he did, by studying books (or today, YouTube videos). Important skills to acquire include the graceful flick and whip of the line in a cast, and how to choose a fly—feather, fur and fabric creations assembled to look like the larvae and insects trout might be chasing in that particular season, weather or even light. Seven days a week, the Blue Ridge Fly Fishing School offers three-hour introductory courses and full-day guided outings for beginners, gear included. Guides can also be hired via the Cohutta Fishing Company fly shop, which shares a nineteenth-century brick wall with Oyster's storefront.

Beyond a grasp of the basics and a tackle (one's kit of gear), anglers will need a fishing license, and to keep an eye on local dam water release schedules that affect the waterways. Then there is the river etiquette: namely, ensuring fellow anglers can fish undisturbed. "You have your experience, and you make sure everybody else gets to have theirs the way they want to have it," Oyster says.

As important is the community's shared ethos of catch and release: "Once you've taken that fish from the environment, not only is it bad for the fish, but it also means that enjoyment is not there for the next person coming behind you," he says. "If you caught that fish and you kept it, then your son or daughter can't go out there and have that same experience that you had."

To Oyster and many of his neighbors, this is "the perfect hobby," not just because it fosters thoughtful, environmentally conscientious sportsmanship, but because one can learn it quickly and affordably, and no matter how many years one puts into it from there, it's a sport that is never mastered. "Every time you go, you learn something new, and for every new thing you learn, there's another thing to learn behind that— always some new challenge," he says. With that guaranteed unattainability of perfection comes an ability to just relax and take in the views.

"No one gets into fly-fishing because it's the easiest, or the simplest, or the most efficient, or the cheapest way to catch a fish," Oyster says. "As an artist by trade and by nature, I appreciate its artistry—just that it's beautiful."

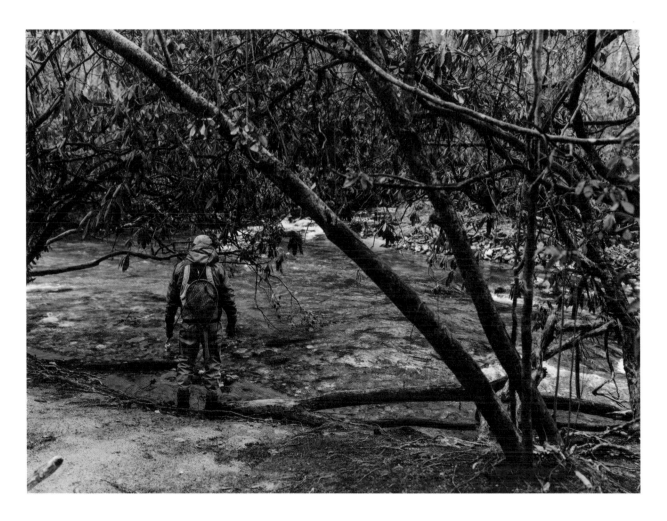

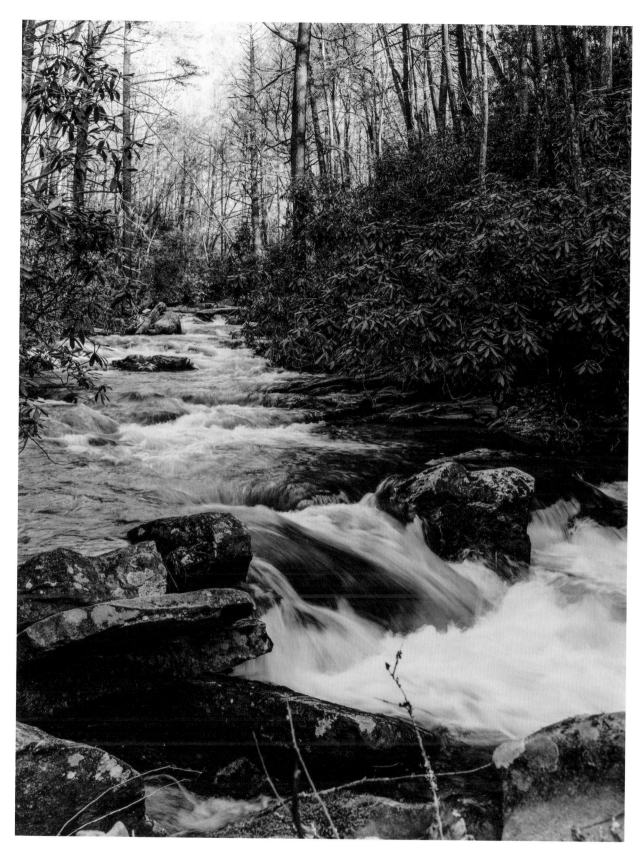

Opposite
—
Noontootla Creek is just outside
of the mountain city of Blue Ridge.
Beyond its convenient location for
outdoor pursuits, the city has a
strong artistic community as well as
breweries and restaurants.

Above
—
The Noontootla Creek has special
regulations that require almost all fish
to be released after catching. This
means the trout grow to heftier sizes
than the average wild fish and makes
it a quieter spot to fish than most.

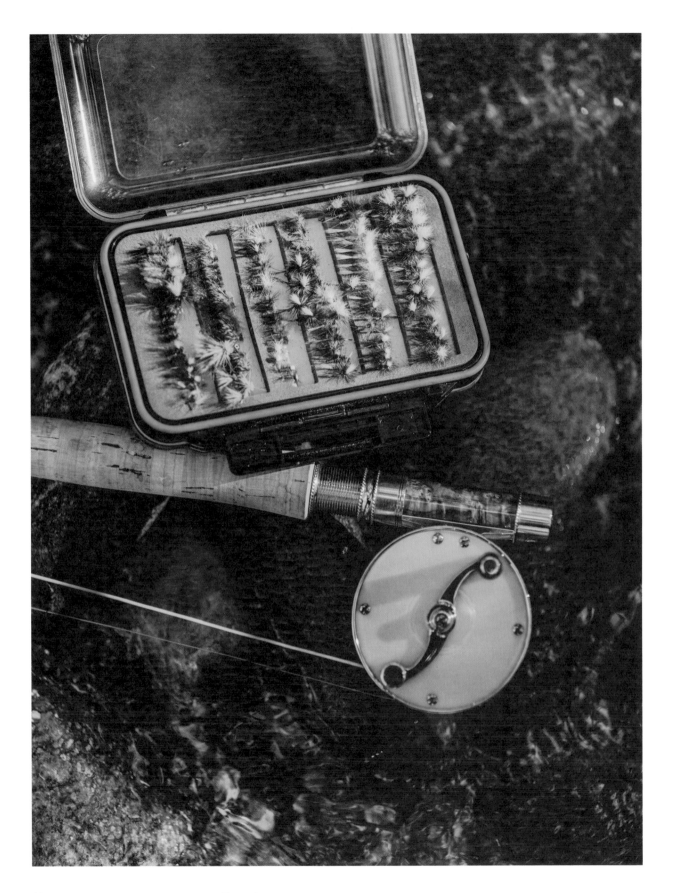

Above
—
Trout flies are artificial lures designed to mimic insects the fish might eat. Traditionally, they are made of materials including feathers, hair and fur.

Opposite
—
Once the trout has been hooked, a landing net is used to safely get the fish to the bank without causing it additional stress.

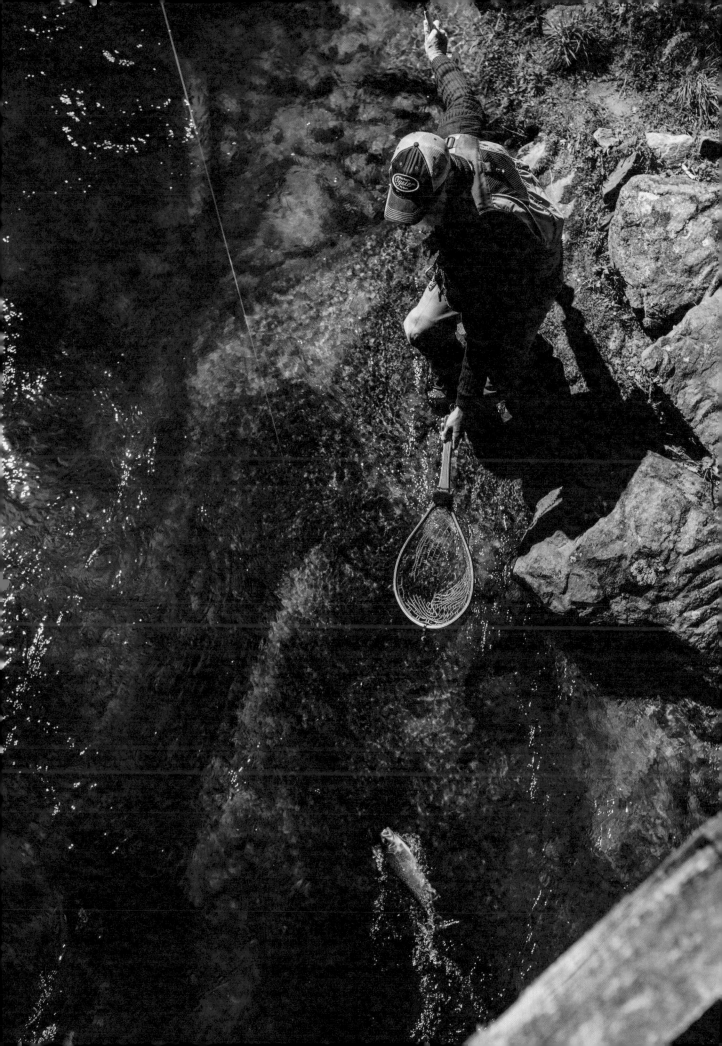

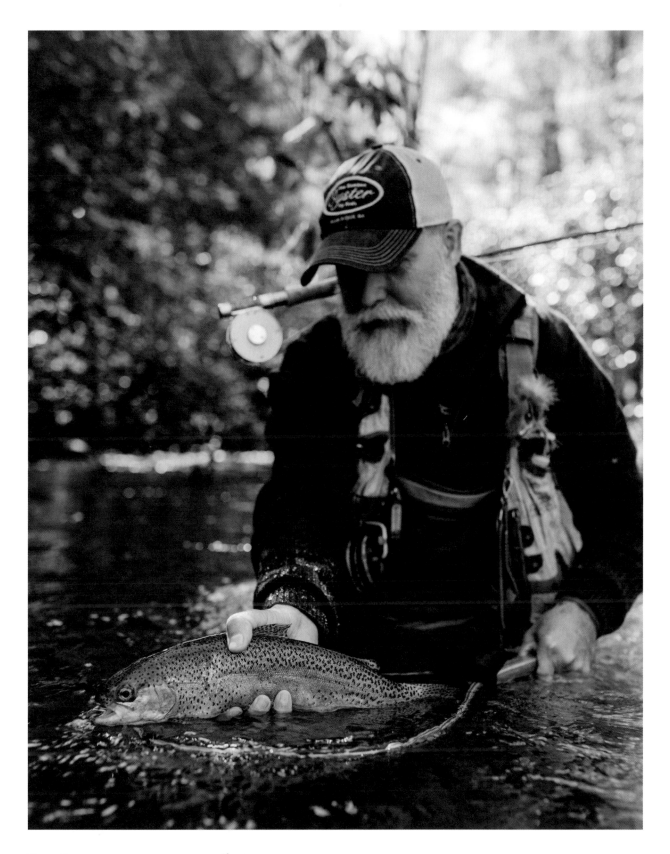

Opposite
—
Lake Ocoee, on the border between
Tennessee and Georgia in Cherokee
National Forest, is another popular
fishing spot in the region.

Above
—
Under Georgia's strict regulations,
anglers are allowed to keep only
a small number of the trout they
catch: one fish daily, and a maximum
of three each year.

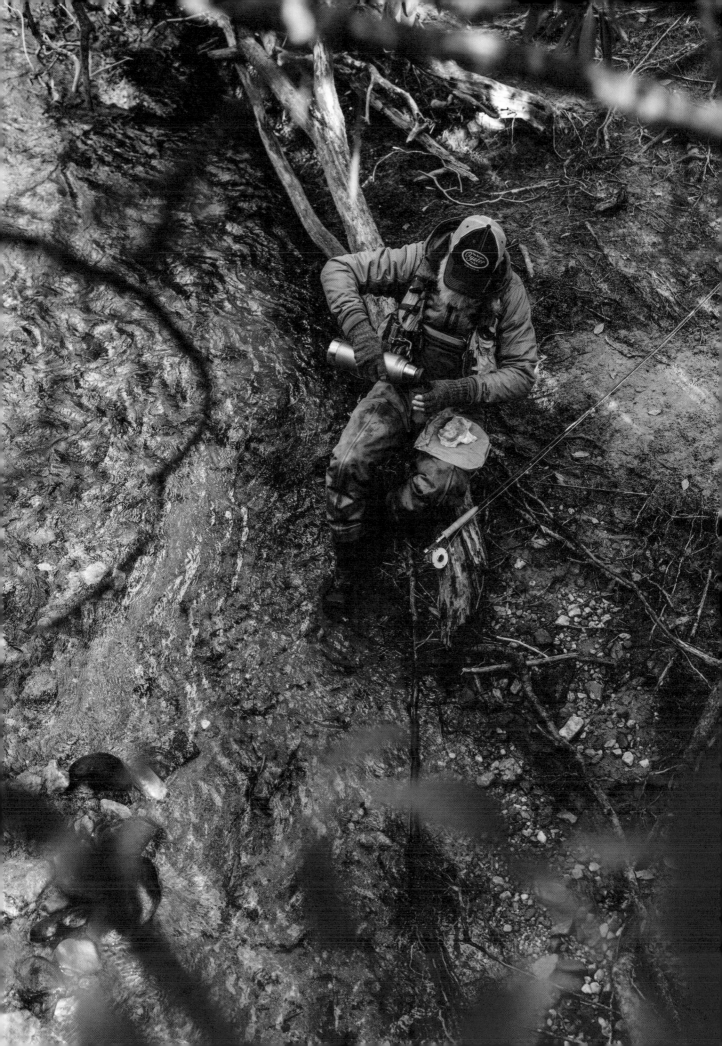

DELGER RIVER, MONGOLIA

Taimen, the largest member of the salmonoid family, can live up to fifty years and reach up to five feet (1.5 meters) in length. If you're up for the challenge, Mongolia's Delger River is the ne plus ultra for taimen fishing. The fun part is how aggressively these monsters will go after the fly—hang on tight.

TSIMANE, BOLIVIA

Bolivia's premier fly-fishing destination is Tsimane, which offers fishers the opportunity to catch trophy fish like massive golden dorado. At the confluence of the Amazon rain forest and the Andes mountains, the views from Tsimane's streams aren't bad either.

GAULA RIVER, NORWAY

If you're after trophy-class salmon, Norway's Gaula River might fulfill your fantasies. Fish over twenty pounds (9 kg) are not uncommon catches, and some lucky fishers even pull in salmon over forty pounds (18 kg). The best time of year for large specimens is just after the season starts in June.

TARRALEAH, AUSTRALIA

Tasmania's Tarraleah area features dozens of waterways connected by canals. You won't find giants here, but it's a great place to learn to cast. Only trout inhabit these waters—there are no eels to gobble up the lures, as you typically find fishing elsewhere in Tasmania.

LAKE NASSER, EGYPT

Lake Nasser was created in the 1960s as the result of a massive dam project along the Nile River in Aswan, southern Egypt. In the largest man-made lake in the world, perch grow to gargantuan sizes; rumor has it that some individuals lurking in its depths are over two hundred pounds (91 kg).

LAKE AKAN, JAPAN

Remote Lake Akan, in the eastern part of Japan's wildest island Hokkaido, is a treasure trove of white spotted char and kokanee salmon. The area also has natural hot springs, or rotenburo, which beckon weary fishers after hours of standing in cold water.

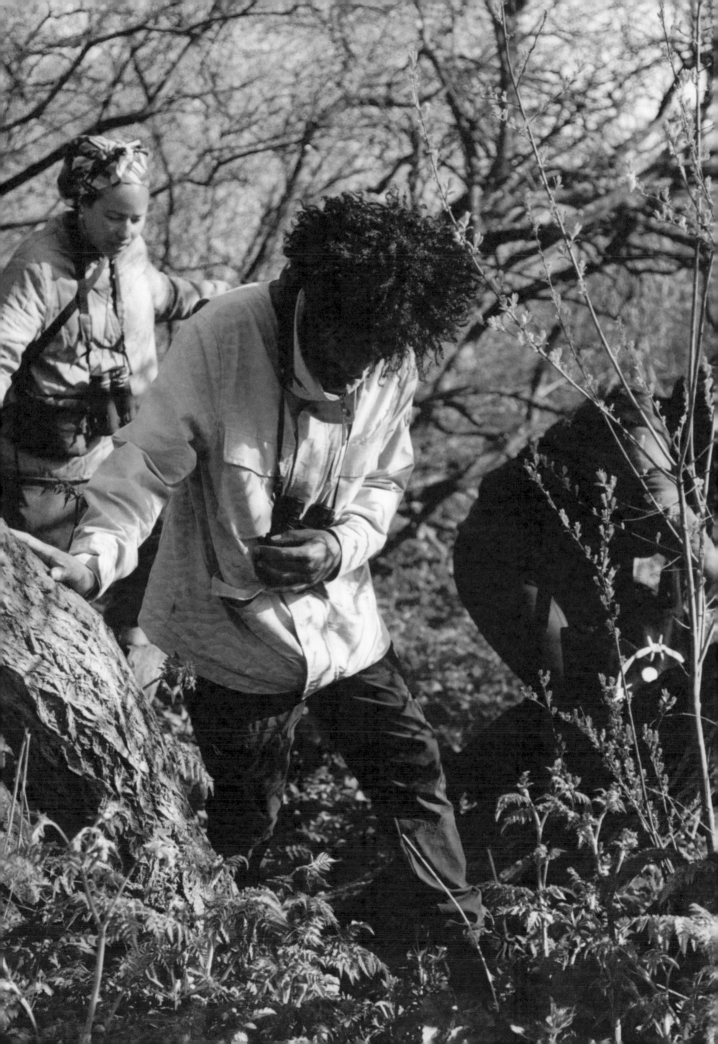

LONDON, UNITED KINGDOM

Alongside its nine million human inhabitants, London is home to three hundred bird species. For curious birders, such as Flock Together founders Ollie Olanipekun and Nadeem Perera, a pair of binoculars is all that's needed for a new outlook on this iconic city.

Birding in the British Capital

Bird-watching is not what most people associate with London. For most visitors, the British capital means business, culture and history—not pelicans, kestrels and swarms of bright green parakeets. But London is a city alive with wildlife.

It has a large network of parks—an astonishing 18 percent of the city is made up of public green space—and the Thames River and its tributaries snake through the city, providing an environment for wildlife on the water. The city is also a jigsaw of private gardens—over three million of them in the Greater London area—which are inaccessible to the public but a haven for the many birds that call London home.

In June 2020, Ollie Olanipekun and Nadeem Perera, two amateur birders, set up a bird-watching group called Flock Together to show young people of color what the city has to offer. Since then, Flock Together has grown exponentially in popularity, hosting outings all over London. Although Olanipekun, Perera and many of their members are Londoners, you don't have to live in London (or indeed be a member of Flock Together) to join one of their bird-watching tours.

The majority of people in a given Flock Together outing will be relatively new to birding, and the founders are keen to paint it as an accessible hobby. They stress that birding is something that anyone can enjoy, either alone or on a tour—although of course an expert guide, a bit of research and the right equipment can make all the difference. For a day out in London, Olanipekun suggests—as a general rule for British weather—equipping yourself with waterproof clothing and footwear. "And the *Collins Bird Guide* is our bible," he says. Finally, you'll need a decent pair of binoculars: "A good £30 ($40) pair will do."

Olanipekun and Perera both radiate a gentle wisdom and generosity and offer an inspiring perspective on their hometown. They know London well, having lived here for the last fifteen years, but they don't take this knowledge for granted. They research each route, walking it themselves for hours before organizing an outing.

"North East London is great for bird-watching," says Olanipekun, waxing lyrical about the rich and varied landscape of this part of the capital. Both he and Perera live in the area, where the Hackney and Walthamstow Marshes connect London to the wider Lee Valley—a twenty-six-mile (42 km) linear park that follows the River Lea up into Hertfordshire.

Perera also recommends visiting Sydenham Hill Wood in the London borough of Southwark, where he recalls an impressive sighting. "I thought, 'What on earth is that?'"

he says. Getting closer, he saw that it was a buzzard—a large bird of prey, which can have a wingspan of up to four feet (1.2 m). "There was a collective gasp," he says. Both men light up when discussing the group's reactions to such sightings. "When I've applied my skills to spotting a bird, and that bird has impressed everyone, that's a good day," says Perera.

The duo has seen a wide range of birds on their travels, from pelicans in St. James's Park to a kestrel in Richmond. Importantly, though, they believe there is more to birding than what you can spot through your binoculars. "Nature isn't all just about what you see," says Olanipekun. "It's about what you feel." Perera agrees, adding that he wants to challenge ideas of what nature lovers—or nature itself—should look like: "People look at us and wonder how we can be birders," he says.

"We're trying to change people's view on nature—that it doesn't have to be a two-hour drive through country lanes, thatched cottages and loads of white farmers," says Olanipekun. "London is beautiful."

Through bird-watching, people change how they see their city, and hopefully themselves. There's also an important educational aspect: Perera teaches young bird-watchers about ecosystems, and Olanipekun encourages them to engage with London's green spaces. "We're all about reclaiming spaces in order to engage with nature, but no one has ownership of it," he says. "That's what we aim to show people."

In doing so, residents and visitors alike are able to access and experience London in a way they might never have before. There is also a powerful emotional element to Flock Together—a safe, social space within the busy metropolis. "It's based on the love for birds, but it's also a support group for people of color, using nature as a source of healing," Olanipekun says.

He explains how Flock Together was born from the traumatic events of 2020. "We were drawn to each other in a time when people of color needed more support than ever," he says. Perera concurs. They are constantly working on how best to support their members' well-being and are optimistic about the future, with branches in New York and Toronto, and more to follow.

Ultimately, theirs is a message of kindness—one that can be appreciated and put into practice wherever you are. "Were it not for the support we've gotten from nature, we wouldn't be here today," Perera reflects. "We just want to offer that up to the rest of our community."

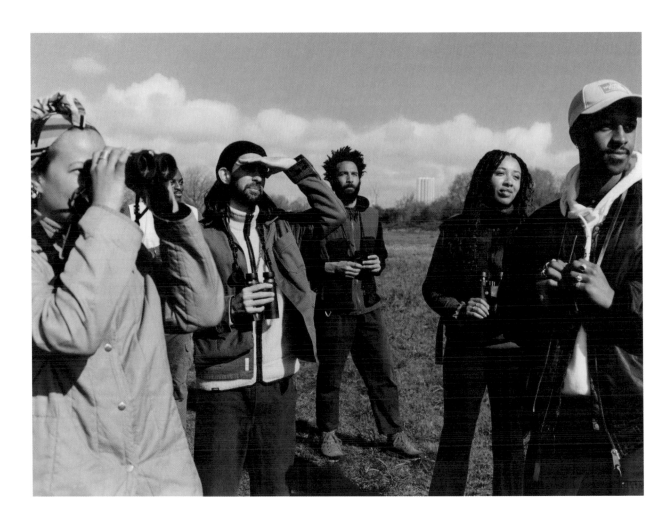

Opposite
—
Flock Together now has chapters in New York and Toronto, which people of color visiting those cities are welcome to join. By the time you're reading this, it's likely their network will have expanded still further.

Above
—
The twenty-six-mile (42 km) green space of the Lea Valley is well-served by London's transport network. Overground stops at Hackney Wick, Clapton and Tottenham Hale will land you a short walk from the park, and there are bus stops dotted along the river's path.

Above
—
With a potential wingspan of almost
eight feet (2.4 m), the mute swan is
the UK's largest flying bird. Though
all swans in the UK do not belong to
the queen, as is often rumored, they
are a protected species and cannot
be hunted.

Opposite
—
Wildlife lovers in London can take
advantage of both the city's pub-
lic parks and its "commons": open
access, ungated land that is relatively
wild, like Walthamstow Marshes
(pictured here). The term dates from
the middle ages, when common land
was used by the poorest people who
owned no land of their own.

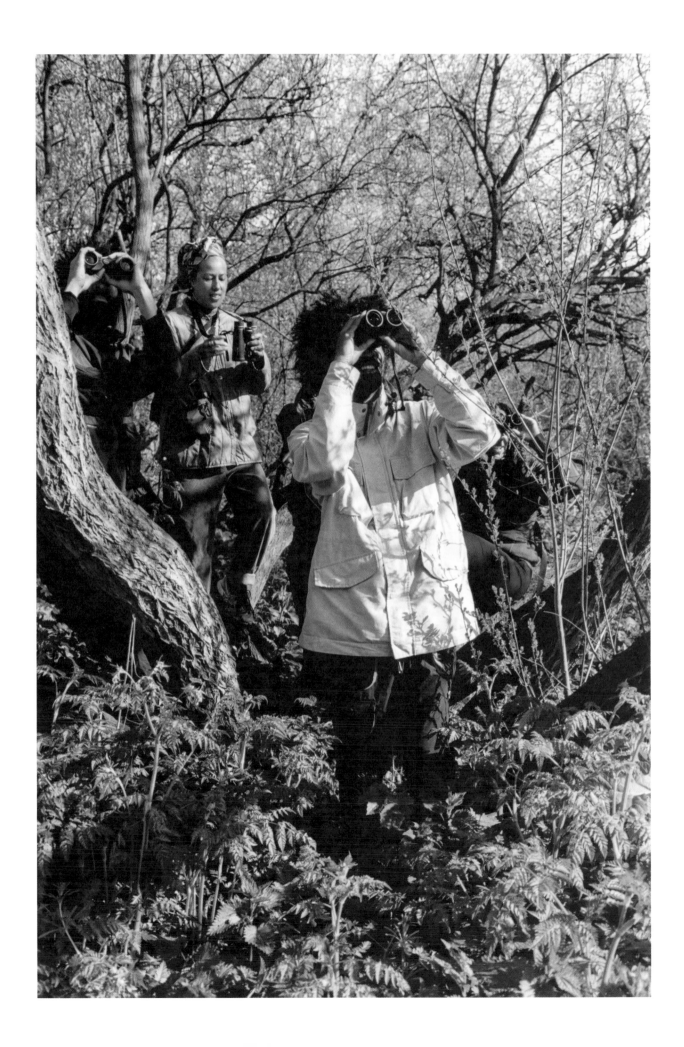

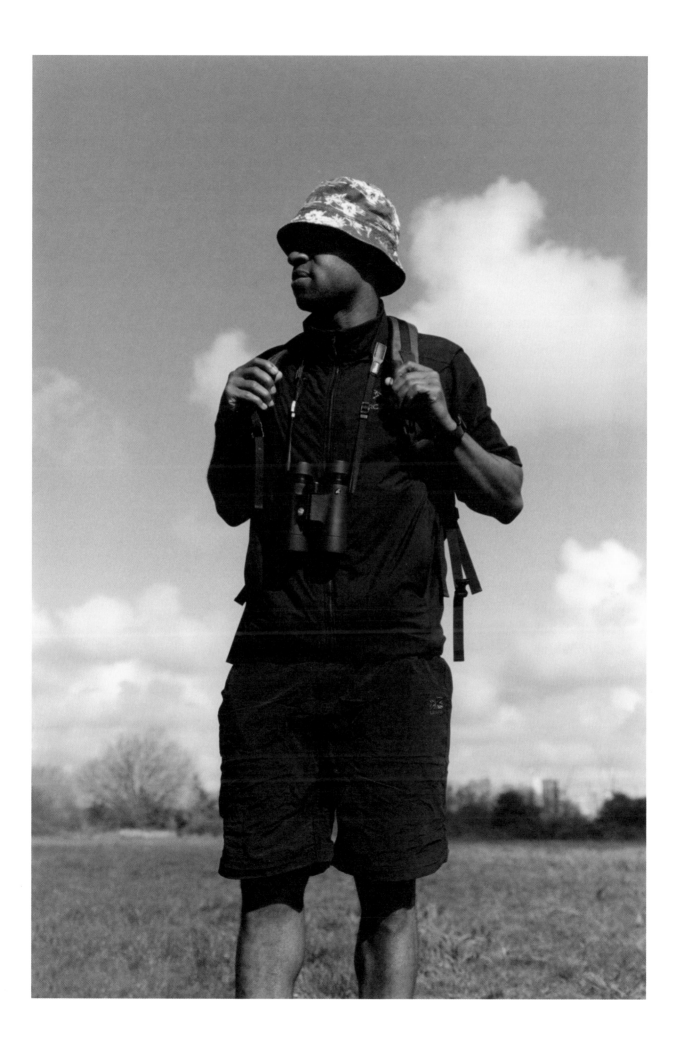

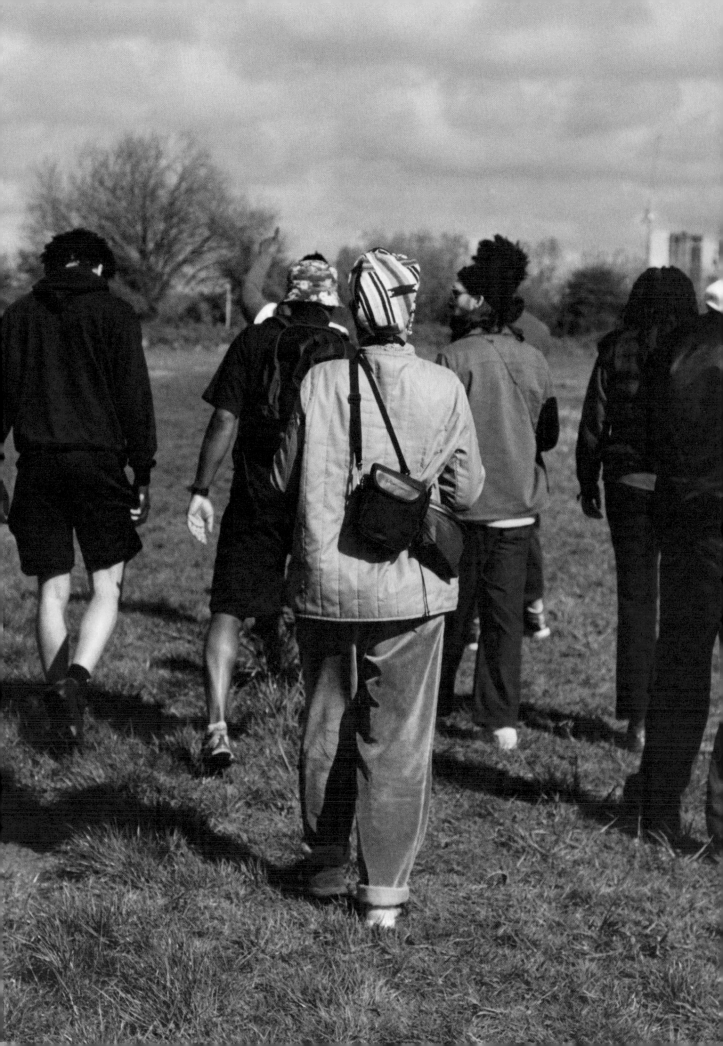

MORE BIRD-FRIENDLY CITIES

HELSINKI, FINLAND

There are oodles of bird-watching towers, bird hides and nature reserves in the wetlands around Helsinki, most of which are easily accessible by public transport or bicycle. Springtime brings migratory birds from the Arctic, like Arctic geese and waterfowl, as well as the dulcet tones of thrush nightingales, marsh warblers and reed warblers.

DELHI, INDIA

To the birds of Eurasia, India is warm grounds for riding out the winter. Flocks from as far away as Siberia fly over the Himalayas to reach the wetlands around Delhi. The male Baikal teal, who makes its summer home in Siberia's Lake Baikal, is an especially beautiful sight, with a brilliant green crescent framing its eyes.

SHANGHAI, CHINA

Coastal Shanghai is chock-full of interesting birds. The city's Century Park is especially popular with yellow-bellied tits, red-flanked bluetails and Daurian redstarts. For more invested birders, Cape Nanhui, about fifty miles (80 km) south of the city, is the most famous birding site in China, where you can clap eyes on Japanese paradise flycatchers and Siberian blue robins.

BERLIN, GERMANY

Berlin is 30 percent green land, which makes it a paradise for birds (and birders). Goshawks and skylarks use the city's largest parks, like Tiergarten, as breeding grounds, and nightingales can be found along the Spree River, which bisects the city.

BUENOS AIRES, ARGENTINA

Costanera Sur is the most important nature reserve for birders in Buenos Aires, ten minutes south of downtown. An early-morning springtime visit offers the chance to spy glittering-bellied emeralds, masked gnatcatchers, rufescent tiger-herons and southern screamers.

KIGALI, RWANDA

One of the greenest cities in Africa, Rwanda's capital offers keen birders the chance to glimpse the endangered grey crowned crane, as well as the reclusive white-collared oliveback. Nyarutarama Lake is also home to a number of East and Central African water species.

BEYOND

SUSTAINABILITY

Long ago, I found myself traveling up a twisting road through the remote Iya Valley on Shikoku, one of the main islands of Japan. My destination was a thatched farmhouse called Chiiori. Perched high on a mountainside amid groves of cedar and bamboo, it looked a bit like an old sedge hat overlooking a valley where swirling mist created the sublime effect of a Song dynasty painting. Ringed by mountains, the Iya Valley had been the redoubt of samurai from the Heike clan defeated in civil wars of the twelfth century. When Japan cut itself off from the rest of the world in the seventeenth century, around the time Chiiori was built, Iya was isolated both politically and geographically. It became one of the archipelago's three "hidden regions" and is still far off the beaten path for most travelers.

But the Iya Valley offered something that many modern resorts lack: the opportunity to improve the destination itself. I joined a crew of staff and volunteers cutting pampas grass to rethatch the roof. It was a small way of contributing to the three-hundred-year-old dwelling as well as its local community, which has been hit particularly hard by depopulation and the rapid aging of those who remain.

Alex Kerr is the author, artist and conservationist who bought this farmhouse in 1973 after it had been abandoned for years. He has spent decades restoring and

maintaining Chiiori, which means House of the Flute, and has hosted many visitors, from backpackers to executives, at his cloudy eyrie. Although Chiiori no longer accepts volunteers, it's run by a nonprofit organization dedicated to sustainable tourism and revitalizing the local community. "In Iya, we took a dying village and gave it some life, and not by bringing in huge tour buses and mobs of people," says Kerr. "When done properly, tourism benefits locals, the culture out of which it's come, the history of the place and even the natural environment. It's quality over quantity."

Kerr has restored a number of other properties in the less-touristed parts of Japan such as Ojika Island. He contrasts his approach to the masses of tourists thronging Kyoto's temples and the country's other big draws; Japan hopes that by 2030, it will attract sixty million travelers (more than half its population). Shirakawa-go, a UNESCO World Heritage village of thatched farmhouses in another of Japan's hidden regions, is infiltrated by busloads of day-tripping tourists. But the amount of money each visitor spends is low, perhaps on a souvenir or a vending machine drink. Kerr estimates that a guest spending the night at Chiiori spends twenty-five times more—money that contributes to the local economy.

Kerr's philosophy is the latest iteration of a sort of travel that has at different points been referred to as ecotourism, green tourism, sustainable travel and more. He points out that Giancarlo Dall'Ara's Albergo Diffuso movement, which seeks to revive historic Italian villages through decentralized tourist lodgings, dates back to the 1980s. These days, there's a growing push for what's being called regenerative travel. As part of a holistic approach to tourism, the movement aims to improve rather than just protect a location. It has gained traction after the coronavirus pandemic forced a rethink of

> "When done properly, tourism benefits locals, the culture out of which it's come, the history of the place and even the natural environment."

travel, including issues of sustainability and the overtourism that has blighted sight-seeing spots from Boracay to Barcelona.

Established in 2020, the Future of Tourism is a coalition of six nongovernmental organizations and some five hundred signatories including the Hilton hotel group, the World Wildlife Fund and the Tourism Council of Bhutan. The purpose of the Future of Tourism is to get travel entities to commit to principles such as fair income distribution, reducing climate impacts and adhering to sustainable tourism practices. The small Himalayan nation of Bhutan is a good example of what a careful tourism policy can hope to achieve: it has for decades limited the number of tourists it admits, requiring most visitors to take guided tours. Not only has this prefigured sustainable tourism as we know it today, but Bhutan's development strategy also influenced the UN 2030 Agenda for Sustainable Development.

Another example is Regenerative Travel, a booking agency founded in 2019. It works with a collection of hotels that adhere to social and environmental principles such as integrating with their environment, being inclusive and egalitarian and considering the well-being of their local communities as well as their guests. "Regenerative travel is about creating better conditions of life for the environment and the community," says Amanda Ho, the company's cofounder and brand director. "In order to move from sustainable to regenerative, you have a whole-systems approach that creates abundance for all stakeholders involved—including the land, the people and community, and the wildlife."

She points to one of the agency's newest resorts, Fogo Island Inn in Newfoundland, Canada, as an instance of regenerative principles at work. The dramatic seaside accommodation posts an Economic Nutrition mark, developed by local charity Shorefast, that shows how and where its revenue is used: operating surpluses are reinvested in the community, which received about 65 percent of the project's economic benefits in 2018. "The travel industry, as it currently operates, is not sustainable," says Ho. "The pandemic was a reminder of the urgent call to repair and replenish the damage we have done not only to our environment but to our communities."

So what should travelers do? Think about their tourism footprint, says Kerr: "I've always wanted to go to the Galápagos, but would my going there be good for the Galápagos? Probably not. What I can do for the Galápagos is not go there. Who needs me? Disneyland? Shibuya Crossing? If I come or go, would it have an impact? No. But in Iya, or Ojika? Absolutely. Those are the places that truly need us. Since you can go maybe one place a year, go to the place that needs you. That's my new philosophy."

LEAVE NO TRACE

In 1845, as the icy blanket that enveloped Concord, Massachusetts, began to thaw, American writer Henry David Thoreau retreated to the woods. Next to a small glacial lake, he built a one-room cabin from recycled materials. Though he lived just a short walk from his friends and family, he also spent time foraging and fishing for his meals, recording his interactions with woodland animals and observing the seasonal rhythms of the natural world. After two years, he left the woodland cabin; a decade later, his collection of essays from that solitary period—*Walden; or, Life in the Woods*—was published.

For today's outdoor enthusiasts, Thoreau's determined self-sufficiency and his belief in the spiritual properties of nature have provided a bedrock for wilderness thought. "We need the tonic of wildness," Thoreau wrote in *Walden*—a sentiment that inspires countless urbanites to pack their Subarus with recreational gear and head for the backcountry in pursuit of their own restorative healing. For those who can afford it, these forays have become increasingly far flung: there's the Bear Grylls Survival Academy in the Scottish Highlands, wild camping holidays in Finland and guided treks to Himalayan base camps. But with so many now seeking the same salve, how do we ensure we're roaming responsibly?

At the turn of the eighteenth century, there were only one billion people in the world, and they lived scattered among colossal expanses of undomesticated nature. Naturalists like Thoreau could chop branches and erect a campfire without a second thought. But contemporary nature lovers are squished among 7.7 billion other humans. In response to the challenges posed by an exploding population and the subsequent shrinking of natural lands, a set of minimal-impact principles, known as Leave No Trace, have emerged to provide a framework for these forays into wild areas.

"Leave No Trace are guidelines that minimize the controlling way that humans cannot help but engage with their environment," explains Ken Shockley, a professor of environmental ethics and philosophy at Colorado State University. Each year, Shockley takes a group of students for a two-week trip into the wilderness. After handing each student a little card that outlines the LNT guidelines, he's observed how this simple outline of best practices—from planning ahead to proper waste disposal—positively impacts their behavior. "It has that extraordinary benefit of making people think twice about what they're doing," he says. "These are vague rules, and whether intentional or not, they inspire personal reflection."

Leave No Trace is a philosophy that emphasizes the importance of preserving the wild from undue human influence. This is a marked shift from earlier American attitudes toward the country's wild areas, which were largely negative until the nineteenth century. "The notion of wilderness is a culturally conditioned concept," says Shockley. When early European settlers tried to conquer the wilderness—and the Indigenous people who lived there—to build a new nation, its harsh extremities evoked fear. Later, Thoreau and his contemporaries romanticized it as a place of profound spiritual and

aesthetic importance. By the 1950s, as new interstate roads suddenly offered easy access to remote areas, nature became a hub for recreational activity. In turn, innovative equipment, like gas stoves and synthetic tents, were brought to market. Suddenly, the wild was not only accessible, but it could be enjoyed with a modicum of comfort.

Exuberantly embraced as part of the country's cultural iconography, these wild spaces began to experience the damaging effects of overcrowding. The emergence of wilderness ethics—led by conservationists like John Muir and Aldo Leopold—built upon Thoreau's elevated view of nature to campaign for the conservation of public lands. Their efforts were codified with the passage of the Wilderness Act in 1964, which declared wilderness to be "an area where the earth and its community of life are untrammeled by man, where man himself is a visitor who does not remain." It was with this environmentally conscious definition in mind that the early messaging around Leave No Trace began to formulate in the '70s, such as the distribution of pamphlets on "Wilderness Manners."

In 1999, the Leave No Trace Center for Outdoor Ethics officially published a set of guiding principles. Each of the seven tenets covers a specific topic related to outdoor activity: Plan Ahead and Prepare; Travel and Camp on Durable Surfaces; Dispose of Waste Properly; Leave What You Find; Minimize Campfire Impacts; Respect Wildlife; and Be Considerate of Other Visitors. Within these broad frameworks, more detailed information is provided: campers are urged to plan one-pot meals that can be prepared on a backpack stove, rely on existing fire rings in campsites and invest in earth-toned tents that blend better with their surroundings.

In recent years, there have been calls for Leave No Trace to incorporate an eighth principle that addresses the impact of social media. Since the advent of Instagram, a new slew of outdoorsy types has been ushered in—the "outdoor influencers"—who share aspirational shots of nature to large followings. When such photos are geotagged, a hidden spot can suddenly attract a rush of attention from crowds.

"Social media geotagging is what I suggest we think of as a second-wave problem associated with the pressures of overuse and overpopulation more generally," says Shockley. "I could totally see an eighth principle in Leave No Trace being built around noise, whether that's literal or in a social media sense. That kind of proximity and invasion takes away from values of the wild and other people's ability to enjoy it."

Ultimately, that's what Leave No Trace is trying to do: allow people to enjoy the wild without impacting others' ability to do the same. As the world's empty spaces continue to shrink, our responsibilities weigh heavier. But the value found in experiencing nature, in its untamed and fragile wildness, remains as powerful now as it was when Thoreau first moved into his cabin.

"There's a sense in which it's just 'the other,'" says Shockley. "It's different from our lives in more institutional settings in a very profound way. It forces a kind of existential reflection on who and what we are."

ON ENDURANCE

The history of the people who have helped—and still do help—wealthy adventurers is, unsurprisingly, opaque. While most history aficionados know the names of Sir Edmund Hillary, the first man to ascend Mount Everest, or Reinhold Messner, the first to get to the top without supplemental oxygen, how many know the names of the men who assisted them?

Sherpas not only climbed the mountain with Hillary and Messner but did so carrying more gear and supplies, and with the added psychological burden of having to assist others in the task. Today, Sherpas in the Himalayas continue to coordinate climbs for foreign adventurers, crossing a trail's dicey crevasses first, fixing lines and going up and down the mountain with vital supplies.

The Sherpa name belongs to a specific ethnic group living in the mountains of Nepal, although not all guides who use the term are part of it. What they do is likely the most dangerous job in the world. These people die at a rate of about twelve per one thousand—nearly four times the death rate of the US soldiers who were on the front lines in the Iraq War, and ten times that of commercial fishermen (which the CDC ranks as one of the most dangerous civilian jobs in America). When Sherpas die on Mount Everest, insurance payouts to their families tend to be paltry—around $5,000.

"As in many areas of life, if we can show that exceptional endeavors and achievements are the product of many people's work, it's more accurate."

"You don't have to be a climber to understand that climbing involves more than one person," says Felix Driver, a professor of human geography at Royal Holloway, University of London. In his research into the visual culture of exploration, he has found that while acknowledgment of guides and local assistants in the nineteenth and twentieth centuries was relatively rare, documentation does exist. He's found watercolor sketches and lithographs showing the local people (and the European women) who carried supplies, or who cleaned and cooked on long expeditions—not just on Mount Everest, but anywhere that conditions were harsh or unknown to foreigners. "As in many areas of life, if we can show that exceptional endeavors and achievements are the product of many people's work, it's more accurate," he says.

Fixers for journalists working in war zones, for example, also tend to be uncredited despite being thrust into dangerous situations to translate, set meetings and provide local knowledge to foreign reporters. A study funded by the Canadian Media Research Consortium and the University of British Columbia Faculty of Arts found that while more than 70 percent of journalists say they have "never or rarely" placed a fixer in immediate danger, 56 percent of fixers said they were "always or often" put in danger. In the same study, 60 percent of journalists said they "never or rarely" give fixers due credit, while 86 percent of fixers would like it to be given.

Norbu Tenzing Norgay, the vice president of the American Himalayan Foundation and the son of the late Sherpa pioneer Tenzing Norgay, who summitted Mount Everest with Hillary in 1953, expressed similar sentiments to *Outside* magazine in 2013: "If somebody in America climbs Everest 19 times, he'd be all over Budweiser commercials. Sherpas don't get the same recognition."

The inability to recognize other people for labor and assistance continues apace on social media. Those who capture adventurers on camera, often in real time, allow the athletes to gain sponsorships and viewers or become influencers, ultimately ensuring they can make money off their daring. Again, the people behind the camera often risk their lives doing the same activity while getting close to none of the credit.

After cameraman James Boole captured Jeb Corliss, a BASE and wingsuit jumper, flying through a miniscule canyon in Italy known as the Death Star Run, the clip was posted to YouTube where it got hundreds of thousands of views and helped Corliss meet his contractual obligations with GoPro, his sponsor. Unknown to most viewers, however, is that Boole was right beside him, doing essentially the same jump to get the shot.

When filming the Oscar-winning documentary *Free Solo*, cameraman Jimmy Chin found himself emotionally distressed every time he began shooting the free-climber Alex Honnold. Chin was torn between the fact that Honnold was his close friend doing

an extremely dangerous activity, but also that he needed to get the best shot of him doing it—even if that shot was of Honnold falling to his death. "I always felt like, as the director-producer, I should carry the burden of shooting the spot that he was most likely to fall," Chin said in an interview on the HBO show *Real Sports with Bryant Gumbel*. "I thought about it every day for two and a half years."

While change is slow, the people working behind the scenes seem to slowly be coming out of the shadows. Tenzing Norgay, for one, is now increasingly celebrated for his climbing abilities—albeit posthumously. In 2013, the Nepalese government proposed naming a 7,916-foot (2,413 m) mountain Tenzing Peak in his honor. And, in 2019, when *Free Solo* won Best Documentary Feature, Chin shared the Academy Award with Honnold.

"What's been interesting to me in the last ten years is how in many different parts of the world people are interested in this [new history]," Driver, the Royal Holloway professor, says. "There is this interest in extending the story, making it more of a shared one from different perspectives, rather than the same old story that keeps getting repeated."

On January 16, 2021, a team of ten Nepalese climbers became the first people to summit the world's second highest mountain, Pakistan's K2, in winter—an achievement that was slated as the last great prize in mountaineering. Led by a thirty-seven-year-old former soldier named Nirmal Purja, the men braved –76°F (–60°C) temperatures and 60-mph (97 kmh) wind to make it to the top.

When they had almost reached the summit, around five p.m., they regrouped and walked the final stretch standing shoulder to shoulder. The climbers had achieved history on their own terms, entering the record books not as assistants but as protagonists of their own story.

TRANSIT

A good journey transports you from A to B via a whole alphabet
of wonder. Embrace slow travel and you'll be privy to new sights—
and new ways of seeing.

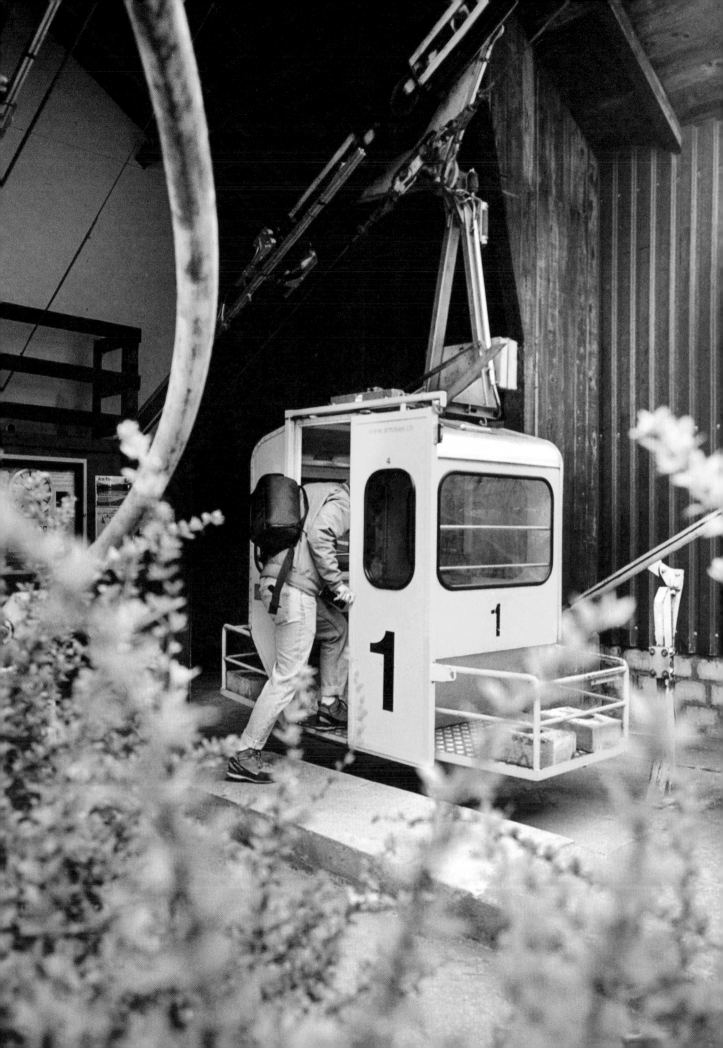

Switzerland's cable cars are as characterful as the remote alpine communities they serve. Sail up into the sky on one of over two thousand tiny rope trains, and you'll discover the heady pleasures—lush meadows, panoramic views and delicious cheeses—of higher pastures.

A Swiss Cable Car Safari

Living in Switzerland requires vertical thinking. So too does traveling here. When visiting many of the dairy farms and summer communities located atop the Alps, the question becomes not how far they are by road and rail but how high up they are. Fortunately, Switzerland's constitution mandates that every village across the country's four linguistic areas must be connected by road, rail, waterway or, in the trickiest locations, cable car.

While much is written about Switzerland's excellent network of punctual red trains, iconic cog railways and funiculars, it's the humble, underappreciated cable car—called *luftseilbahn* in Swiss German—that truly connects the remote alpine communities to rest of the country. Word for word, the translation of *luftseilbahn* is "air rope train." They're called *téléphérique* in French-speaking Switzerland, *funivia* in Italian-speaking Svizzera, and *pendiculara* in Romansh, Switzerland's ancient and endangered fourth language spoken in small alpine pockets.

There are 2,433 federally approved luftseilbahn in Switzerland. Many are privately owned by farmers but open to hikers, and can carry around four to six people at a time. Hikers can use the phone at the bottom station to alert the operator at the top to activate the lift, and voilà, an off-track alpine area that you won't read about in travel guidebooks is all yours.

The Swiss-German-speaking central cantons of Uri, Nidwalden, Obwalden and Schwyz are home to the nation's largest concentration of luftseilbahn. The rides here are also some of Switzerland's most rewarding. Hikers can be whisked up the Alp—a term used locally to indicate mountain pastures where livestock are raised in summer—for a small fee, usually 7 to 18CHF ($7 to $18) and paid at the top afterward. Once at the top, they can access networks of hiking trails often running on ancient nomadic farming routes still used today. Expect to see wildflower-strewn alpine meadows, swimmable alpsee (alpine lakes), rustic stubli taverns serving up gooey melted cheese dishes, and schaukäseri (cooperative cheese dairies) hawking wheels of cheese, milk, butter, yogurt and molke, a whey-based drink popular with farmers.

More often than not, the hiking paths lead to other luftseilbahn that can be taken back downhill so that you can walk a circuit instead of doubling back. Some cable car routes only run in summer; others operate all year. Most are listed on Google Maps, so users can create their own itineraries.

One such network is the Buiräbähnli in Canton Nidwalden. The twelve-hour, multiday hike brings you up and down several luftseilbahn, and takes you past the deep blue waters of the Bannalpsee reservoir and rustic overnight guesthouses.

One of the most traditional guesthouses is Alp Oberfeld—the summer home of sustainable cheesemakers Rita and Josef Waser-Späni. The couple collects thirty-two gallons (120 L) of organic milk every day at their farm and sells goods directly to consumers (they also serve samples and snacks). Inside, copper kettles hang over an open woodfire, bubbling with milk from heritage peacock mountain goats and Rhaetian Grey cattle that will be turned into cheese. Many cheese farmers can identify which Alp a cheese comes from, and even isolate the flavors of individual wildflowers that the cows grazed on.

"The Buiräbähnli is just one of many luftseilbahn hikes possible in central Switzerland," says Hansruedi "Joe" Herger, a tour guide and founder of The Alps by Joe, a slow-travel trekking service specializing in hiking excursions for all skill levels.

Oberaxen, located in Flüelen, just an hour on the train from Zürich, offers another luftseilbahn line to explore. Nestled above the eastern shore of Urnersee, the southern finger of Lake Lucerne, is a station with blue, wooden crate-shaped cable cars. The turquoise lake and chapel steeples come into focus as you rise above the scenic Axenstrasse—a seven-mile (11 km) cliff-hugging motorway below. At the top station, hikers can set out on one of thirteen trails, including the three-hour Eggberge trail, which begins with a vertical scramble up a green pasture before leveling out in mossy woodlands at 4,900 feet (1,494 m).

Elsewhere, Sittlisalp's apple red cable cars glide over a wide valley filled with enzian and magenta orchids before dropping passengers at the start of an easy two-mile (3 km) loop that passes Alpkäserei Sittlisalp—a shepherd's cooperative of nine family farms that run on hydropower and create nutty alpkäse.

Herger offers full moon hikes so that guests can witness the surrounding peaks bathed in moonlight, and a timed hike to see alpenglühen, when the snowy mountain caps sparkle and glow pink during sunrise and sunset. A highlight for many of his guests is the alpsegen, the Blessing of the Alp, an event where farmers cast protecting spells with horns over the high pastures.

"It's a haunting and beautiful tradition that's been carried out in these lands for centuries, harkening back to pagan times," says Herger. "And it's a reminder of the precious transit links to these vulnerable and ancient mountains."

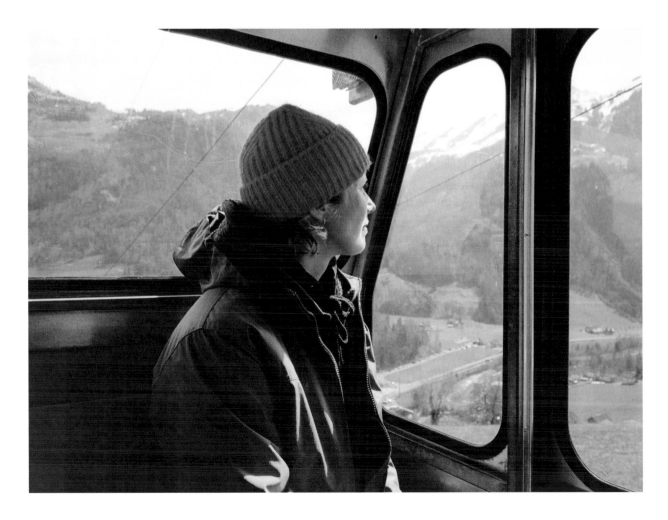

Opposite
—
Visitors travel skyward on the Luftseilbahn Witterschwanden-Acherberg-Kessel, a token-operated cable car that runs around the clock.

Above
—
The bell structure behind this cabin on the banks of the Urnersee is a carillon—a musical instrument that is usually operated via a keyboard.

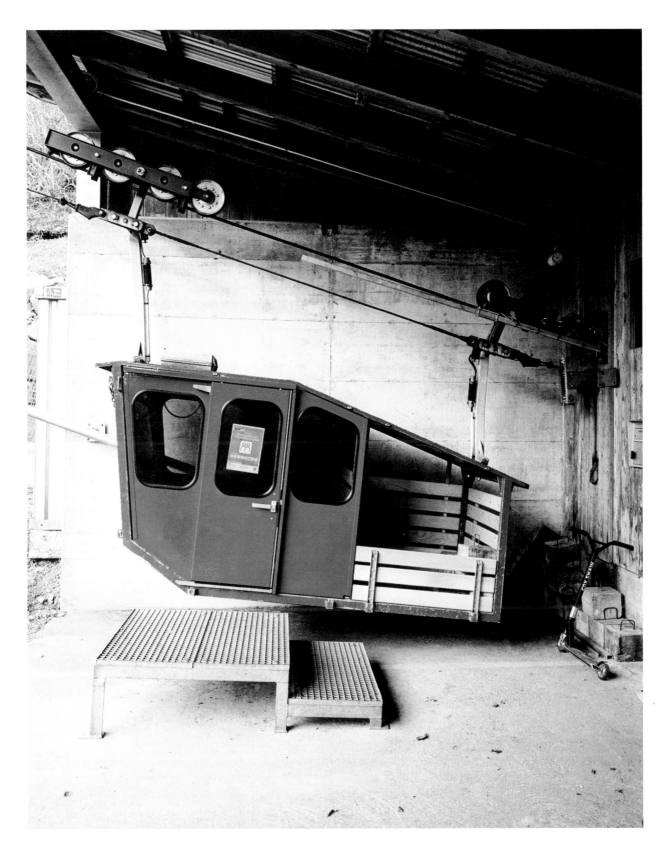

Opposite
—
Toggenburg is a Swiss breed of goat named after the Toggenburg Valley where they originated. They are credited with being the oldest known dairy breed.

Above
—
The lower docking station of the Luftseilbahn Oberaxen near Flüelen. The car takes around seven minutes to ascend to Oberaxen, where you'll find a restaurant with a large out-door terrace.

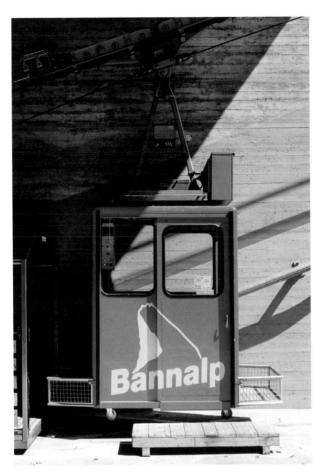

Above Left
—
The canton of Nidwalden in central Switzerland has more cable cars per capita than anywhere else on earth. The Bannalp cable car will transport you from Oberrickenbach to Lake Bannalp, an idyllic spot in the heart of the mountains.

Opposite
—
Mirjam Lustenberger and Oswald "Osi" Ehrler are the owners of mountain hotel Berggasthaus Alpenblick. In addition to running the hotel and its restaurant, Osi handles the tiny post office in the Luftseilbahn Intschi-Arisee's top station.

Opposite
—
Leather seats offer a little comfort on the Luftseilbahn Witterschwanden-Acherberg-Kessel. The cable cars are intended for use primarily by farmers, however, so it is not unusual to see a cabin stacked full of hay bales rather than human passengers.

Above
—
Urnersee, also known as Lake Uri, is one of nine subdivisions of the enormous Lake Lucerne. You can ascend the neighboring Mount Pilatus via a cog railway that is on a forty-eight-degree incline at its steepest.

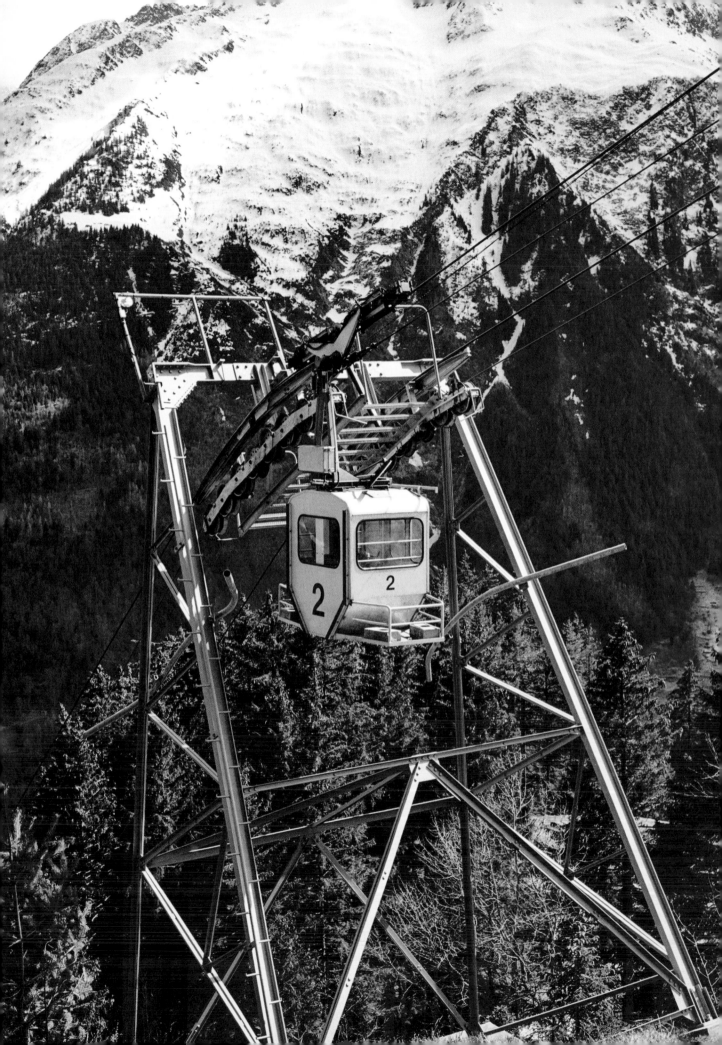

A CABLE CAR SAFARI

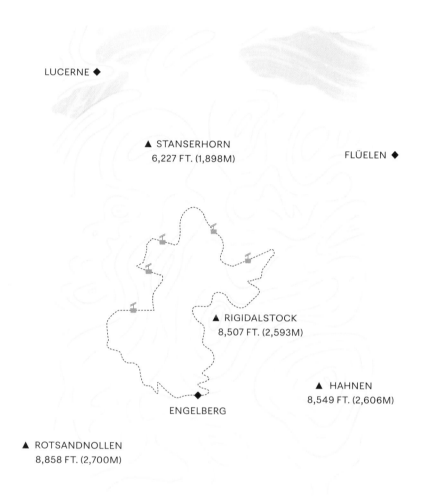

LUCERNE ◆

▲ STANSERHORN
6,227 FT. (1,898M)

FLÜELEN ◆

▲ RIGIDALSTOCK
8,507 FT. (2,593M)

▲ HAHNEN
8,549 FT. (2,606M)

ENGELBERG

▲ ROTSANDNOLLEN
8,858 FT. (2,700M)

WHERE TO STAY

Alp Oberfeld is a beizli (farm snack stand), alpwirtschaft (farm shop) and guesthouse. Visitors can overnight in cozy wooden beds covered in red check duvets. Rooms, which have toilets but no showers, are located in the annex of the barn, where the animals also sleep. Rise at dawn to see the goats heading to pasture. Like most alpine businesses, they're cash-only, so bring Swiss francs.

WHERE TO EAT

Excellent dairy is everywhere in the Alps, but sourcing a great, fresh meal can be hard: mountain terrain isn't hospitable to growing vegetables. Kaiserstock, occupying an old, shingled farmhouse, is a ten-minute walk from the Chäppeliberg luftseilbahn. Classic dishes like poached blue trout and veal with musky morel mushrooms won't disappoint. Reservations are essential.

TIPS

Alpine ecosystems are sensitive to human activity. Limit your footprint by bringing down whatever you haul up. Limit microplastics that can leach into alpine habitats. Be mindful of electric fences. Never get between a cow and her calf. Greet people, including bus drivers and luftseilbahn operators: greetings (grüezi in Swiss German) are particularly important in central Switzerland.

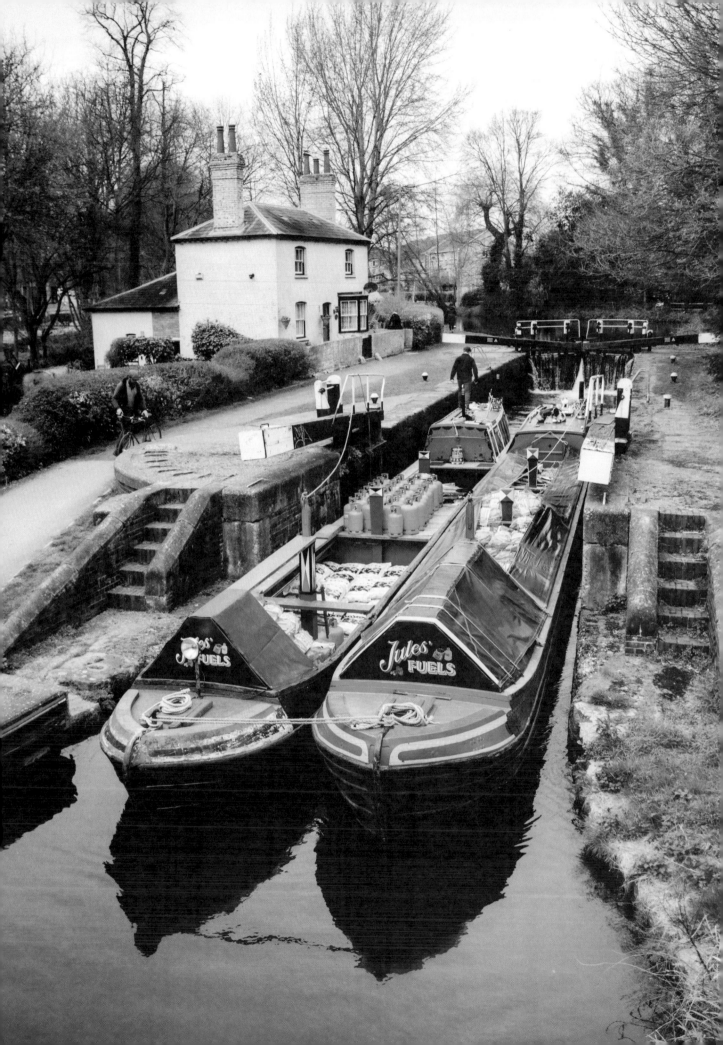

A narrow boat chugging at walking pace down a former industrial waterway: it may not be efficient, but England's Grand Union Canal will lead you from West London to central Birmingham, past all that is green and pleasant about this isle.

A Cruise Along England's Canals

For centuries, Britain's waterways were the vital arteries of a rapidly industrializing nation; an ingenious solution to the difficulty of transporting heavy goods between cities, factories and ports. By the 1960s, however, the rich culture of those living and working in boats on the canals had all but disappeared. The slow decline began with the emergence of the railways in the 1830s. The waterways became unprofitable, poorly maintained and increasingly unnavigable. The unique, nomadic way of life on the canals looked as if it would pass quietly into history.

Today, however, the canals are thriving. With the official recognition of their use for leisure in 1968, the canals found a new generation of enthusiasts. The long, thin "narrow boats" that had once ferried coal, raw materials and finished goods around the country were converted into floating homes, and over the course of the next fifty years, the culture of the canals would be continually reinvigorated by those choosing to cast off from dry land.

"It's a very simple life," says Alexander Wolfe, a photographer who has been living on the Grand Union Canal—which runs for 137 miles (220 km) between London and Birmingham—for over a year. "Rather than find a flat in London, I decided to buy a narrow boat and have a bit of an adventure."

Wolfe is one of an increasing number of young boaters who are discovering the appeal of life on the water. At the London end of the Grand Union, the population has doubled in the past five years. At the height of summer, the canal, once the central trunk road of Britain's canal network, is busier than it ever was during the industrial revolution.

It is perhaps peculiarly British, the desire to eschew modern conveniences and personal space to travel, at walking pace, along a relic of the country's distant industrial past. Yet the canals offer a living connection with Britain's history that is as much for those fascinated by the customs and technology of the day as it is for those who prefer life out on the water. There is even a name for the people who have made a hobby out of watching activity on the canals without participating in it themselves: gongoozlers.

Some 2,700 miles (4,345 km) of canals, or more than half of Britain's network, are connected, allowing you to travel from Bristol in the southwest to Ripon in Yorkshire via nearly all of the major English cities. You are, however, limited by the speed of the boats—around four miles an hour (6.5 kph). To get a taste of life on the canals, and to take in the changing scenery, Wolfe recommends hiring a boat from Kate Boats, who have bases on the Grand Union in Stockton and

Warwick. Beginners are given a crash course in driving the boats and negotiating the locks; and, if you just want to try out a boat for a day, short hires are available. MK Afloat in Milton Keynes has a fleet of shorter boats that are easy to operate, and electric GoBoats can be rented for a few hours from various locations in London.

Most of those living on the canals have residential moorings, but many, like Wolfe, opt for a more itinerant life. His continuous cruising boat license requires him to travel at least twenty miles (32 km) a year, though the restlessness brought by a life spent on the move is eased somewhat by the leisurely speed of the boat. By train, the journey between London and Birmingham can be done in an hour and a half, but the two weeks by canal allow you to really take in the slowly changing landscape.

"It might not always be the most beautiful canal," Wolfe says of the Grand Union, "but it is definitely the most varied." From London it takes about a day to reach the patchwork of gently rolling hills and farmland, the quaint villages and post-industrial towns that continue until the outskirts of Birmingham. Despite the canal's industrial origins, it is a quiet, tranquil journey, and even the great engineering achievements that made the canal the wonder of its day possess a slow, stately elegance. The Cosgrove aqueduct, for example, carries the canal over the River Great Ouse via a flight of twenty-one locks at Hatton that enable a boat to climb 148 feet (45 m) up a hill (in around three hours); and the 1¾ mile (2.8 km) tunnel at Blisworth that, before boats were fitted with engines, could only be passed through by legging—lying on your back and pushing off against the underside of the bridge repeatedly.

"There is a great sense of independence on the canals, and a real community," says Wolfe. "For me, it's been a slower way to experience what England has to offer, to connect with its heritage. It can be hard work at times, but you become emotionally attached to your boat. It becomes something more than a home."

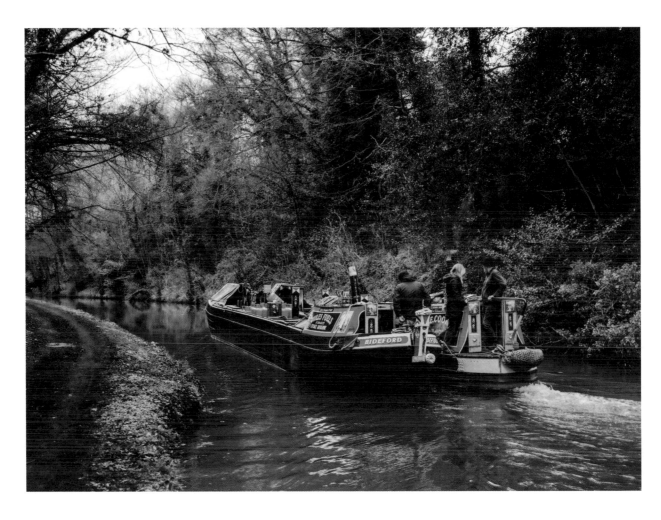

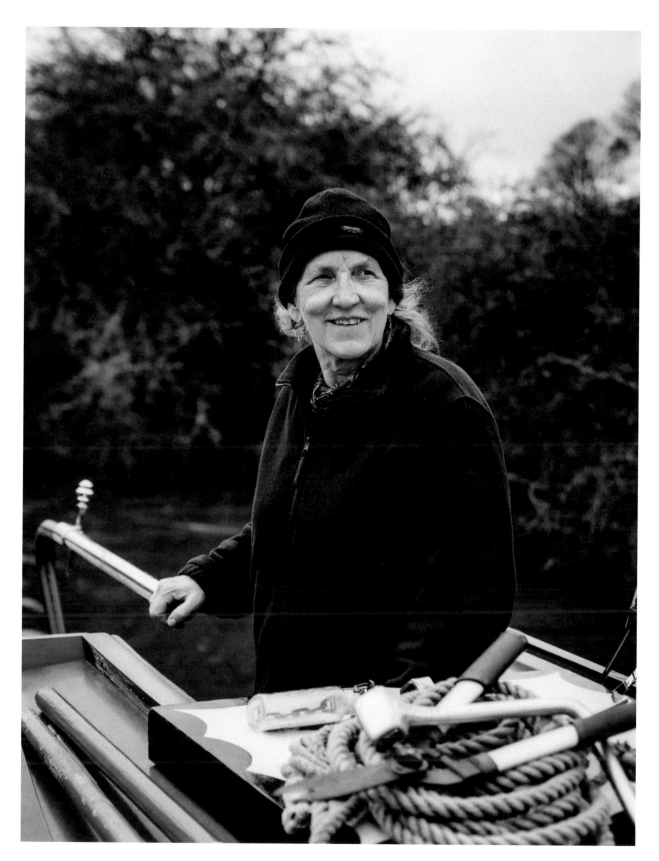

Opposite

—

Two boats make their way past the market town of Tring on the Grand Union Canal. The towpath was traditionally used by horses to pull the boats, before the introduction of motors.

Above

—

Jules Cook of Jules Fuels, which provides boaters with coal along this section of the Grand Union Canal, on her final day at work before retirement, after over fifty years on the water.

Above
—
The lace and ribbon plates above Jules Cook's stove are typical of the traditional decorations on canal boats. Despite their small size, canal boat interiors are often maximalist.

Opposite
—
Two boats near Hunton Bridge on the River Gade—one of the many rivers that are part of the Grand Union Canal—head down into Cassiobury Park.

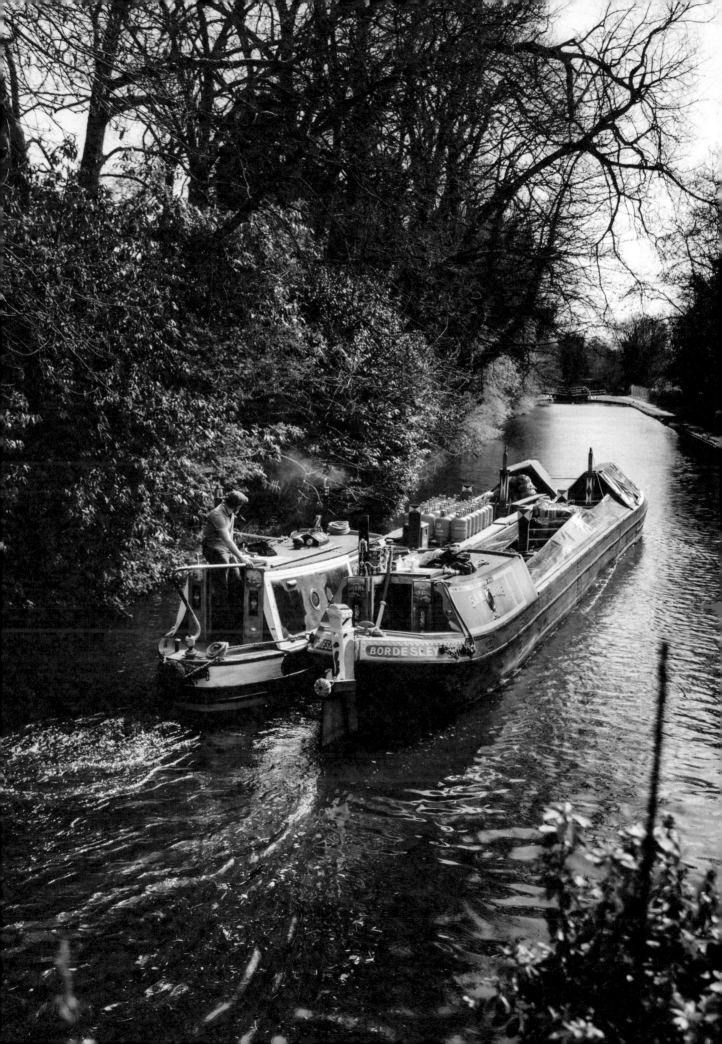

Opposite
—
Locks are used to lift and lower boats along a canal. The boat enters a section of water enclosed between two gates, and sluices are used to either fill or empty the chamber. Once the water level has changed, the gates open and the boat can continue.

Above
—
The boat pole is mainly used when things go wrong: if you've dropped something in the canal, if you're in a tight spot and need to push off, if you need to move obstructions in the water or punt to the bank if the engine fails.

Above
—

Andrew of Jules Fuels steers using the tiller at the back of the boat. When using a tiller, you steer right when you want to go left, and vice versa. An easy way of remembering it: point the tiller at the thing you don't want to hit.

Opposite
—

The Paddington Arm of the Grand Union Canal is a 13.6-mile (22 km) stretch of water that cuts through West London and connects to the main canal near Hayes. The Trellick Tower, seen here, is a 1972 Brutalist residence designed by Ernő Gold-finger.

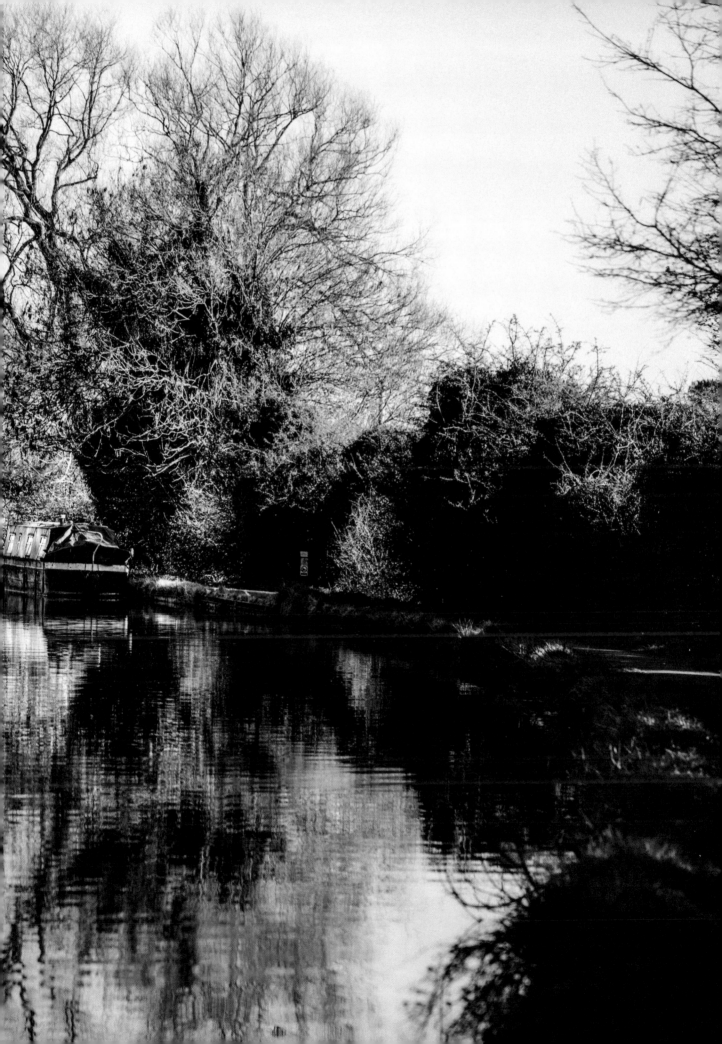

Above Right
—
Terrets (traditional horse brasses) are used as a decorative nod to the former importance of horses on the canals and usually sit atop the pigeon box—a pitched roof used for letting light and air into the cabin.

Opposite
—
Wolfe's boat makes its way through Cassiobury Park, the largest public open space in Watford. Rules about mooring your boat vary from area to area, but most are short-term and allow you to stay for between two days and two weeks.

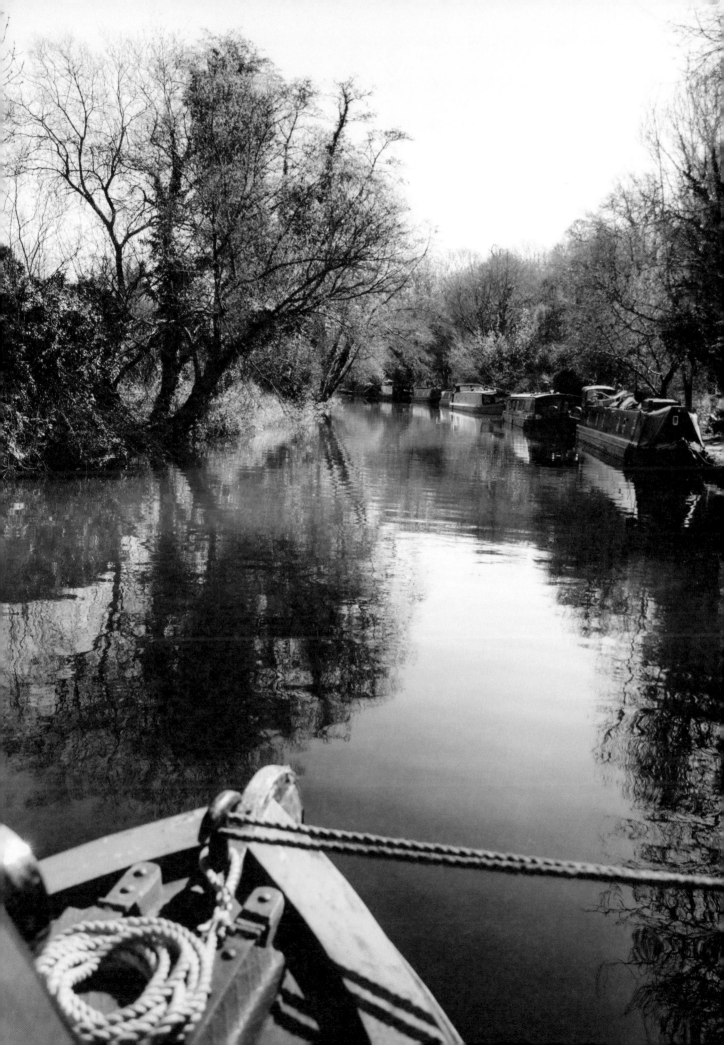

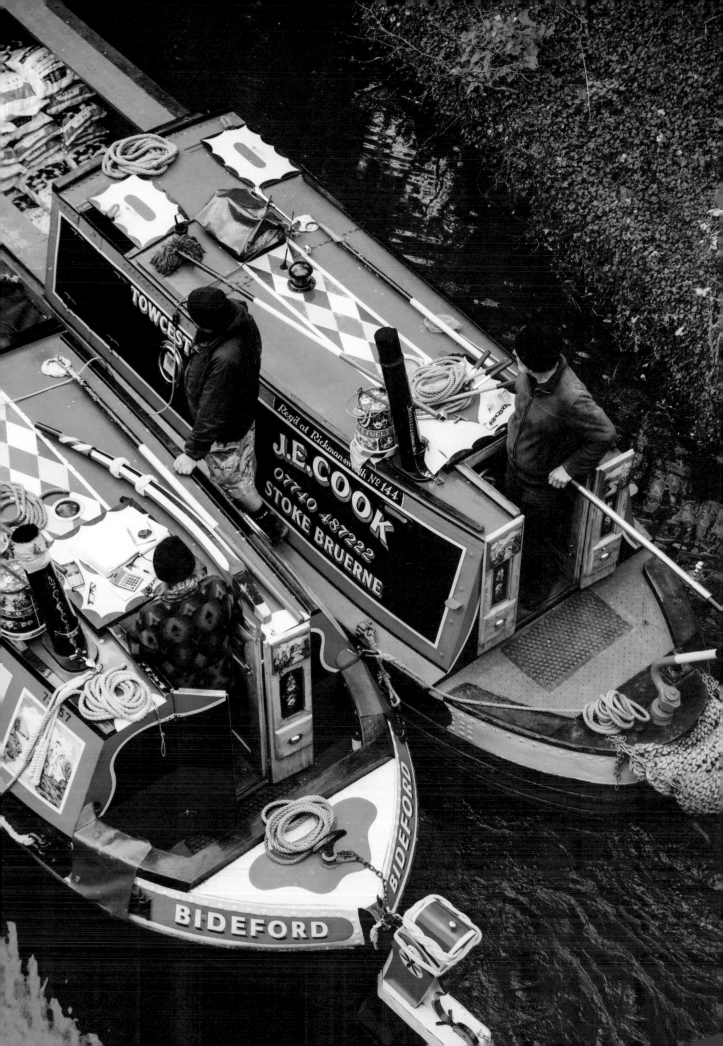

A GRAND UNION CANAL CRUISE

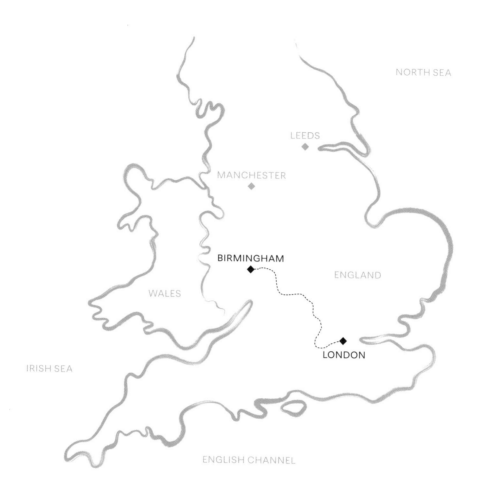

WHERE TO STAY

For those who want to spend a night on the water, most hire companies allow you to rent boats as floating hotels. There are Airbnbs everywhere, from the picturesque basin at Little Venice in London to isolated boats in the foothills of the Chilterns. As a design-led alternative to the traditional canal boat folksy aesthetic, the Boathouse London—moored at the Floating Pocket Park in West London—is a unique way to see the city.

WHERE TO EAT

Pubs, cafés and occasionally café-boats line the Grand Union Canal. Many boaters set off each day with the goal of mooring up at a pub in the evening for a pint and some grub, such as at the Cape of Good Hope in Warwick or the Three Locks in Soulbury. For refreshment on a hot day, the Milk Float in Hackney Wick, East London, offers cocktails and locally made ice cream, while just farther up the Grand Union, London Shell Co. serves a five-course set menu of British seafood as you cruise along the canal.

TIPS

Unlike British road vehicles, canal boats are steered on the right. Although every effort should be taken to avoid bumping into other boats, everyone on the canals knows that boating is a contact sport. Care should also be taken to slow down when passing boats moored on the side of the canal, to avoid disturbing those inside. It is important to remember to close the lock gates after you, both as a courtesy to other boaters and so as not to waste water.

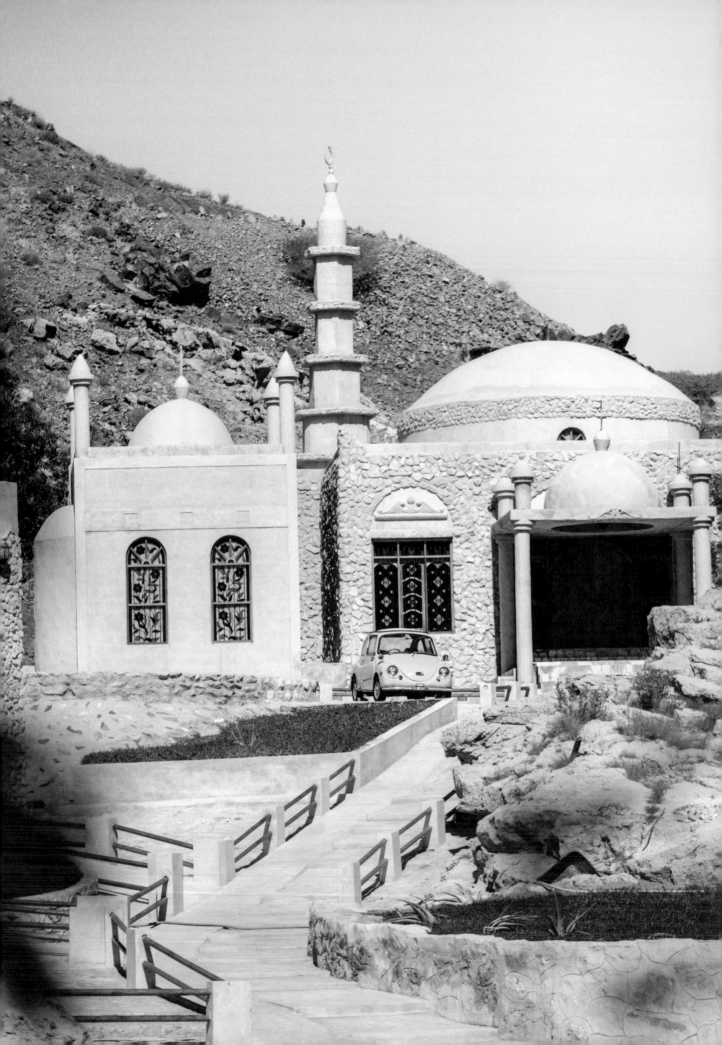

The United Arab Emirates is not what you think. Away from the glamour of Dubai and Abu Dhabi, driving between the dunes of this desert nation reveals surreal, often charming landmarks, forever doing battle with the encroaching sand.

Road Tripping to Fujairah

Travel writers and influencers parachute into the United Arab Emirates (UAE) only to regurgitate the same one-dimensional portrait of gimmicky desert safaris and air-conditioned mega malls as those who came before them. Dubai and Abu Dhabi, two of the seven emirates, are usually depicted as maraschino cherries atop an otherwise sloppy ice cream bowl—the flavors, colors and textures of the nation's five other states left undefined and unexplored.

But to drive across the UAE, and move slowly through its in-between lands, is to learn the story of a country that has been built at an unimaginable pace, shaped by hybrid cultures and abandoned dreams. Driving east from Dubai, a short road trip takes you to the state of Fujairah, where the sand resembles brown sugar and the sky is pierced by the peaks of the Hajar Mountains. Google Maps may suggest a route totaling less than an hour and a half, but this coast-to-coast pilgrimage is not to be hurried.

A good starting point for the road trip is Jebel Ali Beach, a once-desolate cove situated between the industrial zones and shipping ports of south Dubai—now home to a small caravan park overlooking the water. Here, in its eastern territories, the landscapes of the UAE melt into the warm Persian Gulf. "We have people from everywhere coming now, even people already living in the UAE," the lifeguard on duty says. A row of huge, T-shaped cement blocks rises from the water—the remnants of a development plan unrealized due to the 2008 market crash and now known as "the bridge to nowhere."

Head from Dubai toward Fujairah on the E77 highway—an artery that cuts through the middle of the country—and you'll pass Al Qudra, the "backyard" desert of Dubai known for its easy-access off-roading opportunities and fifty-four-mile (87 km) cycling track. All along the highway, small brown dunes are dotted with the national ghaf tree—some standing tall, others forever bending in the direction of the wind. The E44 exit in Lahhab takes you to Al Madam, a ghost village tangled with rumors of paranormal activity. Thought to have been built in the 1970s, it's now a strange site of sha'bi homes—small, traditional Emirati houses—being slowly eaten by the desert.

Accessing Al Madam requires a four-wheel-drive vehicle and some off-roading, or "dune bashing" as it is called in the UAE. A few residents have become unofficial tour guides through word of mouth, such as Hussain—a camel handler who's been offering rides through the desert to Al Madam for 100 dirhams ($27) since 2018. He points to which homes and buildings are worth entering. "This has nice blue walls," he says, gesturing to one. Inside, sand dunes spill through

the glassless windows and Sharpie love notes and cartoons decorate the walls.

The Off-Road History Museum, just twelve minutes north of Al Madam, offers such a kitschy experience that it's an enjoyable visit whether you're a car enthusiast or not. Outside the museum, a colossal Jeep statue greets visitors. The rest of the collection boasts more than 350 cars, including a 1987 Lamborghini LM002 SUV and the world's only 1915 Ford Model T. (Look for the models that are identified by rainbow and star-shaped labels as "rare" or "original.")

The museum offers an insight into the extent to which automobile culture has become ingrained in the UAE's way of life, which can also be seen in action with a quick pit stop in Masafi, a mountainside village twenty-five minutes from Fujairah's center. Around its open-air market, where you can find local honey, fruit, rugs and pottery, shopkeepers will either flag down cars or else attend to the summons of honking horns. On any given day, one vendor will push purple kiwis from Oman; next door, another will advocate for his juicy pomelos. A few shops down, an SUV might crack open a window to haggle over rug prices. The shopkeeper will guide them through the range of options hanging in his store, where a screen-printed image of the Versace medusa hangs next to one of Sheikh Zayed bin Sultan Al Nahyan, the UAE's founding father.

The E89 is the last stretch of road that winds from Masafi down into Fujairah. Black and gray mountains swallow the landscape, and the sun scorches everything in its reach: shaggy date palms, paintings of royal family members, a pineapple-shaped kiosk selling fruit juice. Within thirty minutes, the harsh and arid landscape of the mountains is cut by the sparkling waters of the Indian Ocean.

Roundabouts with elaborate sculptures welcome drivers to Fujairah and function as landmarks, guiding travelers up its coast along the E99. Fujairah's roundabouts, which were first constructed during British colonial rule in the 1950s, honor this emirate's marine life: there is a roundabout fish spouting water and another one with a dolphin statue. In Khorfakkan, a small Fujairah town, one roundabout features an oud incense burner that billows real smoke—a handy midpoint landmark for the emirate's coastal stretch.

In Al Aqah, a small fishing town in northern Fujairah, the Al Aqah Beach Camping caravan park offers travelers an end point and resting place. Swaths of empty nets scatter the shores nearby, and fishermen return to shore with nets nearly overflowing—a clue as to what's on the menu this evening at Estacoza, a nearby Egyptian seafood grill. Here, in the company of fish platters, giant shrimp, hummus and salata baladi, you can toast to a day well spent.

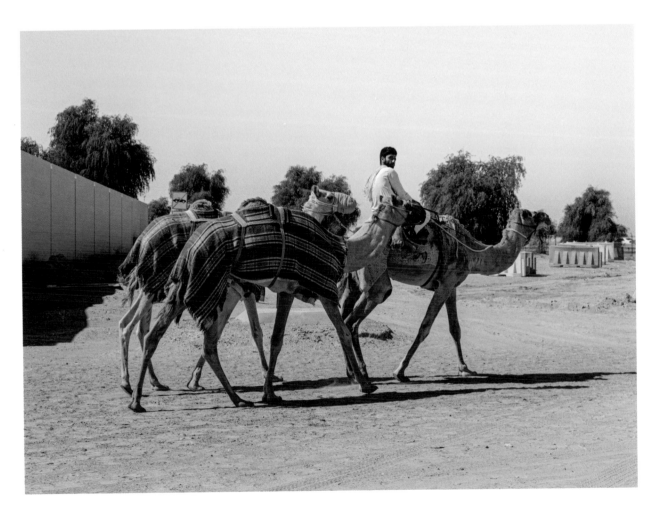

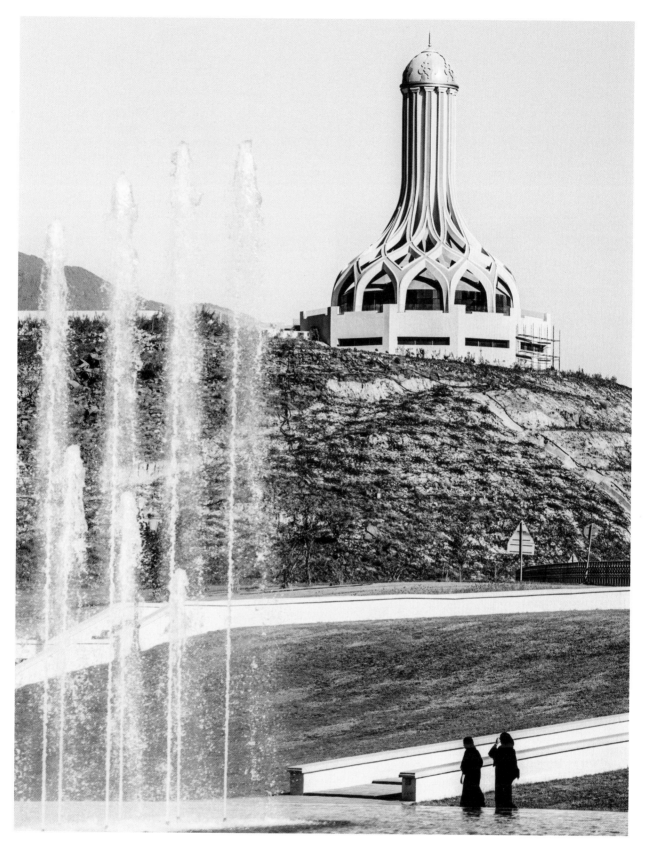

Opposite
—
A camel herder leads his flock from Al Marmoom Camel Race Track along the highway at Al Lisaili. The highway has a dedicated underground pass for safe camel crossings.

Above
—
The central square of Khor Fakkan, a town on the east coast of Sharjah, features fountains and the Resistance Monument, which honors those who resisted Portuguese invasion in 1507.

Above Left

—

There are plenty of places to stop for snacks along the route to Fujairah. In the town of Maleha, you may even find farmers selling locally grown produce out of the trunks of their cars.

Above Right and Opposite

—

Many fanciful sculptures adorn roundabouts in the city of Fujairah, mostly depicting symbols of national pride or heritage. On Corniche Road, one roundabout features a fish and another a coffeepot and cups.

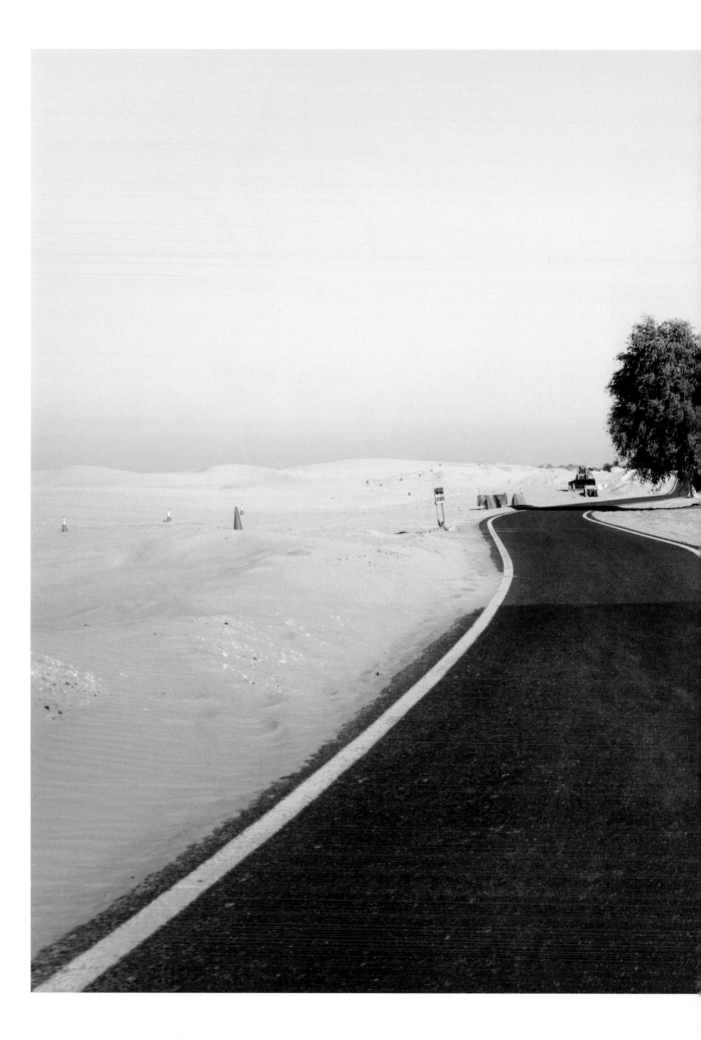

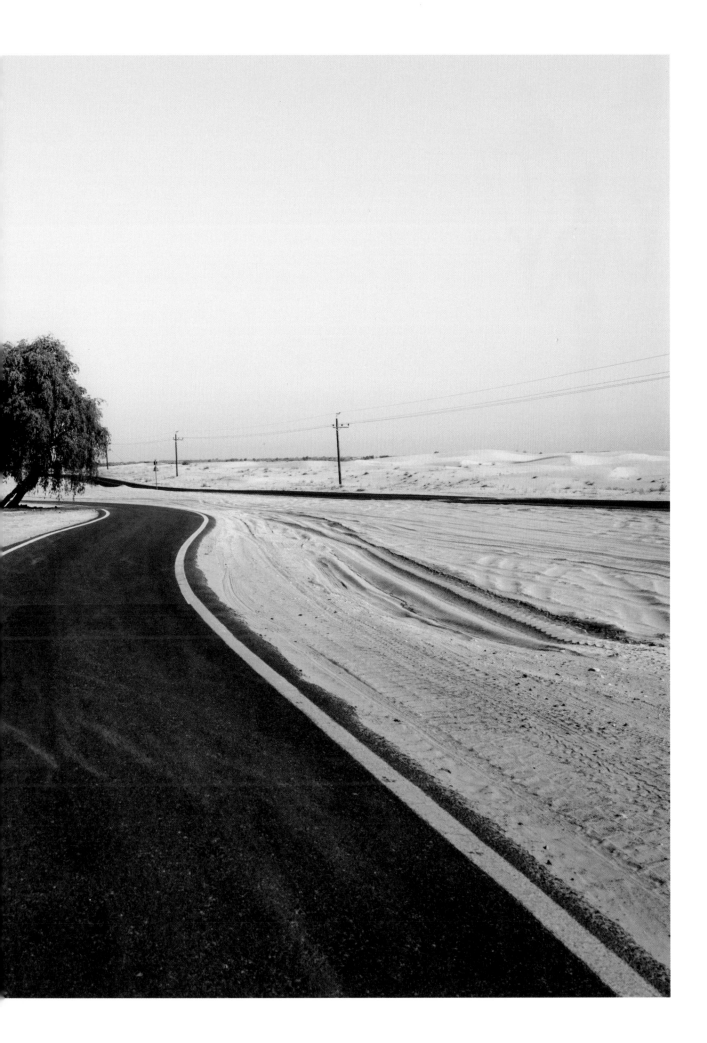

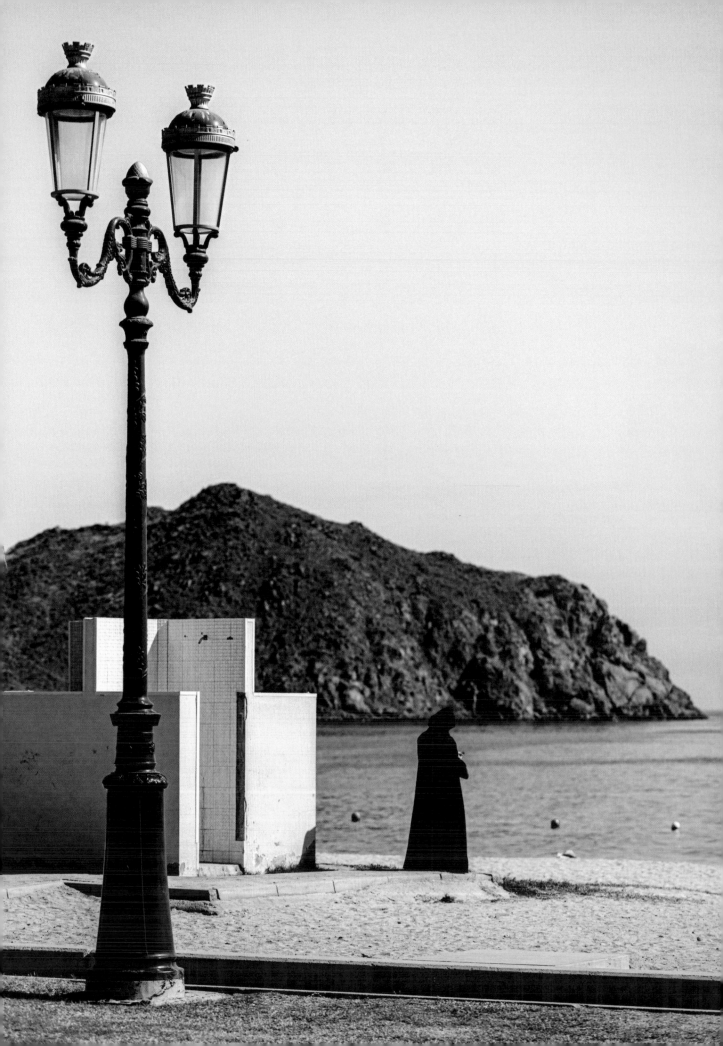

Opposite
—
The Khor Fakkan public beach
stretches along a palm-lined,
crescent-shaped shore. Its coastal
climate is generally breezy, making
it a popular day-trip spot for those
wishing to escape the heat of the
desert.

Above
—
At Jebel Ali, in Dubai, the remnants
of Palm Jebel Ali, an abandoned
urban planning project, include an
unfinished bridge—known locally
as "the bridge to nowhere."

A ROAD TRIP FROM DUBAI TO FUJAIRAH

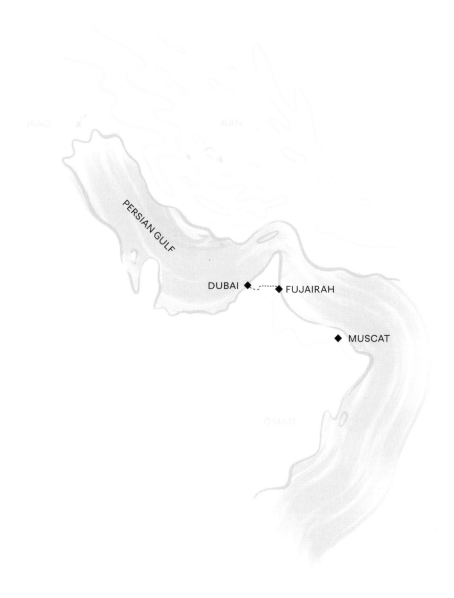

WHERE TO STAY

In Hatta, an hour from Fujairah, Damani Lodges Resort is made up of self-contained accommodations in cantilevered container cabins. Every adventure sport under the sun is on offer here, but you might be just as happy on the balcony of your cabin, tending to the built-in barbecue and admiring the mountains. Nearby, Hatta Dome Park offers glamping in geodesic domes.

WHERE TO EAT

You'll find restaurants all along the waterfront in Fujairah. The roundabouts act as helpful markers toward the best: just off the coffeepot roundabout, Sadaf serves authentic Iranian food; off the roundabout shaped like an incense burner, Asmak Al Bahar comes highly recommended for fish. In Dubai, 21 Grams is the perfect brunch spot prior to the journey.

TIPS

The UAE is built for driving. Roads are generally immaculate and well marked, and petrol is cheap. Car rentals begin at around 220 AED ($60) per day. Whether you need an international driving license or not depends on your country of origin; several are exempt. Be prepared for salik (road tolls), which will be registered electronically on your vehicle and paid via the rental agency.

The cross-country Bergensbanen train is a vital service for Norway's nature-loving city dwellers. The lucky visitors who join them on board will find a slow but spectacular way to absorb the full sweep of the country's majestic, first-class scenery.

The Train from Oslo to Bergen

Indigo in the predawn light, Oslo's sky sails by, ribbons of pink threaded through it. As the train winds its way out of the city, past telephone poles and skimming the backs of terraced houses, wires swinging overhead, its passengers are privy to the morning routines of Norwegians—sitting at kitchen tables, cleaning teeth or brewing strong black coffee. With streetlamps still aglow, the familiar sights of the inner city soon give way to suburban housing, commuters shoveling snow and cyclists breathing heat through the icy air. And then the city has gone, high-rises ironed into the ground and lakes emerging like mirrors in their wake, armies of sugar-dusted spruce circling their banks. The rising sun spreads a molten yellow glow along the horizon, bringing warmth into the carriage and firing the landscape with life.

One of the most famous trains in the world, the Oslo-Bergen railway, known as the Bergensbanen, was built between 1875 and 1909. Starting in Norway's capital in the southeast of the country, it worms its way along 308 miles (496 km) of track before finishing its journey on the western coast, six and a half hours later. The same journey could be done with a one-hour flight, but anyone who chooses that option leaves an unnecessary carbon footprint and misses out on seeing Norway in all of its natural glory. Running year-round, the train attracts curious passengers during both summer and winter; it's a matter of personal taste as to whether you're looking to see sun-kissed meadows dense with purple lupines or ice-covered fjords and wild blizzards. However, in winter, passengers will experience a disarming sense of wonder and powerlessness as the landscape surrenders to the elements. The ride also provides unique insight into the tenacity and ingenuity of Norwegian engineering; the line includes 180 tunnels that appear from the snowy blank canvas like gaping mouths waiting to swallow the train whole.

The route follows the Drammenselva river (a popular spot for salmon fishing) upstream, curving along Tyrifjorden and on toward the pretty little town of Hønefoss. From here, buildings begin to thin out, and miles of untouched landscapes gallop between each village. Look closely from the window and you may spot traditional red mountain cabins in the distance. In deep midwinter, cabins are submerged in snow until barely visible, only a single spiral of smoke from the chimney betraying their hiding places.

Although the train is a rail fan's dream, it also provides a normal mode of transport for Norwegians heading into the outback to hike, fish or ski, and you'll see plenty of equipment stacked up in the luggage holds by those disembarking at

Geilo and Voss. For the same reason, it's worth reserving a seat early. There are four daytime departures and one overnight service, and if booked up to ninety days in advance, the tickets can be as cheap as 249 Norwegian krone ($29) for a single journey. However, it's worth paying the extra 100 krone ($12) or so for a "plus" seat that offers more legroom, outlets and complimentary hot chocolate.

At the mountain village station of Finse, bundle up and hop down onto the platform just to feel the wind burn your cheeks and whistle past your ears. It's the highest station on the line, and on wilder days, the ground and sky merge into one blizzardy expanse with little more than the occasional snow jacket visible, providing you peer hard enough. Still, it's not enough to deter local people and their young children who pass by the train on cross-country skis, unfazed by the drifts and freezing temperatures.

As clouds shift down the mountains, obscuring their craggy sides, it could be the right moment to open up a Jo Nesbø novel and pass an hour or so, but don't get too lost between the pages. Before long, the terrain shrinks to nothing more than a sliver of land stretching across a sheet of water, the train seemingly gliding across its surface. And as the route crosses Hardangervidda—the largest plateau in Europe—you might spot wild reindeer.

On the approach to Bergen, passengers will see a series of houses with perfectly pitched roofs dotted along the hillside. But don't be fooled. There's nothing twee about Bergen: it's a belter of a waterside city, with a rich heritage, museums and Michelin-starred dining. Disembarking from the train, you might feel as though you've completed a cross-country marathon, and in the best possible way, you probably have.

Opposite
—
The Bergensbanen train stops at Finse (the highest station on the line), where there's usually enough time to disembark and enjoy the views of Store Finsenut mountain.

Above
—
From Bergen station, there are four daily departures toward Oslo. Anyone taking the journey for purely practical purposes can opt for an overnight train.

Opposite
—
There are many places to stop off en route and enjoy outdoor pursuits. In winter, many locals cross-country ski over the frozen lake Finsevatnet at Finse station.

Above
—
Between the stations of Geilo and Voss, the route passes through Hardangervidda—northern Europe's largest mountain plateau—and Hallingskarvet National Park.

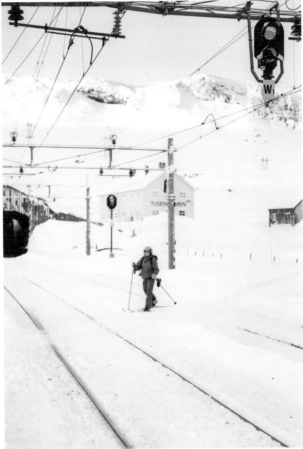

Above Left

—

Despite its beauty, the Bergens-
banen line is first and foremost a
convenient public transport route
for locals. Pets, like Kipo the dog, are
welcome on board (but may require a
ticket, depending on their size).

Opposite

—

There are many mountain cabins
and summer homes available to rent
along the route. Traditionally, rural
buildings in Norway were painted
red—the cheapest paint color.

A CROSS-COUNTRY TRAIN RIDE

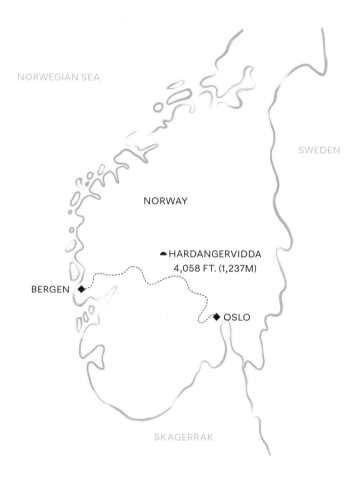

WHERE TO STAY

Located in an old stock exchange from the mid-nineteenth century, Bergen Børs Hotel is an ideal base from which to explore Bergen. With elegant rooms, underfloor heating and suites overlooking the harbor, the hotel exudes a warm welcome to passengers fresh off the train. It's also home to Bare restaurant, a beautiful, mirrored space with a Michelin-starred tasting menu featuring king crab, langoustines and locally foraged ingredients.

WHERE TO EAT

Skaal Matbar is one of Oslo's trendiest food bars. Operating with a no-reservations policy, it often has queues of customers waiting for bite-size salted cod in choux pastry and freshly shucked oysters with Amalfi lemons. In Bergen, seek out Restaurant 1877. In spring, diners can expect asparagus, tomatoes and radishes, and in autumn, you'll find duck, as well as lamb, beets and berries.

TIPS

Seat reservation is compulsory on all long-distance services in Norway, and you can book your ticket ninety days in advance. You might want to relax with a cold beer or a glass of wine once on board, but it's forbidden to bring your own. Alcoholic drinks are available, but they must be consumed in the dining car only.

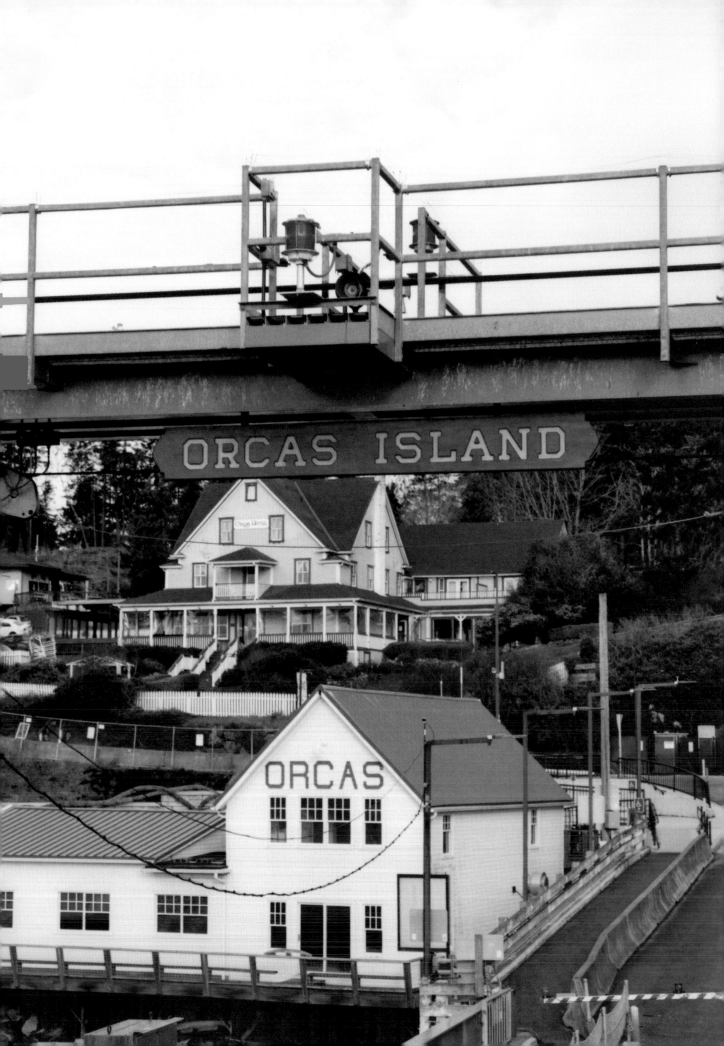

Orcas Island, off the coast of Washington State, radiates a quiet charisma that could pass unnoticed if you didn't adjust your pace accordingly. Arrive via ferry and you'll disembark feeling calm, curious and ready to embrace the slow drift into island time.

The Ferry to Orcas Island

Traveling to Orcas Island in the Pacific Northwest may feel like a journey to the end of the earth. It requires at least two of the following: boat, airplane, train, automobile. Depending on your point of origin, you may take all of these in one day.

For a first visit, the ferry may be the least timely means of transport, but it makes for the most memorable. The ninety-minute route begins in Anacortes, Washington, a coastal town situated halfway between Seattle and Vancouver, BC. The car-loading ferry sails west through the Salish Sea—an intricate network of straits and waterways carved by massive glaciers over ten thousand years ago—to the San Juan Islands, where Orcas is located. For the best view, exit your car and head up to the bow. Wind, sea, rock and towering trees conspire to rouse awe. With your back to the mainland, face turned toward the sun, the wind tugs at your hair and everything else falls away.

The name Salish Sea pays tribute to the region's first inhabitants, the Coast Salish tribes, including the Lhaq'temish (Lummi) or "People of the Sea," who have fished its shores since time immemorial and still do so today. The Salish Sea is home to three resident endangered orca pods, as well as the North Pacific giant octopus (the world's largest) and three thousand species of marine invertebrates.

Orca sightings are to be expected on the ferry, but sightings of land mammals in the water also occur. Spotting a family of deer swimming between islands is possible and, a few years back, a black bear swam to Orcas and stayed a couple of weeks, the only predator on the island. In 2017, a folk song was written about Frieda, a pig that escaped a farm truck and fell overboard, only to be found hours later running down a country lane on Orcas.

The San Juan Islands archipelago comprises over four hundred islands, only twenty of which are inhabited, some with as few as two residents, and only four receiving ferry service. The first glimpse of island life can be found on board, where locals may stir your curiosity: a nun from one of the country's last Benedictine monasteries on Shaw Island; the Ladies Hunting Club; the monthly Floating Ukulele Jam—a collective of strumming musicians from four islands who meet on board.

Once you step foot on Orcas, so much raw beauty is visible that it's easy to understand why the Lummi have no word for nature: they don't see themselves as separate from it. You may learn to see yourself this way too. Challenge yourself to summit Mount Constitution, the highest point in the San Juans, for a stunning panoramic view of the archipelago,

Mount Baker and Vancouver Island. Alternatively, take a more leisurely hike to Cascade waterfall, paddleboard to the islet in the middle of Mountain Lake to nap under cedars or rent a kayak at Cascade Lake and search for the hidden footbridge.

In summer, wild blackberries abound. In fall, forage the forest for chanterelles and rare matsutakes, or visit the handful of unattended farm stands to buy kale, beets and peonies. For lunch, pack a picnic of sandwiches from Roses or Voyager, two cafés in the town of Eastsound, and lie in the shadow of a restored homestead house, now a chapel, in nearby Sara's Garden. After, shop the unstaffed Thrift Cabin on Enchanted Forest Road, where you can peruse vintage threads, write down what you take and leave money for what you think it's worth. Or, in the tiny hamlet of Olga, sit at a picnic table at Buck Bay Shellfish Farm and watch your meal of Dungeness crab get plucked from the bay and the shell remnants later returned to the sea.

If you stay overnight, enjoy a sundowner at the Barnacle. Once a boat shed, the structure is now a tavern adorned with reclaimed windows and live-edge wood tables, all milled from the same walnut tree. The street it sits on, Prune Alley, was originally an orchard of Italian plum trees planted in 1870. Today, the proprietors harvest fruit from two of the original trees to make syrups for drinks.

If you have an important flight to catch on your journey home, it's wise to reserve ferry tickets and plan to return to the mainland the day before. Delays and cancellations are not uncommon, though you may welcome a reason to linger.

Sara Farish, innkeeper at the century-old Outlook Inn, has roots three-generations deep on Orcas. Farish, who is Japanese American, suggests the idiom *ichi-go ichi-e* to describe one's first experience getting to and staying on the island. As she translates it: "Every moment is a convergence of unique elements, making it unrepeatable. Therefore, every encounter should be treasured and met with one's full, attuned senses."

The ferry's steady pulse will ease your return to the mainland, your senses now fully awakened, reminding you to take a moment to slow down and savor the quiet beauty that is life—on Orcas Island or elsewhere.

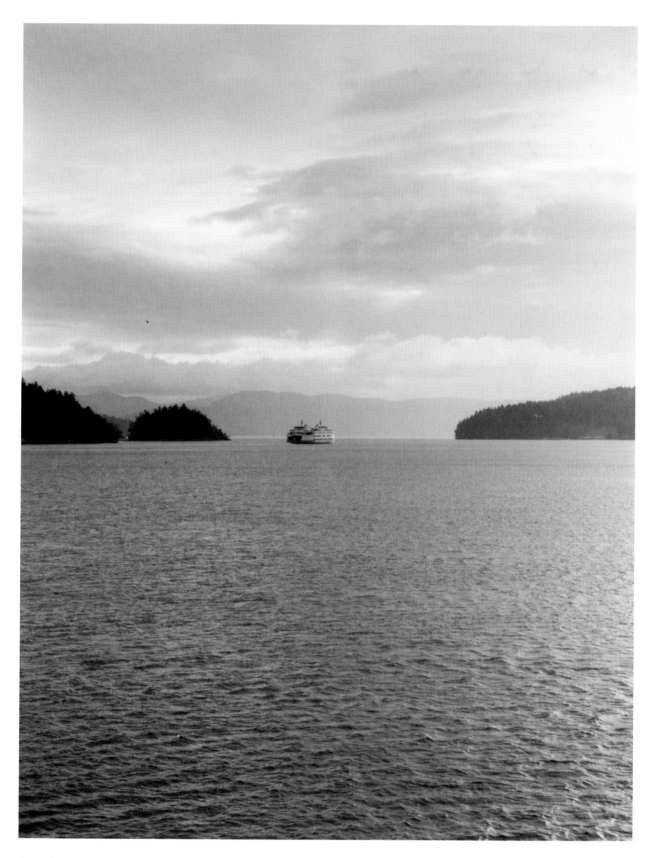

Opposite
—
Although orcas can often be spotted
during the ferry to journey to Orcas
Island, its name was given by Span-
ish explorers to honor a Mexican
viceroy—a man with thirteen names,
one of which was Orcasitees.

Above
—
The ferries that carry passengers
around the San Juan Islands are
named after the Indigenous commu-
nities that lived along the shores of
the Salish Sea: Cathlamet, Samish
and Suquamish.

Above Left
—
The ferry offers both indoor seating and an open-air deck. You can pick up local beers and wines from Washington in the galley cafeteria to enjoy over the course of the ninety-minute journey.

Opposite
—
A challenging 5.7-mile (9.2 km) round trip from Turtleback Mountain Preserve's North Trail trailhead will lead you to Turtlehead Summit, which affords glorious views over countless islands that extend to British Columbia.

Above
—
Lum Farm, located on the historic
Coffelt Farm Preserve, practices
sustainable grazing practices. A
farm stand sells meats, cheese and
eggs, seasonal fruits and vegetables,
plus sheepskins and wool products.

Opposite
—
Many other farms around the island
have stands that operate with an
honor system, trusting guests to let
themselves in, take what they need
and leave payment.

THE FERRY TO ORCAS ISLAND

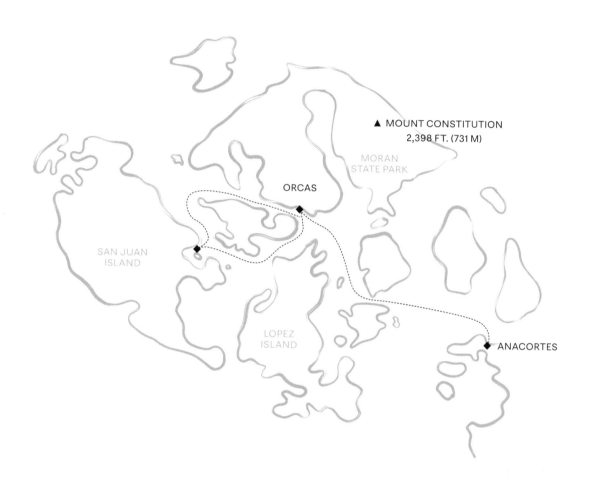

WHERE TO STAY

Modernists might gravitate to the simply designed Water's Edge Suites, where one falls asleep to the sound of waves gently lapping beneath the balcony. Yurts are available to rent where the forest meets sea cove at Doe Bay Resort. Or, if you're seeking rustic charm and like to cook, time at Beach Haven Resort's log cabins will be well spent.

WHERE TO EAT

The perfect itinerary for any gourmand: brunch at Roses Bakery Cafe in Eastsound or Catkin Cafe in Olga; tide-to-table lunch of raw oysters and wine at Buck Bay Shellfish Farm; then dinner under the stars by an award-winning young chef at Ælder/Hogstone, whose culinary creations are deeply rooted in the local setting.

TIPS

Don't worry if ferry reservations are unavailable. Spots are released in phases: two months before the season starts, then two weeks before and again two days before sailing dates. For a bird's-eye view of Orcas Island, a journey by seaplane departs from Seattle and lands in the marina at Rosario Resort. There are no ride-share services, but you can rent a car on the island or take a local taxi.

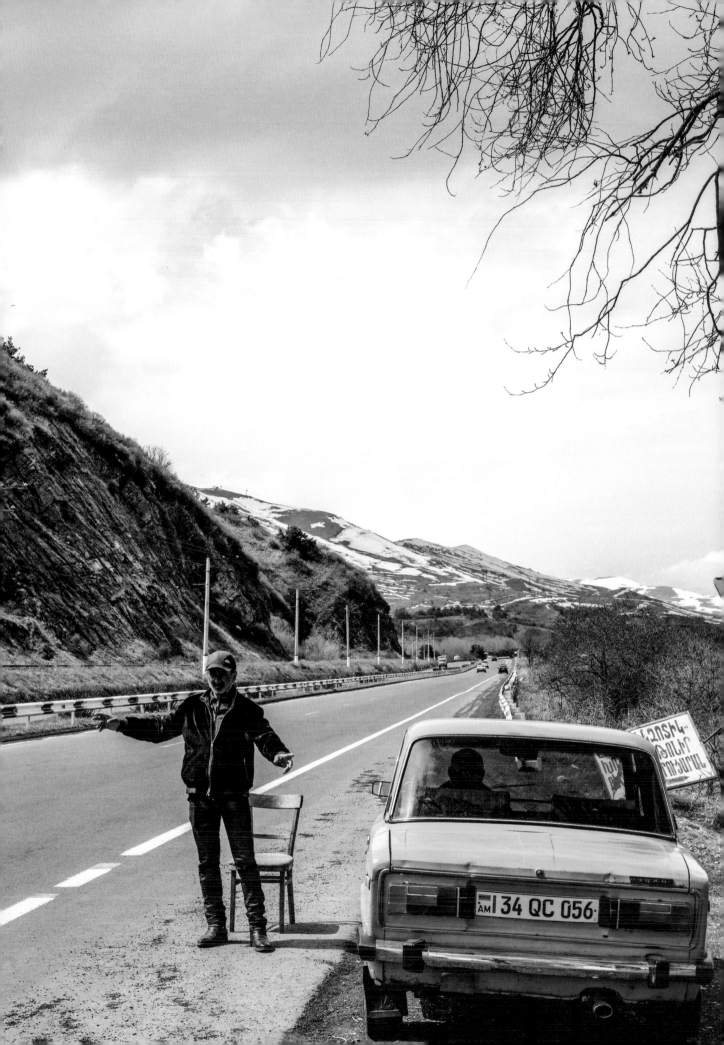

Tiny, landlocked Armenia has always relied on its road network. To drive out of the capital Yerevan is to explore an open-air museum—one populated with historic monasteries, Soviet monoliths and endless rolling countryside.

Armenia's Drive-Through History

The Armenian diaspora numbers some eleven million people. This makes Armenia feel like a far bigger country globally than it is locally: less than three million people live in this mountainous, landlocked state in the southern Caucuses, and its total landmass roughly equates to the size of Belgium. Because of its compact size, and because roads are Armenia's transport arteries, there is no better way to get a feel for it than with a road trip.

Of course, you'd be amiss not to stretch your legs ahead of the journey with a walk around the capital. Yerevan was founded in 782 BCE and is one of the world's oldest continuously inhabited cities. Its nickname is "the pink city"—so called for the color of the stone once used in its buildings—but this belies its most dominant architectural spectacles. Armenia was part of the USSR until 1991, and many of the massive concrete buildings that line its wide streets, like the opera theater, are a legacy of the country's Soviet history.

Vernissage, a large open-air flea market close to Republic Square, is a good place to pick up crafts and carpets. Hidden nearby, Mirzoyan Library hosts a café and photography archive—the largest in the Caucasus—in a beautiful historic building with wooden balconies. For somewhere to eat, Sherep and Tsirani are excellent restaurants that serve traditional Armenian food such as stuffed grape leaves, sorrel soup or khorovadz (roasted lamb). When the sky is clear, the snowcapped Mount Ararat—the country's national symbol (despite no longer being in present-day Armenia)—can be spotted in the background from almost everywhere in the city. To get the best view, climb the 572 steps to the top of the striking Cascade steps at sunrise or sunset.

Armenia is an open-air museum, and its ancient, complex history is best explored by escaping the capital and driving through its rugged hinterlands. The town of Dilijan, set amid the cool hills and forests of the Dilijan National Park, was once a peaceful retreat for bohemians during the Soviet era. Today it offers a window into Armenia's rural charm and traditional architecture. The easiest way to get there is by renting a car in Yerevan. The trip lasts about an hour and a half, but it's worth taking a little longer and stopping along the way to explore the dramatic landscapes.

Leaving through the northeast of Yerevan, the houses soon start to blend into pinkish hills, and farm animals become more frequent companions on the road. As soon as you start to spot Ladas—a blocky Russian car brand still very popular in post-Soviet nations—with piles of fruits and juice on the hood, or people waving their hands at the side of the road, you are in

Gegharkunik Province, approaching the northern tip of Lake Sevan. The waving is to flag you down and show you the fish they are selling (which, while certainly fresh and tasty, are usually smaller than promised). At the side of the road, you can try some of their fried fish in lavash—a traditional flatbread.

The infinite blue of Lake Sevan, considered the "jewel of Armenia," will soon appear on the horizon. There are a few medieval monasteries perched on hills at the edge of this vast expanse of water. One of them is Sevanavank, a monastic complex comprising two small churches on a peninsula at the northwest shore, from where you can enjoy a breathtaking view over the lake. Back on the road and heading in the direction of Dilijan, you'll enter Tavush Province. The roads get rougher, the weather warmer and the landscapes greener. The fish sellers make way for grilled-corn stands.

Dilijan is a town nestled in verdant mountains; the surrounding region is often called "the Switzerland of Armenia." The town has retained more of the classic Armenian architecture—wooden balconies, steeply pitched roofs—than the capital, although the Soviet influence is still tangible, especially at bus stops. The Tufenkian Hotel, a complex where

nineteenth-century architecture was re-created, exemplifies the traditional style and is a good place for lunch or dinner. Dilijan is also famous for its mineral water, which you might have already spotted sold in supermarkets in Yerevan. Many locals come here to relax at one of the spas.

There is plenty to do in the surrounding area. For hikers, the Transcaucasian Trail, Dilijan National Park and Lake Parz should be added to the itinerary (try Kchuch, a good restaurant for wood-oven-cooked meals on its shores). Nearby, the Haghartsin Monastery, perched in a green oasis and almost touching the clouds, is also worth the detour. If you'd like to stay and explore, checking into one of the local guesthouses is the best option. Toon Armeni Guest House in Dilijan offers rustic charm and good food.

A road trip from Yerevan to Dilijan offers a snapshot of Armenia: a mix of beautiful landscapes, traditional and Soviet architecture and urban and rural ways of life—a real sense of Armenian culture today. The local population is famously hospitable and always ready to help. So, if in the unfortunate event that you get lost, you can rest assured that it won't be long until a friendly face appears offering assistance.

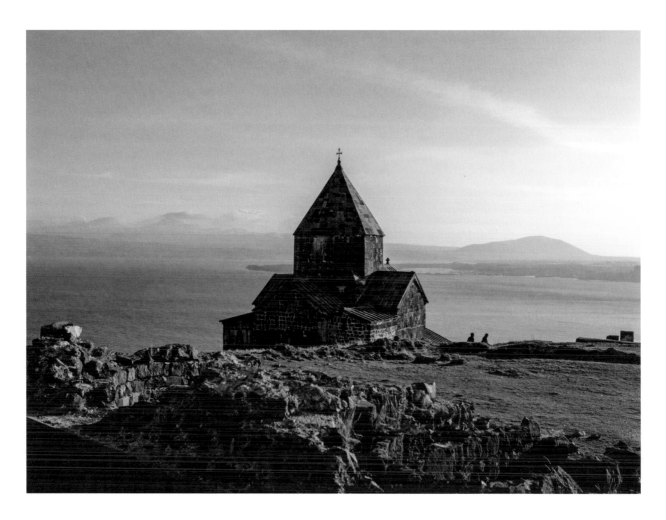

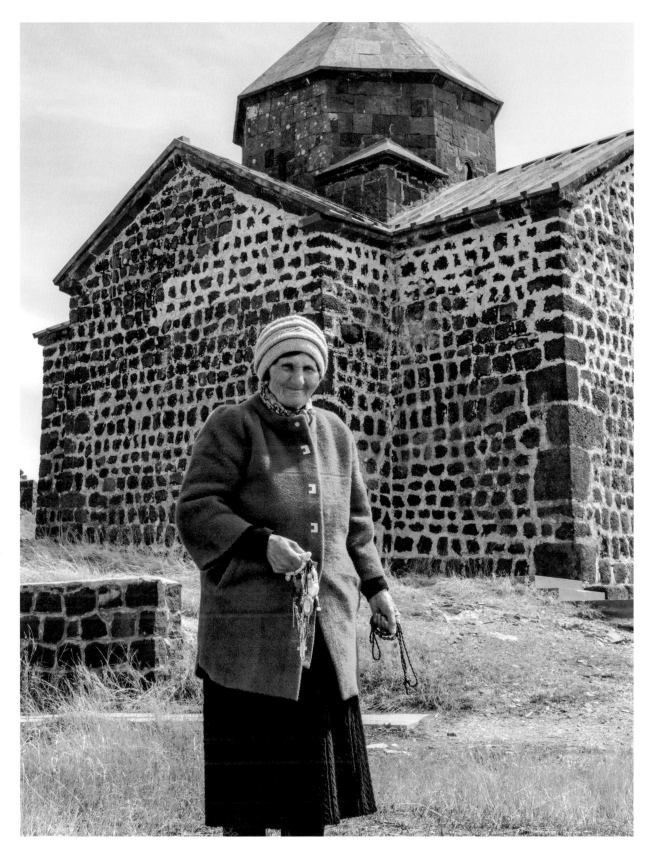

Opposite
—
Many scholars believe Armenia to be the first Christian nation, and the landscape is spotted with monasteries from the medieval period. The Surp Arakelots church of the Sevanavank Monastery overlooks Lake Sevan from the north.

Above
—
A woman sells rosary beads and crucifixes outside the Sevanavank Monastery. About 97 percent of Armenians follow the Armenian Apostolic Church, a denomination of Oriental Orthodoxy.

Above
—

Remnants from Armenia's Soviet
past can be seen en route, such as a
memorial for the fiftieth anniversary
of Soviet Armenia in Dilijan (left) and
the Writers' Resort on Lake Sevan
(right), which was built in the early
1930s by the Writers' Union of the
Armenian Soviet Socialist Republic.

Opposite
—

Dilijan features an open-air amphi-
theater replete with classical
statues. Situated in the center of
town, the amphitheater is actually
one of the newest sites in town.

A DRIVE THROUGH THE HEARTLAND

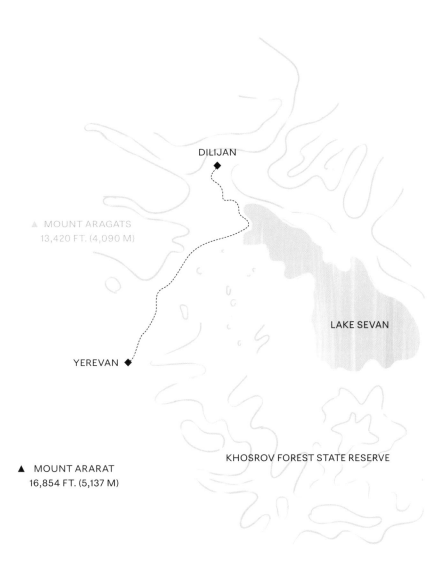

DILIJAN

▲ MOUNT ARAGATS
13,420 FT. (4,090 M)

LAKE SEVAN

YEREVAN ◆

KHOSROV FOREST STATE RESERVE

▲ MOUNT ARARAT
16,854 FT. (5,137 M)

WHERE TO STAY

You won't struggle to find a clean, affordable room in Yerevan, but the atmosphere can often feel a bit sterile. The beautiful, centrally located Villa Delenda is an exception—despite its small size, it has charming communal spaces including a library. In Dilijan, the Toon Armeni Guest House is a simple but welcoming end point, with shared balconies and bucolic gardens. If you're day-tripping, this is another good lunch option.

WHERE TO EAT

In Yerevan, the sister restaurants Sherep and Lavash serve colorful, contemporary Armenian dishes whose nuances will be explained to you by friendly waiters. In Dilijan, Kchuch Restaurant does something similar, but with a simplicity befitting its rural location. Try to get a seat in the garden. At roadside stops along the way you can pick up dried fruit, flatbreads and—if you're feeling adventurous—homemade wine sold in soda bottles.

TIPS

Larger roads in Armenia are generally well maintained, but anything off the beaten track is likely to be extremely uneven. Opt for a car with some ground clearance. There are several rental providers in Yerevan, but note that drivers from certain countries— including the US—must have an international driving license. If you'd like a more companionable journey, take a marshrutka from Yerevan's Northern Bus Station.

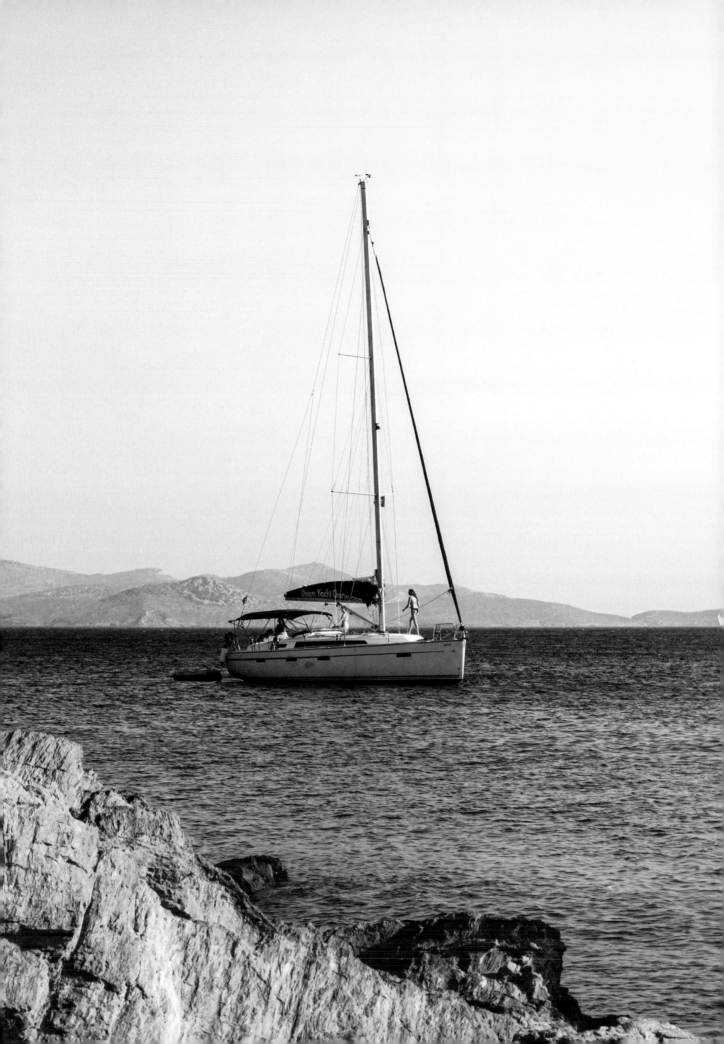

The Dodecanese may not be the most storied Greek islands to sail around, but what they lack in stature they more than make up for with local charm and the freedom to visit villages, eat in small tavernas and overnight in hidden coves all at your own pace.

Sailing Around the Greek Isles

Most people have heard tell of the beauty of at least one Greek island. There's Rhodes, famed for its old city and medieval walls; Kos, home to renowned archaeological sites; and Patmos, "the Jerusalem of the Aegean," where John the Apostle wrote part of the New Testament. But there's a lot more on offer in the Dodecanese—the dozen islands that comprise this rugged archipelago on Greece's south-eastern flank.

Part of the ancient Greek world and ruled successively by the Venetians, the Ottomans and the Italians, the Dodecanese islands are strewn with imposing Byzantine and medieval monuments and traditional settlements that testify to this region's rich history. The chain also comprises four small, inhabited islands and a scattering of uninhabited islets that can only be discovered by boat.

"All of the islands have their own unique charm. A sailing holiday allows travelers to really get off the beaten track," explains Captain Dayyan Armstrong, founder of the Sailing Collective.

Armstrong, who learned to sail in the Gulf of Maine aboard a twenty-four-foot (7 m) sloop when he was a boy, launched his bespoke vacation business back in 2011, offering charters around some of the world's most beautiful islands—including the Dodecanese. "We organize our own itinerary and change it when we want to. If we see a beautiful deserted beach or find somewhere we like, we stay there. It's all about slow travel—as the Greeks say, *siga siga* [slowly slowly], and connecting with the environment," he says.

In the Dodecanese, Captain Armstrong's itinerary includes the island of Kalymnos, renowned for its sea sponge divers, and Nisos, a near-deserted island with only one tavern. "Bigger islands like Kos offer a watered-down experience of the local culture, but on islands like these you get a real flavor of local life," says Armstrong. "We might meet herds of wild goats or discover two-thousand-year-old ancient ruins or eat at a beachside tavern with only the locals sharing their stories over a beer."

His routes vary according to prevailing winds and guests' preferences. Some trips take in Kalymnos, anchoring for the night in coves isolated by sheer cliffs. "Imagine just sailing into a deserted cove with waters so clear you can see the fish swimming beneath the hull of the boat," Armstrong says.

Food is also an important part of any Dodecanese experience. "It's an immediate way to connect with the culture.

"We have talented chefs who try to incorporate the local produce at each place we go, so that we come closer to the culture we're in via the food," Armstrong explains. "In some places, we'll see a grandma who speaks English, and we'll arrange for her to cook us dinner in her backyard, so it's a great way to give back to the community too."

Other ports of call include Lipsi, a rocky cluster south of Samos island where legend has it that the beautiful nymph Calypso kept Odysseus, one of the world's greatest mariners, captive. "History is really important on a Dodecanese sailing itinerary," says Armstrong. "On the highest point of each island, there are Byzantine castles and mighty military fortresses; this is a crossroads of civilizations. Some towns are elevated, some are on the coastline; there's a real mix of architectural styles and often, when sailing, we can see the Turkish coastline too."

One of the highlights is Leros, with its dramatic landscapes and striking capital, Lakki, which was designed as a rationalist model town by Mussolini's architects Rodolfo Petracco and Armando Bernabiti during the Italian occupation of the Dodecanese. "There's a beautiful hidden cove there called Pantelis where we anchor, sheltered from the northerly meltemi winds," says Armstrong.

For visitors, sailing is a great way to discover Greece through a new lens. "Lots of people are well traveled, but they want to see the world in a different way," says Armstrong. "When they climb aboard one of our boats, they find a sense of freedom and of belonging. One of the greatest joys of doing this job is seeing the wild-eyed excitement when we sail to a remote cove or a spot of rare wildlife. It's the thrill of just never knowing what you'll see from one place to the next."

"If we see a beautiful deserted beach or find somewhere we like, we stay there."

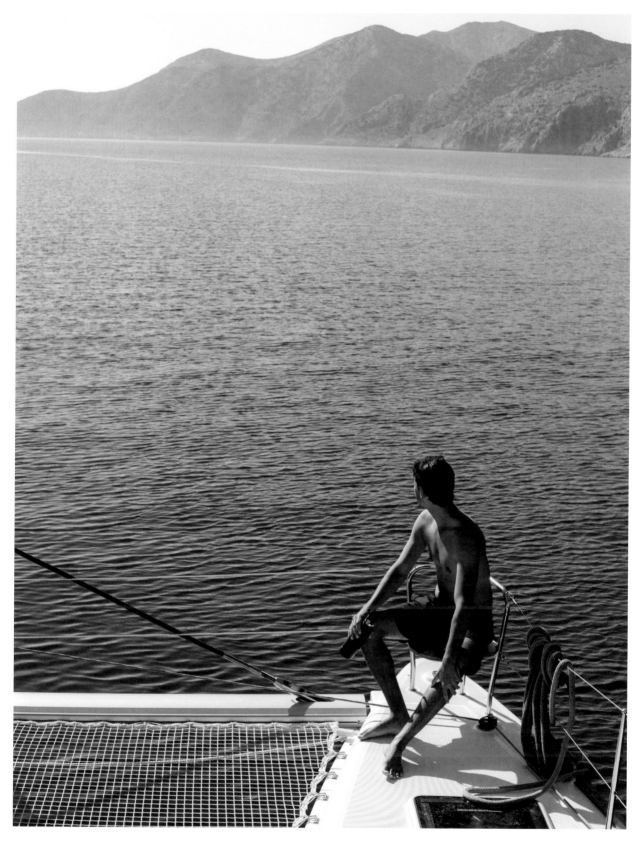

Opposite
—
The picturesque village of Skala on Patmos has a small harbor and good lunch options. There is no airport on the island, which has protected it from the large influx of tourists experienced by other Greek islands.

Above
—
Sailing Collective takes trips around the Dodecanese islands between July and October, offering individual cabins as part of a group voyage as well as the opportunity to charter a private yacht and crew.

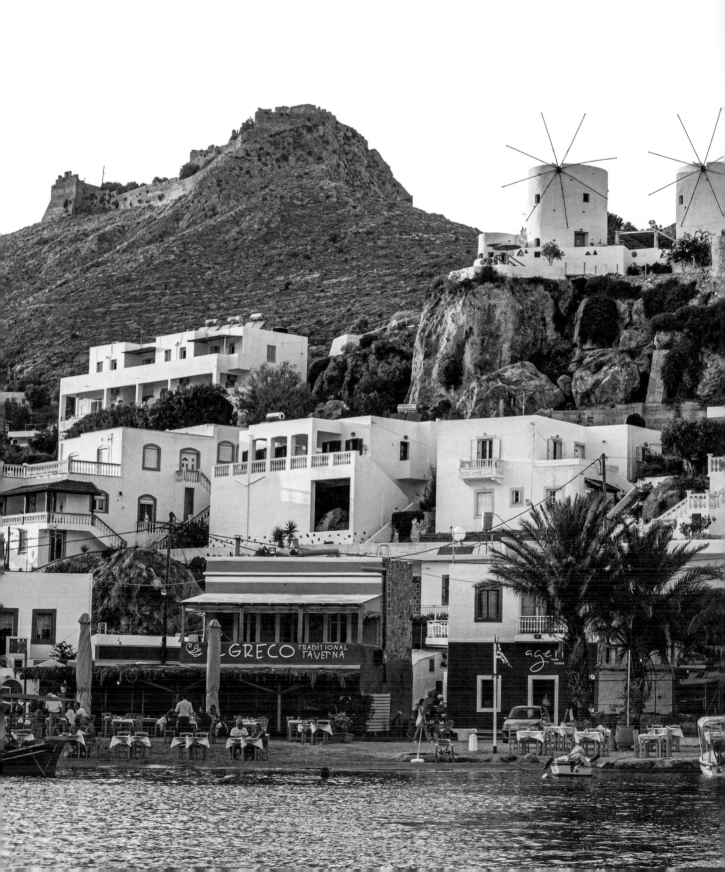

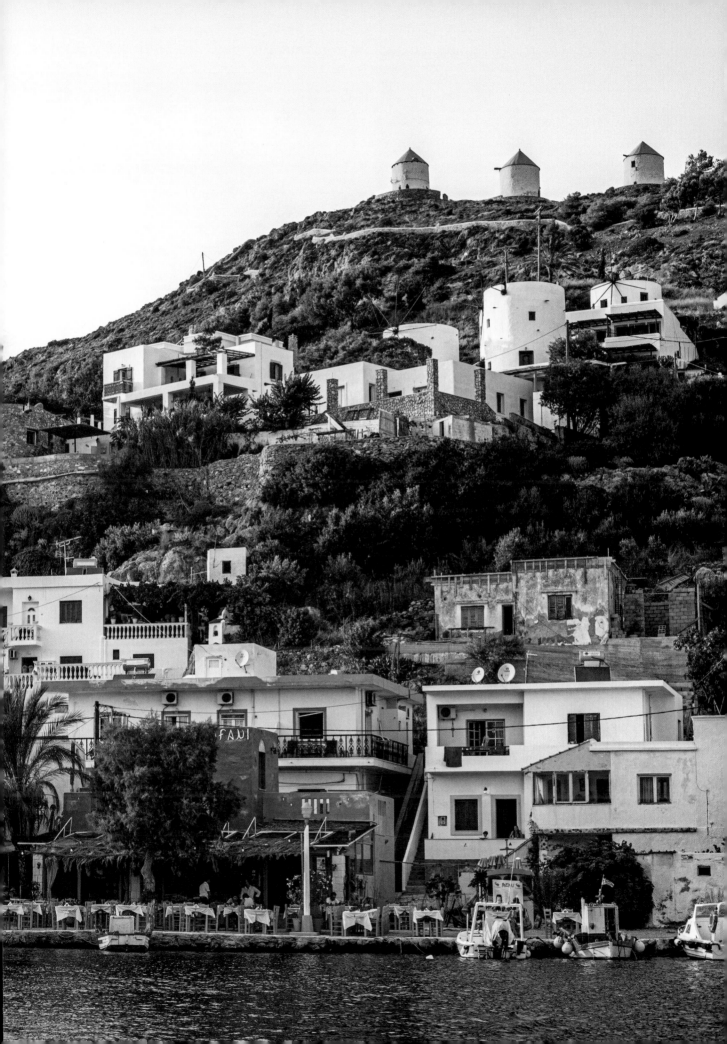

Above Left

—

On Leros, there are fishing harbors at
the busy little villages of Agia Marina
and Panteli. Most tavernas offer
tables at the water's edge, where
wooden fishing boats bob gently
nearby and waves lap at your feet.

Above Right

—

Freshly grilled fish is a staple across
the Dodecanese islands. Taverna
Mylos, a family-run restaurant in
Agia Marina, is touted as one of
the best seafood restaurants in the
entire archipelago.

SAILING THE DODECANESE ISLANDS

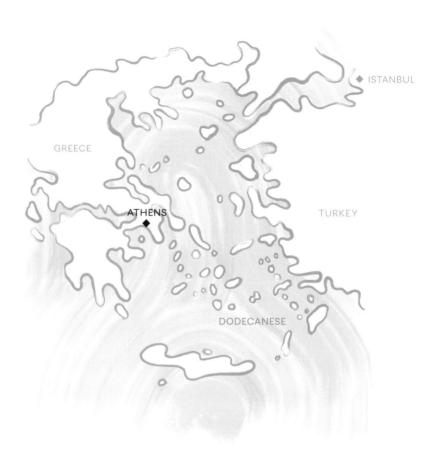

WHERE TO STAY

Away from the larger islands, accommodation on land is simple but comfortable. On the island of Leros, Villa Clara is a delightful guesthouse situated in a neoclassical mansion just steps from the sea. On Lipsi Island, Mira Mare's self-catering studios, within walking distance of lovely Lientou Beach, make the perfect base for exploring.

WHERE TO EAT

Greeks are justly proud of their world-renowned cuisine. On Leros, Taverna Mylos's modern take on local cooking and its stunning setting—in a windmill right by the sea—has earned it a reputation as one of the best restaurants in the Dodecanese. On Lipsi, make sure to order the fresh sautéed tuna at Dilaila on Katsadia Beach.

TIPS

Learning and using a few words— *parakalo* (please) or *excharisto* (thank you)—will be appreciated. Although there is plenty of partying on the larger islands of Rhodes and Kos, most of the smaller atolls are very low-key. The more remote areas rarely have organized harbors, so you can expect to go ashore by tender to visit them.

Expansive but expensive, Iceland is a country made for camping: rent a car, pack a sleeping bag and head off into the great, glacial unknown. Just make sure to do so in summer, and to pack an eye mask for those long, bright Nordic nights.

Car Camping in Iceland

You would be forgiven for wondering whether you've landed on a different planet when touching down at Iceland's Keflavík Airport, from which the road to Reykjavík leads through the otherworldly lava landscape of Reykjanes Geopark. For those looking to explore the country's rugged rural regions rather than its capital, iconic waymarks are available: when you see puffs of steam announcing the famous Blue Lagoon, turn your rental car in the direction of Grindavík.

Revel in the absolute freedom of the landscape. At the wheel of your car, with a tent and sleeping bag in the trunk, you can travel at your own pace, make unexpected discoveries and immerse yourself in the Icelandic landscape by bedding down in it. Summer is the season for camping; the bright summer nights may keep you awake, but the soothing sounds of nature will lull you to sleep. It's also a lot cheaper than other types of accommodation—roughly ISK 1500 to 2000 ($12 to $16) per adult—and there is usually no need to prebook. Keep in mind that wild camping is illegal, however, and stick with official campgrounds.

At the supermarket in Grindavík, you can stock up on snacks for your trip (skyr, flatbread, dried fish, smoked lamb or lamb jerky are all camping staples in Iceland) before joining

Road 427. It takes you past Iceland's hottest new attraction—the site of the 2021 volcanic eruption at Geldingadalir—and to the town of Þorlákshöfn, favored by surfers. At Hafnarnes, you can look out across the open ocean and feel the power of the waves crashing against the rocky shore. At Selfoss, you'll join Ring Road 1, which slings along the south coast past some of Iceland's greatest hits—waterfalls, black-sand beaches and glacier lagoons—and proceeds to circle the entire island. After about two and half hours on the road, you'll arrive at the thundering Skógafoss waterfall and the campsite at its base.

Falling water, birdsong, buzzing flies and the smell of fresh grass are all part of the experience at most campsites, as are cool nights, blankets and the smell of grilled hotdogs and lamb chops drifting through the air. Sometimes there are communal barbecues, but disposable grills are available in most stores, as are pylsur (traditional hotdogs) and bulsur (the vegan variety). Most Icelanders who camp will do so in woolen lopapeysur sweaters while drinking beer, singing and playing games into the night.

In the morning, continue along the south coast Ring Road where bright green vegetation and black-sand plains begin to dominate the landscape and one-lane bridges lead you across roaring rivers. The route also takes you past the

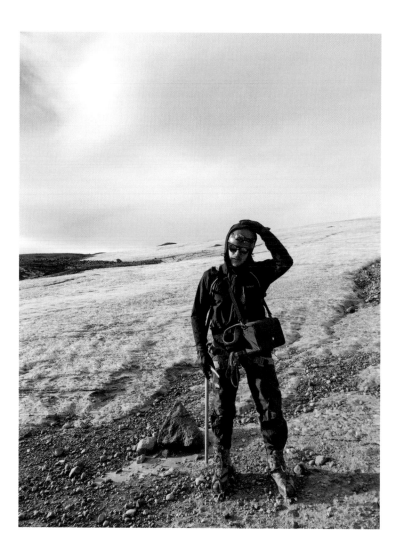

famous arched rock formations of the Dyrhólaey promontory and the Reynisdrangar sea stacks. After another two-and-a-half-hour drive, you'll find Skaftafell campsite in Vatnajökull National Park—an excellent gateway to myriad hiking trails, including one to Svartifoss, a waterfall framed by columnar basalt. Wherever you hike in Iceland, stay on marked paths to spare the sensitive vegetation and not disturb the wildlife. Campfires are absolutely forbidden.

When you're ready to leave Skaftafell, the next leg of the Ring Road leads you along the ridge of Vatnajökull ice cap and past the Jökulsárlón glacial lagoon toward the town of Höfn—a great place for lunch (it's known locally as the "lobster capital"). Continue driving and you'll see narrow fjords, eerie mountains and, occasionally, wild reindeer. After five hours, take Road 95 in Egilsstaðir and then the 931 to camp in Hallormsstaðaskógur—Iceland's largest forest, by the great lake Lagarfljót. When you continue the next day, you could drive around Lagarfljót lake and stop at Hengifoss waterfall, which cascades down distinctly layered cliffs.

A three-hour drive to the north of the island will take you to Húsavík—popular for whale watching and world-class geothermal sea bathing at GeoSea—or onward for another hour to Akureyri, northern Iceland's largest town. You could either spend the night here and enjoy some culture (there's one campsite in town and another on its outskirts), or hop back on either the Ring Road or the Arctic Coast Way for a final night of camping at Laugar í Sælingsdal. Relax in Guðrúnarlaug pool and fancy yourself as one of the protagonists from an ancient Icelandic saga. Before crawling into your tent, take a deep breath and take in the serenity of the peaceful countryside cast in the warm glow of the summer sun. When camping in Iceland, you become one with nature; when you leave, it feels as if you're taking part of Iceland with you.

From here, the drive straight to Reykjavík takes two and a half hours. If you have time to spare, take Road 365 to the campsite at Þingvellir National Park—where Iceland's parliament was founded in 930 CE and tectonic plates drift apart—before your flight home.

Opposite
—
Photographer Robin Falck takes a midhike breather at Vatnajökull, the largest glacier in Europe. It covers 8 percent of Iceland's landmass and conceals active volcanoes and Iceland's tallest mountain peak.

Above
—
In winter, campers can look for the Northern Lights in Iceland's Borgarnes region. Alternatively, the nearby Hotel Húsafell runs an automated alert system, which wakes guests if the aurora borealis appears.

Above
—
It is advised to visit the Vatnajökull glacier only with an experienced guide, even if you are a comfortable solo hiker. The ice can be difficult to navigate without professional help, and snow can cover large crevasses.

Opposite
—
The Hraunfossar waterfall, not far from Reykholt in the west of Iceland, is formed as the water of the Hvítá river flows over lava formations.

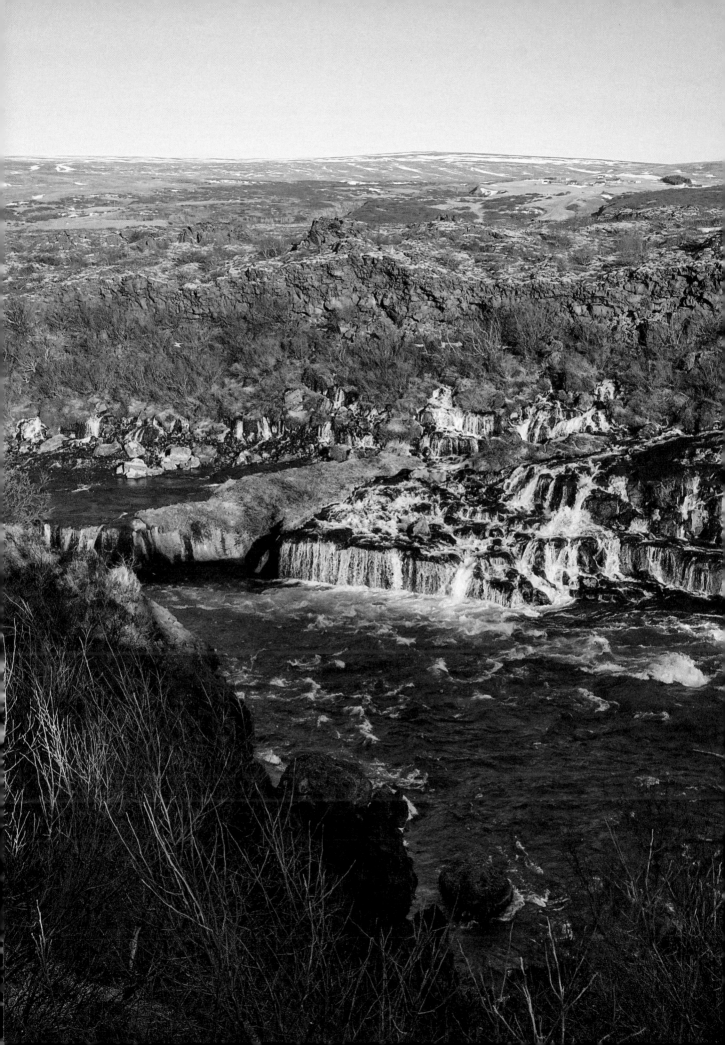

CAR CAMPING ALONG THE RING ROAD

NORWEGIAN SEA

HÚSAVÍK

HALLORMSSTAÐASKÓGUR

REYKJAVÍK ÞINGVELLIR VATNAJÖKULL

HVANNADALSHNJÚKUR
6,923 FT. (2,110 M)

VIK

THE RING ROAD

WHERE TO STAY

If you'd prefer a camping experience with a proper bed, consider sleeping inside a heated, see-through dome—either on the forest floor or hanging from a tree—at Bubble Hotel in south Iceland. For a bit more space, try glamping at Original North—a family-run estate on the banks of a glacial river in the peaceful northern countryside.

WHAT TO EAT

In Höfn, Otto Veitingahús & Verslun is a family-run restaurant offering wholesome food, home-baked goods and scrumptious brunches. In Akureyri, in a red house on Arts Alley, Rub 23 is a seafood restaurant specializing in delicately spiced fish and meat. It's also known for its sushi.

TIPS

Summer is the best season for camping in Iceland, although some campsites stay open in winter. Regardless of the season, bring blankets and warm clothing. It's illegal to build campfires or camp outside of designated campsites. The best rule of thumb is to leave no trace. You can find essential information on driving and camping in Iceland at safetravel.is.

Lanzarote's lunar landscape is home to some of the world's most unlikely vineyards. For hikers eager to escape the island's package holiday enclaves, a day spent on the Camino de la Caldereta is a walk—or stumble—through wine history.

Walking Lanzarote's Wine Trail

The Línea 60 bus to Uga travels back in time. The small town looks like a sunbaked Spanish outpost in nineteenth-century North Africa. Sugar cube houses hide from the heat. Dromedary camels nibble figs. Between May and September, this whitewashed outpost receives just a single day of rain.

Uga can be found on the Canary Island of Lanzarote, however, and is separated from North Africa by eighty-one miles (130 km) of Atlantic ocean. Stranger still, this desert town, on the same latitude as Kuwait and Iran, is the gateway to La Geria—the most unlikely wine region on earth.

The best way to explore the vineyards and bodegas of La Geria is on foot, hiking along an ash-black track named Camino de la Caldereta. From 1730, Lanzarote was riven by six years of volcanic inferno, which pockmarked the island with one hundred caldera sinkholes. Don Andrés Lorenzo Curbelo, a local priest at the time, kept a diary. "Lava ran in cataracts. Huge numbers of dead fish floated about on the sea or were thrown on the shore," he wrote.

Back then, all hell was let loose when crimson magma turned green pastures into black desert. Rain refused to fall. Most of Don Andrés's congregation fled to Cuba. Those who remained in La Geria prayed. Yet when digging into the picón, or ash, islanders found a fertile layer buried below and thrust grapes back into the dust. Today, emerald vines color the moonscape below Montaña Tinasoria, a desolate volcano off the Camino de la Caldereta. Half-moons of stones ring vines, alongside palms, guavas, figs and other thriving fruit, as they have done for centuries.

Visitors to Lanzarote can sample grape varieties that are found nowhere else on earth. During the 1860s, mainland Europe had its own viticultural cataclysm when an invasion by the phylloxera insect destroyed 90 percent of the continent's grapes. These included Vigiriega, which disappeared from mainland Spain. Yet it survived in Lanzarote, where the grape is known today as Diego. La Geria's black-ash vineyards are original—and organic. Each sample of wine punches with volcanic minerality, paired with Atlantic ozone zing. The correct choice of grape was, and remains, essential here. A wimpy Riesling would wilt in these volcanic climes. Instead, wineries have traditionally planted Listán Negro, a grape carried by missionaries to other baking-hot colonies in Mexico and Peru.

The hiking trails that crisscross the twenty square miles (52 sq km) of La Geria can be dizzying, especially if you forget your water bottle or hat. Around lunchtime, the landscape melts like dark chocolate. Wineries like El Grifo, the oldest in

the Canary Islands, tempt hikers with tastings and viticultural boasts, like the chance to sip wines from pre-phylloxera vines, the grapes of which have been crushed by foot.

The secret behind the region's viticultural miracle is told at the winery Bodegas Rubicón, a gentle stroll down the caldera's flank. In the late 1700s, the bodega discovered how best to plant grapes into the picón by digging mini craters ten feet (3 m) deep. These holes helped to collect rainfall, while morning dew seeped down the side toward the vine. Lava rocks were piled above to protect plants against dry prevailing winds from North Africa. Camels were imported from the Sahara to help with the harvest. Grapes grew so abundantly it was all hands—and toes—on deck. The method remains much the same today, minus the camels.

From Bodegas Rubicón, the boozy badlands continue east. Some of the La Geria wine route follows the GR131, a 404-mile (650 km) hiking trail that begins in Lanzarote and zigzags across all seven Canary Islands. Wine-red kilometer posts waymark the route. Other hand-painted signs point to

tastings at more offbeat wineries, like Bodegas Vega de Yuco, which uses organic principles to tend to two-hundred-year-old vines.

Grapes mature indecently fast on the island. Come July, the view from Caldera de los Cuervos—another defunct volcanic crater on the La Geria trail—is enlivened by grape pickers and agricultural trucks. By comparison, in Bordeaux grapes are harvested in September. In Germany's cooler Alsace wine region, the harvest can be as late as November.

There are no trendy wine bars on Caldera de los Cuervos. The three-mile (5 km) path through frozen waves of magma is a primal story of revolution and rebirth. As Don Andrés recorded in 1731: "A gigantic mountain rose and sunk back into its crater on the same day."

Respite at the end of the trail comes in the form of San Bartolomé, another charming town whitewashed against the Canary Island heat. From here, the Línea 20 bus carries hikers back toward Lanzarote's coastal capital Arrecife, where they can explore the city's quiet charm.

Opposite
—
Bodegas Vega de Yuco is a winery that runs sporadic tours and tastings. Although it is a relatively new enterprise, some of the vines growing there are more than two hundred years old.

Above
—
Ermita de la Caridad, a tiny Roman Catholic church in the heart of La Geria, is shaded by a *Schinus molle* tree (also known as a Californian peppertree), which is originally from Peru but is now naturalized in the Canary Islands.

Above
—
Houses on Lanzarote are col-
ored white with local chalk. This,
combined with their simple cube
structure, makes them a striking
intrusion on the black landscape of
the volcanic soil.

Opposite
—
Vines grow just off the side of the
LZ30, the main road stretching
through La Geria. The long and
often entirely straight tarmac road
is popular with cyclists.

HIKING THROUGH LA GERIA'S VINEYARDS

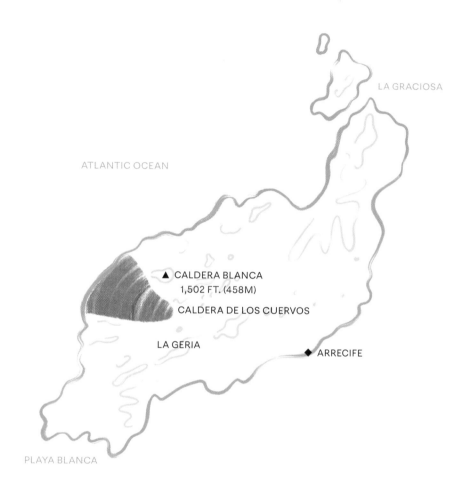

LA GRACIOSA

ATLANTIC OCEAN

▲ CALDERA BLANCA
1,502 FT. (458M)

CALDERA DE LOS CUERVOS

LA GERIA

◆ ARRECIFE

PLAYA BLANCA

WHERE TO STAY

Buenavista Lanzarote is a chic ranch-style hotel bang in the middle of bodega-land. Its five suites mirror the volcanic surrounds: gray stone walls, bare wood paths, crisp white sheets. In this arid zone, lush hotel gardens would be estúpido. Dine instead among cacti, ferns and wine-producing vines.

WHERE TO EAT

El Chupadero is a microcosm of La Geria. The cube-shaped restaurant, which looks from a distance like white dice perched on the black badlands, serves dishes of gazpacho and garbanzos that pair perfectly with the scorching, sky-high landscape. Malvasía Volcánica is served by the glass.

TIPS

Remember, you're hiking through Lanzarote's Wild West. There's no place to purchase bottled water, let alone sunscreen. However, at least you don't need to worry about packing wine: the best bodegas, like El Grifo, will box up bulk purchases and then ship them anywhere in the world—for free.

THE JOYS OF AIRPLANE FOOD

In our globe-trotting era of digital nomads, frequent-flier programs and #travelinspo, it has become chic to look down on airplane food as unappealing and déclassé. On terra firma, the meals might come off as nothing special—at best. But at thirty thousand feet (9,144 m), it's only the most hardened of snobs who can suppress their delight when the dining trolley comes rolling down the aisle.

Everyone looks forward to mealtimes, of course, eating being one of life's great pleasures. It's understandable for lunch or dinner to be even more exciting when you're strapped to a chair in an unnatural position watching Adam Sandler movies on a tiny screen—and have been for the past several hours. Anyone who's been on a long-haul flight will fondly recall the Pavlovian moment those first savory food smells waft through the cabin, distracting the mind from an ever-worsening pinching along the spinal column. Passengers begin shifting and mumbling, and hundreds of eyes stay glued to the flight attendants as they dole out foil-topped pasta and chicken, rolls with individual butter pats, a few leaves of lettuce and plastic pots of chocolate pudding.

But is distraction from boredom and discomfort enough of an explanation for why people go so mad for mile-high mealtimes?

Richard Foss is a California-based food and culture historian and the author of *Food in the Air and Space: The Surprising History of Food and Drink in the Skies*. For him, the question invokes fundamental ruminations about the extraordinary experience of being a human flying through space.

"I believe the appeal of airplane food has to do with the physiology of the human body in flight," Foss says. "Even if you are a regular commuter, on a primal level there is something about the experience of being in an aircraft that puts you on edge. You are in an unnatural and alien environment; a tin can that does not resemble any other environment on earth. There's a low-level sound that constantly reminds you of the differentness of the experience. You're surrounded by strangers, and on some level you're a little bit adrenalized. But food is comforting. It is the most normal thing about the entire airline experience."

The taste of airplane food has been aggressively engineered to telegraph normalcy. It's carb heavy, salty and usually lacking in experimental flavors. "Airline food is formulated to be comfort food. If you are a person who likes adventurous food with unusual flavor combinations, then you can still eat a bland, fatty meal and enjoy it," says Foss. "But if you're someone who likes bland, fatty meals and you're given something wildly adventurous, it's inedible. So, comfort is a calculated decision."

If you're also partial to a single-serving bottle of wine with your cozily bland dinner, you're in decent company. The very first food or drink that was consumed in flight was a bottle of champagne on the first manned hydrogen balloon in 1783, opened to serve a party including Benjamin Franklin and King Louis XVI of France. Here too

"If you're someone who likes bland, fatty meals and you're given something wildly adventurous, it's inedible. So, comfort is a calculated decision."

the purpose was comfort and pleasure: if you're going to die attached to a giant bag of hydrogen, you might as well go out drinking champagne.

As air journeys got longer, the need to feed passengers became more pressing. Because air travel in the early days was astronomically expensive, a tuna sandwich and a few peanuts were never going to cut it. Hot food and drink were required, which presented a problem for flight crews: heat, of course, usually means fire, which is the single most dangerous thing on an aircraft.

Addressing this problem would lead to various innovations over the next few centuries. Some were niche—like the quicklime-water cooking method to heat coffee without fire—but one, in particular, will be familiar to most people who have turned an oven on in the past seventy years.

During World War II, American army personnel realized that troops were arriving in Europe dehydrated and sick due to uncomfortable air crossings "at high altitude in unpressurized aircraft," says Foss. "The US Army put out a military tender looking for entrepreneurs who could find a way of heating food on board. In response to that, an entrepreneur in Los Angeles invented the convection oven, which circulates hot air to heat food very evenly and quickly."

During the post-WWII golden age of airline travel, customer expectations skyrocketed. Before deregulation in 1978, travel prices in the US were fixed by the government. That meant that the only thing an airline could do to win customers was to deliver better service than its competitors. This lead to a new era of airline gimmicks, including a so-called hunting breakfast where Western Airlines stewardesses would parade down the aisles in red hunting jackets, playing recordings of bugles and dogs barking. "There used to be twenty different meals available, from kosher to lactose-free to Hindu vegetarian," Foss fondly recalls. "If you were flying to a Catholic country on a Friday—wow—you were getting fresh seafood!"

Dining on an airplane used to be a luxury affair. Now, in its diminished format, perhaps the thrill of airplane dining is more a testament to the power of food, on a very basic level, to comfort and entertain. Sure, a sumptuous several courses of the finest culinary delights is great. But in its absence, a hot meal is also perfectly adequate. Ultimately, the pleasure of eating on an airplane boils down to the pleasure of eating in and of itself.

HOW TO TRAVEL SLOWER

The antiflying movement started in Sweden, where they call it *flygskam*. Advocates of flight shame, its literal translation, aim to lower carbon emissions by embarrassing passengers into considering alternatives to air travel.

The movement's most famous activist, Greta Thunberg, has rallied adherents behind statistics such as the following: flights contribute 2.5 percent of global greenhouse gases; according to Swiss bank UBS, air travel has been increasing by between 4 and 5 percent each year, essentially doubling every fifteen years; if left unchecked, climatic change might cause sea levels to rise anywhere between twenty inches (.5 m) and six feet (1.8 m) by 2100. As well as sinking entire countries and causing biblical migrations, global warming might sink air travel itself: airports at Key West (five feet/ 1.5 m above sea level) and Venice (seven feet/2 m) would be at risk.

Fortunately, flygskam is already having an effect. In Germany, where the movement is known as *flugscham*, internal flight numbers dropped 12 percent between November 2018 and November 2019. During the same time frame, national rail operator Deutsche Bahn reported record passengers.

Thanks to a new breed of "airline killer" rail routes, it is now a shame to take the plane. Take Milan to Rome. Formerly Italy's busiest air corridor, the route is now served by 186-mph (300 kmh) trains that slice through Lombard orchards and Tuscan hills.

In Smart Class, passengers can work from leather reclining chairs using fold-down desks and free Wi-Fi. Club Class guests receive lounge access and priority boarding, plus the opportunity to consume aperitivi and watch a personal video screen. The journey from city center to city center takes just three hours—far quicker than by jet once you factor in security, baggage claim and the commute into town. Only a masochist would fly Madrid to Barcelona, Istanbul to Ankara or Paris to Marseille, where similar city-to-city rail links exist.

Interestingly, eighteen out of the world's twenty busiest air traffic routes are domestic. As trains get faster (China is currently testing a 370-mph/595 kmh route) and airplanes don't, traffic on the heaviest air corridors could potentially be slashed. High-speed rail projects are currently under construction on two of the world's busiest domestic routes: Tokyo to Sapporo (ten million annual air passengers), and Jakarta to Surabaya (five million).

Taking a train can be a life-affirming joy. On the reopened route from Phnom Penh to Sihanoukville on Cambodia's sun-kissed coast, vintage German carriages rattle along tracks barely used since the Khmer Rouge sealed the country's borders in the 1970s. The little Cambodian train stops at rural villages that sell squid-flavored potato chips before huffing on through jungle silhouettes. Tickets—and a memory to last a lifetime—cost 28 HKR ($7), the same price as an airport sandwich.

Norway's longest passenger train ride runs between Trondheim and Bodø. The 450-mile (724 km) feast of fjords and forests is so telegenic that Norwegian television screened the entire ten-hour journey—minute-by-minute—in a Slow TV special. Tickets for the real thing cost just 300 NOK ($34). Why pay more to fly?

Social media has saved certain rail routes. Turkey's 814-mile (1,310 km) Eastern Express route was slated for the chop until Instagrammers started posting from its decorated train bedrooms (fairy lights, bottles of wine) and strapping GoPros to the train's roof (icy canyons, wild dogs). The official Instagram account for the thirty-hour route now has 400,000 followers. Tickets sell out instantly.

Mark Smith, the train aficionado behind train travel guide *The Man in Seat 61*, has charted rail's rise over the last twenty years. "When I started seat61.com in 2001, and people told me why they wanted to go by train not plane, they'd typically say they had a phobia of flying," he explains. "When I started traveling in the 1980s, climate change wasn't even a thing." Today, passengers tell Smith "two things, together in the same breath: they want an alternative to the airline experience, and they want to cut their carbon footprint."

Smith proposes a second point in favor of slower travel: "I love to travel, but that means the journey as well as the destination," he says. "Trains and ships show you the journey and treat you like a human being. You aren't strapped in, you can stand up and walk around, you can sleep in a bed, eat in a restaurant." Brittany Ferries' routes from the UK now include wildlife volunteers from the marine conservation charity ORCA, who help passengers spot fin whales and striped dolphins en route. "My message is that

you're not suffering to do the planet a favor," says Smith. "On the contrary, you're doing yourself a favor by switching to overland travel."

So why does airline use continue to grow? Bureaucracy doesn't help. It took a decade for Eurostar to launch a single extra route from London to Amsterdam. Ryanair, the world's biggest international airline, typically launches hundreds of new routes—each year. Underinvestment has also been chronic: Amtrak's sleeper services crisscross the great nation they helped unite, but frequently with torn seats and indifferent service. Its flagship high-speed route from New York to Boston averages 68 mph (109 kmh); a cheetah could run faster.

Fortunately, change is in the air. After a seventeen-year hiatus, the Brussels to Vienna Nightjet sleeper recently reopened. It provides cross-continental travel options, with onward connections to London and Paris at one end, and Budapest and Belgrade at the other. By 2022, overnight services operated by Austrian Railways will feature mini-suites that look like capsule hotels. Another new sleeper will link Stockholm to Berlin via Malmö and Copenhagen. Japanese bullet trains have become so speedy that the nation has only a single sleeper service left: the Sunrise Seto from Tokyo to the western coast.

Flygskam has also encouraged travelers to take a look at their carbon footprint more broadly and reduce transportation in general, which accounts for 28 percent of greenhouse gases. Ashamed? Escaping courtesy of an *att smygflyga*, or "a secret flight," the sneaky antithesis of flygskam, isn't the answer.

THE PROS AND CONS OF GPS

You can live in a city for years—a decade, in my case—and still find yourself disoriented at times by its network of streets. Take the neighborhood of Soho in central London: its warren of roads and lanes is so complex that even black cab taxi drivers, famed for their knowledge of the city's geography, often rely on mnemonics to make sense of it. "Good for Dirty Women" spells out the order of the parallel streets Greek, Frith, Dean and Wardour. Or "Little Apples Grow Quickly Please," which pinpoints the location of various theaters on nearby Leicester Square. For anyone navigating a metropolis, small tricks of the mind, drawn from memory or visual cues, have long been necessary to find the way.

Until the advent of GPS, that is. Today, thanks to the prevalence of smartphones, most people walk around with a supercomputer in their pocket. On one hand, this is brilliant news: with easy-access satellite navigation, one need never get lost again. It's a wonderful unifier. Any person, in any city, can find their way by opening an app and waiting for the cursor to settle on the screen, pointing them in the right direction. The blue line that shows the way will bring you to your destination in the least amount of time, and hopefully with the least amount of hassle.

On the other hand, what if we enjoy a little hassle? While nobody would choose a traffic jam over an open road, there is something to be said for the process of navigating

without GPS. Analogue navigation, as we might call it, relies on a constant succession of small choices made by the navigator. Scientific research suggests that making these choices ourselves might actually be good for us. Those aforementioned London taxi drivers? They don't rely on GPS. London's black cab drivers obtain their licenses only after a rigorous course of study and exams referred to as "The Knowledge." It's regarded as the world's most intensive taxi-training program and takes around three years to complete. To pass, drivers must learn 25,000 streets within a six-mile (10 km) radius of the city center and can be quizzed on 320 different routes.

Surprising research from University College London in 2000 showed that black cab drivers have larger hippocampi than other people, and that this section of the brain continues to grow on the job. It's an area that fascinates cognitive scientists like Dr. Eva-Maria Griesbauer, a PhD graduate at UCL who thinks it probably has an impact on how they experience the city too. "I have spoken to loads of black cab drivers who have this knowledge of London and they all reported very similar experiences," she says. "When they are asked to go to a specific place in London, they seem to instantly know how to get there. You might be able to compare it with the neighborhood you live in: you just know where your local supermarket or GP or dentist is. You can get there without actually having to plan a route or look it up on a map."

What this means, Griesbauer says, is that for the taxi driver, the whole city is like their local neighborhood. They can only reach this level of experience through constant use of their brains for navigation, rather than maps or satnav.

"Getting lost is one of the great thrills in life. Surprising things happen. Asking a stranger for directions is one of the few reasons to ask a stranger for anything."

It's a nice idea—that by using our cognitive abilities to navigate, we're capable of making any area into our own turf. And it would suggest that relying on memory, instead of a smartphone, is sometimes a good thing. The New York-based designer and mapmaker Archie Archambault takes this idea and translates it into what he calls "maps of the mind." These maps—paper, of course—outline "the big picture" of a place. It may not be specifically designed to help the user navigate, but instead represents the elements of a place that best define it, such as roads, rivers and landmarks.

These maps are the opposite of the smartphone satnav and more suited to being framed on a wall than being folded into a back pocket. They trade intricate detail for aesthetics and a grasp of how the city looks and feels. But as Archambault notes, there's more to getting around somewhere than simply getting there. "On the one hand, it's really nice to never be lost thanks to satnav," he says. "On the other hand, getting lost is one of the great thrills in life. Surprising things happen. Asking a stranger for directions is one of the few reasons to ask a stranger for anything. Those little interactions help us maintain confidence that society isn't a mess and people are generally good and have some special knowledge."

Running the risk of getting lost can also help you find out new things about a place, even in your hometown. As Griesbauer points out, it takes hard work for cab drivers to turn a whole city into their local neighborhood. "To achieve this level of knowledge, it takes years of training and studying," she says. "But what gets them there is their passion for the city, the challenge of understanding how everything connects in London."

The place I do most of my own idle rambling is Hampstead Heath, an ancient green space spanning 790 acres (320 ha) over north London. When I started walking and running around it, there was limited phone reception, and so I learned my way by getting lost and then eventually getting back on track. I could follow desire lines or paths tramped through muddy woodland, around ponds, up hills and down again. In doing so, I found out new things about the heath: I learned there were woodpeckers to be heard in the trees, and which hills had the best views of London's skyscrapers. I learned about lesser-trodden paths—the best routes to take on busy days—and exactly how far to travel to simply escape the sound of traffic. Years later, I know all of this in a way that feels concrete, even though I am aware that memory is not perfect or permanent—even the hippocampus of a cab driver begins to shrink after retirement. But when I walk on Hampstead Heath now, I do so automatically, relying on nothing more than pleasure, memory and desire to choose my route for me.

Thank You

The *Kinfolk* team would like to extend as many thanks as there are books in Baltimore, or fish in Georgia, to everyone who took part in making this publication.

We would particularly like to thank all of the people featured within its pages—in photographs and in interviews—for welcoming us into the places they call home and for so graciously expending the considerable time and effort required to tell these stories so beautifully. Thank you for your patience, hospitality and generosity of spirit.

We would also like to sincerely thank the many talented photographers and writers around the world who captured these stories and brought them to life. What we do would not be possible without you, and we're grateful that you offered *Kinfolk* your eyes and ears on the world. We consider it an honor and a privilege to collaborate, and we're proud to publish your work. A particular thanks goes to seasoned travel writer Stephanie d'Arc Taylor, who coaxed the tips sections of our Urban and Wild chapters into being.

The *Kinfolk Travel* creative team is made up of John Burns, Staffan Sundström, Harriet Fitch Little and Julie Freund-Poulsen. A special thank-you to Staffan, who designed this entire publication and art directed and commissioned every single photo shoot. For his part, Staffan would like to thank Dr. Anne Glarbo of the Tórshavn emergency room for patching up his head after he was injured while shooting in the Faroe Islands.

In-house production has been the work of Susanne Buch Petersen and Eddie Mannering—thank you for keeping us all on track. Thanks also to the rest of our colleagues at *Kinfolk* for your input and your patience: Chul-Joon Park, Seongtaek Jang, Christian Møller Andersen, Cecilie Jegsen and Alex Hunting.

Thanks to Jessica Posada—the model featured on the cover of this book—and to cover photographer Rodrigo Carmuega for always pulling whatever we ask for out of the bag. Thank you also to Lune Kuipers, who styled the cover shoot, to Michael Harding for hair and makeup and to set designer Phoebe Shakespeare, whose impressive work remains behind the scenes.

We would like to extend an enormous thank-you to our publisher Lia Ronnen at Artisan Books, for always supporting *Kinfolk* and taking it to new heights. Similarly, we'd like to extend the same gratitude to Bridget Monroe Itkin, Nancy Murray, Suet Chong, Zach Greenwald and Carson Lombardi at Artisan Books for their ideas, advice and hard work throughout this project. We'd also like to thank Theresa Collier, Allison McGeehon and Amy Kattan Michelson for bringing the book to life.

As always, we'd like to thank you—the reader—for choosing to spend time with us. We hope this book inspires you to see the world anew.

CREDITS

WRITERS

Astrig Agopian
293–294

Rima Alsammarae
65–66

Amira Asad
259–260

Ann Babe
27–28

John Bartlett
37–38

John Burns
11, 343

Stephanie d'Arc Taylor
330–333

Cody Delistraty
223–225

Daphnée Denis
104–107

Tom Faber
101–103

Heidi Fuller-Love
301–302

Ayn Gailey
281–282

Adam Graham
229–230

Alice Hansen
91–92

Teri Henderson
83–84

Tim Hornyak
214–217

Elle Hunt
137–138

Gauri Kelkar
73–74

Ana Kinsella
338–341

Alexandra Marvar
191–192

Francesca Masotti
47–48

Sarah Moroz
15–16

Lina Mounzer
171–172

Okechukwu Nzelu
203–204

Monisha Rajesh
271–272

Asher Ross
108–111

Tristan Rutherford
319–320, 335–337

Alex Shams
147–148

Ricci Shryock
57–58

Eygló Svala Arnarsdóttir
311–312

Tom Taylor
181–182

George Upton
155–156, 243–244

Pip Usher
115–116, 281–221

Natalie Whittle
127–128

ADDITIONAL COVER CREDITS—Photography Assistants: Darren Smith & Joe Wiles. Styling Assistant: Grizel Salazar. Hair and Makeup Assistant: Olivia Cochrane. Set Design Assistant: Hannah Joynson. Production: Phoebe Hall and Dan Line at The Production Factory. Jessica wears a hat by Mature Ha via Mouki Mou, a jumper by Toogood, trousers by Studio Nicholson, a backpack by Egg and boots by Legres. Bike saddle and grips by Brooks England.

INDEX

Note: Page numbers in *italics* refer to photographs.

Library of Congress Cataloging-in-Publication Data

Names: Burns, John, 1987–
Title: Kinfolk travel : slower ways to see the world / John Burns.
Description: New York, NY : Artisan, a division of Workman
Publishing Co., In., [2021]
Identifiers: LCCN 2021015463 | ISBN 9781648290749
(hardback)
Subjects: LCSH: Travel. | Travel--Psychological aspects. | Slow
life movement. | Mindfulness (Psychology)
Classification: LCC G155.A1 B8827 2021 | DDC 910.2/02—dc23
LC record available at https://lccn.loc.gov/2021015463

Artisan books are available at special discounts when
purchased in bulk for premiums and sales promotions as
well as for fund-raising or educational use. Special editions
or book excerpts also can be created to specification. For
details, contact the Special Sales Director at the address
below, or send an e-mail to specialmarkets@workman.com.

For speaking engagements, contact
speakersbureau@workman.com.

PUBLISHED BY
Artisan
A division of Workman Publishing Co., Inc.
225 Varick Street
New York, NY 10014-4381
artisanbooks.com

Artisan is a registered trademark of
Workman Publishing Co., Inc.

Published simultaneously in Canada by
Thomas Allen & Son, Limited

Printed in China

10 9 8 7 6 5 4 3 2

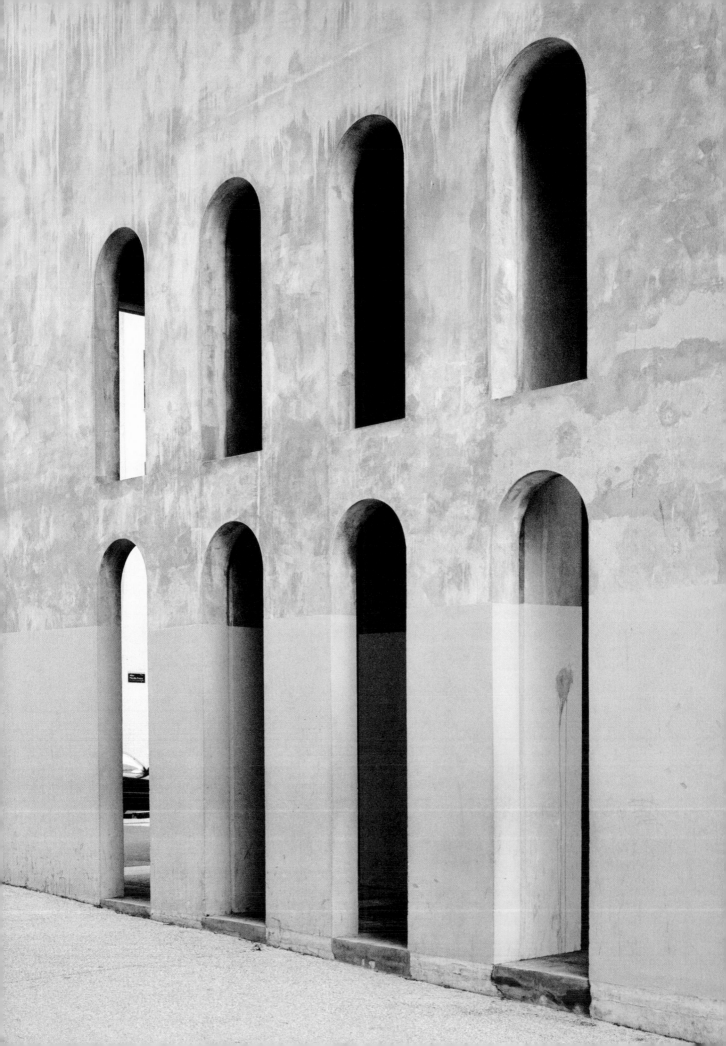